PERFORMING MEDIEVAL TEXT

LEGENDA

LEGENDA is the Modern Humanities Research Association's book imprint for new research in the Humanities. Founded in 1995 by Malcolm Bowie and others within the University of Oxford, Legenda has always been a collaborative publishing enterprise, directly governed by scholars. The Modern Humanities Research Association (MHRA) joined this collaboration in 1998, became half-owner in 2004, in partnership with Maney Publishing and then Routledge, and has since 2016 been sole owner. Titles range from medieval texts to contemporary cinema and form a widely comparative view of the modern humanities, including works on Arabic, Catalan, English, French, German, Greek, Italian, Portuguese, Russian, Spanish, and Yiddish literature. Editorial boards and committees of more than 60 leading academic specialists work in collaboration with bodies such as the Society for French Studies, the British Comparative Literature Association and the Association of Hispanists of Great Britain & Ireland.

The MHRA encourages and promotes advanced study and research in the field of the modern humanities, especially modern European languages and literature, including English, and also cinema. It aims to break down the barriers between scholars working in different disciplines and to maintain the unity of humanistic scholarship. The Association fulfils this purpose through the publication of journals, bibliographies, monographs, critical editions, and the MHRA Style Guide, and by making grants in support of research. Membership is open to all who work in the Humanities, whether independent or in a University post, and the participation of younger colleagues entering the field is especially welcomed.

ALSO PUBLISHED BY THE ASSOCIATION

Critical Texts
Tudor and Stuart Translations • *New Translations* • *European Translations*
MHRA Library of Medieval Welsh Literature

MHRA Bibliographies
Publications of the Modern Humanities Research Association

The Annual Bibliography of English Language & Literature
Austrian Studies
Modern Language Review
Portuguese Studies
The Slavonic and East European Review
Working Papers in the Humanities
The Yearbook of English Studies

www.mhra.org.uk
www.legendabooks.com

Performing Medieval Text

EDITED BY ARDIS BUTTERFIELD,
HENRY HOPE AND PAULINE SOULEAU

LEGENDA

Modern Humanities Research Association

2017

Published by Legenda
an imprint of the Modern Humanities Research Association
Salisbury House, Station Road, Cambridge CB1 2LA

ISBN 978-1-910887-13-4 (HB)
ISBN 978-1-78188-378-5 (PB)

First published 2017

Copy-Editor: Charlotte Brown

CONTENTS

ACKNOWLEDGEMENTS

Reading the *Roman de la Rose*, we were struck by the importance of performance in medieval texts and began to experience, at first hand, how this aspect of medieval culture could fruitfully bridge disciplinary divides and foster interdisciplinary dialogue. We continued to explore the issues of *Performing Medieval Text* at a small two-day conference held at Merton College, Oxford, in May 2013, supported generously by the Music and Letters Trust, the Royal Musical Association, the Society for the Study of Medieval Languages and Literature, the Maison Française d'Oxford, the faculties of Music and of Medieval and Modern Languages at the University of Oxford, Brepols Publishers, and Merton College. As important as the institutional support we received was the encouragement given, in particular, by Daniel Grimley and Almut Suerbaum, who strengthened our resolve to continue this dialogue in printed form. Inspired by her sister's fascination with the medieval, Camille Souleau provided the project with its recognizable face, now the cover of the book.

This collection is decidedly not a conference proceedings. While all but two of the authors were present at the conference, only five of the essays are based on papers delivered in 2013. Inspired by the discussions and ideas exchanged, the six additional contributions were commissioned especially for this volume. The authors are to be thanked for their patience during the editorial process and their willingness to respond to comments from editors from three very different scholarly backgrounds. We are indebted to Ardis Butterfield for her readiness to share her editorial experience and scholarly expertise: her insistence on a critical reflection on performance allowed the volume to develop its nuanced, multifaceted understanding of the term, while nevertheless coming together as a coherent whole.

We would like to thank Graham Nelson and Legenda's editorial board for accepting the present volume and for offering critical guidance and support from the very beginning, as well as Charlotte Brown for her meticulous editorial assistance on the ground. Finally, this volume would not have appeared in print without the generous financial support of the Mariann Steegmann Stiftung (University of Bern) and the Ludwig Research Fund for the Humanities at New College, Oxford. We are grateful to Gene Ludwig and the fund committee for allowing us to turn *Performing Medieval Text* into a printed text, and to Cristina Urchueguía and the Mariann Steegmann Stiftung for enabling the volume to appear in full colour.

H.H., P.S., Oxford and Bern, August 2017

LIST OF ILLUSTRATIONS

❖

LIST OF TABLES

ABBREVIATIONS

BL	British Library
BnF	Bibliothèque nationale de France
KJV	*The Bible: Authorized King James Version*, ed. by Robert Carroll and Stephen Prickett (Oxford: Oxford University Press, 2008)
MGG2	*Die Musik in Geschichte und Gegenwart*, ed. by Ludwig Finscher, 2nd edn, 29 vols (Kassel: Bärenreiter, 1994–2008)
NGrove	*The New Grove Dictionary of Music and Musicians*, ed. by Stanley Sadie, 29 vols (London: Macmillan, 2001)
OED	*Oxford English Dictionary*
VD16	Verzeichnis der im deutschen Sprachbereich erschienenen Drucke des 16. Jahrhunderts, <https://opacplus.bib-bvb.de/Touchpoint_touchpoint/start.do?searchProfile=Altbestand&SearchType=2>
vdm	Verzeichnis deutscher Musikfrühdrucke [Catalogue of early German printed music], <www.vdm.sbg.ac.at>

INTRODUCTION

Performing Medieval Text

Henry Hope and Pauline Souleau

Discussions of performance 'have resonated through the theoretical writings of the past three decades in a carnivalesque echolalia of what might be described as extraordinarily productive cross-purposes'.[1] The claim that concepts of performance and performativity permeate the critical literature across the humanities, made over twenty years ago, continues to hold true today. Yet Eve Kosofsky Sedgwick and Andrew Parker's assertion that this 'carnivalesque echolalia' has been 'extraordinarily productive' may be put to question: the concept's ubiquitous use at 'cross-purposes' has created a complex terminological web that is becoming increasingly difficult to untangle — not least because of its varying connotations in different disciplines and through historical contingency.[2] Consequently, several studies have attempted to come to terms with performance in a comprehensive way, among them the highly theorized collection by Uwe Wirth, who asserts that 'performance can relate to the serious execution of speech acts, the produced staging [inszenierendes Aufführen] of theatrical and ritual acts, the material embodiment of messages in the "act of writing", or the constitution of imaginations in the "act of reading" '.[3] Given the multiple dimensions of performance, it has become a trope to begin volumes concerning the topic with an enumeration and distinction of these disciplinary divides.[4] Avoiding this cliché and acknowledging that this work has been done by authors much more competent in theoretical abstraction, the present introduction seeks not to establish yet another historiographical overview of performance as a critical tool, but to allow it to stand as a 'contested concept'.[5] Instead, in the following, we hope to foreground those aspects from this broad canvas that seem most pertinent for the study of the Middle Ages, arguing for the importance of historical, empirical discussions of theoretical concepts.

Several authors have stressed that, at its core, the concept of performance engenders 'a shift from structure to process, from positions to practices, from the description to the production and reception of meaning'.[6] Literary scholars in particular have been keen to discuss and theorize these aspects: Cornelia Herberichs and Christian Kiening have observed a trend 'to study texts, images, or signs more generally, less for their stable, intentional, or referential meanings than for what happens to them when they become "events", and how they construct ever new

meanings'.[7] These perspectives critique the prevailing approaches to culture through stable, material artefacts — including texts.[8] Traditionally, text and performance might even be understood as opposing concepts.[9] Thus, it could seem ironic that this volume proposes to study medieval texts from precisely such a performative perspective. Medieval repertoires, however, critique modern notions of textual stability. Their heavy reliance on memorization 'challenges us to take account of a precision as well as looseness in medieval citation [and textuality in a more general sense] that is largely outside our experience as modern readers'.[10] In this context, medieval textuality can be understood in the broadest sense as something that calls for performance. Such texts include written, literary sources, but also encompass orally transmitted repertoires, actual performances, as well as texts transmitted through non-linguistic means such as music or art. With reference to the opening lines of the famous *Nibelungenlied*, Almut Suerbaum and Manuele Gragnolati have questioned whether medieval culture can ever be described in the rigid binaries of 'bookish representation and embodied voice', seeking to replace these categories with notions of textual permeability and flexibility:

> On the one hand, medieval culture is seen as dominated by the transition from orality to literacy, by a focus on writing, signs, signification, and hermeneutics. On the other hand, aspects of ritual, gesture, and process are at the forefront of current interest. Often, therefore, studies construct a dichotomy of contrasts between 'static' hermeneutics and a 'process-oriented' focus on presence. Yet the question arises whether such polar oppositions really capture the characteristics of a culture which so often favoured tripartite rather than bipartite structuring, and whether in fact medieval culture is best understood as inhabiting the liminal space, in other words, whether it should [...] be seen as situated 'between body and writing'.[11]

Understood in this fluid, non-categorical way, notions of performance overlap with those of text, making it possible to study 'the performativity of the text, and the textuality of performance'.[12] Thus, the title of this volume, 'Performing Medieval Text', is to be understood as a single semantic unit. Rather than focussing on performance, text, and medieval culture separately, we propose that the three elements ought to be thought *together*. As the contributions to this collection show, the perspective of performance can be made to bear on medieval texts fruitfully in many different ways.

Given the emphasis on the processual, open-ended nature of performance, it may seem paradoxical that performance studies have recently witnessed a renewed interest in the materiality of their objects. According to Foucault, materiality 'is constituent of the statement itself: a statement must have a substance, a support, a place, and a date' ['est constitutive de l'énoncé lui-même: il faut qu'un énoncé ait une substance, un support, un lieu et une date'].[13] In medieval studies, the manuscript page has attracted particular attention, with scholars now foregrounding its ways of transmitting a message rather than focusing exclusively on the message itself. 'Reading the words on a manuscript page [...] is like watching a performance unfold'.[14] Or, worded more boldly and without the concessionary element of comparison: 'the manuscript page is a site of performance'.[15] The collections edited

by Kathryn Duys, Elizabeth Emery, and Laurie Postlewate, and Kate Maxwell, James R. Simpson, and Peter V. Davies certainly go some way to help establish 'more nuanced understandings of the relations between what have been blandly, confidently distinguished as "text" and "context"', but the present volume tries to avoid such ontological claims.[16] While agreeing that the manuscript page can indeed act as a site of performance, this collection hopes to differentiate such claims by asking 'what kind of performance?' and 'how does it correlate with other kinds of performance?'. Building on the scholarship of the past decades, the volume takes for granted *that* medieval texts are performative, seeking to illustrate and place alongside each other various different guises that these performances can assume. It seems of little use to complicate the already heavily theoretical concept of performance further by likening it to other conceptual categories from individual disciplines, such as the suggestion to understand performance 'along the same lines as the term "musicking", which is widely accepted in ethnomusicology and music education'.[17] The essays collected together here, by contrast, emphasize that different understandings of performance may exist alongside each other without necessarily needing to rely on a common model borrowed from one discipline or another: some authors may overlap, in part, in their shared understanding of performance, while others may instead have a different area of interest, disciplinary approach, or type of repertory in common. By turning to individual examples in order to capture rather than categorize individual modes of performance, the volume practises an approach that could also be fruitful in other fields of performance studies, not only in relation to the Middle Ages.

The renewed interest in the materiality of performance has also called fresh attention to aspects of reception. As Herberichs has argued, the concepts of performance and materiality 'are directed towards the activity of recipients' who create new, equally valid texts.[18] Medieval scholars appear particularly attuned to this aspect of performance and have generally withstood the temptation to consider alternative versions, translations, and later adaptations as 'downgradings'.[19] For example, Emma Campbell and Robert Mills have pointed out that medieval scholars have not fallen prey to 'the evaluative approach [which] assumes that translations can be traced back to an originary "source", that translation is always a second-order phenomenon, and that its success as a transmitter of meaning resides in its ability to keep faith with the "original" from which it derives'.[20] Paul Zumthor's notion of 'mouvance' has been particularly influential in shaping the understanding of variation and adaptation proposed by medievalists: as Lois Potter has argued in the case of Robin Hood, 'the most significant aspect of a legend that is performed is its potential for variation from one occasion to another'.[21] The notion of performativity thus implies a 'means of establishing meaning that can never be fully controlled' in particular, but not exclusively, for medievalists.[22] This lack of control is not to be understood negatively: the performative turn is 'largely animated by an anti-hermeneutic impetus, which is suspicious of the assumption that meaning, authorial intention, identity, substance, or essence could be pre-existing in works of art or literature, or even theatre performances or everyday actions'.[23]

Introductory studies to concepts of performance frequently set up a dichotomy between 'performance' and 'performativity', only in order to suggest that recent scholarship has sought to bridge the gap between them.[24] The former term captures the dramatic sense of performance, emphasizing its theatrical aspects; the latter is rooted in speech act theory as developed by J. L. Austin in the 1950s, who considered how language could constitute (rather than represent) reality. In his conception of such 'performatives', Austin expressly excluded the dramatic words of an actor on stage, which he categorized as 'non-serious'. In his reading of Austin's theory, Jacques Derrida turned to precisely these 'non-serious' utterances, establishing the importance of iterability over Austin's notion of seriousness for performative processes. In the wake of Derrida, Judith Butler has been central in bringing together bodily notions of performance with the 'constructive' understanding of performativity. Originally applied to the construction of gender, Butler's conception of performativity 'has enabled a powerful appreciation of the ways that identities are constructed iteratively through complex citational processes'.[25] Peggy Phelan mediated between Butler's ideas and notions of authenticity, developing the concept of 'unmarked' iteration; Philip Auslander, in turn, strengthened Phelan's claim that authenticity is produced through the reproduction of discursive norms, but critiqued her rigid understanding of performance as unmarked, arguing that performance constitutes itself through the relationship of live enactment and medial capturing.[26] Auslander's contribution to the debate demonstrates that Austin's and Derrida's theories have had an impact beyond the discrete fields of literary and gender studies, reaching out into the fields of media and communication, and even encouraging the self-sufficient discipline of Performance Studies. Crucially, Auslander allows for memory as one such means of medial reproduction, thus making it possible to relate his model of 'liveness' to medieval practices of performance. Avoiding the contested boundaries between performance and performativity, between marked and unmarked citation, between body and speech, the title of the present volume consciously seeks refuge in the gerund 'performing'. This decision acknowledges the difficulty of distinguishing rigidly between performance and performativity in a volume focused on the Middle Ages. Rather than trying to separate these two concepts, the volume sets out to demonstrate that 'performing' can be seen to exist, with Suerbaum/Gragnolati, in 'the liminal space' of medieval culture, both marked and unmarked. Focusing on the overlap instead of the distinctions between performance and performativity, and deliberating the fuzziness of these concepts may also prove an avenue worth pursuing in Performance Studies more generally.[27]

With this conflation of performance and performativity, *Performing Medieval Text* sits squarely with other appropriations of the concept in cultural studies. As Wirth has noted:

> The engagement of performance theory in cultural studies is characterised by three tendencies; firstly, by the tendency to theatricise the concept of performance, contemplating the overlap between doing something [Ausführen] and enacting something [Aufführen]; secondly, by the tendency to insist on the iterative elements of performance, placing into the limelight problems of

citation; both tendencies, thirdly, have merged in a joint interrogation of the conditions of embodiment which lead to a mediatisation of performance.[28]

Moreover, scholars have begun to apply these concepts beyond the confines of the Western world, promoting an ethnographical interest in 'singers, dancers, storytellers, street performers, clowns, preachers, shadow puppeteers, and semi-theatrical performances in many folk and other celebrations'.[29] These divergent interests all find reflection in the contributions that are gathered together in the present collection. Each of the essays situates an empirical discussion of historical performances within the wider theoretical exploration of this term. While individual contributions may lay their focus on one or the other, they all range 'from the micro to the macro', considering the implications of their findings for the theorization of medieval notions of performance or, inversely, applying theoretical musings to historical examples.[30]

The introductory essays tackle three issues which resonate throughout the other contributions. Elizabeth Eva Leach invites readers to consider the various ways in which medieval manuscripts may have related to performance: as objects designed *for* performance, as documents *of* performance, and *as* performances in themselves. Before this backdrop, Leach traces the shift of scholarly attention from considering how songs came to be in books to how books engendered and influenced the further use of songs. Catherine Léglu's essay similarly probes the relationship between written sources and their performances. Focussing on the representation of the story of Samson and Delilah in medieval song and drama, she asks how such stories navigated genre boundaries and how they were transmitted from one cultural milieu to the next. The prophet Job takes centre stage, quite literally, in the contribution by Franz Körndle. Although Job was venerated as the patron saint of musicians in the Middle Ages, there is no evidence to suggest that performers considered the prophet himself to have been a musician. Consequently, Körndle challenges us to reconsider ontologies of performance by reflecting on the self-image and role of the performer.

Moritz Kelber's discussion of the imperial entry into Augsburg in 1530 takes up this challenge by asking how the singers who welcomed Emperor Charles V with the antiphon 'Advenisti desiderabilis' adopted for themselves the image of the forefathers languishing in purgatory. Audiences would have recognized this image given the antiphon's use in liturgical plays, and Kelber points to similar adaptations of the antiphon text in motets that were used in the context of episcopal entries. Purgatory also affords a central site for performance in Dante's *Divine Comedy*. Jennifer Rushworth outlines the way in which the Psalms evoke both individual and communal performance. The performance of the liturgy itself is considered as an act of performance by Matthew Cheung Salisbury, who illuminates Thomas Aquinas's discussion of the sacraments with Austin's speech act theory. In the case of Dante's *Purgatorio* as well as the Augsburg *Adventus*, well-known liturgical material is placed into a new context, generating meaning and affording links for the audience, who held these texts in their memories. Considering the presence of song refrains in thirteenth-century motets, Matthew P. Thomson draws attention

to a different crossing of genre boundaries. Thomson focuses on the crafted nature of this repertoire and proposes nuanced modes of understanding the way in which it employed citation — marked or unmarked, real or fictitious.

The crafted nature of medieval texts is likewise a central concern for Annemari Ferreira's exploration of Skaldic verse. She asks how these texts transmitted news [*tíðindi*], reflecting 'both culturally inherited perceptions about specific experiences, as well as more universal timeless insights' (Chapter 4). Pauline Souleau assesses the telling of stories in Jean Froissart's *Chroniques*. Her contribution shows how Froissart's multi-layered identities as interlocutor, note-taker, chronicler, and performer are crafted in the Béarn episodes. Charlotte E. Cooper takes a different approach to studying the authorial presence of the French poet Christine de Pizan. Cooper discusses the famous images found in Christine's manuscripts and complicates the assumption that the female figure in blue dress was always intended to represent the author. Finally, the manuscript page as a sight of representation and imagination also finds discussion in Henry Hope's contribution. Studying the plethora of re-imaginations of the German song 'Loybere risen' in modern editions, Hope approaches performance through the lens of reception. The printed pages of the editions allow modern performers to engage with the song and, at the same time, they afford an appropriation and resignification of the song's identity.

Hope's contribution is not the only one to look beyond 'those meanings which were relevant at the time', taking up the invitation to 'accept that anachronism — or perhaps more accurately cultural difference — can and does inform interpretation and criticism' and widening the volume's focus on the Middle Ages to offer a sideways glance at modern performances of medieval texts.[31] Souleau, for example, closes her discussion of Froissart's text by drawing attention to Alexandre Dumas's recrafting of Froissart's material and identities in his historical novels. Similarly, Rushworth concludes by emphasizing the value of performing Dante's works in the liturgy of the twenty-first century, and Cheung Salisbury raises the question of how the Second Vatican Council may have reshaped the traditional understandings of the liturgical act. The connections between the individual contributions to this volume thus criss-cross and are multivalent. The order introduced by the editors should be understood as merely one way of tackling the collection. One may, for example, fruitfully read alongside each other the essays by Rushworth, Cooper, and Souleau and consider the ways in which certain authors perform their own identity, but it is equally provocative to read Rushworth's essay against those by Kelber and Thomson from the perspective of citation, or against Cheung Salisbury's from a liturgical vantage point. The volume is to be understood as a dialogue with twelve interlocutors, and coming to realize the multivalent ways in which the articles speak to one another has been one of the most rewarding aspects of bringing together this volume.

However, this diversity also poses challenges, and it is important to acknowledge that the much-applauded ideal of interdisciplinarity is often much easier to invoke than it is to perform successfully on paper. Featuring contributions by literary scholars (from various subdisciplines) and musicologists, tackling topics from *c.* 1000

to 1530 and beyond, ranging from saga literature, the liturgy, vernacular song, to political ritual, the volume offers not only potential for disagreement and misunderstanding, but also for an unmanageable degree of nuance. How much breaking-down and variation can the concept of performance sustain without becoming so refined that it falls through the disciplinary cracks? It is maybe not surprising that, to date, performance has been discussed within disciplines, but has given rise to very few interdisciplinary publications.[32] Perhaps performance is even best understood as an 'anti-discipline'.[33] In addition to the inherent, pragmatic problems of interdisciplinarity — how to reference manuscripts, how much explanation of scholarly debates to include, how to make materials (music, languages) accessible regardless of a reader's background — the volume's discussion of performance uneasily sits *alongside* other interdisciplinary attempts to capture medieval culture. It remains to be seen how the concept of performance is related to those of memory and translation, for instance. Performative processes of citation cannot be understood without recourse to medieval notions of memory; and issues of appropriation share much in common with discussions of reception, medievalism, and translation.[34] None of these terms has the strong sense of action, of bodily enactment that is carried by the double sense of performance, however, which does make the latter an apt means of bringing together the examples under discussion in this volume. Nevertheless, future studies will need to assess the sustainability of these interdisciplinary umbrella terms and spell out in more detail the relationship between them.

Two further, significant problems which edited collections face are those of authorship and readership, all the more so if they are interdisciplinary. The concepts behind such volumes are often ignored by selective readerships whose interest remains firmly focused on the individual contributions directly relevant for their own discipline. In collections, including *Performing Medieval Text*, editors work hard to negotiate and correlate the ideas expressed in the individual contributions, offering multiple rounds of feedback and opportunities to nuance opinions. This iterative process is requisite for interdisciplinary dialogue and for volumes that hope to illustrate overarching phenomena such as performance, resulting in more than the sum of their parts and deriving their value from the variety and nuance of individual contributions while affording large-scale, complex arguments through cross-purposing. In the case of 'translation', for example, 'edited collections have played a vital role in exploring this territory and there is a substantial body of scholarship of this kind examining translation as a pragmatic or creative practice'.[35] The same could be said of performance, and it is no coincidence that almost all of the volumes quoted in this introduction are other edited volumes, albeit limited in their interdisciplinary reach. Multi-author volumes allow sustained engagement with a given topic from a variety of disciplinary vantage points. Over the journal, they have the advantage of focusing on a circumscribed subject area and (hopefully) affording a dialogue between the contributors; over the single-authored monograph, they have the advantage of allowing diverse voices to speak without resulting in a cacophony of antagonistic volumes, bearing little relation to one another.

It is this openness, complexity, and diversity that constitutes the value of *Performing Medieval Text*. The volume opens the floor for a variety of voices in many respects: place (German, Italian, French, Norse), time (*c.* 1000–1530), genre and object (song, epic, chronicle, romance, liturgy, ritual, manuscript). The essays' historical specificity and depth afford the establishment of nuanced understandings of performance as a concept and aid the development of analytical categories for medieval texts.[36] As suggested above, the volume eschews one-dimensional readings. Indeed, 'the potential of performance theory lies not in the establishment of clear-cut oppositions between norm and subversion, stasis and transformation, essence and accidence, but in the ability of its critics to remain continuously aware of the provisionality of their own perspective'.[37] The volume deliberately sidesteps rigid understandings of performance, as they inhibit interdisciplinary scholarship. Instead, our theoretical toolkit must remain open to modification, nuance, and disagreement in order to prove helpful: 'ultimately, performativity and performance will remain workable terms only if they are not codified as values unilaterally, nor extended to become fixed cultural paradigms, principle definitions [Leitbegriffe] which replace reading processes that take the specific as their starting point'.[38] On the basis of such historical readings, *Performing Medieval Text* establishes the Middle Ages as a fecund, privileged site for the exploration of performance, without limiting medieval culture to performance and without wishing to restrict performance to this period; it suggests the possibilities of transcending disciplinary boundaries and the opportunities for interdisciplinary exchange in relation to performance; and it calls for a continued, collaborative discussion on the processes involved in the performance of medieval texts.

Notes to the Introduction

1. Andrew Parker and Eve Kosofsky Sedgwick, 'Introduction: Performativity and Performance', in *Performativity and Performance*, ed. by Andrew Parker and Eve Kosofsky Sedgwick (New York: Routledge, 1995), pp. 1–18 (p. 1).
2. Carolin Duttlinger and Lucia Ruprecht, 'Introduction', in *Performance and Performativity in German Cultural Studies*, ed. by Carolin Duttlinger, Lucia Ruprecht, and Andrew Webber (Oxford: Lang, 2003), pp. 9–19 (p. 18).
3. Uwe Wirth, 'Der Performanzbegriff im Spannungsfeld von Illokution, Iterabilität und Indexikalität', in *Performanz: zwischen Sprachphilosophie und Kulturwissenschaften*, ed. by Uwe Wirth (Frankfurt a. M.: Suhrkamp, 2002), pp. 9–60 (p. 9). All translations in this introduction are by the editors.
4. Eckhard Schumacher, 'Performativität und Performance', in *Performanz*, ed. by Wirth, pp. 383–402 (p. 383).
5. Marvin Carlson, *Performance: A Critical Introduction*, 2nd edn (New York: Routledge, 2004), p. 1.
6. Duttlinger and Ruprecht, 'Introduction', p. 9.
7. Cornelia Herberichs and Christian Kiening, 'Einleitung', in *Literarische Performativität: Lektüren vormoderner Texte*, ed. by Cornelia Herberichs and Christian Kiening (Zurich: Chronos, 2008), pp. 1–13 (p. 2).
8. Vincent Rzepka, *Sangspruch als Cultural Performance: zur kulturellen Performativität der Sangspruchdichtung an Beispielen Walthers von der Vogelweide* (Berlin: Logos, 2011), p. 11.
9. Carlson, *Performance*, p. 209.
10. Ardis Butterfield, 'Introduction', in *Citation, Intertextuality and Memory in the Middle Ages and the Renaissance*, ed. by Yolanda Plumley and Giuliano Di Bacco (Liverpool: Liverpool University Press, 2013), pp. 1–5 (p. 2).

11. Almut Suerbaum and Manuele Gragnolati, 'Medieval Culture "Betwixt and Between"': An Introduction', in *Aspects of the Performative in Medieval Culture*, ed. by Manuele Gragnolati and Almut Suerbaum (Berlin & New York: de Gruyter, 2010), pp. 1–12 (pp. 1–2).

12. Duttlinger and Ruprecht, 'Introduction', pp. 9–10.

13. Michel Foucault, *Archaeology of Knowledge*, trans. by A. M. Sheridan Smith, Routledge Classics (London & New York: Routledge, 1989), p. 113; for the original French, see Michel Foucault, *L'Archéologie du savoir*, Bibliothèque des Sciences humaines (Paris: Gallimard, 1969), p. 133. Foucault's turn to materiality is also discussed in Wirth, 'Der Performanzbegriff', p. 43.

14. Kathryn A. Duys, Elizabeth Emery, and Laurie Postlewate, 'Introduction', in *Telling the Story in the Middle Ages: Essays in Honor of Evelyn Birge Vitz*, ed. by Kathryn A. Duys, Elizabeth Emery, and Laurie Postlewate (Cambridge: Brewer, 2015), pp. 1–10 (p. 1).

15. Kate Maxwell, James R. Simpson, and Peter V. Davies, 'Performance and the Page', in *Performance and the Page*, ed. by Kate Maxwell, James R. Simpson, and Peter V. Davies, Pecia: Le livre et l'écrit, ed. by Jean-Luc Deuffic, XVI (Turnhout: Brepols, 2013), pp. 7–15 (p. 7).

16. Parker and Sedgwick, 'Introduction: Performativity and Performance', p. 15.

17. Maxwell, Simpson, and Davies, 'Performance and the Page', p. 8.

18. Herberichs and Kiening, 'Einleitung', p. 2. For a similar view, see Duttlinger and Ruprecht, 'Introduction', p. 5.

19. Lois Potter, 'Introduction', in *Playing Robin Hood: The Legend as Performance in Five Centuries*, ed. by Lois Potter (Newark: University of Delaware Press, 2003), pp. 13–19 (p. 18).

20. Emma Campbell and Robert Mills, 'Introduction: Rethinking Medieval Translation', in *Rethinking Medieval Translation: Ethics, Politics, Theory*, ed. by Emma Campbell and Robert Mills (Cambridge: Brewer, 2012), pp. 1–20 (p. 3).

21. Potter, 'Introduction', p. 16. See also Duys, Emery, and Postlewate, 'Introduction', p. 8.

22. Herberichs and Kiening, 'Einleitung', p. 1.

23. Suerbaum and Gragnolati, 'Medieval Culture "Betwixt and Between"', p. 5.

24. For an historical overview of 'performance' and 'performativity', see Carlson, *Performance*, and James Loxley, *Performativity*, The New Critical Idiom, ed. by John Drakakis (London: Routledge, 2007).

25. Parker and Sedgwick, 'Introduction: Performativity and Performance', p. 2. Helen Swift has applied the notions of performativity developed by Austin, Derrida, and Butler to discussions of gender in the late Middle Ages: Helen Swift, *Gender, Writing, and Performance: Men Defending Women in Late Medieval France (1440–1538)*, Oxford Modern Languages and Literature Monographs (Oxford: Oxford University Press, 2008).

26. The present discussion of Phelan and Auslander relies on the succinctly worded comments in Schumacher, 'Performativität und Performance', pp. 393–402.

27. Butterfield has discussed the usefulness of 'fuzziness' as an hermeneutic tool in relation to medieval language and literature: Ardis Butterfield, 'Fuzziness and Perceptions of Language in the Middle Ages: Part 1: Explosive Fuzziness: the Duel', *Common Knowledge* 18 (2012), 255–66; 'Fuzziness and Perceptions of Language in the Middle Ages: Part 2: Collective Fuzziness: Three Treaties and a Funeral', *Common Knowledge*, 19 (2013), 51–64; and 'Fuzziness and Perceptions of Language in the Middle Ages: Part 3: Translating Fuzziness: Countertexts', *Common Knowledge*, 19 (2013), 446–73.

28. Wirth, 'Der Performanzbegriff', p. 42.

29. *Medieval and Early Modern Performance in the Eastern Mediterranean*, ed. by Arzu Öztürkmen and Evelyn Birge Vitz (Turnhout: Brepols, 2014), p. xi.

30. Maxwell, Simpson, and Davies, 'Performance and the Page', p. 7.

31. Maxwell, Simpson, and Davies, 'Performance and the Page', p. 13.

32. Suerbaum and Gragnolati, 'Medieval Culture "Betwixt and Between"', p. 12.

33. Carlson, *Performance*, p. 206.

34. For overview studies of these concepts, see *Rethinking Medieval Translation*, ed. by Campbell and Mills; Mary J. Carruthers, *The Book of Memory: A Study of Memory in Medieval Culture*, Cambridge Studies in Medieval Literature, ed. by Alastair Minnis (Cambridge: Cambridge University Press, 1990); Robert C. Holub, *Reception Theory*, The New Accent Series, ed. by

Terence Hawkes (London: Routledge, 2003); David Matthews, *Medievalism: A Critical History*, Medievalism, ed. by Karl Fugelso and Chris Jones, VI (Cambridge: Brewer, 2015).

35. Campbell and Mills, 'Introduction: Rethinking Medieval Translation', p. 8.
36. Herberichs and Kiening, 'Einleitung', p. 7.
37. Duttlinger and Ruprecht, 'Introduction', p. 18.
38. Schumacher, 'Performativität und Performance', p. 402.

CHAPTER 1

Performing Manuscripts

Elizabeth Eva Leach

The title of this essay envisages a double sense of the phrase 'performing manu-scripts'. The more obvious sense denotes manuscripts that have something to do with an act of performing that is external to them. Either, they are designed to be performed from, or they are assembled from a performance or performances — the manuscripts record performances graphically, either in musical notation or, in the case of verbal performance, refracted into verbal text. Such 'performing manuscripts' are concerned primarily with the information contained within them, that is, they are manuscripts used by performers as an aid to, or preparation for performance, or by scribes for recording (noting or notating) performances. The critical sense of 'performing manuscripts', in contrast, points to the significance of the physical manuscripts rather than their contents; it suggests that they perform their contents or something denoted by their contents, such as various forms of identities, whether of the scribe, the reading community, or the patron. I shall return to the former sense of manuscripts for performance, but it is with the latter sense of a manuscript *as* a performance that this essay begins. This introduction thus addresses the question of how manuscripts — often considered 'performing' in the adjectival sense, as merely the material and visual traces of medieval performances, whether descriptively or prescriptively — might themselves be read as a kind of performance.

This double sense of 'performing manuscripts' relates to, without replicating, musicology's continually shifting evaluation of the importance of musical per-formance compared to a focus on that which is performed, namely the musical 'work'. In essence this is a distinction between music as an act or practice and music as a text or object. To return to my distinction above, 'performing manuscripts' in the sense of manuscripts that reflect or produce performances are texts that reflect or generate acts which are separate from the text, both temporally and in their sensory medium (particularly, including a sonic component), and possibly also in the personnel involved. By contrast, viewing the manuscript as itself a performance merges text and act so that the production of the text is itself the act, the scribe-notators and decorators are the actors, and the performance is identical with the visible, material product of the manuscript. Nevertheless, as will be seen below, the scribal performance may still point to acts beyond the manuscript and cue or trigger sensory elements that are not directly depicted in the visual material trace of the manuscript.

In the first instance, viewing an inanimate material and visual medium as a performance makes it necessary to trace the variety of approaches to mapping the static and silent nature of the material onto movement and sound. Furthermore, by treating manuscripts not as texts *for* performance, but *as* performances in alternative media in their own right, scholars have been able to argue for the active agency of scribes and authors, working through the performative potential of the visual as well as the sonic.

This introduction thereby engages directly with the thematization and/or description of performance(s) by narrative texts contained in medieval manuscripts — narrative texts that would themselves have been performed — which is addressed in several of this volume's contributions.[1] For example, Rushworth's discussion of Dante's *Purgatorio* as itself a liturgical performance, a 'singing cure' for the soul (see Chapter 6), and Ferreira's consideration of the performance of skaldic vísa within saga literature are both, in different ways, an analysis of the staging of specifically embodied performative moments on a larger literary stage (see Chapter 4). The performed nature of medieval narratives makes them akin to those moments when a character sings diegetically within the already sung framework of a through-composed post-Wagnerian opera, whose other singing is merely part of opera's basic perceptual code. Only when other characters on stage can hear singing as singing does the musically performative nature of opera become audible.[2] Similarly, the liturgical and lyric performances in Dante and saga literature draw attention to the ordinary transparency of literary performativity.

In the first section below I outline how, since Sylvia Huot's *From Song to Book* (1987), manuscripts have regularly been viewed as scribal-visual performances on parchment: in their use of features of layout, *mise en page*, illuminations, and overall ordering as a way of creating additional meanings by the linking of items within a given manuscript, and also by accessing intertexts beyond it.[3] As detailed below, various musicologists have extended Huot's analysis to consider the visual and layout function of musical notation, aside from its meanings as a cue for actual sonic performance. Studies variously question what manuscripts are performing, how they relate to media, memory, and the senses via readers, and how their silent kinds of performance would have been 'heard' through reading.

The second part of this introduction returns to the other sense of 'performing manuscripts' in order to exemplify the sonic performance of both musical notation and verbal text from manuscripts, the sense in which manuscripts (or their contents) are what is performed aloud by a reader and/or singer. In effect, this is the move not from song to book, but back from book to song. Investigation by musicologists as well as literary scholars of the way that sounds haunt the visual presentation of texts has revealed specific allusions to recoverable musical pieces, even in manuscripts that ostensibly lack any explicit music notation. In discussing both kinds of performance — manuscripts as themselves agents of performance, and as the media from which performances can be enacted — this essay itself loops around the idea of manuscripts performing manuscripts performing manuscripts performing, and so on.

Sound and Text

The apparent paradox in which medieval literature is at once more oral than our own but also, given its disposition in decorated manuscript books, more visual, impels Sylvia Huot's study *From Song to Book*. For Huot the obvious focus is specifically on lyric and lyric's interaction with narrative poetry in the *dits* of the fourteenth century, since lyric frequently thematizes its own performance and the figure of the poet as singer. Furthermore, the extension of this topic into lyrico-narrative poetry witnesses its transformation into a consideration of writing and the figure of the poet. In essence, this shift allows Huot to 'trace a movement from a performative to writerly poetics'.[4] Souleau's analysis of Froissart's 'performing self' in the present volume, for example, tracks a writer towards the latter end of this movement, whose joint roles as interlocutor, note-taker, and recorder of memory in writing is bound into a self-projection as actor within, and author of, his chronicles (see Chapter 8).

The deeply tangled nature of oral and written modes in medieval manuscripts is a reflection of the fact that writing was seen as the visual representation of speech, an externalization of the human memory within which speech was stored, and that letter forms themselves were seen as unmediated in their representation of sound.[5] This lack of visual mediation was less true for music, where the representation of musical figures seems to have been considered more symbolic. When Isidore of Seville notes in his *Etymologies* that 'unless sounds are held by people's memories, they perish, because they cannot be written down' ['nisi enim ab homine memoria teneantur soni, pereunt, quia scribi non possunt'], he is not simply reflecting a period that lacked stand-alone notation for the pitches of a melody.[6] Instead, as the continued citation of his statement well into the period of staff notation for musical pitch proves, Isidore is expressing a deeper and more important truth: musical *sound* cannot be *captured* in *writing*, since it is not writeable.[7] In saying this, I mean 'writeable' in the specific sense that late antique grammarians also frequently applied when defining the sounds proper to grammar as those that could be written in letters.[8]

Huot's study is grounded in the examination of literary works in their manuscript form, as a way of emphasizing the role of the book as a proxy for its performer. The visual aspect of the illuminated manuscript functions as a theatrical (Huot even ventures 'cinematic') version of the events that might be merely described in the text but are staged in the miniatures.[9] The quintessential presentation of this idea in the later Middle Ages is found at the opening of Richard de Fournival's ironic hybrid, *Le Bestiaire d'amour* [The Bestiary of Love], *c.* 1250, which marries Latin bestiary materials with a courtly love topic and tends towards a lyric mode of expression that its prose self-consciously foreswears.[10] In the opening part of the *Bestiaire*, the text describes how the work is designed by its first-person narrator (whose relation to its author is a matter of debate) to impart knowledge by means of the two doors of memory: the eye and the ear. It will do this by depiction (illuminations) and description (text). While the division into illuminations and text might make it seem that the two 'doors' to memory are both visual elements

(pictures and verbal text), the verbal text is described as *conté* ['recounted' or 'told'] rather than *escript* ['written down']. It is a form of dictation: the pictures frequently depict animals making sounds, and the text cites lines from a troubadour song as a form of authority.[11] The distinction between visual and oral media therefore breaks down almost immediately. While the book itself is a visual object, the sonic is very much cued by it. The emphasis is on the audience members as both viewers and listeners for this work: they have the eye and the ear through which they absorb the work and place it in their memories. As medievalists appreciate, the silent reading of this text would have been unusual; texts were usually sounded out vocally, even if the person reading them was alone. And because the usual way in which a medieval 'reader' encountered texts was through hearing them read aloud to a group, the *words* of the book are themselves a picture of, and instruction for, the production of sound.[12] The practice of reading aloud is so different from the solitary, silent reading that counts as normative today that it is worth emphasizing: text was heard sonically, issuing from a live human performer, in a space shared with other listeners. From such a description, it is easy to see how this mediated performance situation places medieval literature far closer to music than is the case with literature today. Although the sonic performance of the *Bestiaire* being read is not a form of singing — the *je* refers to it both as a kind of military command sent to rear-guard troops (an 'arriere-ban') and, by implication, as a letter-like message sent via messenger ('envoy') — the audio-visual implications of an extensive sequence of illuminations in most of the manuscript copies of this popular work make these voices sound in conjunction with memory, which has a particular relation to sound: in medieval terms, memory is a 'machine for invention' ['machinae mentis'].[13] It is not like the rote memory placed at the very bottom of Benjamin S. Bloom's taxonomy, the standard paradigm of modern learning in the United Kingdom, nor is it like the nostalgic memory of modernity.[14] Instead, it is active, bodily, and emotional, and involves the two teachable senses of seeing and hearing.

While Huot traces a path from Richard's mid-thirteenth-century project to the works of Machaut, in which poetic creation is more frequently represented as an act of writing, the route she outlines shifts emphasis from oral to written but maintains both as a kind of performance. The history of the opening illuminations of Richard's *Bestiaire* — a work that survives in over twenty sources dating from soon after its likely time of composition in the mid-thirteenth century, into the fifteenth century — appears to support this shift: earlier manuscripts retain the eye and ear imagery that signals its dual textual and aural mode, but the later sources more often show the work's creation as a written document, a letter to the lady by a scribe on behalf of the lover.[15] For example, as Helen Solterer notes, the late thirteenth-century Paris, BnF, MS fr. 25566 — a source that not coincidentally copies notated songs as well as Richard's *Bestiaire* and other works — has the male *je*-lover and the lady his work addresses *talking* with the God of Love at the opening: a very oral image.[16] Paris, BnF, MS fr. 412 has the *je* in discussion with the lady, but it also has the eye and the ear on the doors of memory's house or castle.[17] The rubric of Paris, BnF, MS fr. 12786 suggests that it, too, would have had this illustration

if it had ever been completed.[18] By the time of the copying of the slightly later manuscript Paris, BnF, MS fr. 15213, the entire epistolary process is shown, with the deskbound scribe, writing implements in hand, giving the written letter to the narrator (who has dictated it, see above) in the upper register of a single-column illumination, while in the lower register the narrator stands by as a messenger gives the letter to the lady.[19] The late fourteenth-century London, BL, Harley MS 273 has lovers in dialogue and the scribe working on the book, and the lover offering the book to the lady.[20] Helen Solterer claims that this pictorial programme takes account of the sonically performed vocal quality of the work while highlighting the textual object and that 'it is obvious from the sequence of miniatures here that the illuminator subordinates this moment of dialogue to the fundamental process of compiling the text'.[21] Seeing groups of illuminators respond to the *Bestiaire*'s problematization of what Solterer deems 'the crisis over oral and textual modes' allows modern users to observe the vocally, sonically performative being depicted visually, iconographically.[22]

The idea of the visual aspect of books as repositories of meaning, as well as constituents of it, has had particular use in studies of musical works whose *mise en page* and notational forms seem to demand a particular kind of reading. This is most clear in picture pieces, as, for example, in the pieces in the shape of a heart and a circle that open the early fifteenth-century Chantilly codex (Chantilly, Musée Condé, MS 564).[23] In some cases, the use of visual features is tied up with the pedagogical and theoretical functions and meanings of music, as in the use of music copied into the cursus of a maze for the song 'En la maison Dedalus', which is found in the Berkeley theory manuscript (Los Angeles, University of California Music Library, MS 744).[24] In other cases, the notation departs from regular music notation entirely, as when Senleches's 'La Harpe de melodie' uses only the lines of the pseudo-stave made by the harp strings. Reinhard Strohm has argued that this depiction binds composer (a harpist), singer, and reader in a mutual understanding of authorship, authority, and selfhood, and it is worth noting that this concept is mediated by performances that are visual, scribal, social — imagine this single sheet being handed as a beautiful object or gift to its patron — and sonic.[25]

The 'picture' does not have to be quite so clearly pictorial. Anne Stone has remarked on the way in which the writing of music can draw visual attention to itself: by being oddly archaic in its note values (as in the refrain of Guillaume de Machaut's 'Pour ce que tous' (Ballade 12), whose longs reveal the harmonic rhythm of the piece); and by being otherwise odd-looking (as in the upside down text that points to the canonic performance of Machaut's 'Ma fin est mon commencement' (Rondeau 14), even though the canon is not one of inversion but one of retrograde).[26] The role of *mise en page* and writing, the visual and scribal, in prompting or enforcing the specific kinds of performance that are desired is part of canonic pieces in general.[27]

In complex multi-media manuscripts like those of Machaut, the whole set of visual gestures (illuminations, para-textual features such as rubrics, musical notation, small-scale layout, *mise en page*, overall manuscript ordering) can work

together to contribute to a performed meaning that can manifest itself in aspects of performance but ultimately contribute meaning beyond the sonic. Emma Dillon's study of the *Roman de Fauvel* in Paris, BnF, MS fr. 146 is a particularly fecund example of this kind of analysis, showing a richness of signification that is not confined within any one of the work's possible sensory manifestations.[28]

Text and Sound

While Huot does not claim that the general movement from a performative to a scribal aesthetics of lyrico-narrative writing precludes an ongoing relation to the sonic, her emphasis on the visual, writerly, and authorial has been influential on later commentators, especially those who have worked on authors who followed Machaut in an emphasis on the single-author codex, as well as on those who want to scrutinize miscellanies for the readerly meanings that may emerge from the juxtaposition of their contents, performed within a single book.[29]

Complementing Huot's emphasis on the writerly and authorial, Ardis Butterfield's study of the same period of French literature draws attention to the depiction within the works of medieval literature, especially lyric-interpolated romances, of a movement in essentially the opposite direction — from book to song.[30] In particular, Butterfield's focus on the importance of the refrain in both senses of the term — that is, the stanza-terminating, repeated refrain of refrain forms, and the intertextual refrain of refrain citation — shows how the increased textualization of the literary in the period between Jean Renart and Machaut was a textualization of song that put visual pressure on the text for it to sound once more. Interpolating song within narrative by cuing sung texts staged oral performances within texts more obviously, and especially more visually in cases in which musical notation was included *in situ*, disrupting generic difference in the process. Butterfield notes a number of manuscripts which signal performance not only by their description of singing in their textual contents but also through the inclusion of short snippets of musically notated material in pieces that are largely not musical, highlighting the performative, diegetic nature of singing. In effect, the combination of the insights from Huot and Butterfield denotes a multi-media and multi-sensory performativity that spans a cycle between the sonic, live performance of song, lyric, and narrative, the visual and textual refraction of that performance in books, and the use of books to produce sonic live performances.

The role of music notation in books — merely the most abstractly technical and precise of many ways of visually representing sound in this period — relates to two of the essays in the present volume. First is Thomson's idea that a refrain can both perform a voice and perform a voice's pre-existence, whether or not we know that refrain to have pre-existed. The refrain interacts with the audience's 'desire to know' and can produce itself as performative even when it is no more than a presentation (see Chapter 10). Second is Hope's study of the ways that a medieval song has been represented (performed) in modern editions, with the notation enacting (and allowing sonic performance of) a song for a later audience. The

scholarly performance on paper can be used to produce a sonic performance, which can now be recorded as sound, as well as being held in memory, in addition to itself performing a given scholar's ideology (see Chapter 11).

Essentially, Butterfield's emphasis on the presence of songs in books shows the ongoing performative nature of French literature in this period, even while the author-as-writer figure began to establish a presence. In fact, the two processes may be linked in that the greater prescriptive nature of musical notation can be seen, like the greater use of para-textual features, as a way of imposing an authorial prescription for (sonic) performance through non-sonic means. I have argued elsewhere that the proliferation of song in which singers imitate bird noises, often using notes smaller than can be written logically within the bounds of the notational system, may be understood as a response to (or commentary on/thematization of) the tension between writer-as-scribal-author and the singer-as-performance-author in the later Middle Ages.[31] My analysis of the role of notation in the so-called mimetic birdsong virelais of the fourteenth century was prompted in part by Anne Stone's understanding of the highly complex rhythmic notation of Zacara da Teramo's ballade 'Sumite karissimi'. Stone argues that this seeming rhythmic complexity can sometimes, as in Zacara's piece, be read as scribally descriptive of the nuances of a virtuoso performance rather than as a composerly attempt to construct a highly intellectualized rhythmic piece, something which is often seen as a marker of the period of the late fourteenth century that modern scholars have labelled the *ars subtilior* [subtler art].

For me, the question of whether the possibility of writing more complex rhythmic relations drove composers to force new, complex creations on singers or drove singers to attempt a virtuosity that could not be reflected in notation is complicated itself by the overlap between singers and composers in the Middle Ages. Ultimately, both pressures may well have provided mutual reinforcement in the context of birdsong pieces, picture notations, and in the theorization of the rhythmic proportions which became possible in the period of the *ars subtilior*.

Conclusion

The two directions of travel described in this essay — from the sonic to the visual and the visual to the sonic — betray the fundamentally entangled nature of sound and vision, something of which Richard de Fournival was only too well aware. A physical book is clearly a visual object and produces little real-world sound beyond the noise of pages turning, but the notation of text (in letters) and music (whether through musical notation or merely via allusion, description of the notation or an associated verbal text for a song) make it a sonic one, at least in interaction with the memory of a reader with suitable knowledge.

The loss of the memory of medieval sounds as sound has led modern scholars, editors, and performers to overemphasize the visual meanings of its material trace, resulting in an understandable and useful disciplinary emphasis on decoding notations and making editions. We should not, I think, counter this bias by allowing

our acousmatic sonic culture to influence us to disregard the visual aspect of most musicking in all periods (and arguably all musicking in the non-acousmatic Middle Ages) and instead overemphasize the sonic.[32] The recent adoption of perspectives from sound studies on the one hand may seem to run counter to the converse and equally current move to a focus on materiality on the other, but both sound studies and ideas of materiality may be seen as related impulses to de-textualize the past in reaction to the post-structuralist idea that there is no outside-the-text. What links these two impulses, too, is their shared valorization of performance, the former as an act, the latter as a text. So while musicology as institutionalized within higher education has traditionally juxtaposed text — a concept musicologists have based on notions of authorial intention and the musical work — and act, with an emphasis on the former, it is not necessary to exclude the former to accentuate the latter: a text can be seen as a performative act like any other; an act can be read as a text.

Notes to Chapter 1

1. On the ordinary reception of medieval narrative text through being read aloud to a group, see Joyce Coleman, *Public Reading and the Reading Public in Late Medieval England and France*, Cambridge Studies in Medieval Literature, XXVI (Cambridge: Cambridge University Press, 1996).
2. For the classic exploration of this topic, see Carolyn Abbate, *Unsung Voices: Opera and Musical Narrative in the Nineteenth Century* (Princeton, NJ: Princeton University Press, 1991).
3. Sylvia Huot, *From Song to Book: The Poetics of Writing in Old French Lyric and Lyrical Narrative Poetry* (Ithaca, NY: Cornell University Press, 1987).
4. Huot, *From Song to Book*, p. 2.
5. Even Walter J. Ong's classic study *Orality and Literacy: The Technologizing of the Word* (London: Methuen, 1982), which proposes a one-directional shift, notes the persistence of orality within textuality (see pp. 112–13 in particular). For a nuanced consideration of the interaction of these modes in medieval texts, see Ardis Butterfield, *Poetry and Music in Medieval France: From Jean Renart to Guillaume de Machaut*, Cambridge Studies in Medieval Literature, XLIX (Cambridge: Cambridge University Press, 2002), pp. 55–56.
6. *Isidori Hispalensis episcopi Etymologiarum sive originum libri XX*, ed. by W. M. Lindsay (Oxford: Oxford University Press, 1911; repr. 1966), Book 3, Chapter 15.
7. It is still alluded to, for instance, by Franchino Gaffurio in the late fifteenth century. Franchino Gaffurio, *The Theory of Music*, ed. by Claude V. Palisca, trans. by Walter Kurt Kreysz (New Haven, CT: Yale University Press, 1993), p. 179 (Book 5, Chapter 6, verse 103): 'pitches cannot be notated but are retained in memory, lest they perish' ['voces quidem scribi non possunt sed memoria retinentur ne pereant'].
8. See Blair Sullivan, 'The Unwriteable Sound of Music: The Origins and Implications of Isidore's Memorial Metaphor', *Viator*, 30 (1999), 1–13; and Helen Deeming, 'Music and the Book: The Textualisation of Music and the Musicalisation of Text', in *The Edinburgh Companion to Literature and Music*, ed. by Delia da Sousa (Edinburgh: Edinburgh University Press, forthcoming).
9. Huot, *From Song to Book*, p. 3.
10. Huot, *From Song to Book*, pp. 135–73. See also Elizabeth Eva Leach and Jonathan Morton, 'Resonances in Richard de Fournival's *Bestiaire d'amour*: Sonic, Intertextual, Intersonic', unpublished.
11. See Sarah Kay, 'La Seconde Main et les secondes langues dans la France médiévale', in *Translations médiévales: cinq siècles de traductions en français au Moyen Âge (XIe–XVe siècles): Étude et Répertoire*, ed. by Claudio Galderisi and Vladimir Agrigoroaei (Turnhout: Brepols, 2011), pp. 461–85.
12. See Coleman, *Public Reading*.
13. See Carruthers, *The Book of Memory*.

14. Bloom's taxonomy is widely used in training teachers in higher education in the UK. *Taxonomy of Educational Objectives, Handbook I: The Cognitive Domain*, ed. by Benjamin S. Bloom, and others (New York: Longman, 1956). On nostalgia and memory, see Svetlana Boym, *The Future of Nostalgia* (New York: Basic Books, 2001).

15. Helen Solterer, 'Letter Writing and Picture Reading: Medieval Textuality and the *Bestiaire d'amour*', *Word and Image*, 5 (1989), 131–47 (pp. 144–45); see also Leach and Morton, 'Resonances in Richard de Fournival's *Bestiaire d'amour*'. For a list of sources and their dating, see the introduction in *Li 'Bestiaires d'amours' di maistre Richart de Fournival e li response du bestiaire*, ed. by Cesare Segre, Documenti di filologia, 11 (Milan and Naples: Riccardo Ricciardi, 1957).

16. <http://gallica.bnf.fr/ark:/12148/btv1b6001348v/f173.item> [all websites in this essay accessed 8 August 2017].

17. <http://gallica.bnf.fr/ark:/12148/btv1b84259980/f465.item>.

18. <http://gallica.bnf.fr/ark:/12148/btv1b60003511/f69.item>.

19. <http://gallica.bnf.fr/ark:/12148/btv1b8452195w/f119.item>.

20. <http://www.bl.uk/manuscripts/FullDisplay.aspx?ref=Harley_MS_273>.

21. Solterer, 'Letter Writing', p. 145.

22. Ibid., p. 145.

23. Yolanda Plumley and Anne Stone, 'Cordier's Picture Songs and the Relationship between the Song Repertoires of the Chantilly Codex and Oxford 213', in *A Late Medieval Songbook and its Context: New Perspectives on the Chantilly Codex (Bibliothèque du Château de Chantilly, Ms. 564)*, ed. by Yolanda Plumley and Anne Stone (Turnhout: Brepols, 2009), pp. 302–28.

24. Craig Wright, *The Maze and the Warrior: Symbols in Architecture, Theology, and Music* (Cambridge, MA, & London: Harvard University Press, 2001), pp. 239–42; and Elizabeth Eva Leach, *Sung Birds: Music, Nature, and Poetry in the Later Middle Ages* (Ithaca, NY: Cornell University Press, 2007), pp. 114–19.

25. Reinhard Strohm, ' "La harpe de melodie" oder Das Kunstwerk als Akt der Zueignung', in *Das musikalische Kunstwerk: Festschrift Carl Dahlhaus zum 60. Geburtstag*, ed. by Hermann Danuser, and others (Laaber: Laaber, 1988), pp. 305–16.

26. Anne Stone, 'Music Writing and Poetic Voice in Machaut: Some Remarks on B12 and B14', in *Machaut's Music: New Interpretations*, ed. by Elizabeth Eva Leach (Woodbridge: Boydell and Brewer, 2003), pp. 125–38; see also Elizabeth Eva Leach, *Guillaume de Machaut: Secretary, Poet, Musician* (Ithaca, NY: Cornell University Press, 2011), pp. 296–301.

27. See, for example, the essays in *Canons and Canonic Techniques, 14th–16th Centuries: Theory, Practice, and Reception History*, ed. by Katelijne Schiltz and Bonnie J. Blackburn, Leuven Studies in Musicology: Analysis in Context, 1 (Leuven: Peeters, 2007).

28. Emma Dillon, *Medieval Music-Making and the 'Roman de Fauvel'* (Cambridge: Cambridge University Press, 2002). See also Ardis Butterfield's contribution to this volume (Afterword).

29. See Jane H. M. Taylor, *The Making of Poetry: Late-medieval French Poetic Anthologies*, Texts and Transitions: Studies in the History of Manuscripts and Printed Books, 1 (Turnhout: Brepols, 2007); *Jean Froissart: An Anthology of Narrative and Lyric Poetry*, ed. by Kristen M. Figg and R. Barton Palmer (New York & London: Routledge, 2001); Ardis Butterfield, 'Articulating the Author: Gower and the French Vernacular Codex', *The Yearbook of English Studies*, 33 (2003), 80–96. See also the commentary on the Chaucer MS tradition in A. S. G. Edwards, 'Bodleian Library MS Arch. Selden B.24: A "Transitional" Codex', in *The Whole Book: Cultural Perspectives on the Medieval Miscellany*, ed. by Stephen G. Nichols and Siegfried Wenzel, Recentiores: Later Latin Texts and Contexts (Ann Arbor: University of Michigan Press, 1996), pp. 53–67.

30. Butterfield, *Poetry and Music in Medieval France*.

31. See Leach, *Sung Birds*.

32. Christopher Small's term 'musicking' is frequently used in musicology to denote music as an activity in the broadest sense rather than a thing, as act rather than text. Christopher Small, *Musicking: The Meanings of Performing and Listening* (Hannover, NH: Wesleyan University Press, 1998).

CHAPTER 2

Why Job Was Not a Musician:
Patron Saints of Music and
Musicians in the Middle Ages

Franz Körndle

Any volume that concerns itself with notions of performance in the Middle Ages would be incomplete without a consideration of the agents of sonic performance themselves. While a number of essays in this volume consider silent forms of performance, this contribution turns to performers, focusing in particular on the concept of musicianship. A key element in the definition of performers' identities was their claim to respectable patron saints. It has long been known that the prophet Job was upheld as the patron of musicians in the Middle Ages, and numerous recent accounts have claimed that Job was assigned this role as a result of his own musicianship. The present essay questions these interpretations and seeks to demonstrate the contrary: that Job was not a musician. More precisely, it outlines why it would have been impossible for a medieval musician to regard Job as a musician. As a consequence, what follows is less about the performance of medieval music than about the performers, the musicians, and their understanding of their profession when they sang or played an instrument in the streets or in church. Drawing on texts from the Bible and from patristics, this essay places the prophet Job centre stage, as well as the interpretation of the biblical story of Job in the Old Testament in relation to music. For the medieval musician, other biblical narratives were also important, for instance myths surrounding the invention of music and the story of King David — composer and singer of the Psalms who could himself play the harp.

Musical Instruments, Latin Terminology, and Vernacular Translations

During the Middle Ages and the Renaissance, knowledge of the Bible was confined to the Latin translations of the original Hebrew and Greek texts, the Septuagint and the Vulgate.[1] There was apparently little interest in exactly which instruments could have been in use in the Middle East in ancient times. Readers simply translated the Latin terms with names of instruments currently in use. The names which occur most frequently in the Latin versions of the Bible, in patristics, in the encyclopaedias,

and in medieval music theory are *organum* and *cithara*, and it should not be taken for granted that these translate in every case as 'organ' and 'harp'. *Organum* can be translated as a tool of any kind, and the term can also refer to an organ of the body, for example the hand, the most important human tool. Moreover, it can mean any musical instrument and, most specifically, an organ. All these meanings occur in dictionaries used in medieval and renaissance universities and schools. In the Old Testament, King David is described as playing the harp which is why *cithara* is mostly translated as 'harp'. In the late fifteenth century, however, the Bohemian scholar Paul Paulirinus of Prague abandoned this interpretation of the biblical *cithara* and interpreted it as a lute, an instrument which was becoming fashionable at the time.[2] Likewise, the Latin word *buccina* could designate a brass instrument, trumpet, or trombone, depending on register/pitch. Scenes from the Old Testament which contain the term could be illustrated with either trumpets or trombones.

This lexical wealth extends to musical professions, revealing a clear understanding of the implications and nuances of such professions very early on. Words like *organista* and *cantor* were commonly used in early sources; later, terms such as *buccinator* (trumpeter), *citharista* (harpist), and *figellator* (violin- or fiddle-player) can also be found.[3] A fourteenth-century dictionary written at the monastery of Saint Emmeram in Regensburg classifies the words not alphabetically but systematically. The section on performance and singing is followed by one headed 'De qualitate auditu sensibili' [On the quality of the sense of hearing], discussing the specific character of what we hear.[4] The words listed in this section represent an evaluation of musical sounds. For instance, the terms *sonorus* or *sonorosus* are described as 'clear' or 'high'; *absurdus* as 'hard on the ear'; while *canorus* means that something can be sung.

Music and Authority

From today's perspective, the history of Christian music can be understood as the continuous development of a tradition which stretches over a period of more than two thousand years. However, the relationship between music and the Church has been anything but straightforward. The prevailing hierarchical line of thought which continued into the late Middle Ages, and the desire to celebrate the liturgy in line with the Holy Scriptures and their interpretation in patristics, made it necessary to refer regularly to authorities such as Augustine in order to be sure that the practice of music was legitimate and correct.[5] The authority of tradition was greater than that of any contemporary religious or political idea, as is exemplified in parallel cases of medieval legal history, for instance in the so called *Sachsenspiegel* of Eike von Repgow (between 1180 and 1190 to 1233). Justinian Law was just as authoritative for the conception of law as the Bible was for theology.[6] Church music was seen as standing in a line of succession with the music which King David had instituted in the Temple, and also with the Book of Psalms, in which singing and the playing of instruments were explicitly encouraged in several places. Furthermore, David himself was known as a harpist from both Books of Kings in the Old Testament.[7]

According to the biblical texts, David could play traditional instruments, so this art must have been discovered before his time. Indeed, Genesis 4:21–22 provides

a reference to the invention of music: 'Et nomen fratris eius Iubal ipse fuit pater canentium cithara et organo. Sella quoque genuit Thubalcain qui fuit malleator et faber in cuncta opera aeris et ferri' ['And his brother's name was Jubal: he was the father of all such as handle the harp and organ. And Zillah, she also bore Tubalcain, an instructor of every artificer in brass and iron'].[8] Right up to the eighteenth century, Jubal (alternatively known as Tubal) was believed to be the biblical founder of music, giving the practice of this art a strong authoritative significance which was not doubted for centuries. The concept of a biblical, and hence divine origin of music, characterized the self-understanding of singers and instrumentalists. In order to uphold this concept of a continuous tradition, Jerome's and Augustine's critical comments about music had to be explained.[9] The fundamental authorization for plainsong was given in the time of Charlemagne when the texts and melodies were believed to have been given to Gregory the Great (c. 540–604) by the Holy Spirit and were hence called Gregorian chant.[10]

The attitude to musical instruments and those who played them throughout the Middle Ages is far more complex. There was a general aversion to the use of instruments — not only in church services, but even at home.[11] In the figure of Job, however, worldly instrumental music found a fitting patron, while Saint Cecilia provided the equivalent for the legitimization of vocal and organ music in church.

Job as a Patron of Music

Saint Cecilia is undoubtedly the most familiar patron of music today, but one of the odd features of music history in the Middle Ages is the veneration of Job as a patron of music.[12] Although Job is a figure from the Old Testament, he came to be venerated as a saint.[13] In contrast to the early Christian martyr Cecilia, he had the advantage of appearing as the main figure in one of the books of the Bible. In the Old Testament, Job is described as a blessed man who lives righteously and according to God's law (Job 1:1–5). Because God praises his servant Job, the devil decides to challenge Job's integrity, insinuating that Job serves God only in order to secure his protection. So as to put Job to the test (Job 1:6–12), God removes his protection, allowing the devil to take his wealth, his children, and his physical health, but leaving him alive (Job 1:14–19 and 2:7–8). Satan's intention is to tempt Job to curse God, but Job refuses to do so and stands firm in his faith in the face of all hardship. A central element in the story is the dialogue between Job and his three friends (Job 3:31). The friends — one after the other — question the possible reasons for Job's misery. They propose that he must have done something wrong and think that God is punishing him for his misdeeds, but Job himself refuses to accept their interpretation. Because of his steady faith, in the end, Job is restored by God (Job 42:10–17).

The story itself does not give a prominent place to music, nor does it establish any kind of relationship between Job and music that could explain the veneration of this man as a patron of this art in the late Middle Ages. Old Testament scholars have been unable to provide any evidence that Job was a musician.[14] There is,

however, at least one apocryphal text about Job, known as the *Testamentum Jobi* [The Testament of Job].[15] Although it is known by a Latin title today, it was probably written in the first or second century BC and was originally in Greek. The text begins with the last hours before Job's death as he remembers his life in the presence of his wife and children — and in this testament there is a lot of information which suggests that Job made music:

> I also had six harps and also a *cithara*, a ten-stringed harp, and I struck it during the day. And I took the *cithara*, and the widows responded after their meals. And with the musical instrument I reminded them of God that they should give praise to the Lord. And when my female slaves would murmur, then I took the musical instruments and played as much as they would have done for their wages.[16]

The original text uses the Greek words *psalterion* and *kithara*, which can best be translated as 'psaltery' and 'harp'.[17] Given the evidence from the *Testamentum Jobi* — that Job possessed several instruments and regularly played them — one could conclude that he was a musician or at least knew a lot about music.[18] In the scene of his death, Job presents his daughters with miraculous girdles, and when the women wear them, they can hear the song of the angels, understand the heavenly music, and answer the angels who carry away the body of Job. His daughters thereafter devoted themselves to singing and playing their instruments for the rest of their lives: Hemera received a harp, Kasia a censer, and Amalthea a percussion instrument from Job's possessions.[19] Based on these passages from the apocryphal *Testamentum Jobi*, it is understandable that, in the Middle Ages, texts and pictures were produced on the topic of Job playing music, and scholars imagined that Job himself was a musician. In the opinion of musicologists and art historians, this must have been the reason why fraternities and guilds revered Job as a saint in the fifteenth century, and these explanations have now been accepted for over sixty years. Kathi Meyer was convinced that she had found the reasons for Job's veneration in the accounts of the *Testamentum Jobi*. Her work has since been taken as the basis for this assumption: Wilfried Brennecke, for example, emulated Meyer's idea almost immediately; Leopold Kretzenbacher, also unable to explain the medieval veneration of Job with reference to the Old Testament narrative, likewise turned to the *Testamentum Jobi* for an explanation.[20] Right up to the most recent publications, the *Testamentum Jobi* has been regarded as the basis for the medieval iconography of Job and his veneration by musicians.

There are several problems with this explanation that have been ignored up to now. In spite of the research done by Kathi Meyer, Wilfried Brennecke, Michael Heymel, and others, it still cannot be shown indisputably that people in the Middle Ages were familiar with the *Testamentum Jobi*. The earliest manuscript to contain the text dates from the fifth century and is in Coptic.[21] The other early manuscripts of the *Testamentum Jobi* are in Greek, Coptic, or Slavonic (Table 2.1). Without providing any evidence, Kretzenbacher claims that the trust in Job as a protector had prevailed since Antiquity and endured for centuries in the Middle Ages.[22] The transmission of the *Testamentum Jobi* is relatively scant: although there

are copies in Greek from the Middle Ages, the text never seems to have received a Latin translation. At the end of the fifth century, Pope Gelasius had declared the *Testamentum Jobi* to be an apocryphal text with no relevance to the canonical books. For this reason, it enjoyed no further consideration by Catholic authors.[23] The theological works of the Church Fathers, those of Augustine or Gregory the Great for example, never quote the *Testamentum Jobi*. It was only in 1833 that Angelo Mai published a version that was based on a single source.[24] A modern bilingual version in Greek and English was published by Robert A. Kraft in 1974.[25]

Coptic:
Cologne, Universität, Papyrussammlung, MS Papyrus Köln 3221 (fragment), 5th century

Greek:
Paris, BnF, MS gr. 2658, fols 72r–97r, 11th century
Vatican, Biblioteca Apostolica Vaticana, MS Vat. gr. 1238, fols 340r–49v, 1195
Messina, San Salvatore, MS 29, fols 35v–41v, 1307–08
Paris, BnF, MS gr. 938, fols 472v–92v, 16th-century copy of MS gr. 2658

Old-Slavonic:
Belgrade, Biblioteka Srpske patrijarsije, MS 219, pp. 267–318, 1381
Moscow, Rossiyskaya Gosudarstvennaya biblioteka, collection of P.I. Sevastjanov MS 43, fols 97v–110v, second half of 15th century (incomplete)
Prague, Knihovna Národní Muzeum, MS IX H 21, fols 158r–77v, 188r–88v, 16th century
Belgrade, Muzej Srpske Pravoslavne Crkve, collection of Radoslav Grujic MS 219, fols 53v–68r, 16th century
Sankt Petersburg, Rossíiskaya akadémiya naúk, collection of Sirku MS 13.4.10, fols 122r–51v, 16th century
Sofia, Archiv na Bŭlgarska akademia na naukite, MS 86, fols 47v–51v, second half of 17th century (incomplete)

TABLE 2.1: Early (extant) sources for the *Testamentum Jobi*
(For a complete list, see Lorenzo DiTomasso, 'Pseudepigrapha', 316–17.)

Byzantine manuscripts from the ninth to the fourteenth centuries always illustrate their stories of Job with pictures. None of the pictures, however, gives any indication of a knowledge of the apocryphal *Testamentum Jobi*.[26] Vatican, Biblioteca Apostolica Vaticana, MS Vat. gr. 749, fol. 28v, depicts Job and his wife. This source, as well as a further item (Patmos, Monastery of St John the Theologian, MS 171, p. 53), dates from around 900. The typical scene with Job on the dung heap shows his wife or the three friends as additional figures, and the scene is depicted in the same way in Paris, BnF, MS gr. 134, fol. 46r, which dates from the thirteenth century. Tempting as it is to see the *Testamentum Jobi* as the reason for the devotion to Job as a patron of music, the explanation for it is clearly to be found elsewhere.

A close study of the images representing the story of Job, especially of those dating from the fifteenth and sixteenth centuries, reveals that Job is never depicted holding an instrument himself. It is always the other figures standing near Job who

have instruments in their hands. Often, three people are depicted making music. It might seem logical to see in these three musicians Job's three friends, Eliphaz, Bildad, and Zophar — but, again, this information is nowhere to be found in the biblical Book of Job.[27] Not even in the *Testamentum Jobi* are the three friends referred to as musicians. A Book of Hours dating after 1475, for example, shows Job's three friends standing behind him while three musicians stand behind Job's wife on the other side of the image (Paris, BnF, MS lat. 1171, fols 58v–59r; see Figures 2.1 and 2.2). The only evidence concerning the musicianship of Job's friends is found in Chapter 43 of the *Testamentum Jobi*, which contains a song performed by Eliphaz. Yet it seems unlikely that this scene would have been sufficient to regard all three friends of Job as musicians. An examination of the medieval reception of the Book of Job in the paraphrases of the Bible, *bible historiale*, moralizing Bibles, and the *Historia scholastica* of Peter Comestor reveals no indication whatsoever of musicians being with Job. This result is surprising as there is almost always some expansion of the biblical stories in these texts, which help modern scholars to interpret iconography. For instance, the reference to Jubal as 'pater canentium cithara et organo' (discussed above) is turned into a short story: 'Quo fabricante Tubal de quo dictum est sono metallorum detectatus ex ponderibus eorum proportiones et consonantias eorum quae ex eis nascuntur excogitauit: quam inuentionem greci pythagore attribuunt fabulose'[28] [While Tubal, who has already been mentioned, was working, he detected in the sound of the metals the proportions deriving from their weight and thought out the harmonies (intervals) which arise out of them: the Greeks miraculously attribute this invention to Pythagoras].[29] Petrus Comestor portrayed Tubal as the inventor of musical instruments who had also made 'sculpturas operum in metallis in libidinem oculorum' [metal sculptures to please the eyes].[30] In contrast, Comestor made no additions to the Job narrative. Nevertheless, scholars believed that they had found the connection between the Old Testament story of Job and the odd manner of its representation in the late Middle Ages.

Alongside the *Testamentum Jobi*, Kathi Meyer called attention to the French play *La Pacience de Job* which dates from around 1475. This seven thousand-line drama remained remarkably popular. It appears in no fewer than twelve printed editions up to the seventeenth century.[31] In numerous, at times rather lurid, scenes the devil appears in manifold forms and is given plenty of opportunity for tempting Job. In addition to the three friends, various other characters appear and visit Job, among them — oddly enough — a shepherd and shepherdess, Robin and Marote, who seem to have wandered in intertextually, from a thirteenth-century pastoral play by Adam de la Halle. In *La Pacience de Job*, they are introduced first as a couple.[32] After Robin appears alone, they are reunited with another shepherd, called Gason, and a messenger. At the end of the play, Eliphaz and the other friends praise God for the healing of Job. Job's brother, his sister, his cousin, and his wife bring him a sheep, a cow, and a golden ring in thanksgiving for his salvation, begging his forgiveness.[33] Finally, Robin (now without Marote), Gason, and the messenger also appear, and as they have no gifts, they perform some music for Job. The messenger invites all to join (p. 218): 'Allons trestous veoir nostre maistre | Chantant & dançant par la voye'

FIG. 2.1. Paris, BnF, MS lat. 1171, fol. 58ᵛ (Job and his friends)

FIG. 2.2. Paris, BnF, MS lat. 1171, fol. 59r (Job's wife and three musicians)

[Come, let us go and visit our master | Singing and dancing along the way].[34] The stage directions in italics are as follows: 'Icy le messagier commence à dançer et les autres | Sembablement et entrent en la maison de Job | En grand liesse' [Here the messenger begins to dance and the others do likewise and enter Job's house with great happiness].

As in the Book of Job, the extended dialogues between Job and his friends occupy the central position from the middle of the drama onwards. Job opens the scene (p. 117) with the Latin words 'Parce mihi domine', which are taken word for word from the Bible (Job 7:16). All of the following speeches by Job are either preceded by quotations in Latin, or these are woven into them, the French words paraphrasing the original text. The second speech (p. 120) opens with 'Taedet animam meam'; the third (p. 122), 'Manus tuae Domine; fecerunt me'; the fourth (p. 136), 'Responde mihi'; the fifth (p. 143), 'Homo natus'; the sixth (p. 151), 'Quis mihi hoc tribuat'. Seven, eight, and nine open with the words 'Spiritus meus' (p. 155), 'Pelli meae' (p. 158), and 'Quare de vulva' (p. 162). The page numbers of the printed edition already provide an indication of just how long this central passage is: it occupies a good fifth of the entire play. These quotations from the Book of Job were not chosen arbitrarily but follow the selection in the liturgical books of the Middle Ages. The nine texts are exactly those of the nine readings used at Matins in the Office for the Dead, whose order varied regionally.[35] If the play's unknown author chose them not simply because they were familiar, then perhaps their intention was to pass on an idea.[36] In the Office for the Dead, the readings describe the end of earthly travails for the deceased and, at the same time, express the certainty of resurrection and salvation. In the drama, this scenario is played out at least in part: we do, in fact, see how Job is liberated from his troubles. Thus, with its Latin quotations, the central section of the play La Pacience de Job realizes the dramatic potential of the series of nine liturgical lessons from the Book of Job.

The guilds and fraternities, particularly in the Low Countries but also in north-west Germany, were interested in Job as a patron saint.[37] Table 2.2 shows that Job was venerated as a patron of guilds and fraternities in Bruges, Wezenaal, Ghent, Leuven, Antwerp, and Brussels. One of the duties of these organizations was to care for the salvation of the souls of their deceased members. Money and objects from the estate of the deceased were added to their income. Payment was made out of these funds for Masses which were read on the anniversary of the defunct. Depending on what was requested in the will, embellishment with music could also be financed from these funds.[38]

In the Middle Ages, musicians were not very well regarded, particularly by the Church.[39] This could have been a reason for them to want to ensure their salvation in the afterlife. If this was indeed a primary concern, then it is crucial that Job himself was *not* a musician, as older scholarship claimed. As a musician, Job would indeed have been a splendid intercessor, but the pictorial evidence gives no grounds for this interpretation. Instead, the musicians in the many pictures are meant to be seen as doing a good deed by playing for Job (Figures 2.1 and 2.2).[40] Contrary to the final scene in La Pacience de Job, most of the pictures show Job, not restored to

Year	Statutes	City	Church
1421–31	1534	Bruges	—
c. 1450	—	Wezenaal	St Martin
1478	1478	Ghent	St John; later St Nicolas
1502	—	Leuven	St Peter
1505–10	1555	Antwerp	—
1507–08	1574	Brussels	St Nicolas

TABLE 2.2. Job-fraternities in the Low Countries
(compiled from Peter Mannaerts, 'Die Bruderschaften und Zünfte und die kirchenmusi-kalische Praxis in den Niederlanden (14.–16. Jahrhundert)', in *Der Kirchenmusiker.*
Berufe — Institutionen — Wirkungsfelder, ed. by Franz Körndle and Joachim Kremer,
Enzyklopädie der Kirchenmusik, III (Laaber: Laaber, 2014), pp. 101–19 (p. 104); Samuel
E. Balentine, 'Job and the Priests: "He Leads Priests Away Stripped" (Job 12:19)',
in *Reading Job Intertextually*, ed. by Katharine Dell and Will Kynes (New York, and
others: Bloomsbury, 2013), pp. 42–53 (p. 52))

health, but still diseased, sitting on the dunghill. Looked at in this way, playing
for the sick can be interpreted as an act of mercy — an idea that has implications
for understanding the position of musicians in society in the late Middle Ages. In
addition, Job could be regarded as pleading before God. At the end of the biblical
story (Job 42:7–8), God speaks to Job's friends who have doubted the righteousness
of the sorely tried Job:

> Iratus est furor meus in te et in duos amicos tuo, quoniam non estis locuti
> coram me rectum sicut servus meus Iob. Sumite igitur vobis septem tauros et
> septem arietes et ite ad servum meum Iob et offerte holocaustum pro vobis.
> Iob autem servus meus orabit pro vobis. Faciem eius suscipiam ut non vobis
> inputetur stultitia neque enim locuti estis ad me recta sicut servus meus Iob.[41]

> [My wrath is kindled against thee, and against thy two friends: for ye have not
> spoken of me the thing that is right, as my servant Job hath. Therefore take unto
> you now seven bullocks and seven rams, and go to my servant Job, and offer up
> for yourselves a burnt offering; and my servant Job shall pray for you: for him
> will I accept: lest I deal with you after your folly, in that ye have not spoken of
> me the thing which is right, like my servant Job.]

Job then prays for his friends, asking for God's mercy. This prayer gives rise to the
certainty that Job would indeed intercede with God, especially for the musicians
who were doing a work of charity by playing and singing for him. This scene is
well illustrated in the Book of Hours (MS lat. 1171, fols 58v–59r; Figure 2.1 and 2.2):
before the beginning of the Office for the Dead, which includes the nine readings
from the Book of Job, the facing page shows the friends and a group of musicians
playing for Job. If we go a step further and imagine that, in the course of a real
Office for the Dead, musicians are singing Job's own texts as prayers for the deceased
person, multiplying this intercession by the polyphony of the music, we can see why
performers were so sure that this prayer would be heard. It is likely that another

sentence played a role in this context, producing a *lectio difficilior*. Only once in the Book of Job is music mentioned explicitly. In Chapter 30, verse 31, Job says: 'Versa est in luctum cithara mea et organum meum in vocem flentium' ['My harp also is turned to mourning, and my organ into the voice of them that weep'].[42] Gregory the Great commented on this verse in his *Moralia in Iob* (Book XX, Chapter 41) as follows: 'Quia organum per fistulas et cithara per chordas sonat, potest per citharam recta operatio, per organum vero sancta praedicatio designari. Per fistulas quippe organi ora praedicantium, per chordas vero citharae intentionem recte viventium non inconvenienter accepimus' ['Whereas the organ gives its sounds by means of pipes, and the harp by chords; it may be that by the 'harp' right practising is denoted and by the 'organ' holy preaching. For by the pipes of an organ we not unsuitably understand the mouths of persons preaching, and by the chords of the harps the bent of those living aright'].[43] The *Moralia in Iob* circulated widely in the Middle Ages, both in manuscript and later in print, posing a strong influence on the understanding of music and art.[44] Late medieval mysticism, for example, developed an interpretation which saw music as a part of the divine plan of salvation.[45]

Music as Salvation

When, in the late Middle Ages and early Renaissance, traditions of theological inter- pretation took seriously the images they had produced, this led to very interesting iconography. For instance, the traditional image of King David is transformed at the beginning of the penitential Psalm 6 in a Breviary from Laon (Bibliothèque municipale, MS 243q, fol. 86[r]; third quarter of the fourteenth century). Not only has David's harp been put aside as a sign of penitence, but so has a small organ. The artist has obviously made a connection between the penitent David and the text in Job 30:31 (see above).[46]

As noted, Pope Gregory the Great had interpreted the harp as right practising and the organ as holy preaching in his *Moralia in Iob* — an interpretation borrowed from Saint Augustine's commentary on Psalm 57, which in verses 8 and 9 speaks of the praise of God: 'Cantabo et psalmum dicam, exsurge gloria mea exsurge psalterium et cithara exsurgam diluculo' ['I will sing and give praise. Awake up, my glory; awake, lute and harp'].[47] Augustine writes:

> Duo organa video, corpus autem Christiunum video: uno caro resurrexit, et duo organa surrexerunt. Alterum ergo organum psalterium, alterum cithara. [...] Sed quid est psalterium? Quid est cithara? [...] Caro ergo divina operans, psalterium est: caro humana patiens, cithara est. Sonet psalterium; illuminentur caeci, audiunt surdi, stringantur paralytici, ambulent claudi, surgant aegroti, resurgent mortui: iste es sonus psalterii. Sonet et cithara; esuriat, sitiat, dormiat, teneatur, flagelletur, ittadiatur, crucifigatur, sepeliatur.[48]

> [Two organs I see: but Body of Christ one I see, one flesh hath risen again, and two organs have risen. The one organ then is the psaltery, the other the harp [...] But what is psaltery? what is harp? [...] The flesh therefore working things divine, is the psaltery: the flesh suffering things human is the harp. Let the psaltery sound, let the blind be enlightened, let the deaf hear, let the paralytics be braced to strength, the lame walk, the sick rise up, the dead rise again.]

If people in the late Middle Ages understood these texts by Gregory and Augustine to mean that these musical instruments were part of the divine plan of salvation, then the playing of music for Job in his suffering could have a truly healing effect: music as therapy. Perhaps Job's healing could be seen as the best evidence for the salvation of his soul. If so, a musician could be sure of the saint's good offices. In the picture of the penitent King David, the harp and organ he has put aside represent the failure to speak rightly and act rightly, leading to sin. It is crucial to realize that David could play these instruments (or lay them aside) because music as an art had been invented by Jubal in the forge of his brother Tubalcain.

A similar hermeneutics is found in the illustrations of the invention of music in the *Speculum humanae salvationis*, the mirror of human salvation.[49] Numerous illustrated manuscripts of the Latin original, as well as its German translations, depict the scene from Genesis 4 (see Table 2.3). Tubalcain is hammering in the forge; listening, his brother Jubal discovers musical intervals in these sounds and reproduces them as a tune played on a stringed instrument. This picture is accompanied by another illustration, which represents the nailing of Christ to the Cross (Figure 2.3). The connection between the two is established not only by the observation that both involve nails, a product of the forge, which in one image make music and, in the other, are used in the Crucifixion. It is not the clang of the hammers which is being referenced in the Crucifixion picture, as one might imagine. The Latin text of the *Speculum* contains the following passage:

> Jubal et Tubalcain filii Lamech fuerunt,
> Qui inventores artis ferrariae et musicae existerunt.
> Quando enim Tubalcain cum malleis sonos faciebat,
> Jubal ex sono malleorum melodiam inveniebat.

Ad talem ergo melodiam et malleorum fabricationem Comparamus Christi orationem et crucifixorum malleationem:

> Quando enim crucifixores Jesum ad crucem fabricant,
> Christus dulcissimum melodiam pro ipsis Patri suo decantabat:
> 'Pater, dimitte illis, quia nesciunt quid faciunt.
> Ignorant enim quod Filius tuus sum, quem crucifigunt.'[50]

[Jubal and Tubalcain were the sons of Lamech. They were known as the inventors of the smith's trade and of music. Once, as Tubalcain's hammers resounded (on the anvil), Jubal discovered a melody in the clang of the hammers. To this melody and the smithy we can compare the words of Christ and the hammer-blows of the people who crucified him. For as they nailed him on the cross, Christ sang a very sweet melody to his father for them. 'Father, forgive them, for they know not what they do. They know not that I, who they are crucifying, am your Son.]

The German *Speculum humanae salvationis,* which was widely disseminated, offers similar interpretations. Konrad of Helmsdorf in his Middle High German version sees the relationship in an indirect sense:

> Die hamer schleg hort schellen
> Und waidelich stimm hellen,

Library	Shelfmark	Approx. date
Copenhagen, Kongelige Bibliotek	GKS 80 2°, fol. 47v	1400–50
Copenhagen, Kongelige Bibliotek	GKS 79 2°, fol. 55r	1430
Darmstadt, Universitäts- und Landesbibliothek	Hs. 2505, fol. 42v	1360
Den Haag, Museum Meermanno-Westreenianum	10 B34, fol. 23v	1450
Den Haag, Museum Meermanno-Westreenianum	10 C23, fol. 26v	1400–1500
Karlsruhe, Badische Landesbibliothek	3378, fol. 23v/p. 72	mid-14th ct
London, BL	Sloane 346, fol. 13v	1330–40
Madrid, Biblioteca Nacional d'Espana	B. 19 (Vit 25-7), fol. 22v	1420–40
Oxford, Bodleian Library	Douce f. 4, fol. 33r	1460–70
Paris, BnF	lat. 511, fol. 13	early 15th ct
Paris, BnF	fr. 188, fol. 27v	mid-15th ct
Stuttgart, Württembergische Landesbibliothek	Theol. et phil. 2° 122, fol. 73v	1490
Vienna, Österreichische Nationalbibliothek	Ser. n. 2612, fol. 25v	1330–40
Vienna, Österreichische Nationalbibliothek	Ser. n. 12883, fol. 72r	1445–55

TABLE 2.3. Selection of manuscripts containing the *Speculum humanae salvationis*

> Des nam er war dik und vil
> Und fand da by das saiten spil.
> Suss unser herre Jhesus Crist,
> Der aller kunst ain maister ist,
> By maengem grymmen hamer schlag,
> Der man ob sinem libe pflag,
> Och hat die suessen kunst erdacht
> Und hat och minneklich zu veld bracht
> Das wir nach goettlichem sitten
> Fúr unser vyent soellend bitten.[51]

[The hammers are to be heard clearly; he heard it and invented the playing on stringed instruments. Our sweet lord, Jesus Christ, the master of all arts, for the many hammer blows to his body, invented the sweet arts. Because of his love, he made that we, imitating the divine example, should pray for our enemies.]

In the illustration of the invention of music in Darmstadt, Universitäts- und Landes-bibliothek, MS 2505, fol. 42v, Jubal hears the music of the hammers on the anvil and reproduces this sound on his instrument. It is unlikely to be a coincidence that his psaltery is held in parallel to the cross, with its sound holes mirroring the wounds of Christ. Thus the instrument itself becomes an image of the Crucifixion. A second manuscript (Karlsruhe, Badische Landesbibliothek, MS 3378, fol. 23v; fourteenth century; see Figure 2.3) shows, on the right, two hammering figures and, on the left, a man with a harp, alluding to the information given in Genesis 4, revealing Jubal

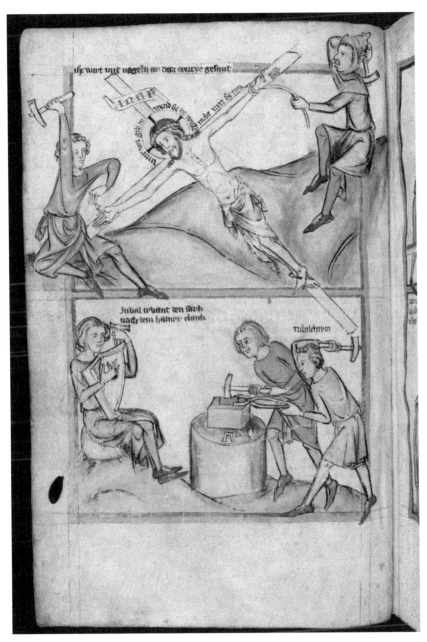

FIG. 2.3. Karlsruhe, Badische Landesbibliothek, MS 3378, fol. 23v/p. 72

FIG. 2.4. Augsburg, Universitätsbibliothek, MS 1.3.8° 1, fol. 139v

as the father of harpists and organists.[52] A Stuttgart manuscript (Württembergische Landesbibliothek, MS Theol. et phil. 2° 122, fol. 73v; 1490) replaces the harp with the lute, which was the more modern instrument at this time.[53] According to the inscription, 'Isti sunt inventores artis ferrariae et omnium melodiarum' [these are the inventors of the arts of metal-working and of all melodies], the early idea of a biblical invention of music or, better, of musical instruments has now become the invention of melodies — and these could be represented completely without instruments. The illuminator of the early fifteenth-century Copenhagen, Kongelige Bibliotek, MS GKS 79 2°, fol. 55r, frames the story in even more drastic fashion.[54] On the far right, a notator transcribes the music he hears onto a system of lines. He is writing down part-music in a form of late medieval notation typical of German sources.

Finally, the connection between music and the divine work of salvation is also manifest in representations of the Mass of St Gregory. According to legend, during a Mass in Santa Croce in Gerusalemme in Rome, a vision of Christ as the Man of Sorrows appeared to Pope Gregory with the instruments of the Passion. In several fifteenth- and sixteenth-century books, a group of singers, apparently performing liturgical music, is placed close to Gregory as he celebrates the Mass. A miniature from Nuremberg (Augsburg, Universitatsbibliothek, MS 1.3.8° 1, fol. 139v; c. 1510; see Figure 2.4) shows, above the altar, two galleries with an organ (left) and singers (right). During the consecration — that is, the transubstantiation of bread and wine — Christ shows himself to the Pope who was revered as the founder of plainsong. The characteristic components of church music, plainsong and organ music, are represented at this decisive moment and they are legitimated by the words of Gregory from the *Moralia in Iob*, where he described the organ as an emblem of right preaching.[55]

Conclusion

Knowing about the possibilities of intertextuality when looking at musicians in medieval images, we should reconsider our current ways of understanding music. In the late Middle Ages, the ontology of music and the practice of this art were firmly rooted in mysticism. Even if the evidence discussed in this essay — texts by SS Augustine and Gregory, the *Speculum humanae salvationis*, and broader ideas that can be gleaned from sources such as plays — does not necessarily present us with a coherent vision of music, free from all contradictions, these small building blocks are essential in reconsidering the hermeneutics of phenomena such as the medieval veneration of Job as the patron of musicians. There was no need to see Job as a musician himself: on the contrary, Job's intercession was strengthened by his position as a neutral party who had benefitted from the performance of instruments. It is worthwhile, therefore, to expand our current scholarly perspectives and suggest that music-making in this period was understood performatively, in the context of human salvation.

Notes to Chapter 2

1. Martin van Schaik, *The Harp in the Middle Ages: The Symbolism of a Musical Instrument* (Amsterdam & New York: Rodopi, 2005), pp. 16–17; Max Haas, *Musikalisches Denken im Mittelalter* (Frankfurt a. M.: Lang, 2005), p. 192, n. 343.
2. Josef Reiss, 'Pauli Paulirini de Praga Tractatus de musica (etwa 1460)', *Zeitschrift für Musikwissenschaft*, 7 (1924/25), 261–64 (p. 263); Standley Howell, 'Paulus Paulirinus of Prague on Musical Instruments', *Journal of the American Musical Instrument Society*, 5/6 (1979/80), 9–36 (p. 12).
3. Franz Körndle, 'Vocabularien im Musikunterricht um 1500', in *Lehren und Lernen im Zeitalter der Reformation: Methoden und Funktionen*, ed. by Gerlinde Huber-Rebenich (Tübingen: Mohr Siebeck, 2012), pp. 203–12 (p. 207).
4. Munich, Bayerische Staatsbibliothek, MS Clm 14610, fol. 178ᵛ.
5. Norbert Fischer, *Augustinus: Spuren und Spiegelungen seines Denkens*, 2 vols (Hamburg: Meiner, 2009), I, 4.
6. Stephan Meder, *Rechtsgeschichte*, 3rd edn (Cologne: Böhlau, 2008), pp. 153 & 178.
7. Klaus Seybold, 'David als Psalmsänger in der Bibel: Entstehung einer Symbolfigur', in *König David — biblische Schlüsselfigur und europäische Leitgestalt*, ed. by Walter Dietrich and Hubert Herkommer (Freiburg (CH) & Stuttgart: Kohlhammer, 2003), pp. 145–64; Therese Bruggisser-Lanker, 'König David und die Macht der Musik: Gedanken zur musikalischen Semantik zwischen Tod, Trauer und Trost', in *König David — biblische Schlüsselfigur und europäische Leitgestalt*, ed. by Dietrich and Herkommer, pp. 589–629; Walter Salmen, *König David — eine Symbolfigur in der Musik* (Freiburg (CH): Universitätsverlag, 1995).
8. *Biblia sacra iuxta vulgatam versionem*, ed. by Robert Weber and Bonifatius Fischer, 3rd edn (Stuttgart: Deutsche Bibelgesellschaft, 1983), p. 9; the English translation is from: *The Bible. Authorized King James Version*, ed. by Robert Carroll and Stephen Prickett (Oxford: Oxford University Press, 2008), p. 5 (hereafter referred to as KJV).
9. Franz Körndle, 'Musikanschauung im Mittelalter', in *Geschichte der Kirchenmusik*, ed. by Wolfgang Hochstein and Christoph Krummacher, 4 vols (Laaber: Laaber, 2011), I, 92–96.
10. Helmut Hucke, 'Über Herkunft und Abgrenzung des Begriffs "Kirchenmusik"', in *Renaissance-Studien: Helmuth Osthoff zum 80. Geburtstag*, ed. by Ludwig Finscher (Tutzing: Schneider, 1979), pp. 103–25 (pp. 104–05).
11. Schaik, *The Harp in the Middle Ages*, p. 9.
12. Kathi Meyer, 'St. Job as a Patron of Music', *The Art Bulletin*, 36 (1954), 21–31.
13. Valentin Denis, 'Saint Job, patron des musiciens', *Revue belge d'archéologie et d'histoire de l'art*, 21 (1952), 252–98; Karl Vötterle, 'Hiob: Schutzpatron der Musiker', *Musik und Kirche*, 23 (1953), 225–32; Wilfried Brennecke, 'Hiob als Musikheiliger', *Musik und Kirche*, 24 (1954), 257–61.
14. Hans Seidel, 'Hiob, der Patron der Musiker', in *Alttestamentlicher Glaube und Biblische Theologie*, ed. by Jutta Hausmann and Hans-Jügen Zobel (Stuttgart, Berlin, & Cologne: Kohlhammer, 1992), pp. 225–32.
15. *Testamentum Jobi*, ed. by Sebastian P. Brock, Pseudepigrapha veteris testamenti Graece, II (Leiden: Brill, 1967), pp. 19–57; *Das Testament Hiobs*, ed. by Bernd Schaller, Jüdische Schriften aus hellenistisch-römischer Zeit, III, 3 (Gütersloh: Mohn, 1979), pp. 301–87.
16. *Testament of Job the Blameless, the Sacrifice, the Conqueror in Many Contests. Book of Job, Called Jobab, His Life and the Transcript of his Testament*, trans. by M. R. James, Apocrypha anecdota: Texts and Studies, II, 5/1 (Cambridge: Cambridge University Press, 1897), pp. 104–37.
17. A different interpretation is given by Michael Heymel, 'Hiob und die Musik: zur Bedeutung der Hiobgestalt für eine musikalische Seelsorge', in *Das Alte Testament und die Kunst*, ed. by John Barton, J. Cheryl Exum, and Manfred Oeming (Münster: LIT, 2005), pp. 129–64 (p. 162).
18. Meyer, 'St. Job', p. 23.
19. Ibid., p. 23.
20. Brennecke, 'Hiob als Musikheiliger', p. 260; Leopold Kretzenbacher, *Hiobs-Erinnerungen zwischen Donau und Adria*, Bayerische Akademie der Wissenschaften, Phil.-Hist. Klasse (Munich: Beck, 1987), pp. 141–56 (p. 145).

21. Emil Schürer, *The History of the Jewish People in the Age of Jesus Christ*, rev. and ed. by Géza Vermes, Fergus Millar, and Martin Goodman, 3 vols (London, and others: Bloomsbury, 2014), III.i, 552–55; *Der Koptische Kölner Papyruskodex 3221, Teil I: Das Testament des Iob*, ed. by Gesa Schenke, Papyrologica Coloniensia, XXXIII (Paderborn, and others: Schöningh, 2009); Lorenzo DiTommaso, 'Pseudepigrapha Notes IV: 5. The *Testament of Job*. 6. The *Testament of Solomon*', *Journal for the Study of the Pseudepigrapha*, 21 (2012), 313–20 (particularly pp. 314 & 316).

22. Kretzenbacher, *Hiobs-Erinnerungen*, p. 153.

23. Schürer, *The History of the Jewish People*, III.i, p. 554.

24. *Testament of Job the Blameless, the Sacrifice, the Conqueror in Many Contests, the Sainted: Book of Job Called Jobab, and his Life and Transcripts of his Testament*, ed. by Angelo Mai, Scriptorum Veterum Nova Collectio, VII (Rome: Typis Vaticanis, 1833), pp. 180–91.

25. *The Testament of Job, According to the SV Text. Greek Text and English Translation*, ed. by Robert A. Kraft (Missoula, MT: Scholars Press, 1974).

26. Images of these Byzantine manuscripts can be found at <https://en.wikipedia.org/wiki/Book_of_Job_in_Byzantine_illuminated_manuscripts> [accessed 8 August 2017].

27. Brennecke, 'Job als Musikheiliger', p. 260; Kretzenbacher, *Hiobs-Erinnerungen*, pp. 154–55; Heymel, 'Hiob und die Musik', pp. 141–42; recently also, Samuel E. Balentine, *Have You Considered My Servant Job? Understanding the Biblical Archetype of Patience* (Columbia: University of South Carolina Press, 2015), n. 99.

28. Petrus Comestor, *Historica scholastica*, ed. by Jacques-Paul Migne, Patrologia Latina, CXCVIII (Paris: Gernier Frères, 1855), cols 1055–1722 (cols 1097A & 1079B).

29. My own translation.

30. Frank Hentschel, *Sinnlichkeit und Vernunft in der mittelalterlichen Musiktheorie*, Beihefte zum Archiv für Musikwissenschaft, XLVII (Stuttgart: Steiner, 2000), pp. 185–86.

31. Meyer, 'St. Job', p. 23; Lawrence L. Besserman, *The Legend of Job* (Cambridge, MA, & London: Harvard University Press, 1979), p. 94; *La Pacience de Job: mystère anonyme du XVᵉ siècle*, ed. by Albert Meiller, Bibliothèque française et romane, Série B: XI (Paris: Klincksieck, 1971).

32. Butterfield, *Poetry and Music in Medieval France*, pp. 151–68.

33. Besserman, *The Legend of Job*, pp. 106–07.

34. The page numbers refer to the edition of *La Pacience de Job* printed by François Didier at Lyon in 1600, which is available online at <http://gallica.bnf.fr/ark:/12148/bpt6k79022w> [accessed 8 August 2017].

35. Knut Ottosen, *The Responsories and Versicles of the Latin Office of the Dead* (Norderstedt: Books on Demand, 2007), pp. 51–93.

36. Besserman, *The Legend of Job*, pp. 63–64; Ottosen, *The Responsories*, p. 56.

37. John T. Winemiller, 'Lasso, Albrecht V, and the Figure of Job', *Journal of Musicological Research*, 12 (1993), 273–302 (pp. 283–88); Maarten Wisse, *Scripture between Identity and Creativity: A Hermeneutical Theory Building upon Four Interpretations of Job*, Ars Disputandi, Supplement Series, 1 (Utrecht: Igitur, 2003), pp. 92–95.

38. Franz Körndle, 'Die Musikpflege bei den Kölner Bruderschaften im Vergleich zu anderen Städten', in *Das Erzbistum Köln in der Musikgeschichte des 15. und 16. Jahrhunderts: Kongressbericht Köln 2005*, ed. by Klaus Pietschmann, Beiträge zur Rheinischen Musikgeschichte, CLXXII (Berlin & Kassel: Merseburger, 2008), pp. 157–69.

39. Samuel Terrien, *The Iconography of Job through the Centuries. Artists as Biblical Interpreters* (Pennsylvania: Penn State University Press, 1996), pp. 107–09; Christopher Page, 'German Musicians and their Instruments: A 14th-Century Account by Konrad of Megenberg', *Early Music*, 10 (1982), 192–200 (p. 196).

40. An overview is given in Terrien, *The Iconography of Job*.

41. *Biblia sacra iuxta Vulgatam*, p. 765; KJV, p. 640.

42. *Biblia sacra iuxta Vulgatam*, p. 755; KJV, p. 629.

43. *Sancti Gregorii Papae I Cognomento Magni, Opera omnia*, ed. by Jacques-Paul Migne, Patrologia Latina, cursus completus, LXXVI (Paris: Migne, 1857), II, cols 185–86; translation taken from *Morals on the Book of Job by St. Gregory the Great* (Oxford: Parker, 1845), II/4, p. 510, <http://www.lectionarycentral.com/GregoryMoraliaIndex.html> [accessed 8 August 2017].

44. Max Manitius, *Geschichte der lateinischen Literatur des Mittelalters*, 4th edn, 3 vols (Munich: C. H. Beck, 2005), I, 97–101; Walter Muschg, *Die Mystik in der Schweiz 1200–1500* (Frauenfeld & Leipzig: Huber, 1935), p. 33.

45. René Wasselynck, 'Les Moralia in Job dans les ouvrages de morale du haut moyen âge latin', *Recherches de Théologie ancienne et médiévale*, 31 (1964), 6–11; and 'L'Influence de l'exégèse de S. Grégoire le Grand sur les commentaires bibliques médiévaux (VIIe–XIIe s.)', *Recherches de Théologie ancienne et médiévale*, 32 (1965), 157–204.

46. Thomas Connolly, *Mourning into Joy: Music, Raphael, and Saint Cecilia* (New Haven, CT, & London: Yale University Press, 1994), pp. 90–91.

47. *Biblia sacra iuxta Vulgatam*, p. 838; KJV, p. 670. KJV translates the Latin 'psalterium' as 'psaltery', replaced here by 'lute'.

48. *Sancti Aurelii Augustini, Hipponensis Episcopi, Opera omnia*, ed. by Jacques-Paul Migne, Patrologia Latina, cursus completus, XXXVI (Paris: Petit-Montrouge, 1865), IV, cols 671–73; translation from *Expositions on the Book of Psalms, by St Augustine, Bishop of Hippo* (Oxford: Parker, 1849), III, 94–95, <http://www.ccel.org/ccel/schaff/npnf108.toc.html> [accessed 8 August 2017].

49. Franz Körndle, 'Hiob, König David, Hl. Gregor, Hl. Cäcilia: Die Autorisierung der Kirchenmusik im Bild', in *Die Kirchenmusik in Kunst und Architektur*, ed. by Ulrich Fürst and Andrea Gottdang, Enzyklopädie der Kirchenmusik, V/1, (Laaber: Laaber, 2015), pp. 69–90; particularly pp. 73–75.

50. *Speculum humanae salvationis*, ed. by Jules Lutz and Paul Perdrizet, 2 vols (Leipzig: Hiersemann, 1907), I, 48; the translation is my own; see also Bruce W. Holsinger, *Music, Body, and Desire in Medieval Culture: Hildegard of Bingen to Chaucer* (Stanford, CA: Stanford University Press, 2001), p. 203, and n. 39 (p. 391).

51. Konrad von Helmsdorf, *Der Spiegel des menschlichen Heils. Aus der St. Gallener Handschrift*, ed. by Axel Lindqvist, Deutsche Texte des Mittelalters, XXXI (Berlin: Weidmann, 1924), p. 38, ll. 1883–92. The translation is my own.

52. Available online <http://digital.blb-karlsruhe.de/urn:nbn:de:bsz:31–1732> [accessed 8 August 2017].

53. Available online <http://digital.wlb-stuttgart.de/purl/bsz330594400> [accessed 8 August 2017].

54. Available online <http://www.kb.dk/permalink/2006/manus/218/> [accessed 8 August 2017].

55. Connolly, *Mourning into Joy*, pp. 90–91.

Giving Voice to Samson and Delilah: Troubadour and Monastic Songs of the Thirteenth and Fourteenth Centuries

Catherine Léglu

This exploratory essay sets out to analyze the complex claims that have been made for the orality and written transmission of medieval lyric poetry. The central issues concern the status of the written text, whether it should be viewed as the core of the enquiry, or rather as a witness to medieval practices of composition, transmission, and performance. In order to set out these issues clearly, this essay focuses on two versions of the biblical narrative of Samson and Delilah. This narrative is taken from a stable Latin text, the Vulgate, but it was reworked in musical and other forms; moving easily between sacred and secular audiences, the two examples discussed below were performed by tonsured clerics. Therefore, the sung performances and evocations of this story can be viewed in the light of Barbara Newman's suggestion that 'crossover' in medieval literature, as in modern musical culture, both reflects and represents widespread patterns of dialogue and fusion.[1]

Recent studies of the transition of medieval song from an oral medium to a written text focus on dissociating the oral, performed text from its written form. For example, Marisa Galvez views the troubadour *chansonnier* as a collaboration between compilers, scribes, illuminators and readers, who are engaged in an essentially silent dialogue with the fictive lyric persona of the troubadour or trobairitz. Thomas Cramer has made similar suggestions in relation to the written transmission of Minnesang, but as Henry Hope has argued, it is not necessary to view the lack of written notation as evidence that songs were not performed.[2] It is clear that a song's oral and physical traces are erased further by the omission of melodies. However, much can still be done to give voice (however theoretically) to silenced songs. In her monograph on troubadour poetry, Judith A. Peraino provides audio recordings of the monophonic songs that she studies as examples of plurivocal poetic expression. By plurivocal, Peraino designates a monologue that contains fragments of others' voices, either in dialogue, or through reported speech.[3] Reconstructing medieval performance itself is the subject of numerous concerns. Elizabeth Eva Leach, for example, stresses that written notation even for late-medieval polyphony does not suffice as a guide for performers.[4] Modern reconstructions of medieval music

depend on a combination of scholarship and sensitivity to contemporary tastes, as Hope shows in his contribution to this volume (see Chapter 11).[5]

The Latin song 'Samson, dux fortissime' is a strong case in point. It is composed for a single voice, featuring three speaking characters: Samson, Delilah, and a first-person commentator who is identified by modern editors as the Chorus. The song has been recorded three times in recent years, and these performances illustrate the complexity of performing multi-voiced monophonic poetry. An audio recording released in 1996 by the professional ensemble Sequentia assigns the Chorus to several male voices, which complies with modern expectations of a chorus based on the classical model. Sequentia also have several male voices at once sing Samson's lines. Listeners can follow the dramatic narrative by reading a translation into the modern vernacular in the accompanying booklet. In contrast, two other recordings, both of them available online at the time of writing, limit the number of performers to three, and have a female vocalist perform the Chorus. One of these two recordings was created by New York University students as part of Evelyn Birge Vitz's project 'Performing Medieval Narrative' in 2007. The parts are shared between a female and male vocalist, and a violinist. No translation is provided. Instead, two of the performers act out key moments in the drama. The other recording (from 2012) captures a live performance by the professional group Ensemble Labyrinthus.[6] A screen next to the performers enables the audience to hear the unabridged Latin text, and to see a translation into modern Russian. The performers do not attempt to enact any of the scenes. These recordings present three very different ways of transmitting a Latin lyric song to a modern audience. Each provides a 'translation' of the text in a way that enables the listener or viewer to follow the drama as it unfolds. None of the three attempts to recreate an authentic medieval performance of the piece, which is wholly understandable on aesthetic as well as historical grounds: nothing is known about how such a piece would have been played in a monastery, and to whom.

Samsons in the Vernacular

The troubadour Raimon de Cornet (active c. 1324–49) alludes to the story of Samson's downfall, in a poem rubricated as a *truffa*: a joke.[7] The *truffa* raises questions about performance. It is a rhymed monologue in stanzas and therefore probably designed to be sung. Its speaker, a priest, narrates his misadventure at the hands of his jealous mistress:

> Hyeu fuy dolens, a for prop d'avol cauza,
> Que, lies bayzan e tocan sas popetas,
> Dormigui tan tro qu'en fon ora bassa;
> E dir vos ay quem fetz la vils bagassa:
> De flic en floc ab unas tozoyretas
> Tot lo mieu cap tondet, vejatz gran bauza,
> Pueus anet s'en ab mos pels en sa borsa. (ll. 22–28)

[I was unhappy with good cause, because, after lying down, kissing and touching her breasts, I slept so late that it was evening. I'll tell you what the

vile creature did to me: with a 'flick' and a 'flack', with a pair of little shears she shaved all of my head — look at the mess! Then she went off with my hair in her purse.][8]

The priest is humiliated when he celebrates Mass the next day, on the major feast of Saint Michael the Archangel (ll. 36–42). The story is set in Saint Martial d'Albigeois, a rural parish where priests share lodgings and take local girls as mistresses.[9] Presumably while the priest has his back turned, he hears the congregation commenting that the pope should grant a pardon to the 'preveyressa' (the priest's concubine) because she has 'shaved him well' (ll. 36–42). There is no explanation of what the priest's new tonsure means to the crowd but, clearly, he is being shamed by it. He exclaims 'Look at the mess!' (l. 27), as if he were showing the tonsure to his audience. One of the two extant copies of the poem, possibly compiled by Raimon himself, adds a small image of a man with a conventional tonsure next to the poem's rubric.[10] The designated author of the poem is a tonsured cleric: the chaplain 'Frayre Raimon de Cornet'. He had been a Franciscan friar but ended his life a Cistercian monk. His authorial persona oscillates between high moral tone and satire.

The priest's narrative alludes to the well-known, simplified version of Samson's humiliating defeat by his Philistine concubine, Delilah (Judges 16).[11] In the Vulgate, Delilah makes four attempts to cajole Samson into telling her the source of his superhuman strength. After he has admitted that he will lose his strength only if his hair is cut, she waits until he is sleeping off the wine that she has given him, and she invites a Philistine man to cut off his seven braids of hair. Captured, Samson is blinded, mocked, and enslaved. Months later, once his hair has grown back, he kills the Philistines and himself by pulling down the pillars of the palace. Raimon de Cornet's use of the story to add a little spice — as well as authoritative precedent — to his own anecdote deserves further attention, in that it begs the question of how a biblical narrative flowed from Vulgate to song, and from Latin to the vernacular.

The medieval Samson is multi-layered. He is one of a series of heroic figures who overcome the lion (Judges 14:5–6), a favourite subject in Romanesque sculpture.[12] A Romanesque bas-relief in Saint-Orens, Auch (Gers) presents Samson defeating the lion with the epigraphical gloss: 'The courage of Samson rules over the mouth of the raging lion'. The lion is a figurative representation, variously, of the World, the Devil, or the impious.[13] The story of Samson was also known from more domestic objects. Sets of illustrated tablemen depicting the life of Samson were produced in various parts of Europe but the centre for their design and making appears to have been Cologne.[14] However, the finer points of the narrative were not commonly known in the Middle Ages, and Delilah's shearing (in person) of the sleeping Samson was used as a shorthand for the danger that the love of women was deemed to pose to the strength and dignity of men.[15]

The priest in Raimon de Cornet's *truffa* is no hero. In fact, the priest insists that his mistress's actions were legitimate, in the sense that she took revenge for his infidelity (ll. 11–14). Moreover, the song works on a second, figurative level,

because 'shearing' in Old Occitan had the same idiomatic sense as modern English 'fleecing'. The priest's mistress runs away with his shorn hair in her purse, and the congregation comment with admiration on her 'fleecing' him. Far from being blinded, the priest's eyes are (figuratively) opened to his loss of dignity through his incontinence.

Raimon de Cornet provides an intriguing example of a poet-performer who places his own body within the story that he tells. On the basis of codicological analysis, Marina Navàs concludes that Raimon's poems were compiled in a monastic environment.[16] His work is thus transmitted by the religious community that chose to preserve its full range as an author who was neither wholly secular nor completely religious. Troubadours were often trained performers of liturgical song, either through their education — several are said to have studied in a religious house — or their profession: the Monk of Montaudon preserved his monastic habit; Daude de Pradas and Gui d'Ussel are both said to have been cathedral canons.[17] Melodies could do joint service, carrying profane and sacred content. Jonathan Glasser notes that 'transmission is simply one of the multiple forms of circulation' for sung music.[18] He also points out that the circulation of songs, as a social act of exchange, means that the object moving between performers is never exhausted, in the sense that it is not damaged or diminished by use. Consequently, he concludes that 'performance is the ultimate form of keeping-while-giving'.[19] The song remains inalienably part of its musical tradition while developing, even changing, through successive iterations.

The lyric poems of the troubadours survive for the most part without music: some 2500 written texts correspond to a mere 256 written melodies.[20] Furthermore, a troubadour song did not sound quite the same in 1150 as in 1300: Elizabeth Aubrey concludes that troubadour melodic structures fall into six generations, which corresponds neatly with the two-hundred-year span of the troubadour tradition, from Guilhem IX (d. 1116) to Raimon de Cornet.[21] According to Christelle Chaillou, however, even quite different melodies assigned for one particular song can be found to share common features, hinting at the kind of improvised developments that are typical of oral transmission.[22] Nevertheless, it is also important to bear in mind that modern scholarly frames for understanding orality may overlook the cultural specificity of a particular form of composition and transmission. Dominique Casajus's comparison of modern Touareg oral poetry, Homeric poetry, and medieval troubadour songs points out that the modes of composition, improvisation, and performance observed in the three genres are diverse. For Casajus, troubadour practice is reminiscent of Touareg songs of the twentieth century, which were composed and memorized as complete pieces, and then reproduced in performance.[23] This notion privileges a system that relied on the memorization of a complete piece. Disrupted textual traditions are easily ascribable to external factors such as the alteration of a song to serve a particular occasion, or a change of patron or performer.[24]

Part of the process of transmission from one textual witness to another relies on the quality of listening. In Paul Zumthor's theory of *auralité*, 'reading' in the

Middle Ages was a spoken process; 'writing' involved the spoken word, whether in composition or dictation, and the term *auctor* indicated the patron, scribe, or narrator more than the modern notion of the author.[25] In this volume, Cooper and Souleau both examine the complex self-representation of the late-medieval French *acteur*, the author who 'acts' within their own narrative, who places their subjectivity centre-stage, and who devises visual images of this figure, both hero/heroine and writer (see Chapters 7 and 8). As noted above, Raimon de Cornet's *truffa* presents him as the *acteur* of his poem, its speaker and protagonist, while in the manuscript, the rubrics and the image of a tonsured cleric also construct him as the *acteur* of his own compilation. The *acteur* is sometimes also the quoted glossator or commentator of a given text, neither the author nor the protagonist of a text, but rather its *auctoritas*, the secondary source that gives its statements some measure of support. The *truffa* melds some aspects of the satirized priest and the *acteur*, notably their shared clerical status. In brief, however, what defines the *acteur* of a text is almost always the use of the first-person voice.

First-person poetry would have been inculcated in elementary education via the Psalter. Rushworth's chapter on Dante's use of the Psalter in *Purgatorio* draws on Cheung Salisbury's work on the performativity of the liturgy, but she also notes that the Psalter's first-person verses are performed chorally, collectively, at key points of the poem (see Chapter 6). Cheung Salisbury's study develops the dialogue between the performed rituals of liturgy and the common agreement of participants and congregants that the ritual itself has an impact on each individual participant (see Chapter 5). The first-person voice is therefore both collective and singular.

The story of Samson is not, however, from the Psalms. Rather, it is part of the historical books of the Bible. Kelber's chapter stresses the importance of performance context and milieu for the narration of biblical and paraliturgical materials (see Chapter 9). Performing an antiphon outside the liturgical ritual in order to mark a political occasion could arguably constitute its performers as actors of a scene from the Bible or from para-biblical traditions such as the Harrowing of Hell. By extension, these actors become re-enactors, and the ancient scene is collapsed into the day and location of the ceremony in which they are participating. Thus, while religious theatre, as Kelber comments, 'formed a space of communication which allowed a transfer of knowledge across social boundaries' and taught catechism as well as biblical history, this powerful tool could also be put to political use. According to Kelber, the familiarity of biblical stories and of liturgical antiphons could become tools for collective action. In addition, Rushworth suggests that they could have a subjective, personal value as therapeutic modes of performance. She argues that 'Dante's *Purgatorio* is the realm of a "singing cure", a place where liturgical language and monophonic music are therapeutic, cathartic, and trans-formational'. Hypothetically, the performance of a penitential or emotional song provided opportunities for members of the audience to reflect on personal emotions and regrets — a feature that is certainly evident in the common invitation made by poets to their audiences to share in the troubadour's emotions.

If the Psalter was learned and performed as a first-person text, it was both

liturgically effective, and a ritual with subjective, intimate effect. These aspects ensured its relevance for the development of lyric poetry, both in Latin and the vernacular. Once the Psalms were performed outside the strict context of the liturgy or of personal devotion, they could be adapted to serve more subjective purposes. The penitent David is the *acteur* of the medieval Psalter, depicted in many illuminations with a harp, engaged in the act of composing and singing his poems (see Cooper and Souleau).[26] However, the material and cultural conditions of medieval lyric performance remain largely unknown and many questions persist: practical concerns about how dialogue songs were enacted, social issues governing the acceptability of a woman or a priest singing their own words, and questions of dramatic practice, such as the degree of sorrow involved in penitential songs.[27]

The Transmission of 'Samson, dux fortissime'

So far, this essay has touched on the reconstruction of past performance practice both secular and sacred, and the understanding of what constituted the voice of the *acteur*, the subjective 'I' of lyric expression, if the Psalter is taken as paradigm. It is useful to explore these two issues further by examining the transmission and text of 'Samson, dux fortissime'. It is a lyric drama with no named author. It blends vernacular (secular) and Latin (religious), musical and poetic genres. Despite its proven transmission exclusively in religious houses for men, the song includes a woman's voice. Her voice is rubricated in one manuscript (Stuttgart, Württembergische Landesbibliothek, MS HB 1.95) as a designated singing character: 'Dalida dixit' [Delilah speaks/utters]. 'Samson, dux fortissime' combines monophonic music with dialogue. In performance, it was noted for its theatrical aspects, as well as for its strong emotional impact.[28] A monastic or conventual context begs the question of what the performed and performable aspects were (both liturgical and aesthetic) of a dramatic, sung lyric piece such as this.[29]

'Samson, dux fortissime' is extant in four manuscripts. A fragment and an inventory entry are further evidence of its transmission in religious houses (see Table 3.1).[30] These manuscripts situate the song in four Benedictine houses. The Abbey of Weingarten, near the Hohenstaufen seat of Ravensburg, may be the source of the fourteenth-century copy in Sankt Georgen-im-Schwarzwald. 'Samson, dux fortissime' was copied three times in England in the later thirteenth century. Full copies were held in Reading Abbey and Christchurch Priory, which was attached to Canterbury Cathedral.[31] A fragment was copied onto the first folio of a compilation of schoolroom texts and sermons owned by the Cistercian abbey of Buildwas in Shropshire.[32] That the song's opening lines should have been jotted down in a margin, so far away from the prestigious royal abbeys, points to its wider transmission, possibly via performances. Finally, a copy survives at the end of a Dominican troper from Palermo in Sicily. Three of these sources contain music, and the version at Reading Abbey was modified with mensural notation by a later hand; all the sources imply a musical context. There are, therefore, strong signs of transmission via performance.

★Stuttgart, Württemburgische Landesbibliothek, MS HB 1.95, fols 30r–31v Date: after 1250 Provenance: Benedictine, Abbey of Weingarten, near Ravensburg
★London, British Library, Harley MS 978, fols 2r–4v Date: late thirteenth century Provenance: Benedictine, Reading Abbey, Berkshire
★Canterbury, Christchurch Priory (lost)† Date: late thirteenth century Provenance: Benedictine, Christchurch Priory, Canterbury, Kent
★Palermo, Biblioteca Nazionale, MS I.B.16‡ Date: late thirteenth century Provenance: Dominican convent, Palermo, Sicily
London, Lambeth Palace Library, MS 456, fol. 1a (fragment) Date: late thirteenth century Provenance: Cistercian, Buildwas Abbey, Shropshire
Karlsruhe, Badische Landesbibliothek, MS St Georgen 38, fols 117r–20r Date: fourteenth century Provenance: Benedictine, Abbey of Sankt Georgen-im-Schwarzwald, Baden-Württemberg

TABLE 3.1. Manuscript witnesses of 'Samson, dux fortissime'; asterisks indicate musical notation

† Stevens, 'Samson', p. 1, n. 3.
‡ See Stevens, 'Samson', p. 5, n. 12, citing David Hiley.

Bryan Gillingham has suggested that 'Samson, dux fortissime' is part of a French, Cluniac musical repertoire. His hypothesis has been disputed by Lisa Colton on the grounds that his key supporting evidence (the inclusion of texts in French in London, BL, Harley MS 978) owes more to the Anglo-Norman socio-cultural context than to a continental Cluniac presence at Reading Abbey. In any case, for those who copied and performed 'Samson, dux fortissime' at Christchurch Priory or at Buildwas Abbey, the repertoire was not primarily that of a Cluniac foundation.

'Samson, dux fortissime', like the Marian pieces that it precedes in Harley MS 978, is a sequence. Thus it shares a number of formal features with the secular lyric genres, the *lai lyrique* and the *estampie*. In terms of musical traditions, the connection with the *lai lyrique* points to northern French lyric, but it can also be related to the very similar German *Leich*, which also developed in the thirteenth century.[33] The diffusion of 'Samson, dux fortissime' in German-speaking lands further suggests the interaction between the liturgical sequence, the *lai lyrique*, and the *Leich*.

Harley MS 978 shows that both instrumental music and polyphony were practised and composed by the monks of Reading Abbey.[34] The exceptional status of Harley MS 978 has tended to overshadow the other copies of 'Samson, dux fortissime', though its traces in Canterbury and rural Shropshire support its wider diffusion in England. Weingarten Abbey was a Welf foundation that became an imperial abbey in 1274. The copy from Sicily is said to date from the mid-thirteenth century,

which also points to the Hohenstaufen milieu of Sicily up to 1268. As discussed above, tablemen and mosaic pavements depicting Samson are also attested in the Rhineland city of Cologne. Between the late twelfth and the early thirteenth century, Cologne merchants were awarded exceptional privileges in London by the Plantagenet kings, who were keen to build up an anti-French alliance with the Welf rulers.[35] While not discounting the Benedictine musical network, there is thus also a strong likelihood of an entertaining, para-liturgical song like 'Samson, dux fortissime' circulating between friendly Welf and Plantagenet secular and ecclesiastical retinues.

Performing Voices in 'Samson, dux fortissime'

John Stevens has summarized the problems posed by 'Samson, dux fortissime' which breaks with the conventions of the *lai lyrique* while not quite adhering to those of the sequence:

> As a creation in words and music 'Samson' raises interesting questions, some obvious and answerable, some equally obvious but baffling. We may begin with questions about the text. Unlike most surviving 'lyrical' *lais,* it is a narrative. [...] It is also, in some sense to be defined, a dramatic piece, most obviously because the speeches are uttered by different protagonists in the story.[36]

The piece is composed for three voices and modern editors have assigned the anachronistic label of Chorus to the first, undefined, protagonist who acts as an external onlooker. The second speaker is Samson, who sings most of the text. A third voice intervenes only twice, identified as that of Delilah. As noted above, MS HB 1.95 has a rubric 'Dalida dixit' which has been taken to imply that a singer was specifically playing the role of Delilah.[37] Stevens notes that the late-medieval editor of Harley MS 978 altered the length of notes in order to enhance the dramatic effect of the narrative's key moments and therefore acted with performance in mind.[38]

Typologically, Samson's heroism, humiliation, and redemptive death have long been interpreted as a prefiguration of Christ.[39] Jacques Handschin suggested that 'rather than a sacred or hymnic song it is the celebration of the feat of a hero'.[40] On the other hand, the treatment of the story in 'Samson, dux fortissime' may also be read in terms of the hero's shameful inability to withstand the emotional manipulation of his lady. This is also evidence of the song's hybrid positioning between secular and religious genres. Samson was placed in the medieval schoolroom, as well as in courtly literature, amongst a series of men who were brought low by women. Samson was a shorthand for the courtly knight as a victim rather than a servant of his lady.[41]

Empathy for Samson's emotional and physical downfall was expressed in Peter Abelard's lament of Israel for Samson, which is dated to *c.* 1130.[42] Pascale Bourgain describes the song as a celebration of the hero's redemption of his foolish lust through an act of courage.[43] Stevens, on the other hand, prefers to view the song's 'musical rhetoric' as an attempt 'to enforce a medieval reading of the story, a reading which is both strongly antifeminist and strongly theological in its glorification of

the hero'.[44] Bourgain suggests that the opening questions directed to Samson by the Chorus are not necessarily sympathetic. Rather, they can be viewed as a shocked reaction, even mockery.[45] The humiliation bestowed on Samson by the Chorus's questions places the audience in the same position, as witness to his downfall:

> Samson, dux fortissime,
> victor potentissime,
> quid facis in carcere,
> victor omnium?
> Quis te quivit vincere,
> vel per sompnium?
> O victor omnium, victus es!
> O captor principium, captus es!
> O raptor civium, raptus es! (st. 1a, ll. 1–11)[46]

[Samson, strongest of leaders, most powerful of victors, what are you doing in prison, defeater of all? Whoever could have overcome you, even in your sleep? Oh defeater of all, you have been defeated! Oh capturer of princes, you have been captured! Oh abductor of men, you have been abducted!]

The Chorus claims that Samson's downfall was the result of 'fraus mulieris' [a woman's deceit] (l. 15) before it describes his reduction to an object of mockery:

> Avulsis oculis cecus es,
> [et risus hostibus factus es].
> Iam tonsis crinibus calvus es,
> set si recreverint, salvus es! (st. 1a, ll. 16–19)

[Your eyes plucked out, you are blind [and you have been made a laughing-stock for your enemies]. Your hair shaved off now, you are bald. If it grows back, you will be saved!]

The hint that he owes his suffering to a woman is confirmed by Samson's own words. He recounts his achievements, but cries out to the 'young woman' (possibly his lost wife rather than Delilah) that they were undertaken exclusively for her sake:[47]

> Milli rupi vincula.
> Mille per pericula.
> Propter te, iuvencula,
> feci tot miracula. (ll. 26–29)

[I broke a thousand chains, I overcame a thousand dangers; for your sake, young girl, I accomplished these miracles!]

Samson concludes that the moment of his downfall came when he fell in love with Delilah (st. 9, ll. 68–69). His description of Delilah handing him a cup of wine with a kiss (st. 9, ll. 70–73) is followed by Delilah's own voice, as she asks Samson about the source of his superhuman strength (st. 10, ll. 75–82). Samson's regretful lament, 'Proh dolor, proh dolor, | detego miraculum' [Grief, grief, I revealed my secret!] (st. 12, ll. 94–95), is followed by the blunt description of himself as a drunkard seduced by a harlot into sleeping with his head in her lap (st. 13a, ll. 100–03). Delilah sings again, this time in triumph:

> I et o, I et o,
> hostem victum teneo!
> I et o, I et o,
> decalvatum rideo! (st. 14, ll. 110–13)

[Hurrah, hurrah, I have captured your enemy! Hurrah, hurrah, I am laughing at him, shaven!]

Samson narrates his humiliation and his own suicide. Forced to dance in front of his captors, he recounts how he pulled down the gateposts and killed both his tormentors and himself (st. 18–19b). At this point (narrating beyond his own death), Samson's verses contrast laughter with lamentations (st. 19b, ll. 142–43) and mark his own glorious end: 'Glorianter crucior, | crucianter glorior' [I am tormented in triumph, I triumph in torment] (st. 20, ll. 146–47).[48]

The Chorus concludes with a single, simple line, proposing that Samson should be glorified for his victory (st. 21, l. 150). However, the stress placed at the end on his captors' laughter echoes the mocking tone of the Chorus's opening series of questions and exclamations. At the start, the Chorus's point of view is that of Samson's Philistine tormentors. The Chorus — and the audience — have experienced a change of perspective by the end, as the fallen hero has retold his story and then emerged triumphant from his own death. The audience realize also that by virtue of being onlookers, sharing the Chorus's point of view, they were placed among the hero's tormentors ('Amorites, Canaanites, Jebusites, [...] Idumeans, Gergesenes, Pharezites'; st. 15, ll. 114–17). This shifting point of view is complemented by the multiple shifts in the song's temporal levels; these are both powerful and disorientating. Audience and Chorus are bystanders for Samson's first-person, subjective voice, as he laments and rejoices. 'Samson, dux fortissime' thus illustrates the discussion of the Psalter as a flexible model for expressing subjective emotion as well as for expressing community (see above). Despite its plural voices (Chorus, Samson, Delilah) and collective witnesses (Chorus and audience), 'Samson, dux fortissime' remains a single-voiced lyric composition, in the sense that it retains its focus on the hero's emotions.

Conclusion

The Latin song 'Samson, dux fortissime' was performed at Benedictine, Cistercian, and Dominican religious houses. In secular culture, decorative objects and tales depict the familiar figure and story of Samson both as hero and as victim of love; and Raimon de Cornet performed his very own version of the Samson tale. Where, then, did these songs sit? Few written reports of lyric performances survive and most of these are, at best, evocative rather than precise. The generic classification of various genres as 'high' and 'low' style, 'courtly' and 'popular', has been questioned, making it impossible to assume that the performers and audience of a *rondeau de carole* differed dramatically from a *grand chant courtois*.[49] While the descriptive nature of the text may preclude enactment and costume in 'Samson, dux fortissime', it may also indicate that the piece could be performed outside the monastic setting by

the singers of the monastery and its school. The monastery could provide its own instrumentalists and compose a musical accompaniment.

'Samson, dux fortissime' is a malleable work and was able to cross borders of genre and audience from the outset. It is useful to recall Glasser's statement that 'written transmission is simply one of the multiple forms of circulation'.[50] Performance practice is the lost element for much medieval lyric song, but the fragmentary evidence discussed here suggests that the reception and transmission of a reasonably familiar story, presented as it is with some flexibility for its performers and audiences, could be both creative and dynamic. 'Samson, dux fortissime' moved between monastic houses, and it is plausible that it had some success beyond them. In fact, the biblical story of Samson and Delilah was also appealing to a troubadour who lived and performed in both liturgical and secular contexts. Raimon de Cornet's shorn rural priest alludes gently to the laments of the heroic but fallen Samson.

The questions about how medieval songs and stories travelled, and how they reached their audiences can be tackled through careful codicological and historical detective work — but, ultimately, nobody can know why a Cistercian book compiled in rural Shropshire came to include someone's jottings of the first stanza of 'Samson, dux fortissime', or how exactly this song managed to travel across Europe so successfully (see Table 3.1). Yet memory and performance have left a trace, and this points to a soundscape in which laments concerning 'fraus mulieris' were sung in a monastic context. Monasteries with priested monks and schools touched a wide audience of adults and children, and these songs cannot, therefore, have been limited to the cloister or the church in which they were written down and preserved. They were known in locations where a performer — a member of the clergy or the laity — could amuse, entertain, and move an audience. The essays in this volume explore these spaces for performance and for building new communities of audiences and singers.

Notes to Chapter 3

1. Barbara Newman, *Medieval Crossover: Reading the Secular against the Sacred*, Conway Lectures in Medieval Studies (Notre Dame, IN: University of Notre Dame Press, 2013). This chapter informs my book, *Samson and Delilah in Medieval Insular French: Translation and Adaptation*, forthcoming Palgrave Macmillan.

2. Henry Hope, 'Miniatures, Minnesänger, Music: The Codex Manesse', in *Manuscripts and Medieval Song: Inscription, Performance, Context*, ed. by Helen Deeming and Elizabeth Eva Leach (Cambridge: Cambridge University Press, 2015), pp. 163–92.

3. Marisa Galvez, *Songbook: How Lyrics Became Poetry in Medieval Europe* (Chicago: University of Chicago Press, 2012); Thomas Cramer, *Waz hilfet âne sinne kunst?: Lyrik im 13. Jahrhundert: Studien zu ihrer Ästhetik* (Berlin: Schmidt, 1998); Judith A. Peraino, *Giving Voice to Love: Song and Self-Expression from the Troubadours to Guillaume de Machaut* (New York & Oxford: Oxford University Press, 2011).

4. Elizabeth Eva Leach, 'Nature's Forge and Mechanical Production: Writing, Reading and Performing Song', in *Rhetoric Beyond Words: Delight and Persuasion in the Arts of the Middle Ages*, ed. by Mary Carruthers (Cambridge: Cambridge University Press, 2010), pp. 72–95 (pp. 76 & 84–85); see also, Ardis Butterfield, 'Music, Memory, and Authenticity', in *Representing History, 900–1300: Art, Music, History*, ed. by Robert A. Maxwell (Philadelphia: Pennsylvania State University Press, 2010), pp. 19–30.

5. On the adaptation of medieval songs in popular music, see Céline Cecchetto, 'Médiévalismes d'une sémiose: le Moyen Âge en chanson', *Itinéraires*, 8.3 (2010), 177–88. Recent 'cross-over' approaches in adapting medieval song to contemporary music are discussed by Konstantin Voigt, 'Gothic und HIP — Sinn und Präsenz in populären und in historisch informierten Realisierungen des Palästinalieds', *Basler Jahrbuch für historische Musikpraxis*, 32 (2008), 221–34.

6. Sequentia, *Visions from the Book* (BMG Classics, 1996, catalogue no. 05472773472). 'Samson and Delilah', recorded by students as part of Evelyn Birge Vitz's project 'Performing Medieval Narrative Today: A Video Showcase', filmed in 2007 and put online in 2012, <http://mednar.org/2012/06/13/samson-and-delilah/> [accessed 8 August 2017]. Ensemble Labyrinthus, 'Carmina Anglica', 2012, <https://www.youtube.com/watch?v=ujRpJ4rW2AI> [accessed 8 August 2017].

7. Jean-Baptiste Noulet and Camille Chabaneau, *Deux manuscrits provençaux du XIVe siècle contenant des pièces de Raimon de Cornet, de Peire de Ladils et d'autres poètes de l'école toulousaine* (Montpellier & Paris: Société pour l'étude des langues romanes, 1888), poem LI, p. 98. The *truffa* is preserved in two manuscripts compiled in 1335 and 1349, see Marina Navàs, 'Le Registre Cornet: structure, strates et première diffusion', *Revue des langues romanes*, 117 (2013), 161–91 (p. 189, n. 41).

8. All translations are my own unless otherwise stated.

9. This is probably the church of Saint-Martial at Orban, in the Tarn, some fourteen kilometres south of Albi. On Raimon de Cornet's ambivalent clerical persona, see Marina Navàs, 'La figura literària del clergue en la poesia de Ramon de Cornet', *Mot so razo*, 9 (2010), 75–93, and Catherine Léglu, 'Vernacular Poetry and the Spiritual Franciscans of the Languedoc: The Poems of Raimon de Cornet', in *Heresy and the Making of European Culture: Medieval and Modern Perspectives,* ed. by Andrew Roach and James R. Simpson (Farnham & Burlington, VT: Ashgate, 2013), pp. 165–84.

10. Toulouse, Bibliothèque municipale, MS 2885, fol. 43v, <http://numerique.bibliotheque.toulouse.fr/ark:/74899/B315556101_MS2885> [accessed 8 August 2017].

11. 'Delilah', in *A Dictionary of Biblical Tradition in English Literature*, ed. by David Lyle Jeffrey (Grand Rapids, MI: Eerdmans, 1992), pp. 193–94.

12. J. Cheryl Exum, 'The Theological Dimension of the Samson Saga', *Vetus Testamentum*, 33 (1983), 30–45. For an excellent overview, see Greti Dinkova-Bruun, 'Biblical Thematics: The Story of Samson in Medieval Literary Discourse', in *The Oxford Handbook of Medieval Latin Literature*, ed. by Ralph J. Hexter and David Townsend (New York & Oxford: Oxford University Press, 2012), pp. 356–75.

13. Robert Favreau, 'Le Thème iconographique du lion dans les inscriptions médiévales', *Comptes-rendus des séances de l'Académie des inscriptions et des belles-lettres*, 3 (1991), 613–36 (pp. 613–14).

14. Vivian B. Mann, 'Mythological Subjects on Northern French Tablemen', *Gesta*, 20.1 (1981), 161–71; and by the same author, 'Samson vs. Hercules: A Carved Cycle of the 12th century', *Acta*, 7 (1983), 1–38, and *Art and Ceremony in Jewish Life: Essays on the History of Jewish Art* (London: Pindar, 2005), pp. 153–73.

15. See Dinkova-Bruun, 'Biblical Thematics', passim.

16. Navàs, 'Le Registre Cornet', Appendix.

17. Hans Tischler, 'The Performance of Medieval Songs', *Revue belge de Musicologie / Belgisch Tijdschrift voor Muziekwetenschap*, 43 (1989), 225–42; Jean Boutière and Alexander H. Schutz, *Biographies des troubadours: textes provençaux des XIIIe et XIVe siècles* (Paris: Nizet, 1964); Susan Boynton, 'Troubadour Song as Performance: A Context for Guiraut Riquier's "Pus sabers no'm val ni sens"', *Current Musicology*, 94 (2012), 7–36.

18. Jonathan Glasser, *Genealogies of Al-Andalus: Music and Patrimony in the Modern Maghreb* (doctoral dissertation, University of Michigan, 2008; published online by ProQuest and UMI Dissertation Publications, 2009), pp. 8–9, <https://search.proquest.com/docview/304571085> [accessed 8 August 2017].

19. Ibid., pp. 8–9.

20. Hendrik van der Werf, *The Chansons of the Troubadours and Trouvères: A Study of the Melodies and their Relation to the Poems* (Utrecht: Oosthoek, 1972); Elizabeth Aubrey, *The Music of the Troubadours* (Bloomington: Indiana University Press, 1996). See the recent discussion by Cory McKay, 'Authentic Performance of Troubadour Melodies', <http://www.music.mcgill.ca/~cmckay/papers/musicology/TroubadourMelodies.pdf> [accessed 8 August 2017].

21. Aubrey, *The Music of the Troubadours*, pp. 132–97.

22. Olivier Cullin and Christelle Chaillou, 'La Mémoire et la musique au Moyen Âge', *Cahiers de Civilisation Médiévale*, 49 (2006), 143–62. For similar points, see Mary O'Neill, *Courtly Love Songs of Medieval France: Transmission and Style in the Trouvère Repertoire* (Oxford: Oxford University Press, 2006), and Butterfield, 'Music, Memory, and Authenticity'.

23. Dominique Casajus, *L'Aède et le troubadour: essai sur la tradition orale* (Paris: CNRS Éditions, 2012).

24. Recent studies disagree over seeing the association of modern Arabic performance practice with medieval music as Orientalist cultural appropriation, or a timely re-inscription of Arab culture into medieval European poetry. See John Haines, 'The Arabic Style of Performing Medieval Music', *Early Music*, 21 (2001), 369–78. Haines's article is discussed by Jonathan Shull, 'Locating the Past in the Present: Living Traditions and the Performance of Early Music', *Ethnomusicology Forum*, 15 (2006), 87–111. For a discussion of the debate, see Kirsten Yri, 'Thomas Binkley and the Studio der Frühen Musik: Challenging "the Myth of Westernness"', *Early Music*, 38 (2010), 273–80.

25. Paul Zumthor, *La Lettre et la voix: de la 'littérature' médiévale* (Paris: Seuil, 1987).

26. Clare L. Costley, 'David, Bathsheba, and the Penitential Psalms', *Renaissance Quarterly*, 57 (2004), 1235–77.

27. See Christopher Callahan, 'Hybrid Discourse and Performance in the Old French Pastourelle', *French Forum*, 27 (2002), 1–22; Catherine Léglu, 'Did Women Perform Satirical Poetry? *Trobairitz* and *Soldaderas* in Medieval Occitan Poetry', *Forum for Modern Language Studies*, 37 (2001), 15–25; Ria Lemaire, 'Femmes, jongleurs et troubadours: la mise-en-forme du discours médiéviste', <http://www.crimic.paris-sorbonne.fr/IMG/pdf/lemaire.pdf> [accessed 8 August 2017]

28. Jacques Handschin, 'The Summer Canon and its Background, I', *Musica Disciplina*, 3.2 (1949), 55–59 (pp. 57–59); Bryan Gillingham, *Music in the Cluniac Ecclesia: A Pilot Project* (Ottawa: Institute of Medieval Music, 2006), pp. 143–44 & 168; reviewed by Lisa Colton, 'Reconstructing Cluniac Music', *Early Music*, 34 (2006), 675–77.

29. *The Oxford Book of Medieval Latin Verse*, ed. by Frederic James Edward Raby (Oxford: Clarendon Press, 1959), pp. 428–33. An improved edition of 'Samson, dux fortissime' was published by Richard William Hunt in his review of Raby's book, *Medium Aevum*, 28 (1959), 189–94. An edition by Peter Dronke is cited by John Stevens, '"Samson, dux fortissime": An International Latin Song', *Plainsong and Medieval Music*, 1 (1992), 1–40. I thank Peter Dronke for allowing me to quote from this edition, as published in the booklet of the CD by Sequentia.

30. Helen Deeming, *Songs in British Sources, c. 1150–1300*, Musica Britannica, XCV (London: Stainer and Bell, 2013), with the companion online resource, *Sources of British Song, 1150–1300*, <http://www.diamm.ac.uk/resources/sbs/> [the entry on 'Samson, dux fortissime' had not been put online yet when this website was last accessed on 8 August 2017].

31. The Christchurch Priory copy is known from a booklist of the late thirteenth century, see Stevens, 'Samson', p. 1, n. 3. Manuscripts detailed in Stevens, 'Samson', pp. 5–6, 9–12, & 14.

32. M. R. James, *A Descriptive Catalogue of the Manuscripts in the Library of Lambeth Palace* (Cambridge: Cambridge University Press, 1895; digital repr. 2011), pp. 631–65. For recent establishment of the provenance of the manuscript, see the entries for MSS 456 and 488 in *Lambeth Palace Library Database of Manuscripts and Archives*, <http://archives.lambethpalacelibrary.org.uk/CalmView/Default.aspx> [accessed 8 August 2017].

33. *Medieval German Literature: A Companion*, ed. by Marion B. Gibbs and Sidney M. Johnson (New York & London: Routledge, 2000), p. 238.

34. Helen Deeming, 'An English Monastic Miscellany: The Reading Manuscript of *Sumer is icumen in*', in *Manuscripts and Medieval Song*, ed. by Deeming and Leach, pp. 116–40; Alan Coates, *English Medieval Books: The Reading Abbey Collections from Foundation to Dispersal* (Oxford: Clarendon Press, 1999), p. 75.

35. Derek Keene, 'Text, Visualization and Politics: London, 1150–1250', *Transactions of the Royal Historical Society*, 18, 6th series (2008), 69–99 (pp. 92–93).

36. Stevens, 'Samson', p. 2.

37. Ibid., p. 39, n. to l. 75.

38. Ibid., p. 23.

39. Felix Heinzer, 'Samson dux fortissimus — Löwenbändiger und Weiberknecht vom Dienst? Funktionen und Wandlungen eines literarischen Motivs im Mittelalter', Mittellateinisches Jahrbuch, 48 (2008), 25–46.

40. Handschin, 'The Summer Canon', p. 57.

41. Pascale Bourgain, 'La Honte du héros', in Nova de veteribus: mittel- und neulateinische Studien für Paul Gerhard Schmidt, ed. by Andreas Bihrer and Elisabeth Stein (Munich: Saur, 2004), pp. 385–400 (p. 389). James A. Rushing terms it the topos of the 'Frauensklaven or Minnesklaven'; James A. Rushing, 'Iwein as Slave of Woman: The "Maltererteppich" in Freiburg', Zeitschrift für Kunstgeschichte, 55 (1992), 124–35 (p. 126). For related issues in troubadour poetry, see Catherine Léglu, 'L'Amant tenu par la bride: itinéraires d'un motif dans la poésie du troubadour Gaucelm Faidit et un coffret en émail "œuvre de Limoges" du douzième siècle finissant', in Gaucelm Faidit: amours, voyages et débats, Trobada tenue à Uzerche les 25 et 26 juin 2010, Cahiers de Carrefour Ventadour (Moustier-Ventadour: Carrefour Ventadour, 2011), pp. 149–66; Susan L. Smith, The Power of Women: A Topos in Medieval Art and Literature (Philadelphia: University of Pennsylvania Press, 1995), pp. 143–47 & 160–64.

42. Peter Dronke, Poetic Individuality in the Middle Ages: New Departures in Poetry (Oxford: Clarendon Press, 1970), pp. 114–45; Heinzer, 'Samson', pp. 36–39.

43. Bourgain, 'La Honte du héros', p. 389.

44. Stevens, 'Samson', pp. 22 & 24.

45. Bourgain, 'La Honte du héros', p. 389.

46. All quotations and stanza numbers are from Dronke's edition and translation, in the booklet for the CD Visions from the Book, pp. 18–26. Translations are mine, based on Dronke's translation.

47. Most of Samson's great deeds, including killing the lion, are accomplished out of love for the woman of Timnah (Judges 14:1–7, 14:20, and 15:3–6). He breaks the ropes that bind his arms twice, first for the sake of reclaiming his wife (Judges 15:13–14), and later at Delilah's request (Judges 16:10–12).

48. Stevens, 'Samson', pp. 17–18.

49. Butterfield, 'Music, Memory, and Authenticity', pp. 24–29; Tischler, 'The Performance of Medieval Songs', pp. 238–39; Elizabeth Aubrey, 'Reconsidering "High Style" and "Low Style" in Medieval Song', Journal of Music Theory, 52 (2008), 75–122.

50. Glasser, Genealogies of Al-Andalus, pp. 8–9.

CHAPTER 4

Tíð, Tíðindi:
Skaldic Verse as Performance Event

Annemari Ferreira

Skaldic poetry refers to a body of courtly texts produced by skalds (or *skálds*) —
that is, Norse poets of Viking and Medieval Scandinavia. It is, for the most part,
encomiastic or elegiac in nature and appears to have originated in a courtly society,
celebrating both living and deceased Norse kings, jarls, and chieftains by extolling
their (typically martial) achievements, wisdom, and generosity with gold. 'Gold'
usually serves as a metonym for the valuable resources bestowed through gift-
giving rituals upon members of a *hirð* [retinue] by their *dróttinn* [lord] as a means of
securing political loyalty and continued military support. Skalds who, as retainers,
belonged to the *hirð* were themselves dependent on such material generosity and
often composed *drápur* or *flokkar* — long skaldic compositions distinguished by the
inclusion (in the case of the *drápa*) or exclusion (in the case of the *flokkr*) of a *stef*
[refrain] — in order to procure wealth from the rulers whom they praised, advised,
and at times even admonished.[1] Skaldic composition became a wide-spread and
enduring phenomenon, with itinerant skalds attending kings and other powerful
rulers throughout Scandinavia, the Orkney Islands, the Danelaw, and elsewhere.
The form was also adopted in the treatment of extra-political subjects such as love
and insult, especially in an Icelandic milieu, and was appropriated for venerative and
homiletic purposes in post-conversion contexts.[2]

Imparted as memorized vocal entities from one generation to the next, skaldic
verse survived as orature for centuries.[3] Most extant skaldic material has, however,
been transmitted to modern audiences in individual stanzaic units incorporated into
saga literature or poetic and grammatical treatises recorded on parchment in the
twelfth and thirteenth centuries. In these later literary frameworks, skaldic stanzas
are typically disjointed from their primary setting in lengthier *drápur* or *flokkar* and
inserted into saga narratives as *lausavísur* [loose stanzas]. Nearly all skaldic poems
presented in supposedly authentic and complete configurations within modern
textual editions are therefore the products of careful academic reconstruction and
must ultimately submit to the fragmentary nature of their preservation: one can
never be entirely certain that any *drápa* or *flokkr* is complete once it is reassembled,
or that the order of any (re)arrangement reflects a conclusive interpretation of the
available material. This is not to say that useful information regarding skaldic praxes

in an originally courtly context cannot be gleaned from the manner in which detached stanzas are woven into saga narratives. Such an assumption overlooks the very probable coexistence of oral and literate performance modes after the Viking Age: one mode might easily affect and influence another.[4]

This essay maintains that even non-authentic stanzas — verses not taken from pre-existing skaldic works but likely composed, instead, by saga authors themselves in order to emulate a practice in which skaldic stanzas serve as literary devices — demonstrate conceptual as well as technical continuities with oral antecedents and can contribute to a more comprehensive understanding of Viking Age skaldic poetics.[5] Of particular value in this regard are those features which reveal a phenomenological understanding of skaldic poetry that may reflect both culturally inherited perceptions about specific experiences, as well as more universal and timeless insights. One such characteristic is the performative nature of skaldic extracts in their various prose settings and it is with this aspect that I am preoccupied in the present study. The performative nature of these poetic inserts is of special interest because of the often overtly literary nature of such saga-situated stanzas. Since literary texts are often contrasted to oral texts based on a perceived absence (in the former) and presence (in the latter) of performance or performativity, establishing that literature also exhibits performative aspects can help to demonstrate the sustained compositional relationship between oral and literary skaldic compositions.[6] Recognizing the performativity of skaldic poems in a literary situation is important in shaping an understanding of the manner in which these poems have been incorporated into Norse-Icelandic saga contexts. The framework through which poetry is crafted into the prose at times reveals an awareness of exactly those features one would associate with the performative nature of skaldic poetry as orature — specifically with regards to the relationship between time and performance, usually reserved for those arts which most clearly exhibit temporal movement.

In what follows I investigate the skaldic stanza as a literary performance event, exploring its relationship to narrative time within a prosimetric framework. To begin with, I briefly expand on the way the term 'performance' is used in this essay and outline some of the primary characteristics with which I am concerned in establishing the performativity of skaldic verse. Chief among these characteristics is the temporal nature of performance which most obviously marks out performance as an event or happening. I investigate the way in which rhythm, as a phenomenological expression of 'being in time' within performative contexts, serves as a framing mechanism for skaldic performance and what such rhythmicity constitutes. The concept of rhythmic embodiment as the means through which the performance-engendered experience of rhythmic 'being in time' is expressed in skaldic poetry itself is another feature which may contribute to the fictional rendering of stanzas as spoken dialogue when incorporated into saga narratives. Finally, I turn my focus to the relationship between *lausavísur* and the time-related concept of *tíðindi* [tidings], a term which saga authors often apply when referring to skaldic utterances: the representation of skaldic compositions as *tíðindi* may stem directly from the performative nature of the poetry.

Performance, Performing, Performative

According to the *OED* the verb 'perform' has eight distinct senses of which two in particular, with their lineage of subsequent linguistic relations, seem to characterize the primary distinction between these variations: 'perform' as *action*, signifying 'to do, to carry out, to execute [...], to act,' etc.; and 'perform' as a *type of action* pertaining specifically to *(re)presentation*, signifying 'to present (a play, ballet, opera, etc.) on stage or to an audience' and 'to act or play (a part or role in a play, ballet, etc.); to represent (a character) on stage or to an audience'.[7] These definite, if subtle, conceptual distinctions between the variant uses of 'performance' must subsequently affect one's application of J. L. Austin's theory on speech acts, in which the concept of the 'performative utterance' is first established.[8] 'Performative' in Austin's theory, as well as ensuing linguistic theory and philosophy, refers to the effecting of action through utterance. This employment of the term, derived from the sense of performance as action, is also the only sense recorded and therefore acknowledged by the *OED* and constitutes the way in which Margaret Clunies Ross and other Norse scholars have approached the matter of skaldic performance in saga contexts.[9] However, many scholars (particularly in the fields of literature and music) have used 'performative' in equally valid and relevant ways, but bearing far closer resemblance to the sense of performance as (re)presentation.[10] For the purposes of the present essay, I differentiate between a) 'performance', 'performing', and 'performative' as terms referring to all uses of 'perform' in its *general action* sense (particularly its speech-act sense); and capitalized b) 'Performance', 'Performing', and 'Performative' as terms referring to 'Perform' in its *representational action* sense. It is this latter sense with which I shall be primarily concerned in this essay, although it is important to note that the two senses do not necessarily preclude each other, as they are far from being mutually exclusive. Uttering wedding vows, for instance, is no less Performative than it is performative, and it is in the performance of cultural rites and ceremonies that we often find a use of 'performance' which straddles both of these senses.

 A more refined definition of Performance is now required if a conflation of Performance and orature is to be avoided. This is an important consideration when treating skaldic Performance in its written manifestation within saga literature. As I shall demonstrate below, such manifestations are not un-Performative because they are encountered on the page. Neither are they Performative simply because of their supposed oral genesis: not all *lausavísur* stem directly from Viking Age orature, and some originate as written medieval creations composed for distinctly literary purposes. In order to appreciate fully the Performativity of literature, it is crucial to relocate the primary site of Performance, whether in oral or literary form, from the written or spoken text (neither of which incorporates that purposeful, agency-led action which the concept of Performance, as an act of representation, demands) to the mind in which the interpretative processes inherent in the consideration of representational material occur.[11] Even writing or speaking in Performance-related actions can only be said to be Performative when there occurs a self-conscious consideration of how language, including all symbolic gestures of communication,

is employed in the representation of an artistic image beyond the commonplace communicative associations that the language conveys in a non-Performative context. Writing, speaking, and all other actions that might pertain to Performance are Performative only when there is a self-aware employment of, and engagement with, artifice. A child who reactively cries 'Spider!' when they see an arachnid is not Performing. The same child who, in the absence of such a creature, cries 'Spider!' in order to frighten their parent *is* Performing but not because they are uttering a cry. Nor can the cry (as text) itself be said to constitute a Performance, although it is certainly evidence that a Performance is taking or has taken place and may engender a Performance of audience-recipiency in someone who recognizes the cry as a Performative utterance. The child is Performing, instead, because they are self-consciously employing the word 'spider' to construct an artefact of representational meaning, the interpretative response to which they have already imagined before (or at least whilst) uttering the cry. It is through a self-conscious interpretative participation in listening or reading that speech acts, whether spoken or written, become art acts. In the words of Mikhail Bakhtin, 'artistic representation' is differentiated from 'everyday speech' through an active '[recognition of] images lying *behind* the isolated utterances of social language' and these images are likened to the 'hewn and carved' products of a 'sculptor's chisel'.[12] His words support a broader definition of Performance as a self-conscious engagement with artifice.

Having established a working definition of Performance for the following essay, I can now summarize those key characteristics that one may recognize in Performative acts and which one may try to discern in skaldic Performances specifically. In the first place, a Performance event can be shown to be crafted as a form of artistic portrayal — that is, it can be shown to be *artificed*. As a form of communicative representation it will also be *dialogic* in nature since Performance is founded on the relationship between performer and audience-recipient, even if the performer or recipient is internal and imagined. More discernibly than any other utterance, Performance assumes reception: the cry of 'Spider!' which a child utters in Performance is Performative because the child imagines that their parent will respond through attention, interpretation, and/or reaction. This is the case even if the child only imagines their parent to be present. By contrast, a tune whistled alone and subconsciously is not Performative because not even the self is imagined as recipient. Because Performance always assumes a response — which may in the case of reading be one's own response, where the imagined recipient is also the Performer — one can point out a dialogic relationship between various perspectives of symbolic utterance and interpretative understanding. The 'dynamic quality of Performance that allows each expressive event to be shaped by the interactions between Performers and audiences' is known as emergence and is related to a 'chronotopic' understanding of language and discourse.[13] Each Performance *must* be unique and inimitable since the conditions of a particular Performance event emerge out of an interactive process between a Performer and recipient within an ongoing flow of space-time and can never, therefore, be exactly replicated. Variations between Performances are therefore guaranteed. It is

this spatio-temporal conditioning of the Performance context which leads to the final characteristic of Performance with which I am concerned, that is, its incessant 'presentness'. As a *type of action*, Performance naturally denotes a temporal process and is forever situated in the here-and-now — in the present continuous.[14] The phenomenological perception of skaldic poetry's presentness is clearly demonstrated in the manner of its incorporation into the saga text with stanzas seeming to happen in the present of narrative events. To begin with, however, I shall direct my focus to rhythmic artifice — often related to Performance and which may be used, phenomenologically, to express the characteristics of Performance outlined above: its artifice, its dialogism, and its relationship to time.

Rhythmic Artifice

The temporal nature of skaldic poetry is reflected in its use of an artistic mechanism intimately associated with time, namely rhythm. Rhythm phenomenologically affects listeners or readers of a saga, and Stuart Grant describes it not as 'the same thing as the actual events of our movements, but rather their condition'.[15] If the adaptation of skaldic verse into a mode of Performance within the saga narrative is indicative of a bodily perception of skaldic poetry as a temporal phenomenon, then the condition of that perception is indeed rhythmical. Such a sensory interpretation of skaldic material, rooted in physiological and neurological responses to the poetic Performance as an aural stimulus, can outweigh the cognitive interpretation of a verse's informational content: the news conveyed is secondary to the conveying *of* the news. One may, for example, be deeply affected by a Performance of an opera without being able to understand the language of the libretto. In such a case, the sensory experience engendered by the music conveys a message which is independent of, and need not support, the philological content. This aspect of poetic reception is often exploited by skalds who engage the listeners' awareness of the skaldic process rather than their understanding of the information which the process is ostensibly meant to communicate.[16] As I shall demonstrate, stanzas are often incorporated into saga narratives as units of speech that are meant to report news to kings or other characters. Yet skaldic verse is hardly the simplest or clearest way to deliver an unambiguous record of events, and mnemonics alone does not account for its being used as *tíðindi* [news] in saga narratives. This is particularly true when a strong self-referential tendency in the poetry focuses the attention of the listener on the event of telling rather than on the event being recounted in the telling.[17] By highlighting the event of the poetry itself, the Performativity of the skaldic composition is brought to the fore. The communicative act of the poetic Performance ceases to operate in a functional semantic way: instead, in becoming aware of the constructedness or craftedness of the communication, its artifice, a Performance emerges through the self-conscious realization that the language is employed representationally. It is the highly rhythmic nature of the poetic text — far removed from a normal way of speaking — which alerts the recipient to this artifice.[18] Noting a similar trend in the plays of Jean Genet, Clare Finburgh understands these processes as 'rhythmical

micro-systems [which] crystallise into self-conscious essences of artifice'.[19] The conscious engagement with such rhythmic artifice through Performance gives rise to the co-emergence of a dialogic relationship between audience and Performer in which the Performance calls forth a response through recipiency.

The self-referential awareness of stanzas as poetic events or tidings to which a skaldic audience is responding, can be observed in Þorbjǫrn hornklofi's 'Glymdrápa' [The Clangour Poem]. Þorbjǫrn's poem, probably composed towards the end of the ninth century, is 'the earliest known skaldic praise-poem in regular *dróttkvætt*, [which] illustrate[s] events in the life of King Haraldr hárfagri "Fair-hair" Hálfdanarson'.[20] As the title 'Clatter- or Clash-*drápa*' suggests, Þorbjǫrn's poem has a strong auditory focus with its 'battle-kennings and metaphors primarily convey[ing] the acoustic effect of battle'.[21] Significantly, there is also little contextual consistency between the ways in which the various stanzas of 'Glymdrápa' have been incorporated into different prose narratives.[22] The lack of specific information pertaining to details of battles and persons — information essential to historic accounts and therefore to the narrative consistency between historic sagas which is absent here — contributes to the impression that Þorbjǫrn's *drápa* is not fundamentally concerned with apprising its audience of news.

The following stanza from 'Glymdrápa' (stanza 7) is inserted into the pseudo-historical king's saga of *Haralds saga hárfagra* [Saga of Harald Fairhair, hereafter *Haralds saga*] in order to substantiate the events depicted in the narrative. It is introduced with the narrative formula *svá segir* [so says] which transports the voice of the narrator from past to present, thereby instigating a Performance frame through which the spoken words of Þorbjǫrn are received:[23]

Ríks þreifsk reiddra øxa	[Forceful;[24] felt was their flight-flung axes'
rymr — knôttu spjǫr glymja —	roar — spears were able to clash —
svartskyggð bitu seggi	black-bright swords bit speaking shreds of men[25] —
sverð — þjóðkonungs ferðar,	the escorts', of the [forceful] king of people,
þás hugfyldra hǫlða	courage-filled conquerors
(hlaut andskoti Gauta)	— the rival of Geats gained glory —
hôr vas sǫngr of svírum	when over their prows
(sigr) flugbeiddra vigra.	went high the song of flight-bidden spears.][26]

The internal rhyme as well as the vocal rise and fall of stressed and unstressed syllables, combined with the alliterative percussion of consonants bind the meter, pulse, and resonance of this skaldic stanza. What results is a textual unit flooded with a distinctive sonic character that calls not only for a situation external to the body of the prosaic narrative, but also for representational embodiment which establishes itself in the 'present' speech of the narrating voice (through a rhythmicity which brings the poetic event into focus within the emerging present).[27] This is a verse that must be spoken prosimetrically.[28] The bodily response to the rhythmic utterance in time — the anticipation or expectation that characterizes rhythm — situates the skaldic text in a temporal framework and gives rise to the phenomenological expression of speech as an embodied phenomenon: poetry becomes a living substance closely linked to the experience of human existence. Susanne Langer's observation that rhythm 'relates [poetry] intimately and self-evidently to life' is particularly

insightful and echoes Grant's summation of rhythm's temporal structure as a '*lived time of expectations*'.[29] To feel rhythm is to be within the body which makes us aware of time, in the mind's attempt to rationalize change and its related tensions. Rhythm cannot be experienced statically. In literary contexts, skaldic rhythmicity is recognized in the verbal embodiment of imagined speaking (usually in the form of character dialogue), thereby manifesting a physically experienced presentness in the narrative structure which is associated with the Performance event.

In the stanza above, Þorbjǫrn's awareness of the physiological impact of sound and speech is clear from his employment of words such as *þreifa* [to feel with the hand] in relation to battle-sounds: the 'roar of flight-flung axes' is presented as a phenomenon which is physically tangible. The *heiti* [poetic synonym] chosen for 'men' in line 3, *seggi*, is significant in that it can also signify 'messengers'. This clearly illustrates a linguistic development of *seggr* from the verb *segja* [to say], emphasizing the perceived poetic relationship between speech and man. Humanity speaks and, moreover, exists in speaking. In being subjected to the 'biting of swords', *seggi* plays on the similar sounding noun, *segi* [slice or shred]. The visceral mental image created by the wordplay stresses not only the traumatic fragmentation and mutilation of the human body in battle, but also the laceration of speech itself, of 'messengers'. When the rhythmic utterance of the skaldic message ceases, so does the embodied experience of 'lived expectation' in Performance — a 'futurity' of existence also noted by Langer in her treatment of rhythm.

The phenomenological perception of skaldic rhythmicity is reflected in the metaphorical portrayal of poetry as a vital, corporal essence. Like the blood of Kvasir — a mythological being of wisdom and knowledge — which constitutes the principle ingredient of Odin's poetic mead, skaldic verse is perceived as a life-sustaining, wisdom-enfolding entity which draws its audience into Performance. It is not surprising that poetry should be portrayed as a blood-like substance. Blood runs with its own pulse through the body, and it is blood's rhythm that gives life to the individual within whom it flows. Poetry rushes through the mind with its own rhythmic essence and sustains the art-body that it generates. If rhythm serves as a framing device which refocuses the view of the poetic utterance as a Performative utterance through a self-referential process, then the metaphorical representation of skaldic art as Kvasir's blood within the content of the poetry itself contributes in equal measure to such self-referential framing. The symbolic reference within the poetry to its own existence emphasizes the characteristics which distinguish it as being both artificed and presently situated. This framing causes the recipient to become aware of their role as audience-participant — as someone who hears or reads the event of poetry and not the events related by the poetry; it elicits a Performance of their audience-reception. This is particularly clear in stanzas such as the sonorous opening *helmingr* [half-stanza] of Einarr skálaglamm's 'Vellekla' [Lack of Gold]:

Hugstóran biðk heyra	[The lofty-minded, I bid him listen,
— heyr, jarl, Kvasis dreyra —	— listen, Jarl, to Kvasir's blood glistening[30] —
foldar vǫrð á fyrða	earth-warden, to the warriors
fjarðleggjar brim dreggjar.	of the firth-bone's yeast-surf.][31]

The introductory stanza from 'Vellekla' is self-referential on a number of levels.[32] Both *Kvasis dreyra* [Kvasir's blood] and *fyrða fjarðleggjar brim dreggjar* [surf of the yeast of the men/warriors of the firth-bone] are mythological references to the mead of poetry as illustrated by Snorri Sturluson in *Skáldskaparmál*.[33] Both kennings are connected aurally and thematically through the similar-sounding *dreyri* [blood] and *dregg* [yeast]: just as blood animates man, yeast as a living substance animates man's nourishment, causing dough to rise and expand, and ale to breathe and froth.

Einarr's self-conscious employment of metaphorical and periphrastic terms for poetry is analogous to his employment of inherently self-referential stylistic features. Opening stanzas of *drápur* typically call for attention from their audience, and Einarr enhances this generic component through repetition and rhyme: not only do *heyra* [listen] and *heyr* [hear] follow each other in immediate succession, contributing to the insistence of the skald's bidding, but the internal and end rhymes between *heyra*, *heyr*, and *dreyra* create a highly memorable and repeatable entity within the *helmingr* which entices the listener into attendance. The sound-scape evoked — of pulsing blood (*dreyri*) and lapping waves (*brim*) — is one of swell and recession, and serves as a metaphorical expression of the audience's engagement with poetic rhythm so that Jarl Hákon, commanded to 'listen!' through the vocative *jarl* and the imperative *heyr*, is drawn into the action of the skaldic Performance as dialogic audience-participant through an emerging and engineered awareness of the *vísa*'s rhythmicity.

Rhythmic Puns and Dialogue

The rhythmic character of skaldic poetry arises not only out of its metrical pulse but also out of its highly ambiguous vocabulary which contributes to the 'anticipatory [...] lived time of expectations' which Grant and Langer associate with rhythm.[34] Such verbal rhythm is the result, most often, of the equivocal signification of words and images in skaldic wordplay. According to the medieval Icelandic scholar and lawspeaker Snorri Sturluson, the implementation of wordplay or *ofljóst* (literally 'over-clear') is a common practice among skalds:

> Þvílík orðtǫk hafa menn mjǫk til þess at yrkja fóðgit ok er þat kallat mjǫk ofljóst. [...] Þessar greinir má setja svá í skáldskap at gera ofljóst at vant er at skilja ef aðra skal hafa greinina en áðr þykki til horfa in fyrri vísuorð. Slíkt sama eru ok ǫnnur mǫrg nǫfn þau er saman eigu heitit margir hlutir.[35]

> [Such modes of expression are often used by people in order to compose with concealment and that is usually called *ofljóst* [...]. Homophones can be inserted into skaldic poetry in order to create *ofljóst* which is difficult to understand if one meaning shall disagree from what, until then, had seemed to be the meaning of the line before. There are, similarly, also many other instances in which one term names various things.]

The Performance of the skaldic audience as recipients — and of the narrator, the scribe, and the skald as mutual recipients — is a result of the inherently shifting nature of a semiosic process in which the sign of the poetic *tíðindi* under

interpretation is intentionally equivocal.[36] If a recipient becomes aware that multiple interpretations are possible, they become conscious of their active participation in the process of constructing meaning. This Performance is dialogic since a different or contrary understanding of any text requires the mental embodiment of the voice of an Other. This voice is a linguistic position that is framed by one's own contextual inhabitancy of that position. Using the language of praise in the wake of failure, for example, will convey a meaning different from the apparent signification of the words employed, even if the tone used in delivery befits the language of the utterance. If an excited cry of 'Spring!' represents a linguistic image of enthusiasm and happiness during a specific season, the mimicry of that same excited cry on a cold and rainy day in April presents a view of the linguistic image which carries a different meaning. This process most evidently occurs in exercises of mockery and ridicule. For Bakhtin, criticism, parody, and satire are focal points in his discussion of dialogue and polyglossia in the novel:

> Parodic-travestying forms freed consciousness from the power of the direct word, destroyed the thick walls that had imprisoned consciousness within its own discourse, within its own language. [...] A new mode developed for working creatively with language: the creating artist began to look at language from the outside, with another's eyes, from the point of view of a potentially different language and style.[37]

Bakhtin's statement may be taken even further. Not only parodic-travestying forms, but all literary forms which represent linguistic images from multiple, dialogic view-points, are able to free an imprisoned consciousness — and this consciousness is freed, through interpretation, into Performance.

Skaldic verse which accommodates various layers of meaning and invites active, constructive analysis through kennings, metaphor, and wordplay is such a dia-logic form. There may well be a substantial amount of mental strain that can be phenomenologically felt when attempting to accommodate the multiple layers of meaning engendered by wordplay that tax, and are meant to tax, interpretative faculties. The feeling of the effects of crypticism is, in fact, demonstrative of the location of Performance in the mind of the interpreter. This mental Performance, embodied and in time, can also be described as rhythmical — inhabiting a lived interpretative experience *between* possible meanings and encapsulating the stirring movement towards a cognitive arrival.

Tíð, tíðindi: Skaldic Verse as Performance Event

Essential to the recognition and comprehensive appreciation of skaldic verse as Performance is the particularly fertile concept encapsulated in the word *tíðindi*. As with the English cognate 'tiding', *tíðindi* has two particular uses that are intimately related to one another.[38] The linguistic development of *tíðindi* [events] from *tíð* [time] reflects the ingrained conceptual relationship between an event and the dimension of time in which it occurs. This relationship is the fundamental basis of narrative itself, with narrative understood as the communication or account of a series of

events. *Tíðindi* can be understood as the constituent units out of which narrative time is constructed. The second signification of *tíðindi* is 'news'. To bring tidings is to bring an account of one or multiple events: happenings understood through, and shaping, the chronological structure of their verbal transmission.

The literary evidence demontrates that *tíðindi* is employed in both senses by saga narrators, and that its use is, at best, ambiguous. The following example is taken from *Haralds saga*:

> **Tíðendi** þau spurðusk sunnan ór landi, at Hǫrðar ok Rygir, Egðir ok Þilir sǫmnuðusk saman ok gerðu uppreist bæði at skipum ok vápnum ok fjǫlmenni [...]. En er Haraldr konungr varð þessa **tíðenda** víss, þá dró hann her saman ok skaut skipum á vatn, bjósk síðan með liðit ok ferr með landi suðr ok hafði mart manna ór hverju fylki.[39]

> [That **news** was reported from the south of the country that the Hǫrðar and Rygir, Egðir and Þilir had gathered together and were preparing an uprising both with ships and weapons as well as many men [...]. And when King Haraldr came to know of these **events**, he drew together troops and quickly pushed ships into the water, after which he prepared with the host and fared south along the land and gathered many men from each district.]

The translation above makes a subtle distinction between *tíðindi* as 'news' and *tíðindi* as 'events', based on the employment of these terms in English. However, the two respective clauses may be translated instead as a) 'those *events* were reported' and b) 'when King Haraldr came to know of this *news*'.

There are, furthermore, instances in which the phrase *til tíðinda*, in conjunction with verbs such as *verða* [to become, to come to pass], means 'to happen'. This is demonstrated by an example from *Hákon saga góða*:

> Þá er Hákon konungr Aðalsteinsfóstri hafði verit konungr í Nóregi sex vetr ok tuttugu, síðan er Eiríkr, bróðir hans, fór ór landi, þá varð þat **til tíðenda**, at Hákon konungr var staddr á Hǫrðalandi ok tók veizlu í Storð á Fitjum.[40]

> [When King Hákon Aðalsteinsfóstri had been king in Norway for twenty-six years after Eiríkr, his brother, went from the country, then it **happened** that King Hákon was present in Hǫrðaland and received a banquet at Fitjar on Storð.]

Tíðindi is not an unequivocal signifier and, as the ambivalent uses of the term by saga authors demonstrate, there are no clear boundaries of signification between *tíðindi* as events and *tíðindi* as relation(s) of events.

When one considers the conceptual relationship between skaldic verse and *tíðindi,* which seems to resist rigid demarcation and can be qualified only through context (if at all), one needs to take into account the significance of such denotative complexities. That there is a connection between the employment of skaldic verse and the employment of *tíðindi* in sagas is evident, regardless of any particular hermeneutic value to which this connection may attest. Skaldic stanzas in the kings' sagas are, for example, consistently employed by saga authors as narrative devices that are meant to verify the historical account of events by their informational content. Stanzas are often represented as vehicles for conveying news in the Icelandic sagas. The infamous skald Egill Skallagrímsson often speaks a verse when asked to

recount events: '[Þórólfr] stóð hann upp ok gekk til fundar við Egil ok spurði, með hverjum hætti hann hefði undan komizk ok hvat **til tiðinda hefði** orðit í fǫr hans. Þá kvað Egill vísu' [[Þórólfr] stood up and went to meet Egill and ask him how he had escaped danger, and what **had happened** on his journey. Then Egill spoke a verse].[41] This example illuminates the first element of association between skaldic verse as Performance and *tíðindi*: that is, dialogism.

In a literary context, skaldic poetry is often employed as a mode of intradeictic character dialogue or as the direct speech of both narrator and cited skald in an extradeictic dialogue with a saga-audience.[42] These portrayals stem from the attempt to portray the rhythmic embodiment in time which characterizes skaldic Performance. As such, skaldic stanzas are almost always implicated in a communicative relationship between two or more dialogic agents. *Tíðindi* are, in a similar fashion, almost always entangled in an interplay of call and response between those seeking to receive news and those acting to distribute it: tidings are asked for with listening anticipation or, alternatively, purposefully issued in order to achieve a response. It is therefore not surprising that skaldic dialogue is seen as an appropriate form through which to speak tidings into a saga-narrative. Yet the utilization of verse as a conveyer of essential news and events is not due to any capacity of skaldic poetry to communicate information more efficiently than ordinary dialogue — though it may be argued that the mnemonic potential, to which skaldic ambiguity and absurdity contribute, renders this poetry an ideal vehicle for the retention of whatever information it does convey.[43] Skaldic Performance is, as shown above, also dialogic as a result of its complex ambiguity. It is striking that in *Grettis saga Ásmundarsonar*, Grettir's *tíðindi* is itself described in ambiguous terms, depending on how one interprets *ok* [and] in the introductory passage:

Þar var bóndadóttir úti ok spurði at **tíðendum**. Grettir sagði af it ljósasta ok kvað vísu:

[The farmer's daughter was outside and asked for **news**. Grettir told her most clearly of it and spoke this verse:]

'Hœg munat, hirði-Sága ['Not easily now, tending-goddess of
hornflœðar, nú grœða the horn-flood, will heal,
stór, þótt steypðusk fleiri, still more are cast down,
Steinólfs hǫfuðskeina; Steinólfr's great head-graze;
því's of Þorgils ævi heavy hope of Þorgil's life
þung vón, at bein sprungu; because of broken bones;
lýðr segir átta aðra men say eight other
auðbrjóta þar dauða.'[44] bullion-breakers there died.']

One possibility is that Grettir's *vísa* is spoken only after he conveys his news clearly (*ljósasta*), highlighting the contrasting, unclear nature of the verse as news: he tells the farmer's daughter the news *and* recites his poetry. Another possibility is that *ok* connects the act of recitation with the conveying of news: Grettir tells the farmer's daughter the news *through* his *vísa*. Thus equating the highly ambiguous language of Grettir's poetry with a term for clarity (*ljósasta*) is deeply ironic, and recalls the term for skaldic wordplay mentioned earlier, *ofljóst*.[45]

The connection between *ljósasta* and *ofljóst* is supported by Grettir's *vísa*, which in the first *helmingr* alone boasts a great deal of wordplay and can be read in multiple ways: *hirði* can mean 'tending' or 'hide';[46] Sága is a goddess whose name possibly means 'Seeress', etymologically derived from *sjá* [to see];[47] *hornflœðr* refers to mead which can be understood as representing the mythical mead of poetry; *grœða* can mean 'heal' and 'increase'; and *steypðusk* in its reflexive form signifies 'tumbling' or 'falling down', but in the current context may refer to the 'pouring out' of liquid. Given these verbal ambiguities, the *helmingr* can be translated as a self-referential composition: 'Seeress of poetic mead [which] now greatly increases — though more pours out — I will not easily hide Steinólfr's head-graze'. Poetry increases even as it flows from the mind, just as the blood flows from Steinólfr's head-wound, an injury which, as a narrative event, constitutes the poetic material.[48]

The second conceptual link between *tíðindi* and skaldic stanzas arises from skaldic poetry's relationship to time itself, shaped by the strong Performative character of skaldic material. Performance comprises a temporal event. In the context of sagas, skaldic stanzas as Performance(s) parallel and exemplify *tíðindi* by becoming happenings in any given saga's narrative timeframe:

Þá spurði Auðr, hvat hann hafði dreymt — 'nú váru enn eigi svefnfarar góðar'. Gísli kvað vísu:

[Then Auðr asked what he had dreamt — 'now still the dreams were not good'. Gísli spoke this verse:]

'Mér bar hljóm í heime,	['To me was born, into my home,
hǫr-Bil, þás vit skildumk,	Linen-goddess, when I parted from consciousness
skekkik dverga drykkju	— I tilt the dwarves' drink —
dreyra sals fyr eyru.	the sound of blood for the room's ears.
Ok hjǫrraddar hlýddi	And the cherry-tree of the sword-voice
heggr rjúpkera tveggja,	listened to the two ptarmigans'
koma mun dals á drengi	— the dale's dew will come upon the
Dǫgg, læmingja hǫggvi'.	worthy man — loon-execution'.]

Ok er þetta er tíðenda, heyra þau mannamál, ok er Eyjólfr þar kominn við inn fimmtánda mann, ok hafa áðr komit til húss ok sjá dǫggslóðina sem vísat væri til.[49]

[**Whilst this is happening** they hear men's talk, and Eyjólfr has arrived there with fifteen men and has already been to the house, and they see the dew-trail which pointed to the shelter.]

This example demonstrates the saga author's perception of the skaldic verse as an *event*, as a tiding within the narrative structure of the saga account.[50] Even though Gísli's poem recollects and recounts events from a dream, it is the verse itself that happens, after which subsequent episodes can unfold in the ongoing sequence of the narrative's temporal structure.

The connection of the skaldic happening to the concept of *tíðindi* in the narrative timeframe is Performative. *Óláfs saga in helgi Haraldsson* (hereafter *Óláfs saga*), from *Heimskringla*, is a case in point. The saga recounts two episodes in which the term

tíðindi is employed frequently and alludes to a representational use of language which signifies beyond the 'isolated utterances of social language'.[51] The first of these episodes depicts a particular occasion on which King Óláfr's court skald, Sigvatr Þórðarson, and the king's standard-bearer, Þórðr Fólason, need to inform the king that two of his men have been murdered by a now-escaped royal hostage, King Hrœrekr of Hedmark. Though Sigvatr and Þórðr agree that the king ought to be told of the event immediately, they are hesitant to wake Óláfr from his sleep with bad tidings. Instead of waking the king personally, Sigvatr asks the bell-ringer of the church to toll for the souls of the murdered men, and the saintly king wakes with the impression that the church-bell is ringing for Matins. Having woken the king in a manner which has immediately put him in mind of Christian duty, the real reason for the bell-toll can be safely related. Sigvatr's employment of the tolling bell as an ambiguous sign through which his tidings can be related is significant. Sigvatr crafts a communication through the bell-toll which tells of the events through the lens of liturgical time. Moreover, the responsibility for the communication of these tidings falls on a skald who employs artifice in order to relay his message.

The second episode from *Óláfs saga* involves a similar approach to diplomacy taken by the lawspeaker, Emundr af Skǫrum, who confronts the Swedish King Óláfr in the hope of prompting reconciliation between the king and the people of Götaland. The Swedish king, famous for his temper and obstinacy, cannot be confronted in a direct or openly challenging way. Emundr decides to tell the king three tidings that allegorically represent the king's own unreasonable and illegal behaviour. The overtly parable-like examples of Emundr's tidings communicate a message about the king's actions by means of artifice, allowing the king an opportunity to interpret and examine these actions as audience-recipient. It is evident that *tíðindi* here does not signify any real news at all but suggests, instead, a telling of tales. Again, these examples of verbal artifice are produced by a character who, if not a poet by profession, is skald-like: Emundr is said to be *vitrastr ok orðsnjallastr* [wise and eloquent], descriptions often associated with skaldic characters.[52]

The episodes from *Óláfs saga* recount the communication of tidings between characters, demonstrating both the dialogism and temporal presentness that the concept of *tíðindi* implies. The nature of these episodes is equally important because the extensive portrayal of communication by means of artifice indicates that the word *tíðindi*, if not consciously employed as a reference to artifice, at the very least belongs to a narrative register employed in the conveying of material relating to such artifice. The association of skaldic poetry with *tíðindi* is therefore consistent with the use of this term in sagas and reinforces the perception of skaldic verse as prosimetric Performance event.

Conclusion

The properties of Performance in skaldic poetry demonstrated in this essay are threefold: a) Performative utterances are crafted or artificed; b) Performative utterances are dialogic; and c) Performative utterances exhibit temporal 'presentness', taking place in the here-and-now of the present-continuous. Poetic rhythmicity

serves as a framing device for such skaldic Performance and is interrelated with dialogue and artifice. The concept of *tíðindi*, in turn, embodies the notion of events as well as the relation of events, and is often associated with skaldic poetry in saga narratives. The relationship between skaldic verse and *tíðindi* in sagas attests to the authorial perception of skaldic poetry in literary contexts as dialogical, presently situated, and artificed, confirming the perceived Performative nature of skaldic verse in literature.

Treating literary occurrences of skaldic poetry in the manner described above contributes to a broader understanding of skaldic poetics and is particularly important in shaping one's perception of the political function of skaldic poetry during the Viking Age. Viewing skaldic utterances as Performative even in their literary manifestation affords an assessment of those mechanisms of skaldic Performance that may not be immediately evident in what is usually imagined to be an original context for the presentation of skaldic poetry: that is, a public recitation (in which a ruler and their court constitute an audience) of artistic language (overtly symbolic verbal utterances) within the framing chronotope of a culturally determined 'Performance situation' (in, for example, a hall and during a festive or politically significant occasion). This imagined paradigm of the oral recitation at court presents a situation which can be classified, almost intuitively, as a Performance in its theatrical or 'stage' (and hence its representational) sense, and further investigation into the Performativity of skaldic verse beyond oral recitation may therefore seem superfluous. However, the cultivation of a nuanced view of skaldic Performance as a layered phenomenon which can engage a recipient on numerous levels both on and off the page, nevertheless, allows one to consider subtle Performative features of skaldic poetry such as its dialogic rhythmicity when assessing the political employment of skaldic verse even in those seemingly self-evident Performance contexts of imagined oral utterances at court. Understanding that Performativity of skaldic verse is effected, in part, through the instigation of internal mental dialogues in those who listen to it can, for example, aid us in comprehending the role of skalds as diplomats and ambassadors in the political arena of the Viking Age.[53]

Engaging with the entire spectrum of skaldic Performativity is important if one is to try and move beyond an assessment of political poetry in terms of its performativity in the speech–act sense only. The perlocutionary effects of skaldic verse, particularly with regards to the legitimization of Viking Age rulers through skaldic recitation, are often discussed in terms of performativity whilst Performance-contexts are perceived as providing the necessary conditions within which poetic action can take place. If the Performative condition is itself seen as instrumental in the political function of skaldic utterances however, then a wider array of interpretative possibilities present themselves for further investigation.

Notes to Chapter 4

1. The best-known example of such overtly critical poetry is Sigvatr Þórðarson's 'Bersǫglisvísur' [Plain-speaking Verses]; see 'Bersǫglisvísur', ed. by Kari Ellen Gade, in *Poetry from the Kings' Sagas 2: From c. 1035 to c. 1300*, ed. by Kari Ellen Gade, 2 vols (Turnhout: Brepols, 2009), II, 11–30.

2. Margaret Clunies Ross and others, 'General Introduction', in *Poetry from the Kings' Sagas 1: From Mythical Times to c. 1035*, ed. by Diana Whaley, 2 vols (Turnhout: Brepols, 2012), I, xiii–xciii; Margaret Clunies Ross, *A History of Old Norse Poetry and Poetics* (Cambridge: Brewer, 2005); Heather O'Donoghue, *Old Norse-Icelandic Literature: A Short Introduction*, Blackwell Introductions to Literature (Oxford: Blackwell, 2004), pp. 62–93; Anthony Faulkes, *What Was Viking Poetry for? Inaugural Lecture Delivered on 27th April 1993 in the University of Birmingham* (Birmingham: University of Birmingham, School of English, 1993); and Roberta Frank, *Old Norse Court Poetry: The Dróttkvaett Stanza*, Islandica, XLII (Ithaca, NY: Cornell University Press, 1978).

3. In keeping with post-colonial scholarship dealing with questions of orality and aurality, I employ 'orature' as a political and conceptual alternative to the more frequently used 'oral literature' — a term criticized by Walter Ong for being self-contradictory and Ngũgĩ wa Thiong'o for being Western-centric, tentatively defined as that body of verbal art which exhibits 'the use of [vocal] utterance as an aesthetic means of expression'. The term was originally coined by Pio Zirimu; see Ngũgĩ wa Thiong'o, *Penpoints, Gunpoints, and Dreams: Towards a Critical Theory of the Arts and the State in Africa* (Oxford: Oxford University Press, 1998), pp. 103–28 (pp. 105 & 111); Ong, *Orality and Literacy*.

4. Judy Quinn, 'From Orality to Literacy in Medieval Iceland', in *Old Icelandic Literature and Society*, ed. by Margaret Clunies Ross (Cambridge: Cambridge University Press, 2000), pp. 30–60; Coleman, *Public Reading and the Reading Public in Late Medieval England and France*.

5. As literary devices, skaldic stanzas may enhance descriptions, authenticate (pseudo-)historical information, and develop character personalities; see, for example, Heather O'Donoghue, *Skaldic Verse and the Poetics of Saga Narrative* (Oxford: Oxford University Press, 2005).

6. The following texts offer vital contributions to concepts of orality and literacy: Helen F. Leslie, 'The Prose Contexts of Eddic Poetry — Primarily in the "Fornaldarsǫgur"' (unpublished doctoral dissertation, University of Bergen, 2012); Ruth Finnegan, 'The How of Literature', *Oral Tradition*, 20 (2005), 164–87.

7. 'Perform, v.', in *OED Online* <http://www.oed.com> [accessed 8 August 2017].

8. J. L. Austin, *How to Do Things with Words*, ed. by J. O. Urmson and Marina Sbisà, 2nd edn (Oxford: Clarendon Press, 1975). See also Cheung Salisbury in this volume (Chapter 5) for a more in-depth discussion and employment of Austin's theory.

9. 'Performative, Adj. and N.', in *OED Online* <http://www.oed.com> [accessed 8 August 2017]; Clunies Ross, *A History of Old Norse Poetry and Poetics*; Lars Lönnroth, 'Old Norse Text as Performance', in *Scripta Islandica: Isländska sällskapets årsbok 60/2009*, ed. by Daniel Sävborg ([Uppsala: Institutionen för nordiska språk], 2010), pp. 49–60.

10. Mark Amodio, *Writing the Oral Tradition: Oral Poetics and Literate Culture in Medieval England* (Notre Dame, IN: University of Notre Dame Press, 2004); Leslie, 'The Prose Contexts of Eddic Poetry'; Butterfield, *Poetry and Music in Medieval France*.

11. Lauri Honko, 'Introduction: Epics along the Silk Roads — Mental Texts, Performance, and Written Codification', *Oral Tradition*, 11 (1996), 1–17; Finnegan, 'The How of Literature', p. 175. See, however, Elizabeth Eva Leach in this volume (Chapter 1) for an alternative perspective.

12. M. M. Bakhtin, 'Discourse in the Novel', in *The Dialogic Imagination. Four Essays*, ed. by Michael Holquist, trans. by Caryl Emerson and Michael Holquist, University of Texas Press Slavic Series, 1 (Austin: University of Texas Press, 1981), pp. 259–422 (pp. 355–58).

13. Frank J. Korom, 'The Anthropology of Performance: An Introduction', in *The Anthropology of Performance: A Reader*, ed. by Frank J. Korom (Hoboken, NJ: Wiley & Sons, 2013), pp. 1–7 (p. 2); Richard Bauman, 'Verbal Art as Performance', *American Anthropologist*, 77 (1975), 290–311 (p. 302). 'Chronotope' refers to Bakhtin's term for literary 'space-time'. See M. M. Bakhtin, 'Forms of Time and the Chronotope in the Novel — Notes towards a Historical Poetics', in *The Dialogic Imagination: Four Essays*, ed. by Holquist, pp. 84–258.

14. Finnegan, 'The How of Literature', p. 176.

15. Stuart Grant, 'Some Suggestions for a Phenomenology of Rhythm', in *Philosophical and Cultural Theories of Music*, ed. by Eduardo de la Fuente and Peter Murphy, Social and Critical Theory, VIII (Leiden: Brill, 2010), pp. 151–73 (p. 152).

16. This argument is similar to Marshall McLuhan's conceptualization of 'the medium [as] the message' in his *Understanding Media: The Extensions of Man* (London: Sphere Books, 1967); see also Stefanie Würth, 'Skaldic Poetry and Performance', in *Learning and Understanding in the Old Norse World: Essays in Honour of Margaret Clunies Ross*, ed. by Judy Quinn, Kate Heslop, and Tarrin Wills (Turnhout: Brepols, 2007), pp. 263–81.

17. Faulkes, *What Was Viking Poetry for?*, p. 12. See also, Clunies Ross, *A History of Old Norse Poetry and Poetics*, pp. 92, 94, & 96.

18. For an overview of skaldic metrical construction, see Clunies Ross, *A History of Old Norse Poetry and Poetics*.

19. Clare Finburgh, 'Facets of Artifice: Rhythms in the Theater of Jean Genet, and the Painting, Drawing, and Sculpture of Alberto Giacometti', *French Forum*, 27.3 (2002), 73–98 (p. 88).

20. Edith Marold, 'Introduction to "Glymdrápa"', trans. by John Foulks, in *Poetry from the Kings' Sagas 1*, ed. by Whaley, I, 73–74 (p. 73).

21. Ibid., p. 73. These acoustic effects are not necessarily indicative of any onomatopoeic representation of battle-sounds. They are created, instead, through the referral to the sounds of battle in the poem's vocabulary: spears 'clash/rattle/clatter' (*glymja*); we hear the 'roar' (*rymr*) of axes.

22. Ibid., p. 74.

23. Much of the poetry from the kings' sagas, quoted as a form of authoritative substantiation to various saga accounts, is situated before the extradeictic listener or reader of the saga-text as the primary audience-recipient. This mode of dialogue is achieved through the method of quotation employed by the saga author who introduces the poetry as the direct speech of a skaldic source 'speaking' to a saga-audience in the present tense.

24. *Ríks* [forceful] is an adjective for *þjóðkonungr* [king of people] in l. 4 (indicated in square brackets). The current translation retains the word's original position in order to stress the way in which the adjective acts within the initial line.

25. *Seggr* is a poetic term for 'man'; see discussion on wordplay below.

26. 'Glymdrápa', ed. by Edith Marold, in *Poetry from the Kings' Sagas 1*, ed. by Whaley, I, 73–90 (p. 87). All translations from Old Norse are my own. I am, however, indebted to the interpretations of Edith Marold in her respective translations in *Poetry from the Kings' Sagas 1*.

27. One might compare this with the conception of the 'voice from the past [...] speaking in the narrative' developed by Heather O'Donoghue and Preben Meulengracht Sørensen: O'Donoghue, *Skaldic Verse and the Poetics of Saga Narrative*, p. 5; Preben Meulengracht Sørensen, 'The Prosimetrum Form 1: Verses as the Voice of the Past', in *Skaldsagas: Text, Vocation, and Desire in the Icelandic Sagas of Poets*, ed. by Russell Gilbert Poole, Ergänzungsbände zum Reallexikon der Germanischen Altertumskunde (Berlin: de Gruyter, 2001), pp. 172–90.

28. Jürg Glauser, 'The Speaking Bodies of Saga Texts', trans. by Kate Heslop, in *Learning and Understanding in the Old Norse World*, ed. by Quinn, Heslop, and Wills, pp. 13–26.

29. Susanne K. Langer, *Feeling and Form: A Theory of Art Developed from Philosophy in a New Key* (London: Routledge & Kegan Paul, 1953), p. 129; Grant, 'Some Suggestions for a Phenomenology of Rhythm', p. 165 (my italics).

30. 'Glistening' is not a direct translation of the text; it is inserted here in an attempt to convey the acoustic effect of the Old Norse text.

31. 'Vellekla', ed. by Edith Marold, in *Poetry from the Kings' Sagas 1*, ed. by Whaley, I, 280–329 (p. 283).

32. The title 'Vellekla' contributes to the self-referential nature of the *drápa* seeing as it might refer to Einarr's motive for composing the poem as a method of gaining payment (see 'Vellekla', ed. by Marold, p. 280).

33. *Snorri Sturluson Edda: Skáldskaparmál*, ed. by Anthony Faulkes (London: Viking Society for Northern Research, University of London, 2007), p. 11.

34. Grant, 'Some Suggestions for a Phenomenology of Rhythm', p. 165; Langer, *Feeling and Form*, p. 129.

35. *Snorri Sturluson Edda: Skáldskaparmál*, p. 109.

36. Charles Sanders Peirce's concept of Semiosis as the 'action of signs' which encapsulates a 'pragmatic notion of meaning' is used here in preference to Saussure's concept of Semiotics which Peirce views as the 'formal science of signs' since it more closely resembles a Bakhtinian conception of literary and linguistic interpretation. Corresponding to Bakhtin's theory of the 'chronotope', Semiosis is a 'time-bound, context-dependent (situated), interpreter-dependent (dialogic), materially extended (embodied) dynamic process'. João Queiroz and Floyd Merrell, 'Semiosis and Pragmatism: Toward a Dynamic Concept of Meaning', *Sign Systems Studies*, 34 (2006), 37–65 (pp. 37, 60).

37. M. M. Bakhtin, 'From the Prehistory of Novelistic Discourse', in *The Dialogic Imagination*, ed. by Holquist, , pp. 41–83 (p. 60).

38. 'Tíðindi', in *An Icelandic-English Dictionary: Based on the Ms. Collections of the Late Richard Cleasby*, ed. by Richard Cleasby and Guðbrandur Vigfússon (Oxford: Clarendon Press, 1874), p. 633. The alternative spelling *tíðendi* occurs frequently.

39. *Snorri Sturluson Heimskringla*, ed. by Bjarni Aðalbjarnarson, 3 vols, Íslenzk fornrit, XXVI–XXVIII (Reykjavík: Hið Íslenzka fornritafélag, 1941), I, 114–15.

40. Ibid., I, 182.

41. *Egils saga Skallagrímssonar*, ed. by Sigurður Nordal, Íslenzk fornrit, II (Reykjavik: Hið Íslenzka fornritafélag, 1933), p. 113.

42. O'Donoghue, *Skaldic Verse and the Poetics of Saga Narrative*, p. 12.

43. Bergsveinn Birgisson, 'Inn í Skaldens Sinn — Kognitive, Estetiske Og Historiske Skatter í Den Norrøne Skaldediktingen' (unpublished doctoral dissertation, University of Bergen, 2007); Erin Michelle Goeres, 'The King is Dead, Long Live the King: Commemoration in Skaldic Verse of the Viking Age' (unpublished doctoral dissertation, University of Oxford, 2010), p. 33. See also Bergsveinn Birgisson, 'The Old Norse Kenning as a Mnemonic Figure', in *The Making of Memory in the Middle Ages*, ed. by Lucie Doležalová, Later Medieval Europe, IV (Leiden: Brill, 2010), pp. 199–214.

44. *Grettis saga Ásmundarsonar; Bandamanna saga; Odds þáttr Ófeigssonar*, ed. by Guðni Jónsson, Íslenzk fornrit, VII (Reykjavík: Hið Íslenzka fornritafélag, 1936), pp. 197–98.

45. 'Ofljóst', in *An Icelandic-English Dictionary*, ed. by Cleasby and Vigfússon, p. 464. It may be that the term has its origins in the attempt to describe words that are either over-clear in their being 'more-than-clear', or words that are perhaps 'over-transparent', concealing hidden meanings.

46. 'Hirða', in *An Icelandic-English Dictionary*, ed. by Cleasby and Vigfússon, p. 264.

47. 'Sága', in *Cassell Dictionary of Norse Myth and Legend*, ed. by Andy Orchard (London: Cassell, 1997), p. 136.

48. See the section 'Rhythmic Artifice' above.

49. *Vestfirðinga sǫgur. Gísla saga Súrssonar. Fóstbrœðra saga. Þáttr Þormóðar. Hávarðar saga Ísfirðings. Auðunar Þáttr vestfirzka. Þorvarðar Þáttr Krákunefs*, ed. by Björn K. Þórólfsson and Guðni Jónsson, Íslenzk fornrit, VI (Reykjavik: Islenzka fornritafélag, 1943), pp. 110–11.

50. The example from *Gísla saga* is particularly illustrative of how verse may be utilized for functional rather than anthological reasons, since the poems in *Gísla saga* are unlikely to be contemporary. Kari Ellen Gade suggests that the poems from the saga were composed later than the tenth century but no later than the middle of the eleventh: *The Structure of Old Norse Dróttkvætt Poetry*, Islandica, XLIX (Ithaca, NY: Cornell University Press, 1995), p. 264.

51. Bakhtin, 'Discourse in the Novel', p. 356. The episodes respectively mark the densest and second-densest use of the word or one of its declensions in *Óláfs saga: Snorri Sturluson Heimskringla*, ed. by Aðalbjarnarson, II, 122–24 & 148–52.

52. *Snorri Sturluson Heimskringla*, ed. by Aðalbjarnarson, I, 148.

53. See Clunies Ross, *A History of Old Norse Poetry and Poetics*, p. 47.

The Austinian Performative Utterance and the Thomistic Doctrine of the Sacraments

Matthew Cheung Salisbury

This essay aims to compare the modern notion of the performative utterance, as defined by J. L. Austin, philosopher of language (1911–60), with the most important treatment of the causes and efficacy of sacraments in medieval systematic theology, described in Questions 60 to 65 of the Third Part of the *Summa theologiae* of Thomas Aquinas (1225–74).[1] That is to say, although Austin's collected works do not illustrate any direct intertextual connections to Thomistic discourse, the necessary and sufficient conditions for the 'felicitous' action of a performative may be compared with the conditions for the success of a sacrament. I will also suggest what common ground they may have in shared antecedents, particularly with reference to Aristotelian philosophy. Both Austin and Aquinas contribute to a reading of the action and meaning of performative language, and can contextualize our understanding of the performance of the liturgy in medieval and modern contexts.

Preliminaries

This is certainly not the first essay to suggest how Austin's performativity can be brought to bear on the liturgy or public worship of the Church, but it is the first to suggest that the success of an Austinian performative is analogous in its definition with the success of a Thomistic sacrament.[2] Austin and Aquinas employ remarkably similar rhetoric in order to determine the success of an act which, while outwardly expressed in a form of words, represents a substantive happening which is greater than the utterance itself.

Austin described 'performative' as 'a new word and an ugly word, and perhaps it does not mean anything much. But at any rate there is one thing in its favour, it is not a profound word'.[3] This one positive feature may not have stood the test of time, thanks not least to Austin himself. The word has enjoyed a degree of misapplication, or ambiguous application, since Austin's repurposing of it. The first sense of 'performative' in the *OED*, namely 'of or pertaining to performance', takes its first example of usage from a 1922 essay by J. R. Kantor, defining a 'performative memory act' as one 'which require[s] some work to be done'.[4] The second part of

this first sense in the *OED* has rightly enjoyed widespread application, including but not limited to the performativity of gender as proposed in Judith Butler's *Gender Trouble*.[5] Further appropriation of the concept of the performative utterance by literary theory has been discussed elegantly by Jonathan Culler.[6] While performance (of gender, a form of words, or a rite) may be a necessary feature for what is meant by performativity in the Austinian sense, the word 'performative' is often used adjectivally — but rarely as a noun — in discourse that relates to notions of *performing*, for example a musical work. I do not think this usage helpful; it would be more useful to distinguish between a word descriptive of performance and one which suggests that performance *does something*, that it is a means to a substantive end. In this essay I use 'performative' solely in the latter, Austinian sense, where the performance is, or is part of, the 'doing' of an action that is being described.[7]

This blurring of definition and usage is ironic in light of Austin's theory of the constative — a descriptive utterance which makes a statement and which can be deemed true or false — and the performative utterance, which makes no truth-claim and executes the act to which it refers. The performative utterance gives no sense of describing a state of affairs, and it is necessarily part of the doing of an action, which would not normally be described as saying something. In some cases, for instance making a wager, Austin allows that it is possible to perform the act otherwise than in the utterance: one may fill in a betting slip, sign an agreement, or make a verbal declaration. The utterance is not the 'sole thing necessary if the act is to be deemed to have been performed'.[8] Furthermore, the circumstances must be appropriate to the act: to be married as a Christian, one must not be 'already married with a wife living, sane, and undivorced, and so on'.[9] Such constitutive conditions are discussed at length below, in dialogue with the Thomistic doctrine of the sacraments.

For Austin, it is by definition possible to distinguish between these two types of utterance, although subsequent criticism has brought this polarity into question. John Searle suggests that the distinction between performatives and constatives is problematic because each can be the other. For him, 'the performative utterance can also be a true statement: declarations, by definition, make their propositional content true', for instance, 'I order you to leave'.[10] Austin writes, in contrast, that:

> We are apt to have a feeling that their [the words of a performative utterance] being serious consists in their being uttered as (merely) the outward and visible sign, for convenience or other record or for information, of an inward and spiritual act: from which it is but a short step to go on to believe or to assume without realizing that for many purposes the outward utterance is a description, *true or false*, of the occurrence of the inward performance.[11]

The apparent coincidence in phrasing between the popular Augustinian definition of a sacrament as an 'outward and visible sign' and Austin's definition is pertinent for the next section of the present discussion.[12]

The Happy or Infelicitous Performative, and the Successful or Unsuccessful Sacrament

In Lecture II of *How to Do Things with Words*, Austin establishes six conditions which are necessary for the 'smooth or "happy" functioning of a performative':

> A1. That the performative should be endowed with an established procedure with an expected effect, which must include 'the uttering of certain words by certain persons in certain circumstances';
> A2. That the 'persons and circumstances' by whom and in which the performative is constituted should be appropriate for the task;
> B1. That the procedure should be correctly executed by all participants;
> B2. That the procedure should be completely executed;
> Γ1. That the correct thoughts and feelings, if necessary, should be held by the participants, and that any necessary 'consequential conduct' by the participants should be assured;
> Γ2. That such consequential conduct be actually carried out.[13]

In the following, each of these axioms is discussed, considering ways in which the definition, necessity, causes, and conditions for the success of a Thomistic sacrament may be usefully compared to them.

Austin holds that there ought to be a definite verbal form for a performative utterance, with a predictable, expected result: for instance, by the utterance 'I christen' in relation to a ship, it is duly named. In Question 60 of the Third Part of the *Summa*, Thomas Aquinas establishes that determinate things (3.60.5), words (3.60.6), and even determinate words (3.60.7), are necessary in the sacraments. 'The sensible elements of the sacraments', he writes, 'are called words by way of a certain likeness, in so far as they partake of a certain significative power, which resides principally in the very words' (3.60.6). Determinate sacramental matter must be signified and brought into being by a determinate form: 'Since, therefore, in the sacraments determinate sensible things are required, which are as the sacramental matter, much more is there need in them of a determinate form of words' (3.60.7). Aquinas's stance is that it is always the function of the words that determines their form, as in the sacramental words for baptism and the Eucharist, and it is the character of the sacrament that provides the interpretation of the sign: for example, running water is an index of cleansing in the context of baptism. Both Austin and Aquinas, therefore, show the need for the words to help to determine the sense of what is being enacted.

In proposition A2, Austin identifies the need for the correct persons and circumstances for the success of the performative. Only a person who has been asked to christen a ship, he claims, has the power to do so. For Aquinas, the principal agent of the interior sacramental effect is God, and the work of man is merely that of the minister or instrument of that effect (3.64.1). However, ministers can be evil or heretical and still be the instrument of a successfully enacted sacrament, although they sin in so doing (3.64.5, 3.82.5, 3.64.6, & 3.82.7). In the special case of matrimony, consent is the efficient cause of the sacrament (Suppl. 45.1). The matter of the intention of the minister will be discussed in relation to Austin's proposition

Γ1, below. In sacrament and in performative, the fitness of the enactor to the task is essential.

Propositions B1 and B2 relate to the execution of the performative, insisting on the correctness and completeness of the said procedure, by all participants. Austin's examples of 'infelicities' of this type include 'a flaw in the ritual', or matters of vagueness and uncertainty whether deliberate or inadvertent, 'for example if I say "my house" when I have two'.[14] In the *Summa*, Article 8 of Question 60 asks 'whether it is lawful to add anything to the words in which the sacramental form consists'. Aquinas answers that the first point to consider is whether the person saying the words intends 'to perform a rite other from that which is recognised by the Church', in which case the sacrament would be invalid. The other significant point for discussion is the *meaning* of the words. With respect to additions or modifications to the textual form associated with a sacrament, 'the omission of the word "for" [in the form of the Eucharist, "For this is my Body"] does not destroy the essential sense of the words', whereas in the case of baptism the essential sense of the words has not been retained if the Trinitarian formula is omitted.[15] In the case of the Eucharist, and despite imperfections in the rite itself, the words are uttered in the person of Christ, and so they receive their instrumental power from him (3.78.4). In sum, for Aquinas, 'the words produce an effect according to the sense which they convey, [so] we must see whether the change of words destroys the essential sense of the words' (3.60.8). Aquinas further presents the belief that defects in the rite of the sacrament of the Eucharist can either be prevented, or put right by 'employing a remedy, or at least by repentance on his part who has acted negligently' (3.83.6). As both performative and sacrament require a definitive form of words uttered by fit and proper persons, shortcomings in the performance naturally present risks, particularly when the essentials of the rite (those aspects which give it its special and specific character) are not preserved.

Austin's propositions Γ1 and Γ2 require correct thoughts and intentions to be held by the participants, if necessary for the performative, and that any promised behaviour should subsequently be carried out. In Aquinas, the faith and the good intention of the minister are considered in Articles 8, 9, and 10 of Question 64. Throughout this section of the *Summa*, Aquinas makes it clear that ministers work not by their own power but instrumentally, for all principal causes of sacraments come from the divine.[16] As long as the minister has the correct intention, the sacrament is valid. Intention is particularly necessary because it defines the meaning of the words used in the ritual, and the actions which can be variously interpreted; washing, for example, can be said to have many different uses: the symbolic drowning of baptism contrasts with the humble act of foot-washing. A priest who thinks of something else has less than ideal intention, 'yet he has habitual intention, which suffices for the validity of the sacrament [...]. The sacrament is valid in virtue of his original intention' (3.64.8).[17]

Intention is also a particularly useful lens through which to consider the links between the performative and the sacrament. In Austin's list of 'infelicities' relating to the success of performatives, perversions of Γ1 and Γ2 are 'abuses' of a correct and

successfully performed act whereas categories A and B relate to 'misfires' of form, where the performative is 'disallowed, botched', and the act 'is void or without effect'.[18] In relation to category Γ:

> We speak of our infelicitous act as 'professed' or 'hollow' rather than 'purported' or 'empty', and as not implemented, or not consummated, rather than as void or without effect. But let me hasten to add that these distinctions are not hard and fast, and more especially that such words as 'purported' and 'professed' will not bear very much stressing.[19]

Habitual intention of the minister and the 'abuse' of a successful performative seem to share some characteristics, namely the ultimate technical success of an act outside the most desirable state of affairs. The lip service of habitual intention could be compared to the case of Austin's 'behabitives'. In polite phrases such as 'I have pleasure in calling upon the first speaker [...] it is conventional enough to formulate them in this way, but it is *not* the case that to say you have pleasure in *is* to have pleasure in doing something'.[20] Moreover, Austin describes utterances which are part of the social network of interactions (such as the behabitives mentioned here) as 'phatic', following Bronislaw Malinowski's definition of 'phatic communion': 'ties of union are created by a mere exchange of words [which] are neither the result of intellectual reflection, nor do they necessarily arouse reflection in the listener'.[21]

There is no mention, explicit or implicit, of Thomas Aquinas in any of Austin's works, whether published by him or after his death. Perhaps one reason why their thought may nevertheless be seen to be so aligned is the fact that both authors were preoccupied with reading and thinking about the works of a third author: Aristotle. Aquinas spent much time writing commentaries on Aristotelian treatises, and the *Summa* has been described as a Christianized reading of Aristotelian philosophy in its preoccupation with inference, reasoning, experience, observation, and working from first principles.[22] Austin, too, wrote on Aristotle (one essay is in the *Philosophical Papers*).[23] Geoffrey Warnock said of Austin's regular Saturday morning discussions with fellow philosophers in Oxford that 'we discussed most regularly passages in Aristotle's *Nichomachean Ethics*', and that Austin himself was 'perfectly familiar' with the whole of the text of Aristotle.[24]

The Performative and the Liturgy

There are undoubtedly interesting similarities in the ways that Austin and Aquinas choose to define their terms of reference, but beyond the semantic matrix of both series of definitions, it is worth considering how performative utterances and liturgical utterances can be productively associated. I reflect elsewhere on the helpfulness of the performative aspect of liturgy (following Jean Ladrière's liturgical 'operativity'[25]) in interrogating notions of fixity and stability in liturgical texts.[26] One significant point of connection between Austin and Aquinas is the intention which lies behind the words. This is reflected both in Austin's preoccupation with the right thoughts and feelings, and Aquinas's toleration of various abuses and incapacities within the realm of satisfactory performance of a sacramental act. In

the liturgy, what is said to be happening matters less than what is specifically being said.

Is a sacramental text necessarily performative? For present-day pastoral theologians, a sacrament is 'a sign that delivers what it signifies', so in a sense it is itself performative. 'Because pastoral services are not merely services that describe, but also tools of transformation through which God changes us, understanding how to use words in a performative way will be key to constructing pastoral services which not only *mean* something, but *do* something'.[27] For Mark Earey the rightful place is thus 'a context of prayerful faith and the action of God in and through the words, symbols, and actions'.[28] Similarly, Judith Kubicki claims that singing in the liturgy is 'doing something' towards the glorification of God and the sanctification of the faithful.[29] Ritual singing 'can be the doing of something, since by virtue of its illocutionary force [Austin's term for the intended effect of the utterance], ritual song has the power to produce an intended effect'.[30]

It seems clear that liturgical performativity, like the enactment of a performative more generally, and like the performance of a medieval sacrament, may be seen to be effective less through the precise form of words used than as a result of correct circumstances and intention. A further impulse which supports this idea might be supplied by empirical studies of late medieval liturgical manuscripts, which suggest that the patterns of text, music, and ritual which form any given rite are much less precisely and accurately transmitted than might be imagined — even among manuscripts which purport to be accurate witnesses of an authoritative rite.[31]

It is interesting that Kubicki applies some of the rhetoric of the Second Vatican Council (1962–65) to discuss specific examples of worship music which exercise a performative function: in order to 'reinforce the illocutionary force' of a Taizé chant to be sung collectively in worship, 'the verbs are placed on the downbeat at the beginning of each new phrase' and 'the contour of the melody highlights the sense of the text'.[32] The pre-eminence of 'full and active participation' most famously associated with Vatican II is often understood to relate to vocalization of the central features of the service by members of the congregation as well as the clergy. Accessibility for performance by those with a wide range of musical and intellectual abilities characterizes much of the music associated with the post-1965 Catholic liturgy. The expression 'full and active participation' dates back to the beginning of the twentieth century but, in fact, has a much longer history as a sort of 'heightened awareness' of the functionality of the service, and an awareness of the purpose and intention of rites.[33] As Thomas Day and others have argued, meaningful interaction with the rites was sacrificed in Vatican II in the name of vocalization.[34]

Conclusion

Since Austin, there has been a critical turn which has inhibited discussion of intention, the feature which has been seen to be essential to the two theories of the performative discussed here. Intention as a concept has become fraught with anxieties about the debunking of authority of the author and reader, and the

unravelling of the idea that something is truly and unabashedly *meant* in a world of polysemy, relativism, and intentional noise.[35] Jacques Derrida's suggestion that iterability — the use of an utterance in contexts and by persons not linked to the original iteration — is an important feature of the success of a performative utterance seems not to unseat intention at its foundations; rather, it adds new, perhaps even more universalized conditions for performative success, away from the intention of any particular individual.[36]

Is critical discourse a reasonable means of reading theories of the sacrament and the performative? The answer is both yes and no: yes, because the performative from its very institution in Austin's example of the affirmation in the marriage service has been productively associated with liturgy and ritual; no, because a poststructuralist reading of intention seems problematic if, as is hinted above, the goal-posts for performative success are non-static. Austin also helps us to consider the medieval context through interactions with his Aristotelian bedfellow Thomas Aquinas. Thinking of medieval liturgy and its sacraments as performed realities may normalize what are otherwise closed, finished, hieratic, and distant ceremonies enacted for reasons which culture has forgotten. Such imagined performances also help the rite to leap out of the text: the latter can feel well established in critical editions, while the former remains potentially living. It is perhaps the preoccupation with enacting or producing an iteration of the performative utterance — of Thomistic sacramentality, and of the liturgy more generally — and our fascination with the unstable, unfixed, and multifarious conditions in which an iteration happens that provokes theoretical complications but also the great appeal of such discussions.

Notes to Chapter 5

1. William James Lectures delivered at Harvard University in 1955, published posthumously in: J. L. Austin, *How to Do Things with Words* (Oxford: Clarendon Press, 1962); see also J. L. Austin, 'Performative Utterances', in *Philosophical Papers*, ed. by J. O. Urmson and G. J. Warnock (Oxford: Clarendon Press, 1961), pp. 220–39. References to Aquinas's *Summa theologiae* are given from the translation by the Fathers of the English Dominican Province, available online at <http://www.newadvent.org/summa/> [accessed 8 August 2017].

2. Among the useful explorations of the performativity of liturgical language not otherwise mentioned here are J. H. Ware, *Not with Words of Wisdom: Performative Language and Liturgy* (Washington, DC: University Press of America, 1981); Bridget Nichols, *Liturgical Hermeneutics: Interpreting Liturgical Rites in Performance* (Frankfurt a. M.: Lang, 1996); Juliette Day, *Reading the Liturgy: An Exploration of Texts in Christian Worship* (London: Bloomsbury, 2014).

3. Austin, 'Performative Utterances', p. 232.

4. J. R. Kantor, 'Memory: A Triphase Objective Action', *The Journal of Philosophy*, 19 (1922), 624–39 (p. 632).

5. The subsequent passage in Sense A reads: 'Designating or relating to an utterance that effects an action by being spoken or by means of which the speaker performs a particular act'; see, 'performative, adj. and n.', *OED Online*, <http://www.oed.com> [accessed 8 August 2017]. Judith Butler, *Gender Trouble: Feminism and the Subversion of Identity* (London: Routledge, 1990).

6. Jonathan Culler, 'Philosophy and Literature: The Fortunes of the Performative', *Poetics Today*, 21 (2000), 503–19.

7. For further theoretical considerations of 'performance', see the contributions by Leach (Chapter 1) and Ferreira (Chapter 4), as well as the introduction to this volume.

8. Austin, *How to Do Things with Words*, p. 8.

9. Ibid., p. 8.

10. John R. Searle, 'How Performatives Work', *Linguistics and Philosophy*, 12 (1989), 535–58 (p. 536).

11. Austin, *How to Do Things with Words*, p. 9.

12. For an example of Augustine's use of this language, see City of God X.5: 'sacrificium ergo visibile invisibilis sacrificii sacramentum, id est sacrum signum est'; see *Saint Augustine: The City of God against the Pagans: III (Books VIII–XI)*, trans. by David S. Wiesen, The Loeb Classical Library, CDXIII (London: Heinemann; Cambridge, MA: Harvard University Press, 1968), pp. 268–69.

13. Austin, *How to Do Things with Words*, pp. 14–15.

14. Austin, *How to Do Things with Words*, p. 36.

15. It is acknowledged in an editorial footnote in *How to Do Things with Words* that Austin, in one of the early examples of performative language in the volume, uses the incorrect formulation 'I do' rather than 'I will' from the Prayer Book marriage service. Does this matter? 'I do', in the present tense, accrues some ire from the author of the *Supplement* to the *Summa* (completed after the death of Aquinas prevented him from finishing). In the words of Question 45, article 3 (in which the author asks 'whether consent given in words expressive of the future makes a marriage'), 'he who promises to do a certain thing does it not yet. Now he who consents in words of the future tense, promises to marry a certain woman. Therefore he does not marry her yet [...]. When consent is expressed in words of the present tense, not only are the words actually present, but consent is directed to the present, so that they coincide in point of time; but when consent is given in words of the future tense, although the words are actually present, the consent is directed to a future time, and hence they do not coincide in point of time. For this reason the comparison fails'. John Searle considers the matter of the tense of the performative, considering the 'dramatic present' and the performative as promise: see 'How Performatives Work', *passim*.

16. For instance in *Summa theologiae* 3.64.5.

17. Austin notes that 'in the case of promising, as with many other performatives, [there should be] a certain intention, to keep [one's] word'. Compare 'false promise' to 'false bet' or 'false christening'; see Austin, *How to Do Things with Words*, p. 11.

18. Austin, *How to Do Things with Words*, p. 16.

19. Ibid., pp. 16–17.

20. Ibid., p. 81.

21. Ibid., pp. 95–96; Bronislaw Malinowski, 'The Problem of Meaning in Primitive Languages', in *The Meaning of Meaning: A Study of the Influence of Languages upon Thought and of the Science of Symbolism*, ed. by C. K. Ogden and I. A. Richards (London: Kegan Paul, Trench, Trubner & Co., 1923), pp. 451–510 (p. 478).

22. See also Aristotle's comments on language in *De interpretatione* I: 'Spoken sounds are symbols of affections in the soul, and written marks symbols of spoken sounds. And just as written marks are not the same for all men, neither are spoken sounds. But what these are in the first place signs of — affections of the soul — are the same for all; and what these affections are likenesses of — actual things — are also the same'; *Categories and De interpretatione*, ed. and trans. by J. L. Ackrill (Oxford: Clarendon Press, 1963), p. 43.

23. J. L. Austin, 'Ἀγαθόν and Εὐδαιμονία in the Ethics of Aristotle', in *Philosophical Papers*, ed. by J. O. Urmson and G. J. Warnock, 3rd edn (Oxford: Clarendon Press, 1979), pp. 1–31.

24. G. Warnock, 'Saturday Mornings', in *Essays on J. L. Austin*, ed. by Isaiah Berlin and others (Oxford: Clarendon Press, 1973), pp. 31–45 (pp. 36–37).

25. Jean Ladrière, 'The Performativity of Liturgical Language', trans. by John Griffiths, *Concilium*, 9.2 (1973), 50–62 (p. 51).

26. See Matthew Cheung Salisbury, 'Establishing a Liturgical "Text": Text for Performance, Performance as Text', in *Late Medieval Liturgies Enacted: The Experience of Worship in Late Medieval*

Cathedral and Parish Church, ed. by Paul Barnwell, Sally Harper, and Magnus Williamson (Farnham: Ashgate, 2016), pp. 93–106.

27. Mark Earey, *Worship that Cares: An Introduction to Pastoral Liturgy* (London: SCM, 2012), pp. 51–53.

28. Ibid., p. 53.

29. Judith Kubicki, 'Using J. L. Austin's Performative Language Theory to Interpret Ritual Music-Making', *Worship*, 73 (1999), 310–31 (p. 324).

30. Ibid., p. 321.

31. See Matthew Cheung Salisbury, *The Secular Liturgical Office in Late Medieval England* (Turnhout: Brepols, 2015); and 'Rethinking the Uses of Sarum and York: A Historiographical Essay', in *Understanding Medieval Liturgy: Essays in Interpretation*, ed. by Sarah Hamilton and Helen Gittos (Farnham: Ashgate, 2015), pp. 103–22.

32. Kubicki, 'Austin's Performative Language', p. 330.

33. See Matthew Cheung Salisbury, *Hear My Voice, O God: Functional Dimensions of Christian Worship* (Collegeville, MN: Liturgical Press, 2014), pp. 42–43.

34. Thomas Day, *Why Catholics Can't Sing*, rev. edn (New York: Crossroads, 2013).

35. See Roland Barthes, 'The Death of the Author', in *Image — Music — Text*, trans. by Stephen Heath (London: Fontana, 1977), pp. 142–48.

36. Jacques Derrida, 'Signature Event Context', in *Limited Inc.*, ed. by Gerald Graff (Chicago: Northwestern University Press, 1988), pp. 1–23, especially p. 18.

CHAPTER 6

Dante's Purgatory and Liturgical Performance

Jennifer Rushworth

Much scholarship has been devoted to understanding the liturgical backbone of Dante's *Purgatorio*,[1] in particular the psalms, hymns, and prayers that make up much of the penitential souls' vocal acts of contrition.[2] Critics such as John Ahern have also paid attention to the oral performance of the *Commedia*'s early reception.[3] Inspired in part by Annie Sutherland's work on performing the psalms, this essay seeks, against this existing critical background, to examine liturgical performance in Dante's *Purgatorio* particularly as manifested in the transformation of the individual through the collective, performative recitation of psalms.[4] Ronald L. Martinez has observed that 'in *Purgatorio* generally the language of the psalms governs, that is, steers and limits, Dante's vernacular expression', and in this essay I will develop this observation through recourse to the modern concept of performativity.[5] While my focus is on specific examples of psalm-singing in *Purgatorio*, much of what follows is also relevant to Dante's *Paradiso*, as to his *Inferno*, by way of contrast. Complementing this consideration of the performativity of liturgical language in the middle *cantica*, to conclude I highlight a return to Dante's text as liturgical performance, drawing on recent examples of Dante's poetry in action in modern-day worship.

That liturgical language is performative in the sense that it is both performance and transformation has been established theoretically since Jean Ladrière's article on the topic in 1973.[6] Ladrière describes liturgical performativity as a threefold process that, as I will show, also resonates with Dante's *Purgatorio*. The three aspects identified by Ladrière are: the specific use of personal pronouns, in particular the use of certain verbs in the first person, often in dialogue with an addressed second person; the institution of a community through shared language; and the liturgy as a means of rendering the Christian reality present through repetition, proclamation, and the sacraments. The first two principles, in particular, can be seen to be at work in the words of Dante's penitents. Ladrière's understanding of the performative builds on J. L. Austin's assertion that 'the issuing of the utterance is the performing of an action'.[7] In the context of the liturgy, the performativity of language enables, and even enacts, a productive, transformational dialogue between the individual and God within a collective, institutionalized framework.[8] To the already rich bibliography on Dante's *Purgatorio* and the poet's use of liturgical language, the

concept of performativity, drawn from Austin and Ladrière, adds a new theoretical lens through which to view the middle *cantica* afresh.

Singing Psalms in *Purgatorio*

In Dante's *Purgatorio*, the souls' speaking and singing perform a vital role in the process of purgation; liturgical language is an essential part of the transformative process whereby each repentant sinner is prepared for Paradise. Unlike the fixity of Hell, where there is no change and no future, Purgatory is a place of becoming and transformation, 'quel secondo regno | dove l'umano spirito si purga | e di salire al ciel diventa degno' ['that second kingdom, | in which the human soul is cleansed of sin, | becoming worthy of ascent to Heaven' (*Purgatorio* I, 4–6)]. It is through liturgical song as much as corporal discipline that the souls in Purgatory become worthy of such an ascent: thus, *Purgatorio* is the realm of a 'singing cure', a place where liturgical language and monophonic music are therapeutic, cathartic, and transformational, in short, performative.[9]

Purgatorio is replete with examples of how language and music are essential to the journey of the repentant souls up the mountain. In the Valley of the Princes, the evening service of Compline is partially enacted, with the souls singing both the Marian antiphon 'Salve, Regina' (VII, 82) and the Compline hymn 'Te lucis ante [terminum]' (VIII, 13).[10] On passing through the gate of Purgatory proper, Dante-pilgrim hears the singing of 'Te Deum laudamus' (IX, 140).[11] Finally, on the last of the seven terraces at the top of the mountain, the lustful sing the hymn 'Summae Deus clementiae' (XXV, 121).[12]

These musical moments are supplemented by the frequent collective singing of psalms throughout *Purgatorio*, reinforcing the widespread adoption of the liturgy and liturgical language in this realm. The Psalter formed the backbone of the medieval liturgy; every week, in religious communities, all one hundred and fifty psalms would be sung in the Divine Office. Purgatory is introduced almost immediately as such a communal realm of psalmody, since the souls arriving on its shores are heard to be singing Psalm 113: '"*In exitu Isräel de Aegypto*" | cantavan tutti insieme ad una voce | con quanto di quel salmo è poscia scripto' ['"*In exitu Isräel de Aegypto*" | with what is written after of that psalm, | all of those spirits sang as with one voice' (II, 46–48)].[13] This psalm has long been understood as a key text for the *Commedia*, since it is used in the Letter to Cangrande della Scala to illustrate the fourfold method of scriptural exegesis (literal, allegorical, moral, and anagogical).[14] In its celebration of the Israelites' escape from Egypt, it mirrors the journey of the *Commedia* from the slavery of sin to the freedom of grace.[15] Yet, as Martinez has highlighted, this psalm has a further liturgical, funereal function, in accompanying the body to its place of burial, and so is an especially apt choice of text for each soul's journey from Earth to Purgatory alluded to in *Purgatorio* II.[16] Musically, this psalm may also be particularly appropriate for the start of a journey up the mountain, since it is the only psalm using the *tonus peregrinus*.[17]

Later psalms sung in *Purgatorio* are often strikingly relevant to the sin being purged. For instance, those being purged of avarice and prodigality recite verse 25 of

Psalm 118, 'Adhaesit pavimento anima mea' ['My soul hath cleaved to the pavement' (XIX, 73)]. This phrase illustrates well the position of these souls, which is that of 'giacendo a terra tutta volta in giuso' ['lying upon the ground, all turned face down' (XIX, 72)]. Their punishment for being too attached to earthly goods, in particular money, is to be forced to gaze at the ground, away from God and Paradise, and the choice of psalm quotation is a literal embodiment of this posture.[18]

The penitential psalm *Miserere mei Deus* (Psalm 50) also plays a prominent role, since it is sung by those who died suddenly and violently — and so had no time for repentance on Earth (v, 24) — as well as subsequently by the gluttonous, who cite one particularly relevant phrase, 'Labïa mëa, Domine' (XXIII, 11).[19] The full verse 'Domine labia mea aperies et os meum adnuntiabit laudem tuam' ['O Lord, thou wilt open my lips: and my mouth shall declare thy praise' (Psalm 50:17)] suggests that on this terrace the mouth is transformed from the site of sin (specifically, the sin of gluttony) to the means of salvation through worship and song.[20] This same psalm is also alluded to at the start of the *Commedia* when Dante-pilgrim, lost in the dark wood, greets Virgil with the plea '*Miserere* di me' ['Have pity on me' (*Inferno* I, 65)].[21] In the passage from Hell to Purgatory, the setting of this psalm thus moves from a private, personal invocation to a collective performance.

The souls in *Purgatorio*, except for those whose earthly lives necessitated the recitation of the Office (priests, monks, and other clerics), are in fact singing the psalms *collectively* for the first time, however many times they would have read the psalms aloud to themselves in private or heard them sung in the public liturgies. John Harper has remarked that 'the medieval liturgy had little place for the active involvement of the laity' and that, instead, 'their role was passive and devotional'.[22] As Christopher Page charts, this 'silencing of the [layman's] voice in liturgical chanting' was widespread in the early Middle Ages as a result of a growing preference for professional singers in ecclesiastical institutions.[23] Recent work has, however, begun to reassess the notion of participation of the laity in medieval worship, particularly with a view to complicating distinctions between passivity and active participation.[24] In a similar vein, Elena Lombardi has shown how the difference between listening and reading is narrower than we might at first think in the Middle Ages, since 'the person who listens to a book being read aloud is as much a reader as the person actually scanning the text'.[25] Nonetheless, it is crucial that most of the purgatorial souls are vocalizing these liturgical texts for the first time in concert, and that this vocalization marks their belonging to the wider religious community constructed in Purgatory. From this perspective, Dante's middle realm is truly, in the words of Francesco D'Ovidio, 'un colossale monastero salmeggiante' [a huge monastery filled with psalmody].[26]

We get a glimpse of Dante-pilgrim's personal relationship to the psalms in *Paradiso* XXV. When asked by St James to define hope, Dante-pilgrim gives the appropriate reply that hope is 'uno attender certo | della gloria futura' ['the certain expectation | of future glory' (*Paradiso* XXV, 67–68)], and elaborates on this definition as follows:[27]

> Da molte stelle mi vien questa luce;
> ma quei la distillò nel mio cor pria,
> che fu sommo cantor del sommo duce.
> 'Sperino in te' nella sua teodia
> dice, 'color che sanno il nome tuo'.
> (*Paradiso* XXV, 70–74)[28]

[This light has come to me from many stars; | but he who first instilled it in my heart | was the chief singer of the Sovereign Guide. | 'May those' — he says within his theody — | 'who know Your name, put hope in You'.]

Dante-pilgrim is here translating from Psalm 9 verse 11, 'et sperent in te qui noverunt nomen tuum' ['and let them trust in thee who know thy name'], as is reiterated by the 'Sperent in te' (*Paradiso* XXV, 98) of the blessed souls' response to Dante-pilgrim's discourse on hope. In verse 72, Dante-poet's praise of David the psalmist as 'sommo cantor del sommo duce' ['chief singer of the Sovereign Guide'] is important evidence of his own self-identification with the biblical poet-king.[29] In the words of Harold Bloom:

> Dante has nothing positive to say about any of his poetic precursors or contemporaries and remarkably little pragmatic use for the Bible, except for the Psalms. It is as though he felt King David, ancestor of Christ, was the only forerunner worthy of him, the only other poet consistently able to express the truth.[30]

Dante's *Commedia*, like the Psalter, is a 'tëodia', a song addressed to God.[31]

In the *Convivio*, Dante laments that the psalms have lost their beauty in translation:

> E però sappia ciascuno che nulla cosa per legame musaico armonizzata si può della sua loquela in altra transmutare, sanza rompere tutta sua dolcezza ed armonia. [...] E questa è la cagione per che i versi del Salterio sono sanza dolcezza di musica e d'armonia: ché essi furono transmutati d'ebreo in greco e di greco in latino, e nella prima trasmutazione tutta quella dolcezza venne meno.[32]

> [Therefore everyone should know that nothing harmonized according to the rules of poetry can be translated from its native tongue into another without destroying all its sweetness and harmony. [...] And this is the reason why the verses of the Psalter lack the sweetness of music and harmony; for they were translated from Hebrew into Greek and from Greek into Latin, and in the first translation all their sweetness was lost.]

By translating the psalms into the Italian context of the *Commedia* — more commonly through the integration of Latin fragments into Italian syntax and rhyme than through direct translations into the vernacular — Dante seeks to bestow on them some of their original linguistic beauty, as Sergio Cristaldi has explored.[33]

Performing the Liturgy in *Purgatorio*

Dante's *Purgatorio* relies on and emulates the performativity of liturgical language in ways that resonate with Ladrière's characterization of liturgical language, in particular as regards the use of the personal pronouns and the institution of a community. In contrast, Ladrière's third, sacramental aspect lies largely outside of the scope of Dante's afterlife.[34] The psalms are an important model for the *Commedia* since they provide a performative vocabulary on which the individual can draw, in a collective context, in order to engage in a productive dialogue with God. As Sutherland and Ladrière have shown, the psalms are particularly attractive as a literary model because of their emphasis on the first person singular, and their constant, direct address to God.[35] Dante's engagement with the psalms thus goes beyond the explicit citation of specific incipits and lines to a more generalized attempt to adopt key aspects of their style and language.

In the *Commedia* as in the psalms the first-person speaking subject stands for an individual as well as a collective (the Church or Everyman);[36] as is often pointed out, the famous opening lines of the poem play on this relationship between the personal ('mi') and the general ('nostra vita'): 'Nel mezzo del cammin di nostra vita | mi ritrovai per una selva oscura' ['When I had journeyed half of our life's way, | I found myself within a shadowed forest' (*Inferno* I, 1–2)]. The intimate, direct, emotive I–you relationship characteristic of liturgical language (identified as an aspect of Ladrière's performativity) is transposed from the psalms into the *Commedia* itself, where the relationship established is not only between individual and God but also, crucially, between poet and reader. In the psalms, the addressee is primarily God, and this is also the case in *Paradiso*.[37] In addition, Dante frequently addresses the reader throughout the *Commedia* either by name ('lettor'/'lettore') or as an implicit second-person interlocutor.[38]

One of the most emotional of these addresses is in *Paradiso*, where Dante-poet exhorts: 'Leva dunque, lettore, a l'alte rote | meco la vista' ['Then, reader, lift your eyes with me to see | the high wheels' (*Paradiso* X, 7–8)].[39] Here perfect harmony is desired between narrator and reader just as between souls in Purgatory. Such addresses are also a frequent feature of *Purgatorio*, for instance, the exhortation 'Aguzza qui, lettor, ben li occhi al vero' ['Here, reader, let your eyes look sharp at truth' (*Purgatorio* VIII, 19)]. The performance of the *Commedia* thus involves not only Dante-pilgrim, Dante-poet, and the purgatorial souls, but also the reader, who is constantly exhorted to participate in the poetry as a means of self-examination, purgation, and redirection of one's gaze to God. The intellectual and spiritual fruit to be gathered thoughtfully requires performative reading, in a manner akin to monastic *lectio*.[40] The reader must be a willing and active participant in the performance.

Following Ladrière, the use of performative, liturgical language creates a shared sense of community and identity in Dante's *Purgatorio*. For Dante (after Aristotle), humans are social animals, and this society is created in large part through shared language. As Claire Honess has noted, 'the importance of language, as the primary civilizing influence, which enables human beings to live and interact in an

ordered political and social existence, is a medieval commonplace'.[41] This unifying capability of language is particularly true of liturgical language both in the earthly Church and in Dante's *Purgatorio*. Vittorio Montemaggi has proposed that 'for Dante an important part of the theological value of the poem is its narrative creation of communities that Christically participate (in *Purgatorio* and *Paradiso*) or fail to participate (in *Inferno*) in the love which God is' — a participation that is made possible through liturgical language which unites the Church Militant (on Earth), the Church Suffering (in Purgatory), and the Church Triumphant (in Paradise) in worship.[42] The presence of the liturgy in Dante's Purgatory is an innovation on the part of the poet, as Matthew Treherne has noted, and its presence enables one of the key purposes of the middle realm, that of creating links between the living and the departed.[43]

The re-use of liturgical language in Purgatory enables, through collective performance, the institution of a community which unites the souls in *Purgatorio* not only with one another but also with those still living and worshipping in the earthly Church. The unity of the monophonic plainchant of the medieval liturgy is vital in *Purgatorio*, as is evident from the very first psalm (Psalm 113) heard by Dante-pilgrim and which 'cantavan tutti insieme ad una voce' ['all of those spirits sang as with one voice' (*Purgatorio* II, 47)]. Dante's *Purgatorio* enacts, in Peter Hawkins's description, a form of sacred choral training that is at the heart of this creation of community as communion:

> Gone are the operatic soloists of *Inferno*, each singing the words of his or her life song, and nobody listening to anyone else. In their place are individuals discovering what it means to be members of a choir, to make music together. Communion becomes a way of life.[44]

Performing Dante in the Liturgy

What emerges from this discussion of the role of the psalms in the *Commedia* and of the *Commedia*'s own religious, liturgical poetry is the centrality — drawn from liturgical practice — of reading, reading aloud, and singing in groups rather than in isolation. Dante's poem, like the Psalter it appropriates, presents itself as a text to be performed not only in the reader's own heart and mind, but also aloud, collectively, whether as part of an imagined or, preferably, a physically present community of readers. Reference to recent examples of performances of the *Commedia* shows that performance is alive and well as a critical practice and mode of reception, and is not to be relegated merely to a peculiarly medieval phenomenon.[45] While Dante's poem has benefited from collective reading both in the form of the time-honoured tradition of the *Lectura Dantis* and as part of more creative endeavours (such as Robin Kirkpatrick's *Dante Project* and Roberto Benigni's *TuttoDante*), my focus is on performances within a liturgical context, as befitting the topic of the present discussion.[46]

In early 2011, Worcester College Chapel, Oxford, under the direction of the chaplain, the Revd Dr Jonathan Arnold, hosted a sermon series at Sunday Evensong

throughout term, with the theme 'Dante's *Divine Comedy* and the Seven Terraces of Purgatory'. Passages from Dante replaced the Old Testament reading each Sunday, and were placed in dialogue with fitting counterparts from the New Testament. While the focus was theological (the seven capital vices), Dante's poetry (in Dorothy L. Sayers's translation) was at the heart of this exploration.[47] In February 2013, as part of a sermon series on 'Poetry and Faith' also in Worcester College Chapel, the Revd Prof. Alison Milbank preached on Dante and spoke of the importance of reading Dante together and aloud, concluding in the hope that 'once in your life you will read [Dante], perhaps with others because that is the best way to do it'.[48] Similarly, a celebration of Dante's 750th birthday (held on 27 May 2015) took the form of a service of Latin Vespers for the Dead, incorporating readings from Dante, at St John's College Chapel, Oxford, thanks to the chaplain the Revd Dr Elizabeth Macfarlane.

These examples of recent liturgical performances of Dante highlight the interest that performing his text retains, even today, in a context that Dante would most likely have recognized and appreciated. Just as the Psalter provided a vocabulary for the productive dialogue of Dante's penitents, so contemporary worshipping communities have borrowed Dante's words as a means of exegesis. Any iteration of the *Commedia*, liturgical or otherwise, is to be welcomed as a challenge and an opportunity to which we as scholars *and* performers must recommit ourselves time and time again.[49]

To the existing long-established tradition of writing about the liturgy in the *Commedia* I have interposed a new frame, that of Ladrière's liturgical performativity, highlighting the performance of psalms as a practice which effects the transformation of the sinner through performative liturgical recitation. This shared productive performance of the psalms can be seen to build up the collective linguistic identity of the penitents. In a modern scholarly and devotional context, too, the collective reading of Dante's own verse can be productive. Through performance, including reading as a shared, communal act, the essential performativity of the liturgically infused language of Dante's *Purgatorio* can be grasped afresh; there is much still to be learned from returning to an oral, collective relationship with Dante's poetry, as well as to the points of contact and resonance between the *Commedia* and the vibrant, sensuous world of the medieval liturgy.

Notes to Chapter 6

1. I cite throughout from Dante Alighieri, *La Commedia secondo l'antica vulgata*, ed. by Giorgio Petrocchi, 4 vols (Florence: Società dantesca italiana, 1966–68); and *The Divine Comedy*, trans. by Allen Mandelbaum (London: Everyman's Library, 1995). References to the *Commedia* are given in the text and follow the pattern (canticle, canto, verse). Quotations from the Bible are taken from *Biblia sacra iuxta vulgatam versionem*, ed. by Robert Weber and others, 4th edn (Stuttgart: Deutsche Bibelgesellschaft, 1994); English translations are from *The Holy Bible Translated from the Latin Vulgate*, Douay Rheims version, rev. by Richard Challoner (Rockford, IL: TAN, 1989).

2. See, in addition to subsequent references, Erminia Ardissino, 'I canti liturgici nel *Purgatorio* dantesco', *Dante Studies*, 108 (1990), 39–65, and *Tempo liturgico e tempo storico nella 'Commedia' di Dante* (Città del Vaticano: Libreria Editrice Vaticana, 2009); Louis M. La Favia, '"...Chè quivi

per canti..." (*Purg.*, XII, 113): Dante's Programmatic Use of Psalms and Hymns in the *Purgatorio*', *Studies in Iconography*, 9 (1984–86), 53–65; *Preghiera e liturgia nella 'Commedia': atti del convegno internazionale di studi, Ravenna, 12 novembre 2011*, ed. by Giuseppe Ledda (Ravenna: Centro Dantesco dei Frati Minori Conventuali, 2013).

3. John Ahern, 'Singing the Book: Orality in the Reception of Dante's *Comedy*', in *Dante: Contemporary Perspectives*, ed. by Amilcare A. Iannucci (Toronto: University of Toronto Press, 1997), pp. 214–39; Paolo De Ventura, *Dramma e dialogo nella 'Commedia' di Dante: il linguaggio della mimesi per un resoconto dall'aldilà* (Naples: Liguori, 2007); and Bruce Holsinger, 'Medieval Literature and Cultures of Performance', *New Medieval Literatures*, 6 (2003), 271–312.

4. See Annie Sutherland, 'Performing the Penitential Psalms in the Middle Ages: Maidstone and Bampton', in *Aspects of the Performative in Medieval Culture*, ed. by Gragnolati and Suerbaum, pp. 15–38.

5. Ronald L. Martinez, 'Dante and the Poem of the Liturgy', in *Reviewing Dante's Theology*, ed. by Claire E. Honess and Matthew Treherne, 2 vols (Bern: Lang, 2013), II, 89–155 (p. 97).

6. See Ladrière, 'The Performativity of Liturgical Language'; also Cheung Salisbury, 'Establishing a Liturgical "Text"', and his contribution to the present volume (Chapter 5).

7. Austin, *How to Do Things with Words* (1962), p. 6; see also Culler, 'Philosophy and Literature'; and Manuele Gragnolati, 'Authorship and Performance in Dante's *Vita Nuova*', in *Aspects of the Performative in Medieval Culture*, pp. 123–40.

8. Aimé-Georges Martimort, *The Church at Prayer: Introduction to the Liturgy*, ed. by Austin Flannery OP and Vincent Ryan OSB, trans. by Robert Fisher and others (Shannon: Irish University Press, 1968).

9. The phrase 'singing cure' has Freudian undertones; see *The Standard Edition to the Complete Psychological Works of Sigmund Freud*, ed. and trans. by James Strachey, 24 vols (London: Hogarth Press and the Institute of Psycho-Analysis, 1953–74; repr. London: Vintage, 2001), II, 30. I develop this reading of *Purgatorio* in *Discourses of Mourning in Dante, Petrarch, and Proust* (Oxford: Oxford University Press, 2016), especially pp. 18–53. On *Inferno* as cacophonic, *Purgatorio* as monophonic, and *Paradiso* as polyphonic, see Francesco Ciabattoni, *Dante's Journey to Polyphony* (Toronto: University of Toronto Press, 2010).

10. See Andrew McCracken, '*In Omnibus Viis Tuis*: Compline in the Valley of the Rulers (*Purg.* VII–VIII)', *Dante Studies*, 3 (1993), 119–29; Mark Musa, *Advent at the Gates: Dante's 'Comedy'* (Bloomington & London: Indiana University Press, 1974), esp. Chapter 5, 'In the Valley of the Princes', pp. 85–109.

11. See Evelyn Birge Vitz, 'The Liturgy and Vernacular Literature', in *The Liturgy of the Medieval Church*, ed. by Thomas J. Heffernan and E. Ann Matter, 2nd edn (Kalamazoo, MI: Medieval Institute Publications, 2005), pp. 503–63 (p. 540).

12. For the relevance of this hymn, see John C. Barnes, 'Vestiges of the Liturgy in Dante's Verse', in *Dante and the Middle Ages: Literary and Historical Essays*, ed. by John C. Barnes and Cormac ó Cuilleanáin (Dublin: Irish Academic Press, 1995), pp. 231–69 (p. 237).

13. For discussion of this psalm see Helena Phillips-Robins, '"Cantavan tutti insieme ad una voce": Singing and Community in the *Commedia*', *Italian Studies*, 71 (2016), 4–20.

14. Robert Hollander, *Dante's Epistle to Cangrande* (Ann Arbor: University of Michigan Press, 1993).

15. Charles Singleton, '"In exitu Israel de Aegypto"', in *Dante: A Collection of Critical Essays*, ed. by John Freccero (Englewood Cliffs, NJ: Prentice-Hall, 1965), pp. 102–21; Dunstan J. Tucker, OSB, '"In exitu Israel de Aegypto": The *Divine Comedy* in the Light of the Easter Liturgy', *The American Benedictine Review*, 11 (1960), 43–61.

16. Martinez, 'Dante and the Poem', pp. 97 & 149.

17. William Peter Mahrt, 'Dante's Musical Progress through the *Commedia*', in *The Echo of Music: Essays in Honor of Marie Louise Göllner*, ed. by Blair Sullivan (Warren, MI: Harmonie Park Press, 2004), pp. 63–73 (pp. 65–66).

18. Filippo Zanini, 'Liturgia ed espiazione nel *Purgatorio*: sulle preghiere degli avari e dei golosi', *L'Aligheri*, 34 (2009), 47–63 (pp. 54–56).

19. Robert Hollander, 'Dante's Use of the Fiftieth Psalm', *Dante Studies*, 91 (1973), 145–50; and Manuele Gragnolati, 'Gluttony and the Anthropology of Pain in Dante's *Inferno* and *Purgatorio*',

in *History in the Comic Mode: Medieval Communities and the Matter of Person*, ed. by Rachel Fulton and Bruce W. Holsinger (New York: Columbia University Press, 2007), pp. 238–50.

20. Zanini, 'Liturgia ed espiazione nel *Purgatorio*', pp. 58–61, makes the point that *peccatum linguae* and *peccatum gulae* are often connected.

21. In Zygmunt G. Barański's analysis, this '*Miserere*' is a sign of syncretism, since it evokes not only Psalm 50 (amongst other psalms) but also passages from Virgil's *Aeneid*; Barański, '*Inferno* I', in *Lectura Dantis Bononiensis*, ed. by Emilio Pasquini and Carlo Galli, 5 vols (Bologna: Bononia University Press, 2011), I, 11–40 (pp. 36–37).

22. John Harper, *The Forms and Orders of Western Liturgy from the Tenth to the Eighteenth Century: A Historical Introduction and Guide for Students and Musicians* (Oxford: Clarendon Press, 1991), p. 40.

23. Christopher Page, *The Christian West and its Singers: The First Thousand Years* (New Haven, CT, & London: Yale University Press, 2010), p. 197.

24. See the website of the AHRC-funded project *The Experience of Worship in Late Medieval Cathedral and Parish Church: Making, Doing, and Responding to Medieval Liturgy* led by John Harper, <http://www.experienceofworship.org.uk/> [accessed 8 August 2017].

25. See Elena Lombardi, *The Wings of the Doves: Love and Desire in Dante and Medieval Culture* (Montreal & Kingston: McGill-Queen's University Press, 2012), p. 213.

26. Francesco D'Ovidio, *Nuovi studii danteschi: il 'Purgatorio' e il suo preludio* (Milan: Hoepli, 1906), p. 158 (my translation).

27. Robin Kirkpatrick, 'Polemics of Praise: Theology as Text, Narrative, and Rhetoric in Dante's *Commedia*', in *Dante's 'Commedia': Theology as Poetry*, ed. by Vittorio Montemaggi and Matthew Treherne (Notre Dame, IN: University of Notre Dame Press, 2010), pp. 14–35 (p. 25).

28. On this passage, see Kevin Brownlee, 'Why the Angels Speak Italian: Dante as Vernacular Poet in *Paradiso* xxv', *Poetics Today*, 5 (1984), 597–610.

29. Giuseppe Ledda, 'La danza e il canto dell' "umile salmista": David nella *Commedia* di Dante', in *Les Figures de David à la Renaissance*, ed. by Élise Boillet, Sonia Cavicchioli, and Paul-Alexis Mellet (Geneva: Droz, 2015), pp. 225–46; Theresa Federici, 'Dante's Davidic Journey: From Sinner to God's Scribe', in *Dante's 'Commedia'*, ed. by Montemaggi and Treherne, pp. 180–209; and Teodolinda Barolini, *Dante's Poets: Textuality and Truth in the 'Comedy'* (Princeton, NJ: Princeton University Press, 1984), pp. 275–78.

30. Harold Bloom, *The Western Canon: The Books and Schools of the Ages* (New York: Harcourt Brace, 1994), p. 78.

31. 'The word *teodìa* is a neologism of Dante's, created on the pattern of *salmodìa*, and refers to the Psalms' theological significance as well as their performable quality', Ciabattoni remarks in *Dante's Journey to Polyphony*, p. 165.

32. Dante Alighieri, *Convivio*, Book I, Chapter 7, ll. 14–15; *Convivio*, ed. by Franca Brambilla Ageno, 2 vols (Florence: Le Lettere, 1995), II, 30; Dante, *Il Convivio (The Banquet)*, trans. by Richard H. Lansing (New York & London: Garland, 1990), p. 18.

33. See Sergio Cristaldi, 'Dante e i Salmi', in *La Bibbia di Dante: esperienza mistica, profezia e teologia biblica in Dante: atti del convegno internazionale di studi, Ravenna, 7 novembre 2009*, ed. by Giuseppe Ledda (Ravenna: Centro Dantesco dei Frati Minori Conventuali, 2011), pp. 77–120; Simone Marchesi, *Dante and Augustine: Linguistics, Poetics, Hermeneutics* (Toronto: University of Toronto Press, 2011), pp. 95–106.

34. On the *Commedia* as beyond the sacraments, see Peter Armour, *The Door of Purgatory: A Study of Multiple Symbolism in Dante's 'Purgatorio'* (Oxford: Clarendon Press, 1983), but also Denys Turner, 'How to Do Things with Words: Poetry as Sacrament in Dante's *Commedia*', in *Dante's 'Commedia'*, ed. by Montemaggi and Treherne, pp. 286–305.

35. Sutherland, 'Performing the Penitential Psalms in the Middle Ages', pp. 17–18; Ladrière, 'The Performativity of Liturgical Language', pp. 56–57.

36. See Michael P. Kuczynski, 'The Psalms and Social Action in Late Medieval Prayer', in *The Place of the Psalms in the Intellectual Culture of the Middle Ages*, ed. by Nancy Van Deusen (Albany: State University of New York Press, 1999), pp. 191–214 (p. 194), for the comment that 'As Augustine and all the commentators who follow him agree, in the Psalms David always speaks both in his own person and in the person of *ecclesia*, the Church'.

37. Particularly in the lines describing the Trinity, *Paradiso* XXXIII, 124–26: 'O luce etterna che sola in te sidi, | sola t'intendi, e da te intelletta | e intendente te ami e arridi!' ['Eternal Light, You only dwell within | Yourself, and only You know You; Self-knowing, | Self-known, You love and smile upon Yourself!']. See Rossella D'Alfonso, *Il Dialogo con Dio nella 'Divina Commedia'* (Bologna: CLUEB, 1988).

38. Classic studies of this device are Erich Auerbach, 'Dante's Addresses to the Reader', *Romance Philology*, 7 (1953/54), 268–79; and Leo Spitzer, 'The Addresses to the Reader in the *Commedia*', *Italica* 32.3 (1955), 143–65.

39. On these lines, see Piero Boitani, 'The Poetry and Poetics of the Creation', in *Dante's 'Commedia'*, ed. by Montemaggi and Treherne, pp. 95–130 (pp. 102–03).

40. Carruthers, *The Book of Memory*, pp. 170–74. On the image of fruit in this sense, see *Inferno* XX, 19.

41. Claire Honess, 'Communication and Participation in Dante's *Commedia*', in *In Amicizia: Essays in Honour of Giulio Lepschy*, ed. by Zygmunt G. Barański and Lino Pertile (Reading: University of Reading, 1997), special supplement of *The Italianist*, 17 (1997), 127–45 (p. 142).

42. Vittorio Montemaggi, 'In Unknowability as Love: The Theology of Dante's *Commedia*', in *Dante's 'Commedia'*, ed. by Montemaggi and Treherne, pp. 60–94 (p. 76).

43. Matthew Treherne, 'Liturgical Personhood: Creation, Penitence, and Praise in the *Commedia*', in *Dante's 'Commedia'*, ed. by Montemaggi and Treherne, pp. 131–60 (p. 132); Jacques Le Goff, *La Naissance du purgatoire* (Paris: Gallimard, 1981); Brian Patrick McGuire, 'Purgatory, the Communion of Saints, and Medieval Change', *Viator*, 20 (1989), 61–84.

44. Peter S. Hawkins, *Dante's Testaments: Essays in Scriptural Imagination* (Stanford, CA: Stanford University Press, 1999), p. 8.

45. See also *Dante on View: The Reception of Dante in the Visual and Performing Arts*, ed. by Antonella Braida and Luisa Calè (Aldershot: Ashgate, 2007).

46. To clarify: in the tradition of the *Lectura Dantis*, one *canto* is read alone and commented upon in isolation, typically in front of an audience by different invited lecturers and experts on each occasion, with a print publication often ensuing. Roberto Benigni has extended this format to undertake all the *canti* himself, reaching a very broad public through his charisma and the broadcasting of his talks on television and, eventually, DVD. Robin Kirkpatrick's *Dante Project*, in contrast, combined extracted readings with dance and music, for instance in Mansfield College Chapel, Oxford, on 28 November 2010.

47. <http://www.worcesterchapel.co.uk/2011/dante-sermon-series-introduction-the-chaplain/> [accessed 8 August 2017].

48. <http://www.worcesterchapel.co.uk/2013/dante-and-the-lure-of-beauty-sermon-by-rev-dr-alison-milbank-february-24th-2013/> [accessed 8 August 2017].

49. Kirkpatrick remarks in 'Polemics of Praise', p. 24, that 'In their own sphere, literary critics, too, are preparing for performance, even for celebration'.

CHAPTER 7

Ambiguous Author Portraits in Christine de Pizan's Compilation Manuscript, British Library, Harley MS 4431

Charlotte E. Cooper

This essay, which takes author-portraits as its theme, features amongst those in this volume that are concerned with performance in terms of representation, as opposed to an active performance.[1] Indeed, all author-portraits may be said to be performative in a sense, as they must by necessity employ artifice to represent (or to suggest the presence of) an otherwise absent author. The performances they engender are constructed by a series of dualities: author-portraits represent both the author of the work and the subject of the representation; they denote at once the absence of the physical author from the text, whilst acting simultaneously as a reminder of their role in its creation. Finally, author-portraits are generic, although they have a particular referent: denoting an individualized author, the image may nevertheless have been prepared without the artist having ever met their subject and be based, instead, on pre-existing models. In this case, the portrait is only more performative, as it can be seen to stand for (or perform) the author's authority and influence over their creation, whilst not necessarily bearing any resemblance to the historical person it represents.[2]

Author-portraits of Christine de Pizan abound. An analysis of her fifty-four surviving author-manuscripts reveals that Christine is represented in the frontispiece of 57% of those manuscripts — a figure that indicates a certain self-consciousness on the part of the author about the way in which she wished to be represented.[3] Critics often assert that the figure in a blue gown wearing a bi-horned white wimple found across manuscripts of Christine's works is to be identified with the author herself.[4] The figure features frequently in presentation scenes or at the start of individual works, a place in which authors are commonly represented, notably in dedication scenes. However, it is not always clear that an identity between Christine and the figures in blue is posited. Whilst this may be a tempting identification to make, by doing so we run the risk of over-simplifying these enigmatic images simply to make them easier to read. A. C. Spearing has recently suggested that 'the "I" which readers might wish to stabilize by connecting it either to a fictional persona [...] or simply to "the real [author]", has an irreducible instability revealed. [...] The "I"

[...] cannot be the label of a single, self-identical consciousness'.[5] These statements could be extended to Christine's author-portraits: if there is an intended or implied persona behind them, caution should be exerted when identifying it with the author. This essay argues that it is more likely that such images were created deliberately to evoke the possibility of such an identification without seeking to make it clear-cut.

But what are the implications of identifying Christine with a particular representation, and by whom was it created? What might its purpose have been? And is it always unambiguously the case that this figure represents Christine? In order to address these issues, this essay examines what may be termed 'ambiguous' author-portraits, discussed here with reference to examples drawn from a compilation manuscript of Christine's works, London, BL, Harley MS 4431, with a particular focus on two ambiguous portraits in its copy of the *Epistre Othea*.[6] By considering the wider function of ambiguous author-portraits in Christine's works, and the various means by which a performance is staged through representing her in a particular way, the question of who is represented in the images — and in author-portraits more generally — can be tackled.

Creating the Christine de Pizan Brand

The figure of Christine de Pizan is one of the most recognizable portraits in medieval French literature. In her author-manuscripts, Christine is indeed represented in a more or less uniform manner: in a gown with long, trailing sleeves, and a bi-horned white wimple (Figure 7.1). The colour of her dress in the author-manuscripts is often, though not uniformly, blue, yet outside the domain of scholarship images of Christine wearing this colour have become not just iconic, but commercialized: for example, in the form of a Christine de Pizan Halloween costume, which takes a royal blue gown as its focal point, or in a pair of Christine de Pizan blue sapphire-coloured earrings.[7] Representations of Christine in blue continue to be produced by modern artists.[8] However, an examination of the medieval illuminations shows that the colour of her dress is far from consistent — although the style of her costume is almost completely unchanging.[9] Mary Wetzel Gibbons is right in saying that 'Christine's self-portrayal is not distinguishable from her female contemporaries' and that 'all of the women in her manuscript illuminations appear to be cut from the same mold', possibly as a result of their being drawn from similar models.[10] But this view downplays any significance in the consistency with which Christine was represented, and clashes with the view that Christine is always represented in such a distinctive way that the blue dress and white headdress become her 'marque[s] de fabrique'.[11]

A closer look at the author-portraits and the colours used to represent the author may help to explain how such opposing views have come to exist. In earlier illustrations, the author-figure is often drawn in grisaille against a painted background; sometimes, grey, grey-blue, or grey-brown tints have been overlaid, lending a hint of colour to her dress. Where it is painted, her dress is most commonly found in beige, brown, grey, or grey-brown tones. In Harley MS 4431 (Figure 7.2) and in

FIG. 7.1. London, BL, Harley MS 4431, fol. 3ʳ (© The British Library Board)

FIG. 7.2. London, BL, Harley MS 4431, fol. 265ʳ (© The British Library Board)

Paris, Bibliothèque de l'Arsenal, MS 2681 Christine is found in a pink dress, and in one image in Chantilly, Musée Condé, MSS 492–93 she wears a mauve gown. Only eleven of Christine's known author-manuscripts represent her in blue. Scholars and modern artists are therefore mistaken in seeing images of Christine dressed in blue as the norm, a view which Lori J. Walters typifies when she describes Christine as wearing her 'customary blue gown', or her 'characteristic blue robes'.[12] Why, then, is she so often imagined to appear invariably in this way, and where does our association of Christine with this colour come from?

The answer to this question seems to lie in the paintings created in one particular workshop, known to art historians as the workshop of the Maître de la Cité des Dames (MCD).[13] Although twelve different Masters are believed to have worked on Christine's corpus of author-manuscripts at different times, the MCD is the first to have represented Christine in a blue gown during her lifetime, and the only one to do so consistently. The images of Christine wearing blue that are most familiar to modern audiences were all produced by this workshop.[14] This workshop, it seems, is therefore responsible for the creation of the Christine de Pizan brand, and for creating the consistent performance of authorship encountered in manuscripts of her works. Nevertheless, the images produced under the supervision of the MCD are not only favoured by modern audiences, but Christine herself seems to have developed a certain preference for these illuminations. Table 7.1 features a timeline of the various artists believed to have worked on Christine's manuscripts during her lifetime. Dates within the manuscripts and references to historical events in the texts they contain allow a fairly precise dating for most of Christine's manuscripts. Although the MCD did not work on any of Christine's manuscripts before 1405, within two years, the workshop had become almost the only atelier with which Christine collaborated.[15]

The iconographic programme of Harley MS 4431, for which the MCD was almost entirely responsible, might provide an explanation for Christine's preference. Indeed, this preference appears to be connected to this Master's creation of the Christine de Pizan brand which crafted the author into a recognizable figure — an identification that relied on the choice of the colour blue, itself rich in symbolic associations. In the later Middle Ages, blue was most evidently associated with royalty. The colour of the House of France, for example, was blue with gold fleurs-de-lys. The Virgin Mary was depicted in blue from the twelfth century onwards.[16] Although John Gage cautions scholars against attempting to pin down any particular meaning to individual colours in the Middle Ages, a number of Christine's near-contemporaries, including Guillaume de Machaut and Jean Robertet, associate blue with loyalty.[17] Michel Pastoureau observes that blue in the Middle Ages also connoted peace.[18] Whilst this colour may therefore have been chosen without any specific purpose in mind, all of the associations of this colour would have been positive ones for Christine's readers.

Nevertheless, the careful crafting of an author-figure is subtler than the use of a recognizable brand. The images can be used to insert the author-figure into the narrative even when she is not explicitly mentioned. In such cases, it is not

always clear whether the woman represented is Christine, someone else, or just a background figure in a long blue dress. It is for this reason that I propose the term 'ambiguous' author-portraits for instances in which the identity of the figure in a blue dress is unclear. In this essay, I focus on two examples that illustrate how this ambiguity serves to provide coherence to the seemingly random narrative-structure of the *Epistre Othea*. These examples are drawn from Harley MS 4431, produced under Christine's supervision and arguably the most famous of her author-manuscripts: it has been the subject of much scholarship, and a number of editions of Christine's works have been produced that take it as their base source.[19] The manuscript has become particularly well-known for its dedication scene, in which a Christine author-figure is depicted presenting her book to Queen Isabeau of Bavaria (Figure 7.1). This illumination has featured frequently on the covers of scholarly editions of Christine's texts, and books about medieval France or women in general.[20]

The attention that Harley MS 4431 has warranted is not undue: of the compilation manuscripts whose production was overseen by Christine, it is the most homogeneous and the most complete.[21] Of the different incarnations of the *Livre de Christine* (an earlier compilation of Christine's works of which three copies exist), only one is complete, and each copy contains no more than twenty-three works, compared to Harley MS 4431's thirty.[22] But perhaps one of the main reasons why Harley MS 4431 has received so much attention, and one of the justifications frequently given for its being chosen as the base manuscript for critical editions, is that it contains the last version of many of the texts revised and edited under Christine's supervision.[23]

As beneficial as this focus on Harley MS 4431 has been to the field of Christine studies in general, it is perhaps also responsible for the belief that Christine was invariably performed in a pictorially consistent manner. Harley MS 4431 bears a rich iconographic programme that extends to 132 miniatures, within which the author is represented multiple times, often — though not exclusively — in blue (Table 7.2). Sandra Hindman, Marilynn Desmond, and Pamela Sheingorn have explored the political subtext that is carefully woven into some of these images.[24] In the following, I demonstrate that the subtle creation of meaning which these critics have identified extends to the author-portraits, which make up twenty-six of the manuscript's images.

Ambiguous Author-portraits

Within Harley MS 4431, illustrated almost exclusively by the MCD workshop, a total of twenty-four miniatures feature women wearing the blue costume in which this artist usually represented Christine. These miniatures may be categorized as follows (see Table 7.2): ten illuminations in which the figure represents Christine in her role as author (dedication miniatures, the author writing or teaching at her desk, scenes in which the author indirectly presents her work to a patron); those that feature Christine in her role as a character in the story (the seven illuminations accompanying the *Chemin de lonc estude*); and finally, a class of images that are

Year	Manuscript	Masters
1399	Chantilly 492	14 illuminations: 13 by Maître de la Pastoure (MDP); 1 by Maître 'Bleu-Jaune-Rose' (BJR)
1400	BnF fr. 848	4 illuminations, all by Maître de la Première Epître (MPE)
1401	BnF fr. 1740	1 illumination, by Maître du Couronnement de la Vierge (MCV)
1402	BnF fr. 12779 Brussels 11034	9 illuminations, all of which by MDP, 3 with Maître de Jean Ravenelle (MJR) 1 illumination, by MCV
1403	Chantilly 493 Brussels 10983 Brussels 10982 BnF fr. 1188 Brussels 9508 The Hague 78 D 42	11 illuminations, all by BJR 3 illuminations, all by MCV 6 illuminations, all by MCV 5 illuminations, all by MCV 6 illuminations, all by Maître de l'Epître Othéa (MEO) 6 illuminations, all by MEO
1404	Chantilly 494 Ex-Philipps 207	6 illuminations, all by MEO 4 illuminations, all by MEO
1405	BnF fr. 1179 BnF fr. 580 BnF fr. 1176 Brussels 10309 Boston 101 BnF fr. 25636	1 illumination, by **Maître de la Cité des Dames (MCD)** 1 illumination, by Maître de l'Ovide Moralisé (MOM) 1 illumination, by MEO 1 illumination, by MEO 1 illumination, by **MCD** 1 illumination, by **MCD**
1406	BnF fr. 606 BnF fr. 835 BnF fr. 836 Ex-Philipps 128 Arsenal 2681	101 illuminations, 80 by MEO, 19 by Maître au Safran (MAS), and 2 by Maître d'Egerton (MDE) 6 illuminations, 5 of which by MEO, one by MDE 18 illuminations, 10 of which by MEO, 8 by MDE 1 illumination, by Maître de Giac (MDG) 1 illumination, by MEO
1407	Brussels 9393	3 illuminations, by **MCD**
1408	Harley 4431 BnF fr. 607	101 illuminations to *Othea*, all by **MCD** 3 illuminations, by **MCD**
1409	Ex-Ashburnham-Barrois 203 Brussels 10987 BnF n.a.f. 4792	1 illumination, by MDE 1 illumination, by MDE 1 illumination, by MDE
1410	BnF fr. 603 Munich 11 Brussels 10476	11 illuminations, all by **MCD** 6 illuminations, all by **MCD** 1 illumination, by **MCD**
1411	No known MSS	
1412	No known MSS	
1413	Harley 4431 BnF fr. 1178	20 remaining illuminations executed, 15 by **MCD**, 5 by Maître de Bedford (MBF) 3 illuminations, all by **MCD**
1414	Brussels 10366	1 illumination, by **MCD**

TABLE 7.1. Timeline of masters working on illuminations of Christine's work during her lifetime. Where dates are given as a range, I have used the earliest, e.g. MS Chantilly 492 has been dated to 1399–1402. The MCD's name has been highlighted, so as to demonstrate Christine's increasing preference for this artist.

Location in MS	Colour	Type of Portrait
fol. 3r – Prologue	Blue	Dedication scene
fol. 4r – Cent Balades	Blue	Writing scene
fol. 48r – Complainte amoureuse	Blue	Ambiguous
fol. 56v – Une autre complainte amoureuse	Blue	Ambiguous
fol. 58v – Livre du debat des deux amans	Blue	Indirect presentation scene
fol. 71v – Livre des trois jugemens	Blue	Indirect presentation scene
fol. 81r – Livre de Poissy	Blue	Ambiguous
fol. 95r – Epistre Othea	Black	Dedication scene
fol. 100r – Epistre Othea	Blue	Ambiguous
fol. 133v – Epistre Othea	Blue	Ambiguous
fol. 143r – Livre du duc des vrais amans	Blue	Patron solicits author's services
fol. 178r – Chemin de lonc estude	Pale blue	Dedication scene
fol. 180v – Chemin de lonc estude	Pale blue	Christine as character
fol. 183r – Chemin de lonc estude	Pale blue	Christine as character
fol. 188r – Chemin de lonc estude	Pale blue	Christine as character
fol. 189v – Chemin de lonc estude	Pale blue	Christine as character
fol. 192v – Chemin de lonc estude	Pale blue	Christine as character
fol. 196v – Chemin de lonc estude	Pale blue	Christine as character
fol. 218v – Chemin de lonc estude	Pale blue	Christine as character
fol. 259v – Proverbes moraulx	Blue	Teaching scene
fol. 261v – Les enseignemens que Cristine donne a son filz	Blue	Teaching scene
fol. 265r – Oroison de nostre dame	Pink	Ambiguous
fol. 290v – Cité des dames (two figures)	Blue; blue	Writing scene; ambiguous
fol. 323r – Cité des dames	Blue	Ambiguous
fol. 361r – Cité des dames	Blue	Ambiguous

TABLE 7.2. Christine-figures in London, BL, Harley MS 4431

ambiguous in that they show a figure who is the same as the 'Christine' figures but cannot be identified as such so readily in the text. The fact that some of these depictions are located at the opening of a new work, where an author-portrait could be expected, further allows for the possibility that these are indeed representations of the author. These could, however, simply be female figures that the artist has chosen to represent in this particular manner, and I have therefore termed these portraits 'ambiguous'. To this category, I add one further illumination that does not feature a woman in a blue gown (Harley MS 4431, fol. 265r, Figure 7.2), to which I return below.

The term 'ambiguous author-portrait' denotes representations of individuals that can have more than one referent, one of which is the author. Because the figure represented is not carrying out authorial activities such as writing, or presenting a text, and because the image does not coincide with a moment in the narrative in which the author is present (even as a narrator), these are not evidently author-

P vmes amfi a cuer plus now q mieuxe
m̃ e fault lenguir car tout bient me sechace
& st ce bien droit meschief qui me cuert sue
d̃ nant bn̄ tel

FIG. 7.3. London, BL, Harley MS 4431, fol. 48r (© The British Library Board)

FIG. 7.4. London, BL, Harley MS 4431, fol. 56ᵛ (© The British Library Board)

portraits. But since the female figure in these images wears the same costume that Christine does in the non-ambiguous author-portraits, critics have been quick to read Christine's presence into some of these representations — a position that I shall bring into question. A figure visually associated with the author can, however, direct us towards the implied author's point of view, creating didactic coherence within a single text, within the same manuscript, or even within Christine's wider œuvre.

The first example of such ambiguity is the miniature on fol. 48r (Figure 7.3). This image features a messenger who delivers a scroll to a noble lady accompanied by two ladies-in-waiting. Deborah McGrady identifies one of the ladies as Christine, simply because she wears a white bi-horned wimple and a blue gown, also worn by the author-figure in the only two illuminations that precede this one. As this figure is not present in an image depicting the same scene in an earlier manuscript (Paris, BnF, MS fr. 835, fol. 50r), McGrady takes her reading one step further and interprets the author's unexpected presence as having implications for Christine's increasing authority.[25] However, it is by no means evident that the woman represented is unquestionably Christine: she wears a thick, black, decorated or gilded belt around her waist, an unusual addition to Christine's customary outfit in this manuscript. This is a feature also encountered in two further ambiguous author-portraits in Harley MS 4431. The first of these images (Figure 7.4) follows this illumination in Harley MS 4431, and the two miniatures may therefore have been completed at or around the same time. This image is also ambiguous, as it is not clear whether the figure represented is Christine giving her text to a messenger, or the lady to whom the *Complainte* (which the miniature accompanies) is addressed. The other image that shows an author-figure wearing a black belt (Figure 7.2) is one of the illuminations completed by the Maître de Bedford (MBF). It is placed at the start of the *Oroison Nostre Dame*, a position in which, in other manuscripts, a figure carrying out the familiar gesture of an author presenting her book to a patron is encountered. However, the figure in this position in the Harley manuscript is quite different from the rest of the portrayals of the author in the collection, which brings into question its function as an author-portrait: not only is the pink gown an unusual colour choice, but it is also decorated, featuring a grey fur trim around the sleeves and neck, and the gilded belt around the waist. If this were indeed an author-portrait, it would represent Christine's most ornate outfit in any of the manuscripts that she supervised. The figure holds an open scroll that she presents to the Virgin, or from which she might be reading to her.[26] The discrepancy may be the result of decisions made by two different artists, but this is one of three instances in which art historians have ascribed the image in Harley MS 4431 to the MBF; in both other cases (fols 259v and 261v), she is depicted in a plain, deep blue gown. Although I have termed this portrait as ambiguous, the only detail that prevents it from being an unambiguous author-portrait is the unusual outfit worn by the Christine-figure. This example serves to show how fine the distinction between (un)ambiguous author-portraits can be.

To return to the image on fol. 48r (Figure 7.3), there is no reference to Christine's presence at this point in the narrative. It is therefore possible that, rather than being

intended to represent the author, this figure constitutes a third lady-in-waiting; yet, is it necessary for it to be one or the other? Viewing this as an ambiguous portrait allows us to consider the possibility of it being both. The ambiguous figure is both a background figure and a visual reminder of the author's involvement in preparing this text — possibly also drawing the patron's attention towards the importance of a didactic text such as this one, a point to which I return below. Likewise, the woman on fol. 265r can be read as either the author who presents her poem to the Virgin or as an example for the intended reader, who is invited to mirror the figure's gesture and read the text in prayer. Divergence from the usual way of representing Christine, for example by adding the detail of a belt, therefore leaves author-portraits more open to interpretation.

These are not the only cases in which Christine's representation in the illuminations of this particular manuscript is uncertain. Two striking examples are found in the version of the *Othea* in Harley MS 4431. This didactic treatise is a hybrid between a mirror for princes and religious allegory; it takes the form of a letter sent from the Goddess Othea to Prince Hector of Troy as a boy, and it is made up of one hundred sets of verse, each with two prose glosses. Through the Trojan legends, Othea instructs Hector on good conduct in government, war, and love, providing recommendations for good, proper, princely behaviour. Each *texte* or set of verse is followed by an explanation of the Trojan material in the *glose* and supplemented by a moral or Christian reading in the *allegorie*. Among Christine's works, this one is especially notable for its rich iconographic programme, and in Harley MS 4431, each of the one hundred sets of verse is accompanied by its own illumination, with an additional dedication miniature featuring alongside the prologue, giving a total iconographic programme of 101 illuminations.[27] As the content of the *epître* is said to have been composed by the Goddess Othea, it follows that Christine as narrator is completely absent throughout this text — with the exception of the Prologue. However, certain iconographic figures can be seen to perform for the author by making her presence felt.

Of the 101 miniatures that illustrate this text, two depict a woman wearing a long blue gown with bi-horned white headdress. These illuminations, found on fols 100v (Figure 7.5) and 133v (Figure 7.6) are separated by thirty-three folios and illustrate *histoires* VII and LXXXIV respectively.[28] The first image accompanies a story that warns the princely reader against following and worshipping Venus. The *texte* reads:

> De Venus ne fais ta deesse,
> Ne te chaille de sa promesse:
> Le poursuivre en est traveilleux,
> Non honnourable, et perilleux.[29]

[Do not make Venus your goddess or trust in her promise. That pursuit is a laborious task, dishonourable, and perilous.]

Critics such as Desmond have read the prominent figure at the centre of the image as representing the author herself because she wears what is seen to be Christine's usual blue costume.[30] However, once again, there is nothing in the narrative to suggest that Christine's presence should be read into this image, and this figure does

FIG. 7.5. London, BL, Harley MS 4431, fol. 100ᵛ (© The British Library Board)

FIG. 7.6. London, BL, Harley MS 4431, fol. 133ᵛ (© The British Library Board)

not appear in the miniature in an obviously authorial stance. Her presence here is therefore ambiguous. The Christine-figure performs an exemplary function: whilst 'most of the other mortals hold their hearts up towards Venus, as though they are completely enthralled by her', for Desmond, this image undoubtedly represents Christine, who 'clasps a heart close to her chest, as though she refuses to dedicate herself to Venus and the amatory values embodied by the goddess'.[31] The image, in other words, and the Christine-figure in particular, serve a didactic function in reinforcing the message contained within the *histoire*. The familiar manicule that directs the reader towards important passages has been displaced from its usual place in the margins into the centre of the image, as the Christine-figure purposefully points towards Venus. This message would be present in the illumination regardless, but it is rendered all the more poignant by the fact that this exemplary gesture is carried out by a figure visually associated with the author.

The space occupied by the Christine-figure is also not without significance: in an otherwise crowded picture, she is the only one with space around her and she stands at the forefront of the group on the right-hand side; her skirts spread out, giving emphasis to her position as a leading figure in this image. Without this figure, the miniature would not convey the didactic message at all and would represent a variety of people sending their hearts to Venus — exactly what the written part of the *histoire* incites the reader not to do. The Venus image illustrates the means by which the ambiguous author-figure performatively highlights a particular point within certain illuminations or provides the example to be followed.

The second ambiguous illumination I will discuss (Figure 7.6) represents Troilus reaching out to Cupid with one hand and gesturing towards a female figure with the other. The *histoire* tells the prince that if he must follow Cupid, then he should not follow the example of Troilus, who fell in love with the inconstant Briseis. It seems safe to assume that the female figure must be Briseis herself. Her fickle heart is visually represented here, as she appears to reach hesitatingly towards Troilus's hand: her gesture could be interpreted as reaching towards him or pushing him away, and she is shown to have done both in the *glose*. However, there is something unusual about Briseis' costume, since she is represented in the outfit most commonly worn by the author in this manuscript. The possibility of this figure being Christine is particularly problematic when read in conjunction with the text itself:

> S'a Cupido tu veulx donner
> Ton cuer, et tout habandonner,
> Gard toy Briseyda n'acointier,
> Car trop a le cuer vilotier.[32]

[If to Cupid you must give your heart, renouncing all else, do not acquaint yourself with Briseis, for her heart is too depraved.]

It is unlikely that Christine would wish to be associated with a figure she presents so unfavourably, and against whom she warns the reader, in particular in a manuscript in whose preparation we know her to have been heavily involved. However, I contend that this figure was represented in this costume with the purpose of reminding the reader of the message contained in the earlier *Othea* image and of

the author's presence therein.[33] This argument would also account for the figure's ambiguous gesture: whilst Briseis pushes Troilus away, it is Christine who attempts to restrain him from following Cupid.

The ambiguous author-figure therefore accompanies two *histoires* with a similar message, providing a strong intervisual link, one that reinforces the advice being conveyed in each case. These images function neither as author-portraits, nor as illustrations of characters in the story, and the Christine-like figure they represent both *is* and *is not* Christine. The key to understanding these images therefore does not lie in whom they represent, but in what they do and how they function. The identity of the person represented matters only in that it visually conveys the point of view of the implied author. This may have implications for reading supposedly non-ambiguous portraits: because portraits of authors are by their very nature neither textual nor extra-textual — while the author-portrait's referent is extra-textual, the portraits themselves are situated in a (para-)textual space — they are always ambiguous to some extent.[34] Author-figures can only ever stand in for the historical author, or act in their place, and like all textual and visual material, author-portraits are left open to interpretation. By bringing a visual element into play, author-portraits add a third facet to the already ambivalent relationship between the real author and the implied author. Considering author-portraits as ambiguous would enable their role to be re-evaluated. One such role is that they function as manicules, used to draw attention to a particular point, or towards the text as a whole, thereby asserting its own authority and that of its author.

Conclusion

All twelve of the Masters who represented Christine during her lifetime depicted the author in a similar manner. It is possible that one or more of the earlier author-portraits, which may have been based on generic, pre-existing portrayals of women, continued to be used by the different artists, who brought their own particular nuances to the images. As this discussion has shown, there is no doubt that, in Harley MS 4431, these miniatures serve as more than mere author-portraits. This study suggests that the MCD and his workshop were actively involved in creating the Christine de Pizan brand, a finding that questions Hindman's vision of miniaturists as artisan-craftsmen who used little initiative and simply followed the patron's instructions, providing 'a practical or manual [role], rather than an intellectual one'.[35] Christine trusted the MCD to help create an iconographic programme rich in intervisual meanings and to establish an authoritative persona for herself. Although there is a degree of careful self-fashioning and a certain amount of performance taking place in her author-portraits, the idea that Christine is recognizable primarily by the colours of her costume is one that modern readers have imposed.

Not only is this tendency to make simple equivalences between a representational practice and a single referent (where more than one is possible) symptomatic of our desire to render these images more readable by simplifying their meanings, but the reverse is equally problematic. The propensity for identifying Christine

with one particular representational practice is revealing of the modern desire to unify Christine into a recognizable author-figure in these manuscripts, thereby resolving ambiguities, such as the identity of the figures in the Venus and Cupid illuminations of Harley MS 4431. Opposing this common practice, I contend that these images are deliberately ambiguous, carefully crafting a plurality of meanings and a spectrum of selves into the pages of the manuscript.

Whilst critics are more than willing to recognize the multifacetedness of Christine in her texts, they have been too quick to view her as an author represented in a single way. It should not be forgotten, however, that the woman in these images, like the persona encountered in her works, is also a careful creation — an artifice produced by the work of several Masters. A simplified reading only downplays the subtlety and art with which these manuscripts have been constructed, and the care and attention with which supplementary meanings have been worked into the paratext.

However tempting it may be to assume that the visual representation of the implied author was consistent in Harley MS 4431, the apparent uniformity of these representations reveals striking ambiguities. The spectrum of Christine's selves can be seen to extend beyond the boundaries of each text, into the paratext of the written work and beyond, changed and refashioned in additional manuscripts, including later copies and printed editions produced after the author's lifetime. As each manuscript is recopied and its paratextual apparatus recreated, there is potential for the implied author to be rewritten, represented, and performed anew. The implied author encountered in Christine's author-manuscripts takes on a further dimension in ambiguous author-portraits; here, the conventional distinction between the author and the implied author proves unhelpful. Even when considering all aspects of the textual Christine as making up the 'implied author', the self we encounter in ambiguous author-portraits is not the author or the narrator, nor even the implied author, but a proxy-figure — a kind of bouncing point that operates between the real and implied author. This ambiguity engenders a performance of authorship rich in visual associations that may or may not have born any resemblance to the real, historical Christine.

Notes to Chapter 7

1. For a theoretical discussion of this distinction, see the essay by Ferreira in the present volume (Chapter 4).
2. For an alternative consideration of author-portraits, see Souleau's essay in the present volume (Chapter 8).
3. For details of Christine's author-manuscripts, see Gilbert Ouy, Christine Reno, and Inès Villela Petit, *Album Christine de Pizan* (Turnhout: Brepols, 2012).
4. See, for example, Ouy, Remo, and Villela-Petit, *Album Christine de Pizan*, pp. 292, 556, & 564; Laura Rinaldi Dufresne, 'A Woman of Excellent Character: A Case Study of Dress, Reputation and the Changing Costume of Christine de Pizan in the Fifteenth Century', *Dress*, 17 (1990), 105–17; Patricia M. Gathercole, *The Depiction of Women in Medieval French Manuscript Illumination* (Lewiston & Lampeter: Mellen, 2000), p. 49.
5. A. C. Spearing, *Medieval Autographies: The 'I' of the Text* (Notre Dame, IN: University of Notre Dame Press, 2012), pp. 63–64.

6. A digitized copy of the manuscript is available at <http://www.bl.uk/manuscripts/Viewer. aspx?ref=harley_ms_4431_f001r> [accessed 8 August 2017].

7. <http://takebackhalloween.org/christine-de-pizan/> [accessed 8 August 2017]; <https://www. rubylane.com/item/61838-506533x20nx2fa1937/Christine-De-Pisan-Earrings-Sapphire-Quartz?search=1> [accessed 8 August 2017].

8. See, for example, Marsha Monroe Pippenger's *Dinner in the City*, <http://pippengerart. com/?p=14> [accessed 8 August 2017].

9. There is nothing unusual about Christine's style of dress or headdress, which is typical of women's fashion in the early fifteenth century: Françoise Piponnier and Perrine Mane, *Se Vêtir au Moyen Âge* (Quetigny: Société Nouvelle Adam Biro, 1995), pp. 96–103.

10. Mary Wetzel Gibbons, 'Christine's Mirror: Self in Word and Image', in *Contexts and Continuities (Proceedings of the IVth International Colloquium on Christine de Pizan (Glasgow 21–27 July 2000))*, ed. by Angus Kennedy and others, 3 vols (Glasgow: University of Glasgow Press, 2002), II, 367–96 (p. 376).

11. Didier Lechat, 'Christine et ses doubles dans le texte et les enluminures du *Livre du duc des vrais amants* (BnF fr. 836 et BL Harley 4431)', in *Sens, rhétorique et musique: études réunies en hommage à Jacqueline Cerquiglini-Toulet*, ed. by Sophie Albert, Mireille Demaules, Estelle Doudet, and others, 2 vols (Paris: Champion, 2015), II, 693–706. I am grateful to the author for sharing this article with me ahead of the book's publication.

12. Lori J. Walters, 'Depictions of Books and Parchment Sheets in the Queen's MS (London, British Library, Harley MS 4431)', <www.pizan.lib.ed.ac.uk/waltersbooksandletters.rtf> [accessed 8 August 2017].

13. It is unknown whether the Masters were individuals, or groups of artists working in a single workshop. I refer to each Master in the masculine singular form for expediency.

14. This is the case in all eleven manuscripts illustrated by the MCD. Only three manuscripts produced outside this workshop depict Christine in blue: Private Collection, MS Ex-Phillipps 128; Paris, BnF, MS fr. 835; and Paris, BnF, MS fr. 836. These all post-date the MCD's work.

15. The only exceptions are: in 1409, the Maître d'Egerton carried out a single almost identical illumination in three copies of Christine's *Sept psaumes allégorisés*, and in 1413, the Maître de Bedford carried out five of the Harley 4431 miniatures, the rest of which were executed by the MCD.

16. Michel Pastoureau, *Bleu: Histoire d'une couleur* (Paris: Seuil, 2006), p. 44.

17. John Gage, *Colour and Culture: Practice and Meaning from Antiquity to Abstraction* (London: Thames and Hudson, 2009), p. 83; Guillaume de Machaut, *La Louange des dames*, ed. by Nigel Wilkins (Edinburgh: Scottish Academic Press, 1972), p. 94, l. 176; Jean Robertet, *Œuvres*, ed. by Margaret Zsuppán (Geneva: Droz, 1970), p. 84.

18. Michel Pastoureau, *Blue: The History of a Color* (Princeton, NJ, & Oxford: Princeton University Press, 2001), p. 138, pl. 70.

19. Most notably the recent *The Making of the Queen's Manuscript* project, dir. James Laidlaw, <http://www.pizan.lib.ed.ac.uk> [accessed 8 August 2017]; Deborah McGrady, 'What is a Patron? Benefactors and Authorship in Harley MS 4431, Christine de Pizan's Collected Works', in *Christine de Pizan and the Categories of Difference*, ed. by Marilynn Desmond (Minnesota: Minnesota University Press, 1998), pp. 195–214; Tania Van Hemelryck and Christine Reno, 'Dans l'atelier de Christine de Pizan: le manuscrit Harley 4431', in *Du Scriptorium à l'atelier: copistes et enlumineurs dans la conception du livre manuscrit au Moyen Âge*, Pecia: Le livre et l'écrit, ed. by Jean-Luc Deuffic, XIII (Turnhout: Brepols, 2011), pp. 267–86. Editions based on Harley MS 4431 include *Le Livre de la cité des dames (La Città delle dame)*, ed. by Patrizia Caraffi and Earl Jeffrey Richards (Milan: Luni, 1997); *The Love Debate Poems of Christine de Pizan*, ed. by Barbara Altmann (Gainesville: University of Florida Press, 1998); and *Le Chemin de longue etude*, ed. by Andrea Tarnowski (Paris: Librairie Générale Française, 2002).

20. These include *Women and the Book: Assessing the Visual Evidence*, ed. by Jane H. M. Taylor and Lesley Smith (London & Toronto: British Library and University of Toronto Press, 1997); Christine de Pizan, *The Treasure of the City of Ladies, or, The Book of Three Virtues*, ed. and trans. by Sarah Lawson (London: Penguin, 2003); *Paris 1400: Les arts sous Charles VI*, ed. by Élisabeth Taburet-Delahaye (Paris: Fayard, Réunion des musées nationaux, 2004).

21. van Hemelryck and Reno, 'Dans l'atelier de Christine de Pizan', p. 268.

22. On the *Livre de Christine*, see James Laidlaw, 'Christine de Pizan — A Publisher's Progress', *Modern Language Review*, 82 (1987), 35–75.

23. Only two author-manuscripts postdate Harley MS 4431: Brussels, Bibliothèque Royale, MS 10366, the single extant copy of the *Livre de la paix* (1414); and Paris, BnF, MS fr. 24786 (*c.* 1418), of which fols 36r–97r contain a unique author-copy of the *Livre de la prison humaine*. Harley MS 4431 presents the latest version of nearly all of the works it comprises, including for instance the *Chemin de lonc estude* and the *Cité des dames*.

24. Sandra Hindman, *Christine de Pizan's 'Epitre Othea': Painting and Politics at the Court of Charles VI* (Wetteren: Pontifical Institute of Mediaeval Studies, 1986); Marilynn Desmond and Pamela Sheingorn, *Myth, Montage and Visuality in Late Medieval Manuscript Culture: Christine de Pizan's 'Epistre Othea'* (Ann Arbor: University of Michigan Press, 2003).

25. McGrady, 'What is a Patron?', pp. 206–08.

26. In MSS Chantilly 492–93 and Paris, BnF, MS fr. 12779 Christine presents a closed book to the Virgin, but in MS fr. 836 she bears no book or scroll, and her hands are joined together in prayer.

27. Paris, BnF, MS fr. 606 is another author-copy of the *Othea* featuring the same iconographic programme. However, the portraits are much less ambiguous in this manuscript, as there is not the same attempt on the artist's part to represent the author consistently.

28. I use the umbrella term *histoires* to refer to the three sections of text that make up each story, the *texte*, *glose*, and *allegorie*, which in fully-illuminated manuscripts such as Harley MS 4431 might also include a fourth section, the image itself.

29. Christine de Pizan, *Epistre Othea*, ed. by Gabriella Parussa (Geneva: Droz, 1999), p. 213. All translations are my own.

30. See the section 'Creating the Christine de Pizan Brand' above.

31. Marilynn Desmond, 'Christine de Pizan: Gender, Authorship and Life-Writing', in *The Cambridge Companion to Medieval French Literature*, ed. by Simon Gaunt and Sarah Kay (Cambridge: Cambridge University Press, 2008), pp. 123–36 (p. 125).

32. Christine de Pizan, *Epistre Othea*, p. 318.

33. Hindman analyzes further cases of deliberate intervisual links throughout the iconographic programme of autograph *Othea* manuscripts; see Hindman, *Christine de Pizan's 'Epitre Othea'*.

34. Charlotte E. Cooper, 'What is Medieval Paratext?', *Marginalia*, 19 (November 2015), 37–50, available online, <http://merg.soc.srcf.net/journal/19conference/19conference_article4.pdf> [accessed 8 August 2017].

35. Hindman, *Christine de Pizan's 'Epistre Othea'*, p. 68.

Performing Self and (Self-)Representations: Froissart's Identities in *Le Voyage en Béarn* and in Alexandre Dumas's Novels

Pauline Souleau

> Je, Jehan Froissart, prestre et chappellain à mon tres chier seigneur dessus nommé et, pour le tamps de lors, tresorier et chanonne de Chimay et de Lisle en Flandres, me suis de nouvel resveilliés et entrés dedens ma forge pour ouvrer et forgier en la haulte et noble matiere de laquelle du tamps passé je me suis ensonniez.[1]

> [I, Jean Froissart — priest and chaplain to my lord, mentioned above [Guy de Blois], for the time being treasurer and canon of Chimay and of Lille in Flanders, have awoken anew and entered my forge to work and craft the great and noble matter of time past to which I am devoted.]

The prologue to the fourth book of Jean Froissart's fourteenth-century *Les Chroniques* (*c.* 1370–1404) opens with an utterance characteristic of prologues to medieval chronicles and is used as a performative act by the author-narrator.[2] It is a reference to Froissart crafting his raw material, 'la haulte et noble matiere de laquelle du tamps passé je me suis ensonniez', by entering his metaphorical forge to mould historical matters and create his work. Alexandre Dumas's *Monseigneur Gaston Phœbus* (1839) also features a fourteenth-century man in his forge, Gaston III, count of Foix-Béarn, known as Fébus:

> Le quinzième jour du mois d'août de l'an 1385, vers la huitième heure du soir, monseigneur Gaston III, vicomte de Béarn et comte de Foix, assis à une table et penché sur un parchemin, écrivait aux derniers rayons du soleil couchant [...] le soixante-treizième chapitre de son ouvrage sur la chasse des bêtes sauvages et des oiseaux de proie.[3]

> [On the fifteenth day of August in the year 1385, around 8 o'clock in the evening, monseigneur Gaston III, Viscount of Béarn and Count of Foix, seated at a table and bent over a piece of parchment, was, in the last rays of the setting sun, writing the seventy-third chapter of his work on the hunt of wild beasts and birds of prey.]

The image of the artist crafting his work, conjured up in both texts, is far from

being the only link between Froissart and Fébus as protagonists, as well as Froissart and Dumas as authors. In 1388, Froissart the author travelled to Béarn, Fébus's land, intending to learn of distant matters and to find new materials for his chronicle. He stayed at the count's court during the winter of 1388–89. This journey and stay is recounted in Book III of Froissart's chronicle and usually called *Le Voyage en Béarn* [The Journey to Béarn].[4] Dumas, in turn, found inspiration in Froissart's *Voyage* for two of his historical novels: *Monseigneur Gaston Phœbus* and *Le Bâtard de Mauléon* (1846).[5]

The *Voyage* and its intertextual dialogue with its Dumasian counterparts raise questions regarding the performance of identities and authorship. The present essay addresses this issue, examining the different levels of narrative transformation and crafting of the self, in Froissart's historiographical narrative and in the Dumasian novels. Defining and evaluating the concepts of performing self and *mise en abyme* allows for an exploration of Froissart's figure(s). This essay considers the intertextual and performative manipulation arising from Dumas's re-use of Froissart's *Voyage* and his identities: Dumas's Froissard — a transposed version of and new representational dimension to Froissart's own selves — is portrayed meeting and interacting with his informants on the way to Béarn, entering his forge, performing his craft, and writing his chronicle.[6]

Performing Self and *Mise en abyme*

> J'aime assez qu'en une œuvre d'art on retrouve ainsi transposé, à l'échelle des personnages, le sujet même de cette œuvre. Rien ne l'éclaire mieux et n'établit plus sûrement toutes les proportions de l'ensemble. [...] Ce qui dirait mieux ce que j'ai voulu dans mes *Cahiers*, dans mon *Narcisse* et dans *La Tentative*, c'est la comparaison avec ce procédé du blason qui consiste, dans le premier, à en mettre un second 'en abyme'.[7]

> [In a work of art, I rather like to find thus transposed, at the level of the characters, the subject of the work itself. Nothing sheds more light on the work or displays the proportions of the whole work more accurately. [...] What would explain better what I had wanted to do in my *Cahiers*, in *Narcisse* and in *La Tentative*, would be a comparison with the device from heraldry that involves putting a second representation of the original shield *en abyme* within it [the original shield].]

André Gide's oft-quoted comment indicates how closely '[mise] en abyme' is linked to self-reflexivity, and also how much it owes to medieval heraldic practices.[8] Lucien Dällenbach re-interprets the medieval phrase used by Gide: the '"mise en abyme" is any aspect enclosed within a work that shows a similarity with the work that contains it' and 'any internal mirror that reflects the whole of the narrative by simple, repeated or "specious" (or paradoxical) duplication'.[9]

To Martin Stevens, the performing self is a term used to identify 'the artist whose work is centrally concerned with the act of his own creation'.[10] It is not a narrative concept confined to the realms of modern literature or visual art, nor did it originate in the Middle Ages.[11] However, medieval works of literature and art

did make use of the concept:

> What we witness in all medieval works of art containing a self-representation
> of the artist is a facet of the man as performer of his craft. He plays a role much
> of the time but he is also himself, since he is poet and actor or painter and
> subject at once. In this respect, the term 'performing self' is an especially apt
> way of speaking about the medieval artist, for he was, indeed, a performer or
> craftsman, and his immediate role before a living audience can never be totally
> separated from his less intimate relationship with the general reader.[12]

What lies at the heart of this performing self therefore is the artist's work and
thus the artist's identity: 'the mutual construction of the writer and the writing'.[13]
Ultimately, the use of such a figure is a way to perform the self in the sense that it
defines and redefines, writes and rewrites identity.[14]

Froissart's Performing Selves in the *Voyage*

The *Voyage* marks, within the narrative of the *Chroniques*, a metaleptic shift from
a (mostly) heterodiegetic narrator in Books I and II to a (mostly) homodiegetic
narrator in Books III and IV.[15] By becoming, more often than not, a witness of the
events he describes, Froissart-protagonist (and -narrator) enters his own diegesis.
Christiane Marchello-Nizia deems the medieval historian's prologue a threshold,
an intermediary space, a crossing zone, and boundary to narrative temporality.[16]
Her view is applicable to the prologue of the third book of the *Chroniques* as this
beginning is not only a figurative and narrative crossing zone, but a geographical
one: Béarn is at the frontier between French and English territories, as well as
Spain.[17] The prologue is a narrative 'intermediary place' and so is the *Voyage* itself:
a referential, metaphoric, and diegetic zone of exchange. It is in this zone that
Froissart's identities intersect.[18] Froissart portrays himself in the *Voyage* as a traveller,
a craftsman starting to forge his chronicle (as interlocutor, note-taker, and writer),
and a performer reading out his Arthurian romance *Meliador*.

Froissart assumes the role of craftsman when his protagonist-interlocutor self
speaks to Bearnese informants, most of whom also become intradiegetic narrators
in the course of the *Voyage*. He acts here as the actively engaged recipient of the
metadiegetic tales of the informants.[19] Nevertheless, Froissart-protagonist stresses in
direct discourse that it is only through his future chronicler-self that the content of
the informants' narration can be set in *memoire perpetuele*. Their oral and authentic
words can be legitimized and recorded in memory only through Froissart's written
words. Froissart reminds Espan de Lyon — his geographical and narrative guide to
Béarn — of this fact on two occasions:

> Par ma foy, di je, sire, lors au chevalier, vous le m'avez bien declairié, et onques
> maiz je n'en avoie ouy parler. Et puis que je le sçay, *je le mettray en memoire
> perpetuele, se Dieu donne que je puisse retourner en nostre païs*.[20]

> ['By my faith,' I exclaimed, then, to the knight, 'you have expounded it all very
> well. I have never heard tell of it before, but now that I have, *I shall commit it to
> perpetual memory, if God grants me to return to my country*'.]

'Sainte Marie! di je au chevalier, que voz paroles me sont agreables et que elles me font grant bien endementres que vous les m'avez comptees, et vous ne les perdez pas, car *toutes seront mises en memoire et en remembrance, en histoire et en cronique, tout ce que je faiz et poursui, se Dieu me donne que à santé je puisse retourner en la conté de Haynault et en la ville de Valenciennes dont je sui natif.*'[21]

['Holy Mary!' said I to the knight. 'Your words are such a joy to me and are doing me much good even as you speak. You will not have wasted them, for *they will all be recorded for posterity, in history and chronicle, along with everything I do and take forward, if God allows me to return in safety to the county of Hainaut, and to the town of Valenciennes where I come from.*']

Both passages point to Froissart's chronicling processes. The oral account arises from Froissart's partnership with the informants and is coterminous with a dialogical and diegetic situation.[22] The written record lies in the future and is proleptically announced by Froissart-protagonist in both passages, 'je le *mettray* en memoire' and 'toutes *seront mises* en memoire'; it is a solitary activity not accomplished whilst chatting on the open and public roads to Béarn but in the safe and private space of home. There is an in-between status to Froissart-interlocutor and -writer, that of his note-taking self:

Des paroles que messire Espaeng de Lion me comptoit estoie je tout resjouy, car elles me venoient grandement à plaisance, et toutes trop bien les retenoie. Et *si tost que nous estions descendus ensemble es hostelz, je les escrisoie, feust de soir ou de matin, pour en avoir miex la memoire ou temps à avenir, car il n'est si just retentive que c'est d'escripture.* Et ainsi nous chevauchasmes ce matin jusques à Morlens, mais avant que nous y venismes, je le mis encore en paroles et dis.[23]

[I was overjoyed with the tales Sir Espan de Lyon was telling me for they truly delighted me and I committed them all to memory with ease. And *as soon as we dismounted together at the inns we stayed at, I would write them up, whether it was morning or evening, in order that I might have better memory of them in the future, for there is nothing like the written word for preserving the recollection of such things.* So that morning we rode out as far as Morlaàs, but before we reached it, I struck up the conversation again.]

This passage highlights once more the relationship between orality ('paroles', 'mettre en paroles') and the written word ('escrisoie', 'escripture'). A transitionary identity is necessary for Froissart to craft his informants' oral words into his chronicle. Moreover, Froissart's insistence on making Espan speak ('le mettre encore en parole') suggests the author-protagonist's agency in the dialogic process. The use of secondary narrators who tell metadiegetic stories is usually a sign of the primary narrator's effaced involvement in the main narrative. In the present situation, however, it is Froissart-protagonist who leads or, to re-use Oswald Ducrot's metaphor, 'directs' Espan's metadiegetic stories.[24] Froissart-protagonist needs Espan to tell these oral tales and assume a narrative role because of his own ignorance. The tales are prompted by Béarn's topography/toponymy and Espan is privy to these; once this initial guiding step is engaged, the roles become reversed and Froissart-protagonist is the one guiding Espan's narrative with his questions. Froissart-protagonist-interlocutor 'met en paroles' his informants whilst Froissart-chronicler

'met en memoire' their words. There is no doubt as to who has control over the narrative even though its control seems to escape the primary narrator.[25] It is the conjunction of the three identities — interlocutor (oral focus, dialogical activity with informants, zero degree situation, on the public paths to Béarn), note-taker (written focus, solitary activity, zero degree situation, in a private/semi-private space, stopped on the way to Béarn), and writer/recorder of memory (written focus, solitary activity, proleptic, in a private space in native Hainault) — that creates Froissart's performing self as a chronicler.

Froissart's identities in the *Voyage* go beyond the boundaries of the *Chroniques*:

> L'accointance de li à moy pour ce temps fu telle, que je avoie avecques moy apporté un livre, le quel je avoie fait à la requeste et contemplacion de Monseigneur Wincelaus de Boesme, duc de Lucembourc et de Braibant, et sont contenus ou dit livre, qui s'appelle de *Meliader*, toutes les chançons, balades, rondeaulx, virelaiz que le gentil duc fist en son temps, lesquelles choses, parmi l'ymaginacion que je avoie en dicter et ordonner le livre, le conte de Fois vit moult volentiers; et toutes les nuis aprés son soupper je lui en lisoie. Mais en lisant, nul n'osoit parler ne mot dire, car il vouloit que je feusse bien entendu, et aussi il prenoit grant solas au bien entendre.[26]

> [What strengthened our acquaintance during this time was that I had brought with me a book which I had compiled at the request of and to gratify my lord Wenceslaus of Bohemia, duke of Luxembourg and Brabant. Contained in this book, entitled *Meliador*, are all of the songs, ballads, rondeaux, and virelays the noble duke composed in his lifetime. Thanks to the imaginative way in which I had arranged these works in the book, they pleased the count enormously; and every night after supper I would read some to him. While I was reading, nobody dared breathe a word, for he wished me to be heard distinctly and also took great pleasure in being able to hear it well.]

When reading the chronicle, the reader has no access to Froissart's reading of *Meliador* to the court of Fébus. The claim that 'toutes les nuis aprés son soupper je lui en lisoie' is a mere summary of that act.[27] *Meliador* is not an embedded narrative in the chronicle. Rather than creating an extra narrative level on a vertical axis, as Espan's embedded narratives do, the reading of *Meliador* creates a breach between horizontal ontological worlds: 'Froissart portrays himself as hero of his own work, who by his words commands the silence and complete attention of Gaston Fébus and his court, thus successfully bridging the time between the prose of his *Chroniques* and the ideal, verse universe of his *Meliador*'.[28]

The intertextual and intergeneric link is made even more intricate since the *Voyage*, including the reading of *Meliador*, also features in Froissart's *Dit dou Florin*, a narrative poem in which Froissart's persona, after having left Béarn, shares a dialogue with the last coin (*florin*) in his purse. Froissart's chronicling, romancing, and poetic selves truly collide in this *dit* as the persona explains, speaking of his time in Béarn with Fébus:

> Car toutes les nuis je lisoie
> Devant lui et le solacoie
> Dun livre de melyador

> Le chevalier au soleil dor
> Le Quel il ooit volentiers.[29]

[For every night, I read before him and entertained him with a book about Meliador, the knight of the golden sun, which he heard with pleasure.]

In the *Dit dou Florin*, the persona refers to the *Voyage* whose narrator, in turn, refers to *Meliador*.[30] This intertextual mise en abyme, supported by Froissart's self as performer, creates a web of connections between the *Chroniques*, this *dit*, and *Meliador*. Other echoes exist within the boundaries of the *Chroniques*: events told heterodiagetically in Book I are re-told by characters/secondary narrators in the *Voyage* and in Book IV.[31] These reflections point to the self-referentiality of Froissart's narrative(s). His chronicle becomes the type of historiographical work which creates 'new levels of meaning' and draws 'attention to [its] own textuality'.[32] Whilst the narrative never completely lets go of its historical purport, it creates two extra levels of reference: a secondary one (its own textuality) and a tertiary one (the textuality of Froissart's *Meliador*). The latter is manifest through the reference to Froissart's self as a performer reading *Meliador*, and through the multiple mentions of *Meliador* as a book.[33] This moment in the *Chroniques* also shows Froissart as a romancer, *faisant* and *ordonnant Meliador*. Finally, it creates another complex layer of authorship by mentioning Wenceslaus I, whose lyric poems are inserted in Froissart's *Meliador*.[34]

Some illuminators have added yet another level of reference by representing Froissart as a chronicler and/or as a protagonist of the *Chroniques*, for example in the frontispiece of Amiens, Bibliothèques d'Amiens-Métropole, MS 486 F, fol. 1r. Froissart, sitting at his writing desk, forges his chronicle. Although this iconographic representation of Froissart-chronicler stands at the very beginning of the manuscript, it creates a dialogue with the textual performing self of the *Voyage* and of the persona 'dedans sa forge' in the prologue of Book IV.[35] In another source, Besançon, Bibliothèque municipale, MS 865, fol. 201r, Book III opens with an iconographic summary of the *Voyage*.

Froissart is depicted in green in the background of the miniature. In the centre, Froissart takes leave from his protector and patron, Guy de Blois, to set out on his journey. On the left, the kneeling Froissart meets Fébus. The illuminator used the opening of Book III to illustrate and emphasize Froissart's journey and story, creating a self-contained narrative and a graphically inverted journey (from centre to left) in the art-work itself.[36] To do so, he duplicated the Froissart-figure in the illumination, making the chronicler's iconographic representations and identities multiple.[37]

FIG. 8.1. Cliché CNRS-IRHT, Bibliothèques d'Amiens-Métropole, MS 486 F, fol. 1ʳ

FIG. 8.2. Besançon, Bibliothèque municipale, MS 865, fol. 201r

Froissart's Text and Self in Dumas's Historical Novels

Alexandre Dumas is most famous for his *Trois Mousquetaires* (1844) and *Comte de Monte-Cristo* (1844–46). Some of his other historical novels were inspired by Froissart's *Chroniques*.[38] In *Monseigneur Gaston Phœbus* and *Le Bâtard de Mauléon*, he uses and transforms Froissart's narrative and identity to craft his own.

Le Bâtard de Mauléon begins with Froissard and Espaing de Lyon on the road to Béarn.[39] They encounter a mysterious knight without a right hand — the narrative's main protagonist, Agénor, *le bâtard de Mauléon* — who, at the end of Chapter 1, is about to tell both men his life-story. This opening diegetic setting links Dumas's narrative and the *Voyage*, in which a man called the Bascot de Mauléon tells Froissart of his life as a company captain.[40] From the outset, there are hints, however, that Agénor's story strays from its model. The knight's first name (Agénor), his status (a bastard), and his recognizable physical trait (a dismembered right hand) are all additions. Regardless, numerous references are made in Chapter 1 of Dumas's narrative to Froissard's status as a chronicler and recorder of memory: from his exaggerated physical description — also a narrative addition — with references to the ink bottle that he wears like a knife at his belt and parchments bulging out of his pockets, to his direct discourse with Espaing which is reminiscent of Froissart's interventions and performing self.[41] The title of the first chapter makes explicit the filiation between the two narratives: 'Comment messire Jehan Froissard fut instruit de l'histoire que nous allons raconter' [How Master Jean Froissard came to know the story we are about to tell].[42] Froissart's original material, identity, and narrative voice are constantly acknowledged whilst Dumas's own voice is confined to the background. This narrative hierarchy is confirmed by the primary narrator of another novel by Dumas, *Les Gentilhommes de la Sierra-Morena* (1849):

> Au milieu de toutes ces recherches, de toutes ces investigations, de toutes ces nécessités, le moi disparaît; je deviens un composé de Froissart, de Monstrelet, de Chastelain, de Commynes, de Saulx-Tavannes, de Montluc, de l'Estoile, de Tallemant des Réaux et de Saint-Simon.[43]

> [Whilst undertaking all this research, these investigations, and necessities, the self disappears; I become a part of Froissart, Monstrelet, Chastelain, Commynes, Saulx-Tavannes, Montluc, l'Estoile, Tallemant des Réaux, and Saint-Simon.]

Dumas's voice is absorbed by that of Froissart. However, as soon as Agénor takes up his own tale, from Chapter 2 onwards, the diegetic setting of Froissard, Espaing, and Mauléon on the road to Béarn fades into the background to allow for the creation of a new diegesis, a transposition rather than an embedding. The references to Froissard, protagonist, and thus Froissart, original chronicler, disappear. Dumas's narrative voice — the *nous* of Chapter 1's title — announces this intentional narrative transposition to the reader at the very end of Chapter 1:

> Et le même soir, après souper, le bâtard de Mauléon tenant sa promesse, commença de raconter à messire Jehan Froissard l'histoire qu'on va lire, et que nous avons tirée d'un manuscrit inédit, sans nous donner, selon notre habitude, d'autre peine que celle de mettre à la troisième personne une narration qui était écrite à la première.[44]

[On the same evening, after supper, the bastard of Mauléon, true to his word, started telling the story that you are about to read to Sir Jehan Froissard; we have borrowed it from an original manuscript. As is our habit, the only trouble we went through was to substitute a third-person for a first-person narration.]

Unlike the *Voyage*'s embedded narrative of the Bascot de Mauléon's life-story, interspersed with narrative asides and dialogic sequences, the story of Agénor de Mauléon in Dumas's narrative runs uninterrupted. A reader who starts the novel from Chapter 2 onwards would not be able to guess that they are reading a meta-diegetic narrative transposed from a first-person direct discourse narration to an indirect third-person one. A reader who has read the first chapter, however, might be very much aware of this device and might never truly forget the initial diegesis. Yet Froissard and Espaing are never mentioned again until the Epilogue: it is as if they have been erased from the narrative and Mauléon's tribulations are very much Dumas's own creation. The initial and final diegetic settings (Chapter 1 and Epilogue) are coterminous with the *Voyage*, yet the metadiegetic tale is completely renewed. Froissard's framing presence and erasure from the narrative are ways for Dumas to show and recognize what he owes to his original source and simultaneously stray from, and even ignore, it.[45]

The narrative manipulation in *Monseigneur Gaston Phœbus* is of another sort (see Table 8.1). It also features Jehan Froissard as a character and focuses on the *Voyage*'s metadiegetic tales concerned with Phœbus's life.[46] These are framed as a backstory to explain Phœbus's sad demeanour and ultimate death, as the narrative voice explains in the first chapter, referring to the count's sorrows and past story: 'ils seront au récit qui va suivre ce que le cadre est au tableau' [they will be to the forthcoming narrative what the frame is to the painting].[47]

Chapters 1, 2, and 6 are told exclusively by the extradiegetic primary narrator, and Chapter 6 is devoid of any direct discourse. As for the intradiegetic narrators in the other chapters, Orthon's story is told by the Lord of Corasse and then by the primary narrator (Chapter 4); the various embedded stories of Chapter 5 (Pierre de Béarn's sleepwalking; Ernanton's fantastic strength; Actaeon turned into a deer) are told by Yvain, Phœbus, and Froissard. The background stories revolving around Phœbus are mostly faithful to their narrative source, apart from the final narrative segment which recounts his untimely death. Froissart's *Voyage* features all of these stories: the murder of the young Gaston by his father; Horton and the Lord of Coarasse; Ernauton's strength; and Pierre de Béarn's sleepwalking.

The manipulation in *Le Bâtard de Mauléon* mostly results from the invention of Mauléon's narrative and the erasure of the initial diegetic setting in the *Voyage*; in *Monseigneur Gaston Phœbus*, the manipulation arises from the modification of narrative progression (analeptic setting for Chapters 1–4 and diegetic present for Chapters 5–6) and the shift in narrator–narratee pairings. In the *Voyage*, most of the metadiegetic tales concerned with Fébus are told by Espan (Ernauton's strength) or anonymous squires (young Gaston's murder; Horton; Pierre de Béarn's sleepwalking). Froissart is the only recipient of these stories, in order to incriminate Fébus as little as possible. Moreover, Fébus is neither narrator nor narratee in the *Voyage*. The

MGP chapters	Narrative summary	Narrators in MGP	Narrators in the Voyage	Pages in the Voyage
Chapters 1 and 2	Phœbus, burdened by past sorrows, writes his *Livre de chasse*; analeptic story of Phœbus murdering his own son, Gaston	Extradiegetic, primary narrator	n/a	n/a
Chapters 3 and 4	Visit of Raymond de Corasse (Phœbus's vassal); news of Iberian matters and wars; analeptic story of Corasse's encounter with the shape-shifter Orthon	Raymond de Corasse; extradiegetic primary narrator	Intradiegetic narrator; anonymous Bearnese squire	276–87
Chapter 5	Froissard's stay in Béarn and his meeting with Phœbus, Yvain (Phœbus's natural child), and Ernanton d'Espagne; their metadiegetic tales	Yvain; Phœbus; and Froissard	Anonymous Bearnese squire; Espan de Lion; and Froissart	189–93; 151–52; 194–95
Chapter 6	Phœbus's hunt of a mysterious sow and his climactic and symbolic death	Extradiegetic, primary narrator	n/a	n/a

TABLE 8.1. Narration in *Monseigneur Gaston Phœbus* (MGP) and in the *Voyage*

sequencing (Phœbus's backstory) and narrator–narratee shifts in *Monseigneur Gaston Phœbus*, as well as the addition of the final narrative chapter transpose the focal point of the narrative: from an undisclosed aim to uncover Fébus's subversive stories in the *Voyage* to an intentional focus on Monseigneur Gaston Phœbus, his life, his sins, and his redemption. These stories act as an exegetic frame, 'le cadre', to the culminating narrative of his redemptive death, which the primary narrator makes explicit when ending the novel: 'Dieu fasse miséricorde à tout pécheur qui s'est repenti' [May God grant mercy to any sinner who repents].[48]

Conclusion

Froissart, as an author, chronicler, romancer, and poet within and without his texts is at the crossroads of many performing selves. Likewise, the *Voyage* and the *Chroniques* are at the crossroads of history and fiction, chronicle and romance, fact and self-representation, text and image. The journey of the text, its creation by Froissart's multiple selves, is fittingly revealed during a geographical journey which sees Froissart as a traveller.[49] The work becomes a reflection of the self on this metaphorical and geographical journey; and the self becomes a reflection of the work.[50] Froissart's identities and texts are performed by multiple authors and artists: Froissart himself, illuminators such as the Boethius Master, and Alexandre Dumas.[51] Dumas, by borrowing and straying from Froissart's original material, and by crafting his own Froissard, creates his own literary and narrative identity. The extent of narrative crafting, representation, interpretation, and performance of Froissart's material in all of Dumas's Froissartian novels expands beyond the scope of this essay but calls for further investigation.

Notes to Chapter 8

1. Jean Froissart, *Chroniques. Livre III: Du voyage en Béarn à la campagne de Gascogne et Livre IV: années 1389–1400*, ed. by Peter F. Ainsworth and Alberto Varvaro (Paris: Le Livre de poche, 2004), pp. 343–44. My translation. All translations of Book III (*Le Voyage en Béarn*) are from 'Jean Froissart, Chronicles', trans. by Keira Borrill, in *The Online Froissart*, ed. by Peter Ainsworth and Godfried Croenen, version 1.5 (Sheffield: HRIOnline, 2013), <http://www.hrionline.ac.uk/onlinefroissart> [accessed 8 August 2017].

2. Christiane Marchello-Nizia, 'L'Historien et son prologue: formes littéraires et stratégies discursives', in *La Chronique et l'histoire au Moyen Âge. Colloque des 24 et 25 Mai 1982*, ed. by Daniel Poirion (Paris: Presses de l'Université de Paris-Sorbonne, 1986), pp. 13–25; see also Bernard Guenée, 'Ego, je: l'affirmation de soi par les historiens français (XIVe–XVe s.)', *Comptes-rendus des séances de l'Académie des Inscriptions et Belles-Lettres*, 149.2 (2005), 597–611.

3. Alexandre Dumas, *Monseigneur Gaston Phœbus* (La Tour d'Aigues: L'Aube, 2008), p. 7. All translations of Dumas are my own.

4. Froissart, *Chroniques*, pp. 92–287.

5. Alexandre Dumas, *Le Bâtard de Mauléon* (Paris: AlterEdit, 2008).

6. I use spelling variations to distinguish Froissard, Dumas's character, from Froissart, the *Voyage*'s protagonist/author.

7. André Gide, *Journal 1889–1939* (Paris: Gallimard, 1948), p. 41; quoted in Lucien Dällenbach, *Le Récit spéculaire: essai sur la mise en abyme* (Paris: Seuil, 1977), p. 15. Translations of Dällenbach's *Le Récit spéculaire* are from Lucien Dällenbach, *The Mirror in the Text*, trans. by Jeremy Whiteley and Emma Hughes (Chicago: University of Chicago Press, 1989), p. 7.

8. The medieval phrase used by Gide lacks accuracy, however: 'in the curious language of heraldry, the *abyme* or *fess-point* is the exact centre of an escutcheon. To place something *en abyme* literally means to depict it in the middle of the shield. The term is usually reserved however for the practice of placing at that central spot a smaller shield with its own bearings, which modified the meaning of the bearings on the main shield'. Stuart Whatling, 'Narrative Art in Northern Europe, *c.* 1140–1300: A Narratological Re-Appraisal' (unpublished doctoral dissertation, University of London, 2010), p. 173.

9. Dällenbach, *The Mirror in the Text*, pp. 8 & 36.

10. Martin Stevens, 'The Performing Self in Twelfth-Century Culture', *Viator*, 9 (1978), 193–212 (p. 193).

11. See Richard Poirier, *The Performing Self: Compositions and Decompositions in the Languages of Contemporary Life* (London: Chatto & Windus, 1971).

12. Stevens, 'The Performing Self', pp. 194–95.

13. Dällenbach, *The Mirror in the Text*, p. 18.

14. Karen Junod and Didier Maillat, *Performing the Self: Constructing Premodern and Modern Identities* (Tübingen: Narr, 2010), p. 12.

15. On metaleptic shift, see Gérard Genette, *Figures III* (Paris: Seuil, 1972), pp. 243–45.

16. Christiane Marchello-Nizia, 'L'Historien et son prologue', p. 13.

17. The sovereignty and independence of Béarn was established in 1347, a tour de force instigated by Fébus himself. Guilhem Pépin, 'Quand le Béarn se disait gascon', *La Lettre de l'Institut béarnais et gascon*, 16 (2008), 6–8.

18. See Sophie Marnette, 'Experiencing Self and Narrating Self in Medieval French Chronicles', in *The Medieval Author in Medieval French Literature*, ed. by Virginie Elisabeth Greene (New York: Palgrave Macmillan, 2006), pp. 115–34.

19. Froissart, *Chroniques*, pp. 158–59; on metadiegetic tales see Genette, *Figures III*, pp. 241–42 and Dällenbach, *Le Récit spéculaire*, pp. 70–74.

20. Froissart, *Chroniques*, p. 172 (emphasis my own).

21. Froissart, *Chroniques*, p. 167 (emphasis my own).

22. This is what Genette calls the 'degree zero' in which narrative and story temporally coincide; Genette, *Figures III*, pp. 77–121 (p. 79). On Froissart's dialogical partnership with his informants in the *Voyage*, see M.-A. Bossy, 'Donnant, donnant: les échanges entre Froissart et ses interlocuteurs à la cour de Gaston Fébus', in *Courtly Literature and Clerical Culture*, ed. by Christoph Huber, Henrike Lähnemann, and Sandra Linden (Tübingen: Attempto, 2002), pp. 29–38.

23. Froissart, *Chroniques*, p. 162 (emphasis my own).

24. Oswald Ducrot and Danièle Bourcier, *Les Mots du discours* (Paris: Éditions de Minuit, 1980), p. 45.

25. On narrative authority, see Bakhtin, *The Dialogic Imagination*; Alain Rabatel, *Homo narrans: pour une analyse énonciative et interactionnelle du récit* (Limoges: Lambert-Lucas, 2008).

26. Froissart, *Chroniques*, pp. 173–74.

27. On narrative rhythm and summary, see Genette, *Figures III*, pp. 122–44.

28. George T. Diller, 'Froissart's 1389 Travel to Béarn: A *Voyage* Narration to the Center of the *Chroniques*', in *Froissart across the Genres*, ed. by Donald Maddox and Sara Sturm-Maddox (Gainesville: University Press of Florida, 1998), pp. 50–60 (p. 52).

29. *Jean Froissart*, ed. by Figg and Palmer, pp. 500–01, ll. 293–97. Translation by Kristen M. Figg.

30. Jean Froissart, *Meliador*, ed. by Auguste Longnon (Paris: Firmin Didot, 1895); on the *Dit dou Florin*, *Meliador*, and the *Chroniques*, see Coleman, *Public Reading and the Reading Public in Late Medieval England and France*, pp. 111–12.

31. Connections can also be found across Froissart's *œuvre*. Intertextual examples include the myth of Actaeon mentioned in the *Chroniques*, *Meliador*, and the *Espinette amoureuse*; the sleepwalking story of Pierre de Béarn in the *Chroniques* and Camel de Camois in *Meliador*. Laurence Harf-Lancner, 'Chronique et roman: les contes fantastiques de Froissart', in *Autour du roman*, ed. by Nicole Cazauran (Paris: Presses de l'École Normale Supérieure, 1990), pp. 49–65; Michel Zink, 'Froissart et la nuit du chasseur', *Poétique*, 41 (1980), 60–76; Joel H. Grisward, 'Froissart et la nuit

du loup-garou, la fantaisie de Pierre de Béarn: modèle folklorique ou modèle mythique?', in *Le Modèle à la Renaissance*, ed. by Jean Lafond, Pierre Laurens, and Claudie Balavoine (Paris: Vrin, 1986), pp. 21–34.

32. Monika Otter, *Inventiones: Fiction and Referentiality in Twelfth-Century English Historical Writing* (Chapel Hill & London: University of North Carolina Press, 1996), p. 14.

33. The words 'livre' and 'lire' are used twice in the passage quoted above.

34. See Daisy Delogu, 'Armes, amours, écriture: figure de l'écrivain dans le *Méliador* de Jean Froissart', *Médiévales*, 41 (2001), 133–48.

35. Note also the iconographic dialogue of the double *mise en abyme*: the one concerned with Froissart-chronicler's representation and the heraldic *abyme*.

36. The image was produced by the Boethius Master, a Parisian illuminator who worked for Pierre de Liffol, a *libraire*, who made several manuscripts of the *Chroniques*, including the two-volume set now Besançon, Bibliothèque municipale, MSS 864 and 865. Inès Villela-Petit, 'Les *Chroniques* de Froissart', *Art de l'enluminure*, 31 (2010), 24–45; and Godfried Croenen, 'Pierre de Liffol and the Manuscripts of Froissart's Chronicles', in *The Online Froissart*. I will not discuss the other half of the illumination here as this would go beyond the scope of this essay.

37. See Cooper's contribution in the present volume (Chapter 7) for a more detailed discussion of iconographic programmes and the performance of identities and authorship.

38. Besides *Monseigneur Gaston Phoebus* and *Le Bâtard de Mauléon*, Dumas wrote *Isabel de Bavière* (1835) deriving from Book IV of the *Chroniques*; *La Comtesse de Salisbury* (1839) and *Charles le Téméraire* (1857) from Book I.

39. On spelling variations, see note 6 above.

40. Froissart, *Chroniques*, pp. 195–220.

41. Dumas, *Le Bâtard de Mauléon*, p. 10.

42. Ibid., p. 7.

43. Quoted in George T. Diller, 'Alexandre Dumas, lecteur de Jean Froissart', in *Froissart dans sa forge: actes du colloque réuni à Paris, du 4 au 6 Novembre 2004*, ed. by Michel Zink and Odile Bombarde (Paris: AIBL, 2006), pp. 199–211 (p. 203, n. 14).

44. Dumas, *Le Bâtard de Mauléon*, p. 28.

45. The 'manuscrit inédit' mentioned by the narrative voice is also an addition: Froissart's work was known during Dumas's life-time as attested by the narrative voice of *Les Gentilhommes de la Sierra-Morena*.

46. Spellings distinguish Dumas's characters from the protagonists of the *Voyage*: Froissard/Froissart; Phœbus/Fébus; Ernanton/Ernauton; Corasse/Coarasse; Orthon/Horton.

47. Dumas, *Monseigneur Gaston Phœbus*, p. 8; such phrasing and comparison recalls the concept of *mise en abyme*.

48. Dumas, *Monseigneur Gaston Phœbus*, p. 104. The chapter ends with Phœbus seeing his dead son who has come, with God's will, to absolve his father's sins (i.e. his own murder); Dumas, *Monseigneur Gaston Phœbus*, pp. 96–104.

49. On the traveller-figure as the bearer of narrative and performative masks, see Barbara Straumann, '"There Are Many that I Can Be": The Poetics of Self-Performance in Isak Dinesen's "The Dreamers"', in *Performing the Self*, ed. by Junod and Maillat, pp. 153–63.

50. This self-reflexivity brings to mind the *mise en abyme* found in Maurits Cornelis Escher's *œuvre*, most notably in his *Drawing Hands* (1948).

51. I understand 'perform' here as an action ('carrying out') and as a representation ('acting as an agent of'). On performance as action and representation, see the contributions by Ferreira and Hope in this volume (Chapters 4 and 11 respectively).

CHAPTER 9

'Advenisti desiderabilis': Emperor Charles V as the Saviour of True Faith

Moritz Kelber

Despite a widespread acknowledgement of the importance of symbolic components in the ceremonies of the Holy Roman Empire during the medieval and early modern periods, relatively little attention has been paid to the music accompanying these events.[1] This could be due, in part, to the diverse ceremonial life that existed in Germany: every diocese and city had its own regulations and practices for welcoming and hosting important dignitaries. The involvement and arrangement of city trumpeters, instrumentalists, singers, and local brotherhoods during these magnificent events varied, as did the rites of the local clergy. There were, however, also some shared practices that continued to exert their influence until the late sixteenth century, including a number of antiphons and responsories that were sung by a city's clerics to welcome a dignitary. One such chant is the Easter antiphon 'Advenisti desiderabilis', which has a particularly rich history in the context of entry-ceremonies.

Many legends, fashionable in particular in the early seventeenth century, relate to the Reformation's early years and Martin Luther, among them a story about Luther's arrival in the city of Worms in 1521. When he came there in order to be questioned during the Imperial Diet, he was welcomed warmly by the people of Worms and by some young nobles, who rode outside the city walls to greet the famous monk:

> When Doctor Luther came to Worms for the first time on 16 April 1521, he encountered the duke of Bavaria's jester on the street, [...] whose name was Löffler or Cochläus. He [the jester] carried a red cross in his hand, as one commonly does in processions. When he heard that this was Doctor Luther, he started to sing with a bright voice: 'Advenisti desiderabilis, quem expectabamus in tenebris' (You have arrived, oh most desired person, for whom we waited in the darkness).[2]

At first glance, the story about the court jester who encountered Luther, welcoming him with a quotation from an Easter antiphon and addressing him as 'desiderabilis', may seem little more than an amusing anecdote. Surprisingly, it did not find its way into the closer canon of stories surrounding the life of the Protestant reformer, but the story provides an interesting pointer to actual ceremonial practices of the

imperial diets of the fifteenth and sixteenth centuries. Only nine years after Luther's entry into Worms, in 1530, Emperor Charles V was welcomed by the chapter of Augsburg Cathedral with the chant 'Advenisti desiderabilis'. As demonstrated in the present essay, this short piece of ceremonial music played a crucial role in the staging of the Emperor's arrival in the Holy Roman Empire after his coronation in Bologna in February 1530. 'Advenisti desiderabilis' was deeply embedded in medieval thought and loaded with symbolic meaning, giving particular intensity to rituals and ceremonies that had already become fraught through the confessional conflicts of the Reformation era.

Adventus

In a ceremonial context, the term *Adventus* generally refers to the ritual entry of a high dignitary, primarily of a king, emperor, bishop, or cardinal, into a city or a monastery. Welcoming and accommodating the Holy Roman Emperor was a significant economic and logistic challenge for a city, since the guest usually travelled with his entourage of hundreds of servants and officials.[3] However, the investment usually paid off as the sovereign bestowed new or prolonged existing privileges from mining to printing. An imperial visit was the key to a city's prosperity. In the Middle Ages the ruler's presence was believed to effect good weather and rich harvests, and his touch was thought to bring healing from disease and plague.[4] He was a very real saviour, not only for patricians and bankers, but also for the common people, and he was welcomed as such. One famous example is the first entry of Charlemagne, still Frankish king at the time, in Rome in 774. The Romans welcomed him, carrying crucifixes and palm leaves, just as the people of Jerusalem had done when Jesus entered the city (Mark 11:8–11). Ernst Kantorowicz described this entry as 'decidedly messianic', and since his extensive study on imperial entries, their connection with the symbolism of Palm Sunday has become common knowledge.[5]

Various liturgical books regulated the entries of emperors, kings, and dukes during the Middle Ages within the clerical sphere of influence, which was separated from that of a city's authority. The prayer book of Empress Kunigunde and the *Consuetudines* of the abbey of Farfa, both from the eleventh century, are two of the oldest known documents containing an *Ordo ad recipiendum*.[6] In his seminal study of the empire's ceremonial, Gerrit J. Schenk outlines an ideal scheme for the medieval *Adventus*.[7] Outside the city walls, the dignitary was welcomed by the members of the city council, accompanied by a select group of citizens. When the entry took place in the context of an imperial diet or a coronation, the imperial estates had the privilege of welcoming the emperor first. They escorted him to the heart of the city in a large-scale procession through alleys and streets lined with spectators. The church bells tolled and there were gun salutes. At the border of the cathedral district, or directly in front of the city's main church, the clergy took over responsibility for the procession. Accompanied by chants, the emperor moved from the city's canopy of state to that of the clergymen. He was led into the cathedral for a celebration of the Mass and the singing of a solemn 'Te Deum laudamus'.[8] Finally, after the end of this service he was guided to his living quarters.

The imperial *Adventus* was more than a private ritual for the elites of the Holy Roman Empire. It resembled a fair that attracted citizens and local dwellers, for whom the event was a spectacle. However, the common people themselves took on a particular function within the ceremonial. They were eye- and ear-witnesses to the emperor's power, as made evident in the magnificence of the entry, and to the empire's hierarchy that was represented, for example, in the procession's order. The presence of the common people at significant ceremonial events gave legitimacy to the ruling elites.[9] An imperial entry without spectators would have defeated its purpose.

The Augsburg Imperial Entry of 1530

There are two printed sources which document the *Adventus* regulations for the Augsburg clergy in the time around 1500: the *Obsequiale augustense* (Augsburg: Erhard Ratdolt, 1487)[10] and the nearly identical Augsburg *Agenda* (Ingolstadt: Alexander Weissenhorn the Elder, 1547).[11] Both are liturgical books that regulate specific solemnities as well as the procedure for special events like obsequies. In the *Obsequiale augustense*, the *Adventus* is outlined as follows:

> When any emperor, king, legate of the Apostolic See, new bishop, or prince enters any city or town for the first time, the clergy and the citizens go to welcome him in a solemn procession, carrying the relics of the saints. After he has descended from his horse, he is led under a canopy to the church with these responsories: 'Benedixit te dominus in virtute sua, qui per te ad nihilum redegit inimicos nostros, ut non deficiat laus tua de ore hominum'.[12]

The Augsburg regulations for the reception of a ruler or dignitary differ considerably from other *ordines* such as those in the first printed version of the *Pontificale romanum* of 1485.[13] Instead of singing 'Ecce mitto angelum meum', as prescribed in the *Pontificale*, the Augsburg clergy customarily welcomed the emperor by singing the responsory 'Benedixit te dominus in virtute sua'. This responsory is drawn from the apocryphal book of Judith (13:22–25): 'The Lord hath blessed thee by his power, because by thee he hath brought our enemies to nought. Thy praise shall not depart out of the mouth of men'. Augsburg's usual chant of welcome did not elevate the emperor as a Christ-like messiah — as was the case with 'Ecce mitto angelum meum' or 'Advenisti desiderabilis' — but hailed him as a human blessed by God, as the people of Jerusalem did when they welcomed Jesus on Palm Sunday. In light of this variant tradition, the report about the singing of 'Advenisti desiderabilis' in 1530 Augsburg gains special significance.

According to numerous reports about the Diet of Augsburg in 1530, the imperial entry was an event of enormous dimensions.[14] Compared to magnificent entries in Italy or the Netherlands with their typical elements of Renaissance festival culture, however, the structure and symbolism of the 1530 Augsburg entry seem surprisingly conservative: there were no *tableaux vivants*, fireworks, or triumphal arches.[15] Only a few days earlier, when Charles arrived in Munich on his way to Augsburg, the Bavarian dukes had welcomed him with such spectacles.[16] In Augsburg, many things were different. Politically, the situation was more than tense: although it

had not yet officially converted to Protestantism, the city was confessionally deeply divided. Different strands of Protestantism had swiftly become very popular, especially among the middle and lower tiers of society. The pressure on the Catholic establishment of the cathedral city of Augsburg was rising, as it was in many cities and regions of the empire. Hoping for a solution to this confessional conflict and looking to avoid an impending civil war during the imperial diet, the imperial estates placed their trust in Charles V.[17] The people of Augsburg, in contrast, were less optimistic about the arrival of Charles and his entourage. Barbara Stollberg-Rilinger has even suggested the danger of an impending uprising in Augsburg in 1530.[18] During the preparations for the diet, the imperial officials had come into conflict with the inhabitants, so it was a difficult task for the city council to persuade the people to take part in the celebration of the imperial entry. Empty streets during the procession would have been a disgrace for the city and an affront to the emperor.

The chronicler Clemens Sender (1475–1537), a conservative Benedictine monk, gives an insight into the mood of the Augsburg people and a noteworthy report on the ceremonial events during the imperial diet of 1530. His account details the imperial entry and gives an idea of its splendour as well as the ubiquitous confessional and hierarchical conflicts. In the section describing the moment at which the cathedral chapter took responsibility for the ceremony, Sender writes:

> As the emperor rode in front of St Leonard under the chapter's canopy, he had a sceptre in his hand. Then the provost Marquard vom Stain, Philipp von Rechberg, the cathedral's Dean, as well as two members of the *Vierherren* knelt before him and sang: 'Advenisti desiderabilis, quem expectabamus in tenebris, ut educeres hac nocte vinculatos de claustris'. Then the choir sang the antiphon loudly until the end: 'Te nostra vocabant suspiria, te larga requirebant lamenta, tu factus spes desperatis, magna consolatio in tormentis. Alleluja'.[19]

In remarkable detail, Sender reports this deviation from the original regulations of the Augsburg *ordines*. Instead of, or possibly in addition to, the prescribed 'Benedixit te dominus', the cathedral chapter sang the chant 'Advenisti desiderabilis'. Indeed, the antiphon's text seems to have been of some relevance to the monk, for he writes it down in its entirety even though he might have quoted only the incipit, as he does elsewhere in his chronicle. As a member of the monastery of SS Ulrich & Afra, Sender would not have been involved at this particular moment in the *Adventus* ceremonial; yet he would have been well-informed about liturgical and para-liturgical processes.

Understanding 'Advenisti desiderabilis' in an Augsburg Context

'Advenisti desiderabilis' is the second part of the *Canticum triumphale* antiphon which paraphrases Christ's descent into Hell, a subject that originates from the apocryphal gospel of Nicodemus.[20] According to the *Legenda aurea* as well as older scholarship, the antiphon's text appeared first in a sermon of St Augustine.[21] Dolores Ozimic, however, has claimed the authorship of the sermon (including the *Descensus* narrative) for St Jerome.[22] The antiphon's music is assumed to be by Notker

Balbulus and it was included in Einsiedeln, Stiftsbibliothek, MS 33, which dates from the tenth century.[23] The main liturgical function of the *Advenisti* antiphon is to be found within a procession after the Easter Vigil, the *Elevatio crucis*:

> Cum rex gloriae Christus infernum debellaturus intraret et chorus angelicus ante faciem eius portas principum tolli preciperet sanctorum populus qui tenebatur in morte captivus voce lacrimabili clamaverat: '*advenisti desiderabilis quem expectabamus in tenebris* ut educeres hac nocte vinculatos de claustris te nostra vocabant suspiria te larga requirebant lamenta tu factus es spes desperatis magna consolatio in tormentis alleluia.'[24]

> [When Christ, the mighty king of honour, entered Hell for battle and the choir of angels commanded to open the gates in front of him, the nation of the saints imprisoned in the darkness of death cried with tearful voice: '*You have arrived, O most desired person, for whom we waited in the darkness* in which we are imprisoned, that he may lead us out of this night. Our bitter laments longed for you who became the hope of the desperate, and a great solace in our sorrow. Alleluia'.]

The *Obsequiale augustense* of 1487 is the oldest known liturgical source relating to Augsburg that describes a *Descensus* commemoration in the context of the Easter Vigil.[25] These para-liturgical processions, which took place inside the churches, presented the *Descensus* narrative as a whole: after his death on the cross, but before his resurrection, Christ enters Limbo in a procession of angels, breaks open the gates of Hell and frees the forefathers waiting for salvation. There, the imprisoned souls welcome him with the words 'Advenisti desiderabilis'. He frees them and guides them to Heaven. The *Descensus* was one of the vital elements of the medieval Easter feast, and some scholars have even understood it as a symbol of the atonement of Christ.[26]

The singing of 'Advenisti desiderabilis' consequently gives an imperial entry great symbolic power, transferring the usual symbolism of the *Adventus* from Palm Sunday to the Easter feast. The singers now represent the forefathers imprisoned in Hell, who welcome their actual saviour rather than the people of the historical Jerusalem hailing Jesus. Reinforcing the expression of their desire for salvation, the individual situation of the performers changes in a drastic way. There are numerous reports about the singing of 'Advenisti desiderabilis' in the context of an imperial entry outside the city of Augsburg: the chant was sung to welcome Emperor Barbarossa in Verona in 1184; when King Sigismund rode into Heidelberg in 1414, the electoral palatine court singers performed 'Advenisti desiderabilis'; as did the Frankfurt clergy when Frederick III came to the city in 1474.[27]

It is plausible that the members of the chapter altered the ceremonial to welcome Charles V in 1530 as a result of the confessional and political situation in Augsburg and the empire. At first glance, however, the theological symbolism of an antiphon taken from an Easter Vigil procession is too complex for most spectators (and participants) of the entry to understand, in particular for the many common people. According to Klaus Wolf, the Easter celebrations of Augsburg cathedral were addressed mainly to the members of the chapter and to the students of the cathedral school. The public was more or less excluded.[28] For non-professionals, the salvific event would have been nearly incomprehensible through the liturgy only, raising

the question whether the common people who were lining the streets outside St Leonard understood the special proceedings during the imperial entry of 1530.

A possible answer to this question lies in the field of non-liturgical medieval Easter and Passion plays, the 'mass media of the late middle ages'.[29] In these staged, partly vernacular representations of the events of the Easter feast, the *Canticum triumphale* also played an important role. A predominantly vernacular Passion play from late fifteenth-century Augsburg was kept at the library of the Augsburg monastery of SS Ulrich & Afra (Munich, Bayerische Staatsbibliothek, MS Cgm 4370).[30] It contains a *Descensus* scene and the Latin 'Advenisti desiderabilis' as the chant of the forefathers. SS Ulrich & Afra was a centre of sacred plays in late medieval Augsburg.[31] The Benedictine monks used the theatre as a medium to foster the people's piety. In their plays, they simplified the partly mysterious processes of the liturgy for the common people, firmly establishing mystery plays among the general population. In many cities, fraternities likewise performed sacred plays.[32] The Augsburg Passion play contains a Latin version of 'Advenisti desiderabilis' but no direct verbatim translation, although these are provided for many other Latin chants of the play. Nevertheless, immediately before the forefathers begin their singing, Adam paraphrases the Latin text in German:

> Secht irs, ir vätter. Das liecht ist
> unsers schopfers ihesu christ.
> Das er verhieß uns zů senden
> das hat er yetz thon volenden.
> Das liecht ist mir wissend und kund
> dann ich han gred auß meinem mund.
> Das volck, das saß da so lange
> im land der finstrin gefange.
> Das hat mit schatten stoss und pein
> gsehen des waren liechtes schein.[33]

> [Look, fathers. It is the light
> of our creator's son Jesus Christ.
> That thing he promised to send us
> he has now accomplished.
> The light is known to me,
> because I have spoken the words.
> The people who sat for so long
> imprisoned in darkness
> have seen the radiance of the true light
> with shadow, thrust, and pain.]

Adam's words, as well as this entire section from the Passion play, paraphrase the general topic of 'Advenisti desiderabilis': salvation from darkness through the light of Jesus Christ.[34] The verses of Adam, Moses, Isaiah, Jeremiah, Job, David, Simeon, John the Baptist, Joseph, and the Holy Innocents translate the mysterious Latin chant for the common people.[35] Thus, bearing in mind Adam's words and the Passion play's staging, the common people were in all likelihood perfectly able to understand the antiphon's message in the context of an imperial entry, even without any knowledge of Latin.

FIG. 9.1. Altitudes in the Augsburg *Adventus*

Like sacred plays, imperial entries were events that drew thousands of spectators to line the streets of a city. A crucial element of an *Adventus* was the presentation of the urban space. A ruler's entry helped to demonstrate his status and simultaneously visualized the city's self-awareness within the imperial hierarchy.[36] Consequently, all of the urban power centres cared for their visibility and audibility.[37] The choice of the route taken through the streets was vital for the functioning of the ceremonial. In Augsburg, the emperor usually entered the city through the Rotes Tor [Red Gate] and made his way up the hill to the basilica of SS Ulrich & Afra.[38] From there he went down to the Weinmarkt passing the grand residences of the Fugger family. The procession headed past the town hall towards the cathedral. The border between the cathedral area and the city's territory, demarcated by St Leonard, was located in a small valley right between these two places (see Figure 9.1). At this point, in front of a small chapel, the city's clergy took over the ceremonial. Thus, the topography of the city of Augsburg gave the 1530 imperial *Adventus* a remarkable scenic dimension. Coming from SS Ulrich & Afra, the emperor and his entourage had to ride downwards for some distance. The members of the chapter expected him at the very lowest point between the Benedictine basilica and the cathedral. They were literally waiting in limbo in order to escort him upwards to the cathedral. It may not be a coincidence that there was a small chapel dedicated to St Leonard, the patron of captives, at this very point within the city.[39] Thus, the ritual's spatial structure sheds further light on the reading of Clemens Sender's report on the singing of 'Advenisti desiderabilis'.

Singing 'Advenisti desiderabilis'

Unlike in other contemporary plays from Augsburg, the traces of music in the Augsburg Passion play are limited to a number of stage directions. A single trombone signal, sounding after the pronouncement of judgement over Jesus, is the only surviving sign of instrumental music in this liturgical drama.[40] Latin and vernacular chants play an important role in the play's *Descensus* section. There is no music notation in the surviving manuscript, but the usual chant melodies can be reconstructed by consulting contemporary liturgical books. For the *Canticum*

Ex. 9.1. Excerpt from the *Canticum triumphale* in
Copenhagen, Kongelige Bibliotek, MS 3449 8° VI, fols 25ᵛ–27ʳ

triumphale and 'Advenisti desiderabilis', the *Graduale pataviense* of 1511 and an Augsburg manuscript of 1580 both provide a nearly identical, rather expressive melody.[41] The rising fourth at 'advenisti' and the rising triad at 'desiderabilis' (see Example 9.1) are distinctive gestures which would have been easy for listeners to recognize and which can be traced back to the antiphon's melody in the neumatic notation of the Einsiedeln manuscripts.[42] Since there is no evidence of polyphonic music-making, it is likely that Augsburg's cathedral chapter welcomed the emperor with 'Advenisti desiderabilis' in plainchant, probably with a melody familiar to audiences and performers from the plays.

However, the few surviving polyphonic settings of 'Advenisti desiderabilis' offer some interesting information about the antiphon's general milieu. As Rebecca Gerber has shown in her comprehensive edition and discussion of Trent, Museo Provinciale d'Arte, MS 1375 (olim Tr 88), the two 'Advenisti desiderabilis' motets extant in this source relate to entries of Bishop Georg Hack in Trent. Gerber establishes a connection with the tradition of medieval Easter plays for both texts, showing their common origin despite their different appearance.[43]

The three-part motet (no. 89) has two different textual components. Its older text consists of 'Advenisti desiderabilis', the complete second part of the *Canticum triumphale*. In turn, the motet's second part is the chant 'Triumphat dei filius', which is, as Bernhold Schmid has shown, a text trope of the long Alleluia melisma at the end of the *Canticum triumphale*.[44] While the appearance of this chant as the motet's *secunda pars* is nothing unusual, the fact that this text also appears in some medieval Easter and Passion plays at exactly the same point is striking.[45] An alternative text layer for no. 89 is written immediately underneath the text of 'Advenisti desiderabilis'. Closely adhering to the antiphon's original words, it 'turns the motet into a ceremonial composition for the election of the bishop of Trent in 1446'.[46] 'Advenisti desiderabilis' transforms into 'advenit nobis desiderabilis'; and 'triumphat dei filius' into 'triumphat noster dominus'. Thus, the motet's nature as a contrafact is made obvious. Towards the end of the composition, the text deviates from its model. The last few lines read: 'while the clergy is on its way, let it rejoice with songs, and let all the people resound always with pious voice, alleluia'.[47] Little is known about the actual events in Trent that celebrated the triumphal return of Bishop Georg Hack. However, the text embodies the *mise en scène* of the *Adventus*:

Antiphon's text

Advenisti desiderabilis
quem expectabamus in tenebris
ut educeres hac nocte
vinculatos de claustris.

Te nostra vocabant suspiria
et larga requirebant lamenta;
tu factus es spes desperatis,
magna consolatio in tormentis.

Triumphat dei filius
ab hoc superno,
resurgens a morte
delens Eve culpam,
latronem sero flentem,
convictum beata perduxit ad regna.

Quo iturus erat Petrus
cum ceteris visitat
omnesque flebiles consonant
semper voce pia, alleluja.

[Thou art arrived, desirable one,
whom we are awaiting in darkness,
to lead this night
the chained prisoners from their cells.

Our sighs called upon thee
and our copious laments sought thee;
thou art become the hope of the hopeless,
a great consolation in torments.

The Son of God triumphs
over this exalted one;
rising from death,
wiping out the guilt of Eve;
the thief who belatedly wept
he brought with him to the blessed realms.

Where Peter was to go
he visits with the others,
and all the weeping ones sound together
always with pious voice, alleluia.]

Alternative text

Advenit nobis desiderabilis
quem expectabamus in moestitiis
ut educeret hac die
turbulentos de tristiis.

Quem nostra vocabant suspiria
et larga requirebant lamenta;
qui factus est spes desperatis,
magna consolatio Tridentinis.

Triumphat noster dominus,
venit et praesul inclitus
tota cum cohort,
delens moesti dolorem.

Populum suum flebilem
constrictum moerore,
magna perduxit ad leta.

Dum venturus erat clerus
cum canticis iubilet
omnisque populous consonet
semper voce pia, alleluja.

[The desirable one is come to us
whom we were awaiting in sadness,
to lead this night
the turbulent ones from grief.

Whom our sights called upon
and our copious laments sought,
who is become the hope of the hopeless
a great consolation to those of Trento.

Our lord triumphs,
and the renowned bishop has come
with his entire court,
wiping out the pain of the sad one.

His weeping people,
constrained by woe,
he hath brought to great happiness

While the clergy is on its way
let it rejoice with songs
and let all the people resound
always with pious voice, alleluia.]

Ex. 9.2. Text of motet no. 89
(Latin text and English translation are taken from Gerber, *Sacred Music*, pp. 94-95)

it mentions the actual movement of the clergy during the procession and speaks of 'all the people' rejoicing, referring to the spectators on the streets.

In the four-part motet 'Venisti nostras' (no. 116) the references to the *Canticum triumphale* are less explicit. It uses only the chant's 'Advenisti desiderabilis' section as a repeating *cantus firmus* melody in the tenor part. The text of the remaining parts addresses Bishop Hack at the moment of his arrival at Trent: 'You have arrived. Longed for, you have come, O George, to our cities'. As with motet no. 89, this text refers to a precise moment in the ceremonial of a ruler's entry, the instant of his arrival. For Gerber, the three repetitions of the *cantus firmus* constitute a possible reference to liturgical drama. In some Passion plays, Jesus is shown standing at the gates of Hell, where he repeats the words 'tollite portas' three times before freeing the forefathers.[48] Although these two Trent motets are rare examples of the 'Advenisti desiderabilis' chant being adapted into polyphony, they emphasize the strong link between the antiphon and the *Adventus* ceremonial. Given that both motets refer to actual events taking place during the bishop's entry, one could speculate that they were used during the processions into the city of Trent. Although there is no definite evidence, it seems possible that there was polyphony during ceremonial processions such as the *Adventus* at Trent and Augsburg.

> Advenisti.
> Venisti nostras, Georgi, optatus ad urbes,
> poplice cui flexo servit uterque polus.
> Venisti tandem princeps auguste, vocabant
> te procures votis milleque turba piis.
> Salve, o cura dei, princeps mitissime, salve
> et tibi dent longas numina vera moras.
> *Cantus firmus*: Advenisti desiderabilis
>
> [You have arrived.
> Longed for, you have come, O George, to our cities,
> whom either pole serves with bended knee.
> At last you have come, august prince; the nobles
> and the people called you with a thousand pious prayers.
> Hail, O loving kindness of God, most merciful prince, hail!
> And may the true divinities grant you long life.
> *Cantus firmus*: You have arrived, desirable one.]

Ex. 9.3. Text of motet no. 116
(Latin text and English translation are taken from Gerber, *Sacred Music*, pp. 108–09)

Finally, there is one other textual variant of the 'Alle dei filius'/'Triumphat dei filius' trope of the *Canticum triumphale*. After setting the whole *Canticum triumphale* in a four-part motet, Johann Walter (1497–1570) opens a five-part *secunda pars* with the words 'Christus dei filius', which maintains the text of the original trope.[49] While this may seem nothing more than a christological adaptation of the original text, there is an early sixteenth-century motet that begins with a very similar text. The motet 'Christus filius dei' in a 1538 Nuremberg print by Hans Ott (RISM 1538³) is a contrafact of the grand six-part 'Virgo prudentissima' motet by Heinrich Isaac

(*c.* 1450–1517).[50] Royston Gustavson suggested that Hans Ott, editor of the Nuremberg volume, reworked the text of the Marian motet for confessional reasons.[51] Yet there is also a second, equally plausible explanation. Towards the end of the *prima pars*, before returning to the original text of Isaac's composition, the newly texted motet features a reference to Christ's descent into Hell: 'by his death, Christ, the son of God, brought us salvation, tore apart the chains of Hell, triumphed over sin, and rose victorious to the Heaven of heavens'.[52] This reference to the *Descensus* and the broken chains of Hell in combination with the close relation of the motet's first words to the 'Triumphat dei filius' trope may indicate a link between the contrafact and the context of 'Advenisti desiderabilis'. In its second part, 'Christus filius dei' maintains the political symbolism of the original motet and adapts it for Emperor Charles V: 'we pray for the Holy Empire and for Charles the Roman Emperor'.[53] These observations suggest an alternative motive for the motet's new text: the author may have intended to link Isaac's motet to the symbolic cosmos of the *Canticum triumphale* and the imperial *Adventus*; possibly, the motet was adapted for an entry of Emperor Charles, perhaps even after his coronation in Bologna to celebrate him as 'Caesare romano'.

Conclusion

Victor Turner's *From Ritual to Theatre* counts among the classical textbooks of performance studies. In light of the present essay, Turner's title might be adapted to the case of 'Advenisti desiderabilis': from ritual to theatre to ritual.[54] The imperial entry of Charles V into Augsburg in 1530 was special in many ways. The city's cathedral chapter expressed its great expectations of the emperor by ignoring the city's traditional ceremonial regulations for an imperial entry. By singing 'Advenisti desiderabilis', the clergymen no longer represented the population of the historical Jerusalem acclaiming Jesus: they embodied the forefathers imprisoned in Hell, waiting for salvation. Not only did they address the participants of the imperial entry, but also the citizens of Augsburg. Easter and Passion plays helped the common people to understand the ceremonial meanings of Latin texts and chants. Combined with the medieval imperial ceremonial, the plays formed a space of communication that allowed a transfer of knowledge across social boundaries. For the people of Augsburg, the triumphal entry of Charles V was a dazzling event in times of civic unrest. The singing of 'Advenisti desiderabilis', however, was perfectly understandable for everybody: its performance in the new context of the *Adventus* functioned as plea for salvation within a tense social and confessional discourse.

Notes to Chapter 9

1. Helen Watanabe-O'Kelly, 'Entries, Fireworks and Religious Festivals in the Empire', in *Spectaculum Europaeum: Theatre and Spectacle in Europa 1580–1750*, ed. by Pierre Béhar and Helen Watanabe-O'Kelly (Wiesbaden: Harrassowitz, 1999), pp. 721–42; Gerrit J. Schenk, *Zeremoniell und Politik: Herrschereinzüge im spätmittelalterlichen Reich* (Cologne: Böhlau, 2003); Barbara Stollberg-Rilinger, *Des Kaisers alte Kleider: Verfassungsgeschichte und Symbolsprache des alten Reiches* (Munich: C. H. Beck, 2008); *Adventus: Studien zum herrscherlichen Einzug in die Stadt*, ed. by

Peter Johanek and Angelika Lampen (Cologne: Böhlau, 2009); Harriet Rudolph, *Das Reich als Ereignis: Formen und Funktionen der Herrschaftsinszenierung bei Kaisereinzügen (1558–1618)* (Cologne: Böhlau, 2011).

2. 'Als im Jahr 1521 d. 16 April Doctor Luther das erstemahl nach Worms kam, begegnete ihm des Herzogs von Bayern Hofnarr, oder Freudenmacher, wie der damals hieß, Namens Löffler oder Cochläus, auf der Straße, mit einem rothen Creutze in der Hand, wie man es bei Proceßionen vorträgt; da er nun hörte, daß dieses Doctor Luther wäre fieng er mit heller Stimme an zu singen: "Advenisti desiderabilis, quem expectabamus in tenebris", sei willkommen, du lieber Gast, dich haben wir in der Finsternis erwartet', Karl Friedrich Flögel, *Geschichte der Hofnarren* (Liegnitz: Siegert, 1789), pp. 211–12a. Unless otherwise stated, translations in this chapter are my own.

3. Alfred Kohler, 'Wohnen und Essen auf den Reichstagen des 16. Jahrhunderts', in *Alltag im 16. Jahrhundert: Studien zu Lebensformen in mitteleuropäischen Städten*, ed. by Alfred Kohler and Heinrich Lutz (Vienna: Verlag für Geschichte und Politik, 1987), pp. 222–57.

4. Thomas Zotz, 'Präsenz und Repräsentation: Beobachtungen zur königlichen Herrschaftspraxis im hohen und späten Mittelalter', in *Herrschaft als soziale Praxis: Historische und sozial-anthropologische Studien*, ed. by Alf Lüdtke (Göttingen: Vandenhoeck & Ruprecht, 1991), pp. 168–94 (p. 191).

5. Ernst Kantorowicz, *Laudes Regiae: A Study in Liturgical Acclamations and Mediaeval Ruler Worship with a Study of the Music of the Laudes and Musical Transcriptions* (Berkeley: University of California Press, 1946), p. 75.

6. Anna M. Drabek, *Reisen und Reisezeremoniell der römisch-deutschen Herrscher im Spätmittelalter* (Vienna: Verlag des Wissenschaftlichen Antiquariats H. Geyer, 1964), pp. 78–79; Ernst Kantorowicz, 'The "King's Advent" and the Enigmatic Panels in the Doors of Santa Sabina', *The Art Bulletin*, 26.4 (1944), 207–31; for the Farfa *ordo* see Ludwig Biehl, *Das liturgische Gebet für Kaiser und Reich: ein Beitrag zur Geschichte des Verhältnisses von Kirche und Staat* (Paderborn: Schöningh, 1937), p. 168; for the prayer book (*Cantatorium*) of Empress Kunigunde, see Kassel, Universitätsbibliothek, MS 4° Theol. 15, fols 160ᵛ–61ʳ, <http://orka.bibliothek.uni-kassel.de/viewer/image/1318578645716/1/> [accessed 8 August 2017].

7. Schenk, *Zeremoniell und Politik*, pp. 238–42.

8. Extensive studies on the music of the 'Te Deum laudamus' are scarce; see Winfried Kirsch, *Die Quellen der mehrstimmigen Magnificat- und Te Deum-Vertonungen bis zur Mitte des 16. Jahrhunderts* (Tutzing: Schneider, 1966).

9. For the relevance of witnesses for the legitimacy of the imperial ceremonial, Stollberg-Rilinger, *Des Kaisers alte Kleider*, p. 64.

10. *Obsequiale augustense* (Augsburg: Erhard Ratdolt, 1487), vdm 1071–73, <http://daten.digitale-sammlungen.de/~db/0004/bsb00043904/images/> and <www.vdm.sbg.ac.at> [accessed 8 August 2017].

11. *Agenda seu liber obsequiorvm, iuxta ritum, et consuetudinem dioecesis August* (Ingolstadt: Alexander Weissenhorn, 1547), VD16A661, <http://daten.digitale-sammlungen.de/~db/0002/bsb00022172/images/index.html> [accessed 8 August 2017]; and vdm 1127, <vdm.sbg.ac.at> [accessed 8 August 2017].

12. 'Quando aliquis imperator, Rex, legatus de latere sedis apostolice, vel novus episcopus, aut princeps, primo intrat aliquam civitatem vel oppidum, ad suscipiendum eum clerus et populos congregates, processionaliter more solemni et cum reliquiis sanctorum obviat. Et postque descenderit de equo ducatur sub velo ad ecclesiam, cum illis responsoriis. Benedixit te dominus in virtute sua, qui per te ad nihilum redigit inimicos nostros, ut non deficiat laus tua de ore hominum', *Obsequiale augustense*, fol. 85ᵛ; the same guideline is given in the *Agenda seu liber obsequiorvm, iuxta ritum, et consuetudinem dioecesis August*, fol. 106ᵛ.

13. *Pontificale romanum* (Rome: Stephan Planck, 1485), fol. 269ᵛ, <http://diglib.hab.de/inkunabeln/408-theol-2f/start.htm> [accessed 8 August 2017].

14. There are numerous descriptions of the entry, as well as a series of woodcuts by Jörg Breu. For observations about music, the printed report of Caspar Sturm and the chronicle of Clemens Sender are two key sources: Caspar Sturm, *Ain Kurtze anzaygung und beschreybung Römischer*

Kayserlichen Maiestat eintreyten (Augsburg: Phillip Ulhart the Elder, 1530), VD 16 ZV 26691 & S 10013; *Die Chroniken der schwäbischen Städte — Augsburg: Vierter Band*, ed. by Historische Kommission bei der königlichen Akademie der Wissenschaften, Die Chroniken deutscher Städte, XXIII (Leipzig: Hirzel, 1894), pp. 261–64.

15. There are no reliable reports about any elements of Renaissance festival culture, such as triumphal arches or *tableaux vivants*. Amongst the numerous studies of Renaissance festival culture see Anthony M. Cummings, *The Politicized Muse: Music for Medici Festivals, 1512–1537* (Princeton, NJ: Princeton University Press, 1992).

16. For the Munich *Adventus* of Charles V, see Sturm, *Ain Kurtze anzaygung*, fols AII^v–AIV^v; Hugo Laemmer, *Monumenta vaticana: historiam ecclesiasticam saeculi XVI illustrantia* (Freiburg im Breisgau: Herdersche Verlagshandlung, 1861), pp. 36–39; Georg M. Thomas, 'Der Einzug Kaisers Karl V. in München am 10. Juni 1530: zwei Briefe eines Venezianers als Augenzeugen', in *Sitzungsberichte der Bayerischen Akademie der Wissenschaften, Philosophisch-Philologische und Historische Klasse 1882*, ed. by the Bayerische Akademie der Wissenschaften/Philosophisch-Philologische Klasse (Munich: Verlag der Bayerischen Akademie der Wissenschaften in Commission bei G. Franz, 1882), pp. 363–72.

17. Stollberg-Rilinger, *Des Kaisers alte Kleider*, pp. 97–98.

18. Ibid., p. 111.

19. 'Da der Kaiser vor sant Leonards cappel ist geritten under der thomherrn himel, hat er ain spitzru(m)t in der handt gefiert. Da sind vor im niderkniet der thomprobst herr Marquard vom Stain, der thomdechant herr Philipp von Rechberg und mit inen noch 2 thomherrn und 2 aus den vierherrn, die haben gesungen: "advenisti desiderabilis, quem expectabamus in tenebris, ut educeres hac nocte vinculatos de claustris." Daranach hat der gantz chor die antiphen vol hinaus gesungen bis zu(m) end: "te nostra vocabant suspiria, te larga requirebant lamenta, tu factus spes desperatis, magna consolatio in tormentis. Alleluja"', *Die Chroniken der schwäbischen Städte*, p. 276.

20. Helmut Gier, 'Das Oster- und Passionsspiel in Augsburg', in *Das Passionsspiel — Einst und Heute*, ed. by Wilhelm Liebhart (Augsburg: Katholische Akademie, 1988), pp. 50–65 (p. 57).

21. Bernhold Schmid, 'Das Alle dei filius aus dem Mensuralcodex St. Emmeram der Bayerischen Staatsbibliothek München (Clm 14274) und sein Umfeld', *Musik in Bayern*, 42 (1991), 17–50 (p. 19).

22. Dolores Ozimic, *Der pseudoaugustinische Sermo CLX Hieronymus als sein vermutlicher Verfasser, seine dogmengeschichtliche Einordnung und seine Bedeutung für das österliche Canticum triumphale 'Cum rex gloriae'* (Graz: Dbv-Verlag für die Technische Universität Graz, 1979).

23. See Anselm Schubiger, *Die Sängerschule St. Gallens vom achten bis zwölften Jahrhundert: ein Beitrag zur Gesangsgeschichte des Mittelalters* (Einsiedeln & New York: Benziger, 1858); Schmid, 'Das Alle dei filius', 19.

24. Einsiedeln, Stiftsbibliothek, MS 121 (1151), pp. 393–94, <http://www.e-codices.unifr.ch/de/list/one/sbe/0121> [accessed 8 August 2017] (emphasis my own).

25. Walther Lipphardt, *Lateinische Osterfeiern und Osterspiele: Teil III* (Berlin & New York: de Gruyter, 1976), pp. 745–88; *Obsequiale augustense*, fols 35^r–38^r.

26. For further information, see Elisabeth Kunstein, 'Die Höllenfahrtszene im geistlichen Spiel des deutschen Mittelalters: ein Beitrag zur mittelalterlichen und frühneuzeitlichen Frömmigkeitsgeschichte' (unpublished doctoral thesis, University of Cologne, 1972), p. 20.

27. Sabine Žak, *Musik als 'Ehr und Zier' im mittelalterlichen Reich: Studien zur Musik im höfischen Leben, Recht und Zeremoniell* (Neuss: Dr. Päffgen, 1979), p. 33; Fritz Stein, *Zur Geschichte der Musik in Heidelberg* (Heidelberg: Universitätsbuchdruckerei J. Hörning, 1912), pp. 6–7; Drabek, *Reisen und Reisezeremoniell*, p. 79; Reinhard Strohm, 'European Politics and the Distribution of Music in the Early Fifteenth Century', *Early Music History*, 1 (1981), 305–23 (p. 321).

28. Klaus Wolf, 'Theater im mittelalterlichen Augsburg: ein Beitrag zur schwäbischen Literaturgeschichtsschreibung', *Zeitschrift des historischen Vereins für Schwaben*, 101 (2008), 35–45 (pp. 44–45).

29. Ursula Schulze, *Geistliche Spiele im Mittelalter und in der Frühen Neuzeit: von der liturgischen Feier zum Schauspiel* (Berlin: Schmidt, 2012), p. 18.

30. <http://daten.digitale-sammlungen.de/bsb00050902/image_1> [accessed 8 August 2017].

31. Wolf, 'Theater im mittelalterlichen Augsburg', p. 37.

32. See Dorothea Freise, *Geistliche Spiele in der Stadt des ausgehenden Mittelalters: Frankfurt, Friedberg, Alsfeld* (Göttingen: Vandenhoeck & Ruprecht, 2002).

33. Munich, Bayerische Staatsbibliothek, MS Cgm 4370, fol. 61v.

34. The section is titled: 'hystori oder figur der erlösung der vätter auß der vorhell'.

35. Munich, Bayerische Staatsbibliothek, MS Cgm 4370, fols 56r–62v.

36. Regine Schweers, 'Die Bedeutung des Raumes für das Scheitern oder Gelingen des Adventus', in *Adventus*, ed. by Johanek and Lampen, pp. 37–55 (pp. 38–39).

37. For the medieval understanding of space, see Michel Foucault, 'Of Other Spaces: Utopias and Heterotopias', *Diacritics*, 16.1 (1986), 22–27 (p. 22).

38. The Rotes Tor is located at the south-east corner of the old city walls; see Josef Mančal, 'Rotes Tor', in *Augsburger Stadtlexikon Online*, ed. by Günther Grünsteudel, Günter Hägele, and Rudolf Frankenberger (Augsburg: Wissner, 2013), <http://www.stadtlexikon-augsburg.de/> [accessed 8 August 2017].

39. I am grateful to Bonnie Blackburn and Leofranc Holford-Strevens for this suggestion.

40. Munich, Bayerische Staatsbibliothek, MS Cgm 4370, fol. 39r.

41. Neither the Augsburg 1487 *Obsequiale* nor the 1547 *Agenda* give a melody for the chant, see notes 10 & 11. Copenhagen, Kongelige Bibliotek, MS 3449 8° VI, fols 25v–26r, <www.cantusdatabase.org> [accessed 8 August 2017].

42. Einsiedeln, Stiftsbibliothek, MS 121 (1151), p. 394.

43. Rebecca L. Gerber, *Sacred Music from the Cathedral at Trent: Trent, Museo Provinciale d'Arte, Codex 1375 (Olim 88)* (Chicago: University of Chicago Press, 2007), pp. 94–95 & 108–09.

44. Schmid, 'Das Alle dei filius', pp. 20–21; for the origins of the trope, see Barbara Haggh-Huglo, 'Easter Polyphony in the St Emmeram and Trent Codices', *Musiktheorie*, 27.2 (2012), 112–32 (pp. 113–14).

45. Gerber, *Sacred Music*, p. 94.

46. Ibid., p. 94.

47. 'Dum venturus erit clerus cum canticis iubilet omnisque populus consonet semper voce pia, alleluja', English translation by Gerber, *Sacred Music*, p. 95.

48. Gerber, *Sacred Music*, p. 109.

49. Schmid, 'Das Alle dei filius', pp. 33–35.

50. *Secvndvs tomvs novi operis mvsici, sex quinqve et qvatvor vocvm, nvnc recens in lvcem editvs [...]* (Nuremberg: Hans Ott, 1538), VD16 O 1501, vdm 37; for Isaac's 'Virgo prudentissima', see Franz Körndle, 'So loblich, costlich und herlich, das darvon nit ist ze schriben: der Auftritt der Kantorei Maximilians I. bei den Exequien für Philipp den Schönen auf dem Reichstag zu Konstanz', in *Tod in Musik und Kultur*, ed. by Stefan Gasch and Birgit Lodes (Tutzing: Schneider, 2007), pp. 87–109; David J. Rothenberg, 'The Most Prudent Virgin and the Wise King: Isaac's Virgo prudentissima: Compositions in the Imperial Ideology of Maximilian I', *The Journal of Musicology*, 28 (2011), 34–80.

51. Royston R. Gustavson, 'Hans Ott, Hieronymus Formschneider, and the Novum et insigne opus musicum (Nuremberg, 1537–1538)', 2 vols (unpublished doctoral dissertation, University of Melbourne, 1998), I, 237–40.

52. 'Christus filius dei morte sua nos salvos fecit inferni claustra fregit et de peccato triumphavit atque victor coelos coelorum transcendit'.

53. 'Precamur pro sacro imperio pro Carolo caesare romano'.

54. Victor Turner, *From Ritual to Theatre: The Human Seriousness of Play* (New York: Performing Arts Journal Publications, 1982).

CHAPTER 10

Monophonic Song in Motets: Performing Quoted Material and Performing Quotation

Matthew P. Thomson

The usefulness of the concept of performance for analyzing medieval music resides, in part, in its multivalence: its different meanings allow for multiple applications, many of which have already found a place in the field of scholarship dedicated to thirteenth-century motets. The most frequently asked question with regard to motets and performance applies the latter's most basic and broadly accepted meaning: how did musicians perform motets? The question of instrumental involvement in the performance of motets, for example, has proved of special longevity. While scholars of the earlier twentieth century, including Yvonne Rokseth and Hans Tischler, believed that instruments were to accompany each voice part, Christopher Page has undermined these claims in a series of publications, leaning towards a solely vocal performance of motets.[1] Such pragmatic questions have been complemented by scholars applying a different concept of performance, asking not how motets were realized in performance but how motets presented and performed their musical and textual material. Page has contended that the main purpose of motets which feature multiple texts in their upper voices is not to perform the meanings of the texts, but their sounds.[2] Sylvia Huot, in contrast, has argued that the multiple texts of motets perform complex intertextual associations and references.[3] Suzannah Clark's middle way proposes that motets can perform specific intertextual meanings through a combination of their music and text, using their musical characteristics in order to highlight particular interpretative possibilities for the text. She approaches performance as something that motets do, rather than something which is done to them.[4]

Clark's analysis focuses on the ways in which motet voices can perform their relation to each other, to generic norms, and to any pre-existent material that they use. She outlines how motet voices diegetically perform other musical genres, especially monophonic song.[5] The motet that Clark analyzes uses a number of pre-existent materials, including the plainchant melisma on which the tenor is based. Of these materials, the only ones directly linked to monophonic song are the refrains, short sections of music and text that were quoted in songs, motets, and vernacular

literature of the thirteenth century. In other motets, interaction with monophonic songs happens on a much larger scale: there are twenty-one motets which include an entire voice part that is also found as a monophonic song. The motets and songs in this corpus do not all operate in the same way: in twelve cases it can be shown that an original monophonic song was quoted in a motet, while in five cases the evidence suggests that the first version was a motet, from which a voice part was later extracted to make a monophonic song. In the remaining four cases, the extant evidence does not allow a definitive decision to be made.[6]

In the cases in which the song came first, the motets treat their song voices in a number of different ways. While the quoted song voice can be shown to pre-exist the motet in all of these twelve cases, the relationship between different voice parts in some motets is constructed so that the song voice's identity as separate from that of the motet as a whole is highlighted: it is performed as pre-existent. Motets sometimes perform pre-existent song voices and they sometimes specifically perform them as pre-existent, but these are two separate processes. The present essay offers three case studies, which demonstrate that the pre-existence of a voice does not mean that it must be performed as such, while the performance of a voice as pre-existent does not mean that it actually is. The first, *Mout me fu grief* (297)/ *Robin m'aime* (298)/PORTARE (M22), performs pre-existent material and marks that material as pre-existent.[7] The second, *Cil qui m'aime* (1053)/*Quant chantent oisiaus* (1054)/PORTARE (M22), quotes a pre-existent song voice without specifically performing it as pre-existent; whereas the third, *Qui amours veut maintenir* (880)/*Li dous pensers* (881)/CIS A CUI, performs material as if it were a pre-existent song voice without actually containing one.

Mout me fu grief/Robin m'aime/PORTARE

Of the motets which share one of their voices with a monophonic song, *Mout me fu grief/Robin m'aime*/PORTARE has garnered a substantial amount of scholarly attention, notably from Mark Everist and Dolores Pesce.[8] Its motetus is also found as the monophonic song 'Robin m'aime, Robin m'a' which opens Adam de la Halle's *Le Jeu de Robin et de Marion*.[9]

The music of 'Robin m'aime' has an irregular rondeau structure, ABaabAB.[10] In the motet, this form is also present in the tenor, whose musical material is taken from the PORTARE melisma of the Alleluia verse for the feasts of the Invention and Exaltation of the True Cross, 'Dulce lignum dulces clavos'.[11] Instead of presenting the pitches of the melisma in their normal order, the creator of the motet chose to split up the chant into two sections, matching each to the melodic sections of the rondeau material. Each time the motetus sings its A section, the tenor sings the first portion of the PORTARE melisma, and every time the B section appears, the tenor sings the second portion of chant.[12] This organization of the tenor can be seen in Example 10.1, which demarcates the A sections of the motetus and their related portions of the tenor in solid boxes, B sections and their portions of the tenor in dashed ones.

Ex. 10.1. *Mout me fu grief/Robin m'aime/*PORTARE

As the tenor's musical material has been reshaped in order to reflect the form of the motetus, the *Robin m'aime* voice becomes the structural basis for the rest of the motet. By taking the form of the motetus and applying it to the tenor, the motet has become a gloss: it elaborates and extends a piece of pre-existent material in another context.[13] As material which is subject to glossing, *Robin m'aime* is being treated as a quotation: it is acknowledged to be source material, to have an existence outside that of the motet.[14]

Given this distinct identity, the motetus can be analyzed using Mikhail Bakhtin's category of 'citation': it is 'the image of another's language', expressed in 'a voice

adopted by the speaker'.[15] *Robin m'aime* sits at the centre of the motet, as its source material, but also outside it, as someone else's speech. This contradictory combination projects what Roger Dragonetti has called 'the mirage of the source': it gives the motetus a sense of déjà vu (and/or *entendu*).[16]

Sarah Kay has shown that Bakhtinian citations such as *Robin m'aime* are not only a product of re-using pre-existent material, but can result from a specific attempt to perform and play with the conventions of quotation: 'given that any utterance is indefinitely repeatable and hence indefinitely quotable, [...] perhaps we should say, then, that what characterizes quotation is that it foregrounds this repeatability (what Derrida calls doubleness/duplicity [*duplicité*]), and provokes the reader to recognise it?'[17] When song voices are used to form the basis of a motet, it is this *duplicité* that is foregrounded: they are treated as a quotation and so can be recognized as one:

> Quotation [...] plays with expectations of knowledge and recognition; it summons subjects of knowledge and recognition into existence; but it does not necessarily ratify them. In getting to grips with this phenomenon, I have adopted Jacques Lacan's concept of 'the subject supposed to know' ('le sujet supposé savoir'), because it means both that knowledge presupposes a series of subjects that are difficult to locate, and that subjects are supposed to have knowledge that is difficult or impossible to specify.[18]

Mout me fu grief/Robin m'aime/PORTARE therefore performs its motetus as a quotation.[19] Its formal structure forces the listener to turn to knowledge gained from outside their experience of the motet. It sends the audience searching for the reality behind the 'mirage of the source', thereby assigning them a role similar to that of the 'subject supposed to know'. In *Mout me fu grief/Robin m'aime/PORTARE*, the motet's performance of quotation is linked with reality — there is a real source behind the mirage. It is not only possible to demonstrate that the motet treats the *Robin m'aime* voice as if it were pre-existent, but the evidence also suggests that, in its form as a monophonic song, 'Robin m'aime' pre-existed *Mout me fu grief/Robin m'aime/PORTARE*.

Example 10.2 presents the *PORTARE* melisma as it is found in Paris, BnF, MS lat. 1112, where it is texted with the word *sustinere*.[20] As Pesce shows, this melisma ends on a G in all chant sources.[21] In the tenor of *Mout me fu grief/Robin m'aime/PORTARE*, however, an extra *c* is added to the end of the melisma each time that it is sung, as highlighted in Example 10.1.[22] This adaptation is most likely to have been intended to make the *PORTARE* melisma fit to the pre-existent motetus voice.

The pre-existence of the motetus voice is further suggested by the rhythmic profile of the tenor. While it maintains the basic iambic shape of the second rhythmic mode, the tenor makes extensive use of *fractio modi*, breaking up the longs of the mode into two breves or even into two semibreves and a breve, as seen in the box labelled *fractio modi* in Example 10.1. As Friedrich Ludwig noted, this rhythmic motion is highly unusual for tenors.[23] It was most likely caused by the process of fitting the *PORTARE* melisma to a pre-existent motetus: certain notes of the tenor had to be reached by the beginning of a perfection so that they could form a consonance with the motetus. In the movement between perfections 7 and

Ex. 10.2. The *sustinere* melisma, as found in Paris, BnF, MS lat. 1112, fol. 169ᵛ

8, for example, the tenor needed to reach *a* at the beginning of perfection 8 in order to provide a perfect consonance with *e* in the motetus. To get to *a*, the tenor had to move quickly through the three notes that stood between *a* at the beginning of perfection 7 and *a* at the beginning of perfection 8.

'Robin m'aime' therefore most probably pre-existed its related motet as monophonic song. It is also performed within that motet as a pre-existent song. While these two statements are linked, they are not the same statement: two further examples reveal situations in which only one of these statements is true about the song material found in a motet.

*Cil qui m'aime/Quant chantent oisiaus/*PORTARE

The motetus of *Cil qui m'aime/Quant chantent oisiaus/*PORTARE uses material that pre-existed the motet as a monophonic song with a very slightly different incipit, 'Quant chant oisiaus', attributed to Richard de Fournival.[24] Unlike 'Robin m'aime', 'Quant chant' does not form the structural centre of its motet. Instead of granting the voice found in the motet as *Quant chantent* an identity outside the motet and thereby performing it as pre-existent, the motet subsumes the material into its own identity.

That the song 'Quant chant' pre-existed its motet counterpart is suggested by the motet's tenor, the same PORTARE melisma that was adapted to *Robin m'aime*. As can be seen by comparing Examples 10.2 and 10.3, the tenor of *Cil qui m'aime/ Quant chantent oisiaus/*PORTARE does not only consist of the musical material of the PORTARE melisma, but follows two *cursus* of that material (perfections 1–12 and 13–24) with five added pitches in Example 10.3 (see the dashed box). While these longs reiterate the melodic outline of the end of the melisma, a descent onto *G*, they are not themselves found in the melisma. They are set apart from the rest of the tenor by their significantly different rhythmic profile: whereas the main body of the tenor is anchored firmly in the first rhythmic mode, these final five pitches are all either perfect longs or imperfect longs with a breve rest. In contrast, the material that the motetus and triplum have over these added longs is completely in character with the rest of the motet. There is no significant change in rhythm, range, or motetus–triplum coordination. It seems most likely, therefore, that these extra tenor pitches were added in order to accommodate the pre-existent motetus.

Even though it seems likely that the motetus voice pre-existed the piece as a whole, the motet does not perform it as such but ignores the melodic patterns of this voice. If the structure of the motet reflects anything, it is the repeat of the tenor melisma: at the beginning of the first and second tenor *cursus*, the triplum sings the motive marked as **d** in its first and fourth poetic lines.[25] This motive is not exactly

Ex. 10.3. *Cil qui m'aime/Quant chantent oisiaus/PORTARE.*
<1> In the MS, the entire triplum is notated a fifth below its pitch in this edition.

the same in both its occurrences, neither does it appear at the same point in a poetic line, but the use of the same rhyme sound /oi/ could encourage the comparison of these two lines. If listeners were searching for the structural emphasis of pre-existent material in this motet, it would be much easier to hear in the tenor melisma than in the motetus.

In some motets, song voices were not performed as pre-existent for pragmatic reasons: they did not contain sufficiently characteristic musical patterns that could be reflected in other voices. In their compendium of trouvère song, Samuel Rosenberg, Margaret Switten, and Gérard Le Vot see 'Quant chant' as just such a piece, claiming that its melody is 'through-composed' and that it recalls in a written medium the work of 'a singer performing inventively'.[26] It is true that 'Quant chant' could not be designated as a rondeau- or ballade-type structure: its musical patterns are not easily analyzed by an approach that looks only at the repetition of the melody for a whole poetic line. However, it does re-use small musical motives to link together different lines of the poetic text. If someone had actively set out to create a motet that performed *Quant chantent* as a pre-existent voice, they would have had sufficient repetition to work with.

As can be seen in Example 10.4, an edition of the song version of 'Quant chant', the figure labelled as **a** in the first line is recalled in the third line as **a'**. A section of this figure is repeated again at the end of Paris, BnF, MS fr. 12615's version of l. 4, marked **a''**. Motive **b** is found in l. 5 and repeated at the same pitch level in l. 7, while the large majority of l. 6, marked **c**, is repeated in l. 8.

The pattern of the melodic repetitions and references emphasizes that the 'Quant

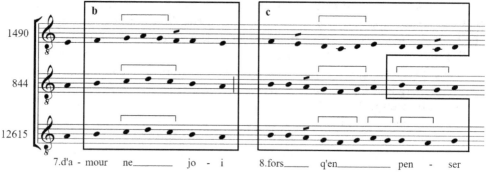

EX. 10.4. Annotated score of 'Quant chant'

chant' text falls into two halves. The musical correlation between ll. 1 and 3 helps to define the four-line unit created by the aabb rhyme structure of the first four lines, while the two sets of melodic relationships between the final four lines create another unit. If this song was the product of a singer 'performing inventively', the inventive performance included a certain amount of melodic structural thinking.

The structural qualities of the song melody seem not to have been set in stone. The differences between each of the manuscript witnesses suggest either that different scribes chose to bring out the melodic repetition to different degrees, or that some of the scribes did not recognize them to the same degree as others. In Vatican, Biblioteca Apostolica Vaticana, MS reg. lat. 1490, for example, it is more difficult to recognize that the two versions of **b** are related, as the characteristic G-*a*-G figure is missing in l. 5. Despite differences between the three manuscript versions, all the melodic parallels outlined above can be found in all manuscripts, with one exception: while MS fr. 12615 recalls **a** at the end of l. 4, the other two extant copies have no trace of such a melodic parallel.

Compared to the monophonic song, the *Quant chantent* voice found in the motet has a less clear motivic structure. The two occurrences of motive **b** (perfections 17–19 and 23–25) are still audibly related. The same is true, to a lesser extent, of motive **c** (perfections 20–22 and 26–28). It is less clear, however, that ll. 1 and 3 are related: there is no motive **a** in the motet. It is possible that the creator of the motet had not perceived the musical structures of the song. If some scribes of the song perceived it as having fewer repetitive structures than others, it is possible that the creator of the motet also did not notice that the two instances of motive **a** were related to each other and therefore did not acknowledge the repeats in other voice parts. It does seem, though, that the creator of this motet understood the structural power of repetition, as the triplum's motivic structure emphasizes the repeat of the tenor pitches at the beginning of the second *cursus*. Complete unawareness of the musical repetition in the song therefore seems unlikely. It is more likely that the creator of this motet chose to 'foreground [the] repeatability' of the tenor over that of the motetus, provoking the listener to recognize the pre-existent plainchant melisma, rather than the pre-existent song motetus. The motet quotes 'Quant chant' in a way that does not perform its pre-existent song material as a foreign body quoted within the text, but as if it were any other motet voice.

Qui amours veut maintenir/Li dous pensers/CIS A CUI

Although none of its voice parts can be found as a pre-existent song, *Qui amours veut maintenir/Li dous pensers/*CIS A CUI uses its tenor to perform song within a motet context.[27] The CIS A CUI tenor has been described as a refrain cento, a motet voice formed entirely from refrains. The tenor is made up of nine short sections of music and text, six of which have concordances in other motets, monophonic songs, and *romans*.[28] The refrain concordances are concentrated in two places in particular: Jacquemart Gielée's *Renart le nouvel* (the refrains labelled 2 and 4 in Example 10.5) and the anonymous continuation to Mahieu le Poirier's *Le Court d'amours* (refrains

6, 7, and 9).[29] Only three of the refrains, numbers 1, 2, and 4, have concordances with extant musical notation. Refrains 2 and 4 are found in *Renart le nouvel*, which has music notation in three of its four manuscript witnesses, although refrain 4 is found in only two of them.[30]

Like *Mout me fu grief/Robin m'aime/PORTARE*, *Qui amours veut maintenir/Li dous pensers/CIS A CUI* places its song voice at the conceptual centre of the motet: the harmonic structure of the motet as a whole is built around the musical patterns of the tenor. The melodic structure of the CIS A CUI tenor is most easily read as tri-partite.[31] As Beverly J. Evans has argued, four of the tenor's nine refrains are linked together through melodic repetition.[32] The music of refrain 1 ('Cis a cui'; vdB366) is repeated for refrain 5 ('Ele m'a navrée'; vdB636), as shown by boxes in Example 10.5.[33] Refrain 1 ('Cis a cui') is found in conjunction with this music in another place, the tenor of the motet *Tres joliement* (874)/*Imperatrix supernorum* (875)/*CIS A CUI*.[34] Refrain 5 ('Ele m'a navrée'), however, has no other extant contexts. It seems likely that the creator of the CIS A CUI tenor engineered this melodic repeat in order to put a structural marker in place, dividing refrains 1–4 from refrains 5–9. This division is also recognized in the upper parts: as the tenor moves from refrain 4 to refrain 5, the motetus sings the text 'cele a qui sui amis', recalling the opening text of the tenor just as the tenor is about to recall its opening melodic material.[35]

The second pair of repetitive refrains comprises numbers 8 ('Diex li douz diex'; vdB542) and 9 ('Or du destraindre'; vdB1439). Both refrains consist of a single repeated melodic phrase, first with an open harmonic ending and then with a closed one. If these two sets of melodic repetitions are taken as structural markers, they divide the tenor into three sections, refrains 1–4, refrains 5–7, and refrains 8 and 9. The first two of these groups are not only related by the use of the same melody in refrains 1 and 5, but by their harmonic structures. Refrains 1–4 and 5–7 use such similar patterns that the creator of the CIS A CUI tenor was likely playing with the concept of *pedes-cum-cauda*, or AAB form: two harmonically and melodically related sections are followed by a self-contained final section that operates differently.

The similarity between the two first groups is strong, as can be seen in Table 10.1: each of the refrains is harmonically similar to its counterpart in the other group. Refrains 1 ('Cis a cui') and 5 ('Ele m'a navrée') begin on *F*, and refrains 2 ('Vous le me defendés'; vdB1869) and 6 ('Diex se j'ai'; vdB565) begin on *b fa*.[36] Refrain 3 ('Diex que ferai du mal'; vdB556) begins on *c*. Although the first note of refrain 7 ('Se vous et vous'; vdB1720) is *a*, it is an upbeat which moves immediately on to *c* at the beginning of the next perfection. The first three refrains of each of the first two groups, number 1–4 and 5–7, therefore begin on the same note. The only imbalance in the symmetry between the first two groups of refrains is provided by refrain 4 ('He amouretes'; vdB793): while the first section has four refrains, the second has only three.

Given that each of the first three refrains in the first two sections of the tenor begin on the same note, they also form the harmonic pattern of all three voices of the motet: at the beginning of each refrain in the first two sections, the three voices cadence onto a chord in which the tenor provides the governing pitch, as

Ex. 10.5. The *CIS A CUI* tenor

Refrain within group		Group 1		Group 2		Group 3	
		Opening	Closing	Opening	Closing	Opening	Closing
1	Tenor Pitch	F	F	F	F	c	F
	Chord	F/f/c	F/c/f	F/c/f	F/c/c	c/F/f	F/c/f
2	Tenor Pitch	b fa	F	b fa	F	d	F
	Chord	b fa/f/f	F/c/f	b fa/f/f	F/f/c	d/f/f	F/c/f
3	Tenor Pitch	c	F	a (c)	F		
	Chord	c/c/c	F/c/f	c/c/g	F/c/c		
4	Tenor Pitch	g (b fa)	F				
	Chord	b fa/f/f	F/c/F				

Table 10.1. Pitches and simultaneities of refrains

seen in Table 10.1. At the beginning of these refrains, the two upper voices shape their harmony around the tenor, singing notes that are either a fifth or an octave above it. The opening upbeat *a* in refrain 7 ('Se vous et vous'), functions only as a harmonic move towards the *c/c/g* simultaneity found at the beginning of the next perfection.[37] This harmonic behaviour changes in the third section of the motet, in which the tenor sings refrains 8 ('Diex li douz diez') and 9 ('Or du destraindre'). At the beginning of refrain 8, the motetus and triplum refuse to let the tenor play the governing role, forcing its *c* into the context of a chord of *c/F/f*. Likewise, they both sing *f* at the beginning of refrain 9, forming a third with the tenor's *d*, a much less stable interval than the fifths and octaves found at the beginning of refrains 1–7.

The CIS A CUI tenor thus performs a tri-partite AAB form by melodic repetition and harmonic structure. The upper parts of the motet acknowledge this form textually and harmonically: the motetus articulates the break between refrains 4 and 5, while all three voice parts emphasize the harmonic similarity of sections 1 and 2 and their collective difference from section 3. The tri-partite form of the CIS A CUI tenor therefore becomes the basis of the motet's formal structure, which projects the 'mirage of the source' and sends the audience looking for a pre-existent concordance. In this case, however, there is none to find: a voice in song form is performed, but not quoted.

The song-like characteristics of the CIS A CUI tenor are not only formal and harmonic: the text of the tenor takes a number of textual motives that are characteristic of monophonic song and performs them in a way that acknowledges their context within a polytextual motet, a genre which complicates the understanding of texts by singing more than one at once: 'any attempt at reading [the tenor's] series of refrains as if the composite text were meant to present a highly logical sequence of ideas is destined to failure'.[38] The tenor presents a number of different subject positions one after the other, mixing different types of material to such an extent that any overarching sense is lost. These materials can, nevertheless, be organized: they fall into three different groups associated by mode of address, as presented in Table 10.2.

Refrain no.

3	Diex que ferai du mal d'amer
	Que ne me lessent durer
6	Diex se j'ai le cuer joli
	Ce me font amourettes
8	Diex li douz diex que ferai d'amourettes
	Quar je ne puis en li merci trouver

God, what shall I do with the pains of love which do not allow me to live? God, if my heart rejoices, love does this to me. God, sweet God, what will I do with my love, for I cannot find pity in her!

Refrain no.

2	Vous me le defendes l'amer
	Mes par dieu je l'amerai
7	Se vous et vous l'avez iure
	L'amerai ie
9	Or du destraindre et du metre en prison
	Je l'amerai qui qu'en paist ne qui non

You forbid me to love, but, by God, I will love her. If you and you have sworn it, I will love her, regardless of it constraining me and bringing me into captivity, still I will love her, whomever it may grieve, whomever it may not.

Refrain no.

1	Cis a cui je sui amie est cointe et gai
	Por s'amour serai iolie tant com vivrai
5	Ele m'a navree la bele. Ele m'a navree
	D'un chapiau de violete que la m'a doune.
4	He amouretes m'ocirres vous donc?

She, whose sweetheart I am, is pretty and gay; on account of her love I will be joyful as long as I shall live. She has wounded me, the fair one, she has wounded me with a crown of violets that she gave me. Hey, love, will you kill me then?

TABLE 10.2. Texts created by combining the refrains in the tenor *CIS A CUI*. Translations adapted from *The Montpellier Codex*, ed. by Tischler, Stakel, and Relihan, IV, 94.

Refrains 3 ('Diex que ferai du mal'), 6 ('Diex se j'ai'), and 8 ('Diex li douz diex') begin with an address to God. If these three are placed together, they form a coherent six-line plea of a male lover, beseeching God to help him with his ungenerous beloved. Another coherent plea is created by joining together refrains 2 ('Vous me le defendés') and 7 ('Se vous et vous'), which begin with the direct address 'vous', with refrain 9 ('Or du destraindre'): a male lover insists to a disapproving third party that he will continue his loving. Finally, a combination of the remaining refrains — 1 ('Cis a cui'), 4 ('He amouretes'), and 5 ('Ele m'a navrée') — establishes the voice of a male lover praising and blaming his beloved in the third person, switching for the final line to a first-person accusation.

Each of these three groups creates a text that would not be unusual in a song, yet the three modes of address are fragmented and spread across the tenor.[39] In its simultaneous, confusing performance of three separate subject positions, this tenor performs a very similar task to the two motets *Mout me fu grief/Robin m'aime/*

PORTARE and *Cil qui m'aime/Quant chantent oisiaus/PORTARE*. In their motet contexts, the sense of the 'Robin m'aime' and 'Quant chant' song lyrics is often lost beneath the cacophony of the simultaneously sung triplum and motetus texts. Likewise, the three different subject positions in the CIS A CUI tenor remain tantalizingly out of reach, hidden by the combination of three people's speech into one text.

There are therefore two three-fold song structures which criss-cross the CIS A CUI tenor, one musical and one textual. The tenor performs an AAB form that is recognized in the upper parts both textually and harmonically; in addition, it also performs a motet-like combination of three typical song texts. Both structures play with the presence of song in motets, commenting on the way that motets shape and misshape quoted song material. Despite this performance of song, the tenor does not perform a pre-existent song voice. Instead, it dangles the 'mirage of the source' for the audience to chase.

Performing Quoted Material, Performing Quotation

Motets perform song in two related, but separate ways. When they perform a pre-existent song voice, they might choose to perform that voice's pre-existence. They achieve this by interacting with processes of quotation, using the song as source material for the motet to gloss. When such songs become the basis for the motet which is built around them, they gain an identity that is simultaneously central to the motet and separate from it. Such a conceptual separation enables song voices to project the 'mirage of the source': because the motets perform the song voice as pre-existent, the burden of discovering the source of the quotation is placed on the audience; they become the 'subject supposed to know'.

Although the behaviour of many motets which treat their song voices as pre-existent is prompted by the fact that these voices did pre-exist their motet context, the two processes can also happen in isolation. Motets can use pre-existent material without performing it as such, subsuming it into the identity of the motet. Alternatively, they can use strategies of quotation to foreground the repeatability of song-like voices that are not actually pre-existent.

The separation between material which is pre-existent and that which is only treated as such requires more nuanced study in the case of thirteenth-century motets. Motets often employ pre-existent materials, including refrains and the plainsong melismas used for tenors. The interpretation of refrains, which have long been conceived as carrying meaning from one context to another, would benefit from seeing quotation as something that could be performed by songs and motets. The hermeneutics of refrains have been studied as being analogous with their chronology. For example, if a refrain began in a certain song and was quoted in a motet, its meaning in the motet must be influenced by its context in the song. Separating actual quotation from the musical and textual techniques that often accompany quotation adds a level of nuance to this process: placing the emphasis on the perception of quotation rather than on the action of quotation might allow for different interpretations of refrains to stand simultaneously, without knowing which context of the refrain was the original and which the quotation.[40]

Notes to Chapter 10

1. Yvonne Rokseth, *Polyphonies du XIIIe siècle: le Manuscrit H 196 de la Faculté de médecine de Montpellier*, 4 vols (Paris: Éditions de l'Oiseau Lyre, 1935), IV, 44–45; *The Montpellier Codex*, ed. by Hans Tischler, Susan Stakel, and Joel C. Relihan, 4 vols, Recent Researches in the Music of the Middle Ages and Early Renaissance, II–VIII (Madison, WI: A-R Editions, 1978), I, xxxii–xxxiii; Christopher Page, 'Polyphony before 1400', in *Performance Practice: Music before 1600*, ed. by Howard Mayer Brown and Stanley Sadie (London: Macmillan, 1989), pp. 79–104 (pp. 90–91).

2. Christopher Page, *Discarding Images: Reflections on Music and Culture in Medieval France* (Oxford: Clarendon Press, 1993), Chapters 2–3; see also Emma Dillon, *The Sense of Sound: Musical Meaning in France, 1260–1330* (New York: Oxford University Press, 2012), Chapters 1–2, & 8; Ardis Butterfield, 'The Language of Medieval Music: Two Thirteenth-Century Motets', *Plainsong and Medieval Music*, 2 (1993), 1–16.

3. Sylvia Huot, *Allegorical Play in the Old French Motet: The Sacred and the Profane in Thirteenth-Century Polyphony* (Stanford, CA: Stanford University Press, 1997). The principle of close intertextual reading has also found resonance in later scholarship: David J. Rothenberg, *The Flower of Paradise: Marian Devotion and Secular Song in Medieval and Renaissance Music* (New York: Oxford University Press, 2011), Chapters 2–3.

4. Suzannah Clark, '"S'en dirai chançonete": Hearing Text and Music in a Medieval Motet', *Plainsong and Medieval Music*, 16 (2007), 31–59.

5. Ibid., pp. 44–54.

6. For a full consideration of this corpus of motets and songs, see Matthew P. Thomson, 'Interaction between Polyphonic Motets and Monophonic Songs in the Thirteenth Century' (unpublished doctoral dissertation, University of Oxford, 2016).

7. Numbers that follow each motet voice in brackets refer to that voice's number in Friedrich Ludwig, *Repertorium organorum recentioris et motetorum vetustissimi stili*, ed. by Luther A. Dittmer, 2 vols (Brooklyn, NY: Institute of Medieval Music; Hildesheim: Olms, 1964–78).

8. The motet is found in Montpellier, Faculté de Médecine, MS H. 196, fol. 292r; and Bamberg, Staatsbibliothek, MS Lit. 115, fol. 52v. Mark Everist, *French Motets in the Thirteenth Century: Music, Poetry, and Genre* (Cambridge: Cambridge University Press, 1994), p. 107; Dolores Pesce, 'Beyond Glossing: The Old Made New in *Mout me fu grief/Robin m'aime/Portare*', in *Hearing the Motet: Essays on the Motet of the Middle Ages and Renaissance*, ed. by Dolores Pesce (New York & Oxford: Oxford University Press, 1997), pp. 28–51.

9. Throughout the essay, songs will be referred to by roman type in inverted commas, to differentiate them from motet voices with the same incipit, which will be referred to in italics. The monophonic rondeau 'Robin m'aime' is found in Paris, BnF, MS fr. 25566, fol. 39r, and MS fr. 1569, fol. 140r; Aix-en-Provence, Bibliothèque municipale, MS 166, fol. 1r. For an edition of the *Jeu*, see Adam de la Halle, *Le Jeu de Robin et de Marion*, ed. by Jean Dufournet (Paris: Flammarion, 1989). The text of the motetus and the monophonic rondeau differ slightly. However, the use of the same music and the similarities between the two texts has been sufficient to convince most scholars that these two voices are very closely related, if not the same. See, for example, Everist, *French Motets in the Thirteenth Century*, p. 107; Pesce, 'Beyond Glossing', p. 28.

10. Regular rondeaux are in either six- or eight-line form: aAabAB or ABaAabAB respectively, where upper case letters designate refrain material. See Everist, *French Motets in the Thirteenth Century*, pp. 91–92.

11. In all Parisian chant sources, the melisma used in this motet is texted with the word 'sustinere'. In contrast, the incipit is given as *PORTARE* in almost all polyphonic uses. Pesce has demonstrated this division but shows that in at least one non-Parisian chant source 'portare' is used: Pesce, 'Beyond Glossing', p. 39.

12. Everist, *French Motets in the Thirteenth Century*, p. 107; Pesce, 'Beyond Glossing', p. 29; Jeremy Yudkin, *Music in Medieval Europe* (Englewood Cliffs, NJ: Prentice Hall, 1989), p. 402.

13. Jennifer Saltzstein, 'Relocating the Thirteenth-Century Refrain: Intertextuality, Authority and Origins', *Journal of the Royal Musical Association*, 135 (2010), 245–79 (p. 265); Butterfield, *Poetry and Music in Medieval France*, Chapter 15.

14. In this case, the material that the motet takes from the song is chiefly its form. There are other cases in which a motet may take literary themes or tonal organization from a pre-existent song. See Thomson, 'Interaction between Polyphonic Motets and Monophonic Songs in the Thirteenth Century', Chapter 1.

15. M. M. Bakhtin, 'From the Prehistory of Novelistic Discourse', in *The Dialogic Imagination*, ed. by Holquist, pp. 41–83 (p. 44). Butterfield has applied Bakhtin's concept of citation to refrains: Butterfield, *Poetry and Music in Medieval France*, p. 243. Bakhtin's category of citation is inextricably linked with his concept of 'heteroglossia': the song voice acts as one of the languages in the motet, expressing the author's intentions precisely because it is in a voice that is not the author's own. See Bakhtin, 'Discourse in the Novel', in *The Dialogic Imagination*, ed. by Holquist, pp. 259–422 (p. 324). For another study that uses heteroglossia to analyze the appropriation of someone else's speech in the context of medieval literature, see Chimène Bateman, 'Irrepressible Malebouche: Voice, Citation and Polyphony in the *Roman de la Rose*', *Cahiers de recherches médiévales et humanistes*, 22 (2011), 9–23.

16. Roger Dragonetti, *Le Mirage des sources: l'art du faux dans le roman médiéval* (Paris: Seuil, 1987).

17. Sarah Kay, *Parrots and Nightingales: Troubadour Quotations and the Development of European Poetry* (Philadelphia: University of Pennsylvania Press, 2013), p. 17.

18. Ibid., p. 19. For more detail on the role of the 'sujet supposé savoir' in this process, see Sarah Kay, 'Knowledge and Truth in Quotations from the Troubadours: Matfre Ermengaud, Compagnon, Lyotard, Lacan', *Australian Journal of French Studies*, 46 (2009), 178–90.

19. 'Robin m'aime' is not the only quoted material in the motet. The triplum voice contains four sections that are also found in the triplum of the motet *Mout me fu grief* (196)/*In omni fratre* (197)/*IN SECULUM* (M13). See Ludwig, *Repertorium*, I, 433–34; Thomson, 'Interaction between Polyphonic Motets and Monophonic Songs in the Thirteenth Century', p. 41, n. 38.

20. See note 11.

21. In this chapter, pitches are designated according to the Guidonian gamut. Pitches in upper case letters (*graves*) run from the *A* an octave and a third below modern middle *C* to the *G* below middle *C*. Lower case letters designate the next octave (*acutes*), from *a* to *g*. Any note from the next octave (*superacutes*) is designated by doubled letters (*aa*–*gg*).

22. Pesce, 'Beyond Glossing', p. 29.

23. Ludwig, *Repertorium*, I, 432.

24. The song is referred to as 'Quant chant' and the motet as *Quant chantent*, following the pattern set out in note 9. The motet is found in Paris, BnF, MS n.a.f. 13521, fol. 386. The song appears in three manuscripts: Vatican, Biblioteca Apostolica Vaticana, MS reg. lat. 1490, fol. 42v; Paris, BnF, MS fr. 844, fol. 153r, and MS 12615, fol. 97r. The ascription to Richard is found in all three sources.

25. Letters in the text denoting musical motives are in bold type in order to differentiate them from pitches, which are given in italics, and formal analyses, which are given in roman type.

26. *Songs of the Troubadours and Trouvères: An Anthology of Poems and Melodies,* ed. by Samuel N. Rosenberg, Margaret Switten, and Gérard Le Vot (New York & London: Garland, 1998), p. 117.

27. *Qui amours veut maintenir*/*Li dous pensers*/*CIS A CUI* is found in three manuscripts: MS H. 196, fol. 314r; MS Lit. 115, fol. 32v; Turin, Biblioteca Reale, MS Vari 42, fol. 28r.

28. The term 'refrain cento' was originally coined by Rudolf Adelbert Meyer, 'Die in den Motetten enthaltenen Refrains', in *Die altfranzösischen Motette der Bamberger Handschrift nebst einem Anhang, enthaltend altfranzösische Motette aus anderen deutschen Handschriften mit Anmerkungen und Glossar*, Gesellschaft für romanische Literatur, ed. by Albert Stimming, XIII (Dresden: Gesellschaft für romanische Literatur, 1906), pp. 141–84. For a historiographical critique of this term, see Everist, *French Motets in the Thirteenth Century*, Chapter 6.

29. Jacquemart Gielée, *Renart le nouvel*, ed. by Henri Roussel, Publications de la société des anciens textes français (Paris: A. & J. Picard, 1961); John Haines, *Satire in the Songs of Renart le Nouvel* (Geneva: Droz, 2010); *Le Court d'amours de Mahieu le Poirier et la suite anonyme de la 'Court d'amours'*, ed. by Terence Scully (Waterloo, ON: Wilfrid Laurier University Press, 1976); Eglal Doss-Quinby, 'Chix refrains fu bien respondus: Les Refrains dans la "*Suite anonyme de la Court d'amours*" de Mahieu le Poirier', *Romance Notes*, 28 (1987/88), 125–35.

30. See Haines, *Satire in the Songs of Renart le Nouvel*, pp. 292 & 335. The single manuscript for the continuation of the *Court d'amours* (Paris, BnF, MS n.a.f. 1731) does not have musical notation, although it may have been intended, as the scribe left space between lines that contained refrains; see Everist, *French Motets in the Thirteenth Century*, p. 122, n. 43.

31. Beverly J. Evans has argued against the possibility of such a division: Beverly J. Evans, 'The Unity of Text and Music in the Late Thirteenth-Century French Motet: A Study of Selected Works from the Montpellier Manuscript, Fascicle 7' (unpublished doctoral dissertation, University of Pennsylvania, 1983), p. 231.

32. Ibid., p. 241.

33. Numbers with the prefix 'vdB' refer to a refrain's place in Nico van den Boogaard, *Rondeaux et refrains du XIIe siècle au début du XIVe*, Bibliothèque française et romane, D: III (Paris: Klincksieck, 1969).

34. This motet is found uniquely in MS H. 196, fols 301v–04v. The tenor consists of the music of refrain 1 ('Cis a cui') repeated six times.

35. The motetus changes the gender of the speaker, who at the opening of the tenor had been feminine, to a masculine *je*. Evans has argued that this point in the motet establishes 'an intertextual nexus from which a complete network of signs for "ele", the masculine *je parlant*, and even the "others" seem to radiate', Evans, 'The Unity of Text and Music', p. 246.

36. The modern B-flat is denoted here with *b fa* in order to avoid confusion with *bb*, a note in the *superacute* range.

37. Chords are designated from the lowest voice on the score upwards, regardless of which voice is actually higher. Hence, in this case (*c/c/g*), the tenor and motetus are both singing *c* in the *acutes* and the triplum is singing *g*, also in the *acutes*.

38. Evans, 'The Unity of Text and Music', p. 232.

39. Evans shows that the order in which the refrains appear in the tenor is determined by sets of linguistic associations: Evans, 'The Unity of Text and Music', p. 235.

40. For a preliminary development of such a model for refrain hermeneutics, see Thomson, 'Interaction between Polyphonic Motets and Monophonic Songs in the Thirteenth Century', Chapter 5.

CHAPTER 11

Performing Minnesang:
Editing 'Loybere risen'

Henry Hope

Minnesang, the German song repertoire of the late twelfth to the early fourteenth centuries, has found little sustained interest among music scholars since the 1970s. Two of the most prolific musicologists in this field of study, Friedrich Gennrich and his former student Ursula Aarburg, died in 1967.[1] While Gennrich's other students, including Werner Bittinger and Johann Schubert, focused their interests on other periods of music history, Ewald Jammers continued to publish on Minnesang in and beyond the 1970s.[2] Jammers's work, however, found very little echo within musicology: the former manuscript curator and later deputy director at the University Library in Heidelberg had no doctoral students of his own and arguably stood outside the close-knit circles of German academia.[3]

One possible, additional reason for the historiographical development that excluded Minnesang from wider musicological discourse in the late twentieth century is the 'monopoly' on the topic held by Horst Brunner. Indicative of Brunner's prominence is his single-handed contribution of the essential articles related to medieval German song to the second edition of *Die Musik in Geschichte und Gegenwart*, as well as his seminal monographs and the *Repertorium der Sangsprüche* (supported by an edition of all extant melodies for the so-called *Spruch* genre).[4] Even though other scholars such as Ulrich Müller, James V. McMahon, and Marc Lewon have also contributed significantly to the discussion of Minnesang's music over the last decades, Brunner's contribution is the most comprehensive and prominently placed.[5]

It is striking that these scholars have a background in German studies, and the relative reluctance of musicologists without the requisite skills in Middle High German or a broad training in literature to engage with Minnesang points to another set of reasons for the current musicological disinterest in this repertoire.[6] On the one hand, much of the twentieth-century debate on Minnesang concerned its rhythm and the role of contrafacture in its development. The arguments on both issues were constructed with intricate reference to the metre and versification of Middle High German, alienating musicologists without such knowledge from the debate. On the other, Minnesang is shrouded by the persistent historiographical trope that very few traces of its music and performance survive. Burkhard Kippenberg, for example, noted that 'by contrast with the text transmission and with the rich legacy of trouvère melodies, the musical transmission of early and high

Minnesang (*c.* 1150–1300) is extremely slender'.[7] Likewise, Horst Brunner has emphasized that 'the lack of sources prohibits writing even the most rudimentary music history of Minnesang'.[8]

At least two phenomena oppose this negative historiographical evaluation of Minnesang's musical facets: the so-called Jena Songbook (Jena, Thüringer Universitäts- und Landesbibliothek, MS El. f. 101; hereafter J), and modern traditions of performing Minnesang. Although its precise dating and provenance remain contested, 'J offers the most comprehensive musical documentation of secular song from the German speaking world of the fourteenth century'.[9] In contrast to the other main sources of Minnesang, such as the Codex Manesse (Heidelberg, Universitätsbibliothek, MS Cod. pal. germ. 848), J originates from the north-east of Germany and contains a total of ninety-one melodies in square notation.[10] By and large, however, music scholars have ignored this corpus of music, as the melodies are associated with didactic, moralizing texts of the *Spruch*, rather than with the courtly love lyrics of the *Lied* genre.[11] In the case of Bruder Wernher, Brunner suggested that 'the melodies [of his *Sprüche*] have little idiomatic character. This feature, however, seems to have made them particularly suited as a vehicle for text declamation — the *Spruch* poet's central concern'.[12]

The renewed performance traditions of a number of songs similarly problematize the view of Minnesang as a non-musical repertoire. While performances and recordings of Walther von der Vogelweide's 'Nu alrest lebe ich mir werde', widely known as the *Palästinalied*, outnumber those of any other German song, two other frequently recorded songs of the repertoire are notated in J.[13] 'Der kuninc rodolp' is representative of J as a whole: its political, satirizing content is typical of the manuscript's predominant genre; and it is transmitted in the main corpus of the manuscript, where it is attributed to a named author (Der Unverzagte).[14] 'Loybere risen', in contrast, is strikingly uncharacteristic of J: it is contained in the manuscript's eleventh gathering which was inserted into the source after it had been completed, possibly around 1350; it encompasses only two stanzas of text, although the scribe left room for the addition of a third stanza; it is not firmly attributed to a named author, even though scholars have sought to ascribe all of the songs in the added gathering to a 'Wizlav' because this name is found in three of its stanzas; and, finally, the text of 'Loybere risen' is a prototypical *Lied*, not a *Spruch*.[15]

Their differences notwithstanding, 'Der kuninc rodolp' and 'Loybere risen' share one aspect which has been crucial to their elevated reception. They are two of three songs which were arranged as modern *Kunstlieder* in the earliest attempt at providing a comprehensive study and edition of Minnesang by Friedrich Heinrich von der Hagen in 1838.[16] Both songs have been edited numerous times since and, as suggested above, have consequently featured prominently on modern recordings. This essay traces the editorial history of 'Loybere risen', outlining the ways in which modern editors sought to present this song.[17] The editions perform the song by placing it into new contexts, by rendering it in new notational clothing, and by evoking as well as enabling performance proper. They enact the song and carry it into effect, making a range of editorial choices in order to do so. Editions act as agents of the song, bringing it to the attention of modern audiences and shaping the

way in which we understand Minnesang.[18] By engaging with editions of 'Loybere risen', this essay traces the song's continued performativity — beyond the notation in its medieval source, which itself points to the song's performance in the past.

Editing 'Loybere risen'

As a whole, J has been presented to modern readers seven times since the manuscript's rediscovery by Basilius Christian Bernhard Wiedeburg in 1754 (see Table 11.1).[19] Despite Johann Gottfried Herder's call for an edition of the manuscript, it was not until von der Hagen's comprehensive study of 1838 that J first appeared in edited form.[20] Even though they claim to present the complete songbook, many of these transcriptions and facsimiles are actually incomplete: that by von der Hagen, for example, uses J only for those stanzas which are unique to this source; and the diplomatic transcription provided by Ferdinand Sotzmann for von der Hagen's publication includes only the stanzas underlaid to notation, not the text-only ones. Julián Tarragó Ribera's edition of 1925, in turn, transcribes only the melodies.[21] Friedrich Gennrich's facsimile of 1963 reproduces only the folios which feature musical notation; like von der Hagen, he excludes all folios which contain text only.[22]

Date	Author(s)	Title	Type/Comments
1838	Friedrich Heinrich von der Hagen	*Minnesinger: Deutsche Liederdichter des zwölften, dreizehnten und vierzehnten Jahrhunderts*	Diplomatic transcription, stanzas with music only (Ferdinand Sotzmann); modern transcription of three songs (E. Fischer); critical commentary
1896	Karl Konrad Müller	*Die Jenaer Liederhandschrift in Lichtdruck*	Full-size, true facsimile
1901	Georg Holz, Franz Saran, Eduard Bernoulli	*Die Jenaer Liederhandschrift*	Diplomatic transcription (Holz); modern transcription (Bernoulli); critical commentary (Saran, Bernoulli)
1925	Julián Tarragó Ribera	*90 canciones de los minnesinger del códice de Jena*	Modern transcription; melodies only
1963	Friedrich Gennrich	*Die Jenaer Liederhandschrift: Faksimile-Ausgabe ihrer Melodien*	Black-and-white, small-size facsimile; folios with music only
1972	Helmut Tervooren, Ulrich Müller	*Die Jenaer Liederhandschrift*	Complete black-and-white facsimile
2007	[Thüringische Universitäts- und Landesbibliothek Jena]	[Die Jenaer Liederhandschrift]	Digital facsimile; freely available online, <http://archive.thulb.uni-jena.de/hisbest/receive/HisBest_cbu_00008190> [acc. 8 August 2017]

TABLE 11.1. Complete facsimiles/transcriptions of J

Given the intended objectivity of facsimiles and diplomatic transcriptions, it is striking that J has been presented in this way as many as six times. Perhaps even more curious is the observation that there are only two editions which transcribe J into modern notation in its entirety: those of Holz/Saran/Bernoulli and Ribera.[23] Thus, even in the seemingly identical intentions to present J as a whole, 'Loybere risen' has been situated and performed in different ways. The facsimiles and diplomatic transcriptions reveal *editorial* choices, exemplifying James Grier's claim that they afford 'editors the opportunity to revise and correct the text according to their critical investigations of the work and its sources. The procedure by which the text is established is a matter for the individual editor to decide'.[24] In the following, I focus only on modern transcriptions of 'Loybere risen'. Doing so allows insight into an even broader range of editorial contexts and adds further examples to the skeletal backdrop outlined by the complete editions of J. Table 11.2 presents a comprehensive (though likely incomplete) list of transcriptions of 'Loybere risen'. Their contexts can be grouped into three broad categories: full transcriptions of J, anthologies, and individual pieces of scholarship.

As part of his four-volume life and works of the Minnesänger, von der Hagen commissioned Prof. E. Fischer to comment on the musical features. While Fischer is never referred to by his full name in von der Hagen's study, it is likely that the person in question was Gottfried Emil Fischer.[25] He taught at the Gymnasium zum grauen Kloster in Berlin, composed a number of songs and chorales for use in schools, and published some musicological/music pedagogical work.[26] In addition to the musicological commentary, Fischer prepared modern transcriptions of three pieces for von der Hagen's project: 'Der kuninc rodolp' by Der Unverzagte, as well as two songs from the eleventh gathering of J: 'De erde ist untslozen' and 'Loybere risen'.

'Loybere risen' is the first of Fischer's three transcriptions, appended to the final volume of von der Hagen's work (Figure 11.1). It attempts to bring the song into his present (the first half of the nineteenth century) as well as to emphasize its historical displacement. Fischer's decision to arrange the song with piano accompaniment turns it into a *Kunstlied*-setting. The notion of situating 'Loybere risen' within the aesthetics of the present is corroborated by the use of a fixed key-signature and modern clefs, as well as fixed rhythms and modern metres. The conflation of the A section, the so-called *Stollen*, into a single repeated line rather than maintaining the written-out format of the manuscript further supports this impression. Fischer edits only the first stanza (transmitted with music), dropping the second (text-only). One may wonder whether Fischer used J itself for his arrangement, or whether he relied on the transcription by Sotzmann, which omits the text-only stanza. Though these features seem to modernize the song, they also serve to highlight its difference from contemporary traditions. The transcription shifts between a metre of 3/4 and 2/4 twice, lacking the metrical consistency of romantic art-songs. The lack of bar lines between the three bars of 2/4 further underlines the oddness of this metrical shift. The key-signature also provides a distancing element: Fischer notates three b-flat accidentals at the beginning of the B section (the *Abgesang*), even though doing so is superfluous given the F major key-signature. The very simple harmonization

Date	Author(s)	Contained in	Context
1838	Gottfried Emil (?) Fischer	*Minnesinger: Deutsche Liederdichter des zwölften, dreizehnten und vierzehnten Jahrhunderts*	Three transcriptions appended to full diplomatic transcription of J and critical commentary
1901	Eduard Bernoulli, Franz Saran	*Die Jenaer Liederhandschrift*	Transcription (alongside diplomatic transcription) of J
1905	Hugo Riemann	*Handbuch der Musikgeschichte*	Historical overview of medieval music
1925	Julián Tarragó Ribera	*90 canciones de los minnesinger del códice de Jena*	Full transcription of J
1948/50	Friedrich Gennrich	Liedkontrafaktur in mittelhochdeutscher und althochdeutscher Zeit	Journal article on contrafacture
1951	Friedrich Gennrich	*Troubadours, Trouvères, Minne- und Meistergesang*	International anthology of medieval vernacular song
1958	Margarete Lang, Walter Salmen	*Ostdeutscher Minnesang*	Regional anthology of Minnesang
1963	Ewald Jammers	*Ausgewählte Melodien des Minnesangs*	Anthology of Minnesang
1967	Wesley Thomas, Barbara Garvey Seagrave	*The Songs of the Minnesinger, Prince Wizlaw of Rügen*	Complete edition of songs by Wizlav von Rügen
1968	Hugo Moser, Joseph Müller-Blattau	*Deutsche Lieder des Mittelalters: von Walther von der Vogelweide bis zum Lochamer Liederbuch*	Anthology of Minnesang, including substantial selection from J
2002	Mark Emanuel Amtstätter	Ihc wil singhen in der nuwen wise eyn lit: die Sub-Strophik Wizlavs von Rügen und die Einheit von Wort und Ton im Minnesang	Journal article on the relationship between text and music, focusing on Wizlav's songs

TABLE 11.2. Transcriptions of 'Loybere risen'

FIG. 11.1. Fischer's transcription of 'Loybere risen'

provided by Fischer — consisting almost exclusively of tonic, subdominant, and dominant chords within a rigid metrical frame — likewise questions the modernity of 'Loybere risen'. Particularly noteworthy is the static, four-fold repetition of the F major chord which opens the *Abgesang*, a simplicity which might be understood in light of the late eighteenth-century phenomenon that Walter Wiora has termed 'kunstloses Kunstlied' [artless art-song].[27] Fischer's decision to present the piece anonymously and title it as 'No. 1' provides little potential for its performers to claim ownership of the song.

The transcription of 'Loybere risen' presented by Georg Holz, Franz Saran, and Eduard Bernoulli in 1901 distances the song even more starkly, as their edition is intended primarily for academic study rather than live performance (Figure 11.2). The authors and their text stanzas are numbered throughout the source and so are the individual sections of the songs. The tonality of 'Loybere risen' is classified as 'Lydian' at the beginning of the piece, and accidentals not included in the manuscript are added in brackets above the stave rather than being subsumed into a key-signature of F major. There is no explicit indication of metre, although the song is grouped into semibreve-bars. Editorial comments are inserted into the transcription with footnote markers. For example, 'dem' is emended to 'den' in the first line, and Saran notes that the music of the fourth section is almost identical to the *Stollen*. As in Fischer's rendition, the Middle High German text has been retained with its superscript letters and the text-only stanza is not included. Bernoulli adds little dots over text-syllables which ought to be elided, for example on 'man<i>gher' at the beginning of the *Abgesang*. Moreover, Bernoulli's transcription is annotated with different types of lines above the stave in order to clarify the song's structural design.[28] The minim is the basic temporal value in this transcription whereas Fischer's used the crotchet. As a result, Bernoulli's rendition consists entirely of white notes, making the song's appearance very sterile. This whiteness also links the song with the presentation of Renaissance counterpoint in modern editions, perhaps trying to engender some of the latter's authoritative nature and high estimation as art.

Although Bernoulli's transcription can be used for modern performance, its scholarly apparel suggests that enabling the song's performance was not his main concern. Georg Holz underlines the joint edition's academic intent in his introduction to the first volume, which contains his diplomatic transcription of J:

> My transcription of the material contained in J which I present to the public in this study is prompted by the critical essays contained in the second volume: following the two-fold purpose of making the manuscript's melodies palatable to us, and of making use of the extremely rare fact that such melodies are transmitted at all for the theory of Old German metrics, *these essays are to be considered the true core of the entire study* — the diplomatic transcription is only the means to an end.[29]

As in von der Hagen's multi-volume study, however, the critical commentary on the melodies is relegated to the very end, suggesting that the musicological and philological essays do not hold equal stakes in the 'core of the entire study'. The

FIG. 11.2. Bernoulli's transcription of 'Loybere risen'

philologist Saran provided the extensive discussion of rhythm and structure, and insisted that the principles underlying the transcriptions prepared by the musicologist Bernoulli derived from his ideas rather than from musicological considerations.[30] Saran depicted himself as the driving intellectual force while the musicologist's contribution was to be understood as mere craftsmanship.

The second (and final) edition to contain 'Loybere risen' in the context of a full transcription of J was published by Julián Tarragó Ribera in 1925 (Figure 11.3). It contains a mixture of polyphonic and monophonic settings of J's songs, and Ribera orders his study according to the texture of his renditions: first all polyphonic transcriptions, then the monophonic items. Within these two broad categories, he maintains the authorial corpora as found in J. As a result, his 'complete' transcription of J distorts the manuscript's original ordering. Given that he also strips the songs of their texts, it is difficult to find a particular song in his edition. This re-ordering

FIG. 11.3. Ribera's transcription of 'Loybere risen'

FIG. 11.4. Ribera's transcription with fictitious text underlay

suggests that Ribera's endeavour is less an academic venture than an attempt to
bring the songs to the attention of modern performers — a notion corroborated
by the image of a performer with a plucked string instrument on the cover of his
volume. There are no critical annotations within the transcription itself. They
are, instead, separated from the transcriptions and very brief, limited to comments
on overall tonality and rhythm. Ribera's remarks on 'Loybere risen' emphasize
his reliance on aesthetic rather than historical justifications. Discussing the song's
tonality, he notes that it is 'very beautiful, and even richer in harmony when the
motifs are set in minor key'.[31] Consequently, he renders the melody within an F
minor key-signature — to my knowledge, the only edition to favour a minor over
a major presentation of 'Loybere risen'.

Given the prevalence of music-aesthetic criteria for his editorial decisions, Ribera
aims to present the melody in as modern a fashion as possible. The transcription
adheres to a metre of 2/4 throughout, uses a treble clef, and indicates the repeated
A section at the end of the song as a da capo return rather than notating it in full
again. Ribera's edition provides rhythmic variety by using four different rhythmical

values (semiquaver, quaver, crotchet, and minim) while Fischer used only three (quaver, crotchet, and minim), and Bernoulli used only two (minim and semibreve). Although monophonic, Ribera's transcription implies a modern tonal framework: the minim beats suggest a tonal development from tonic to dominant and back to the tonic in the A section, and from the parallel major via the dominant to the tonic in the B section. This musical structure is facilitated by Ribera's decision to exclude the text. If it were to be underlaid to his version, its grammatical and metrical emphases would be distorted (Figure 11.4).

The rationale behind Ribera's decision to present the songs without their texts can be related to his claim that Minnesang was influenced heavily by Arab-Andalusian traditions.[32] Such an assertion is illustrated most easily with reference to shared musical idioms. Without their texts, the songs might well be imagined by their users to be no different than the cantigas. Edited with their texts, in contrast, the songs would have looked decidedly German (or French, in the case of Ribera's editions of Romance repertoires), requiring a larger leap of faith from the user to see their origin in Arab-Andalusian practices.

The transcriptions of 'Loybere risen' by Fischer, Bernoulli, and Ribera are representative of their authors' divergent intentions. Von der Hagen provides a comprehensive overview of the Minnesang corpus — its texts, authors, sources, and music — and Fischer's modern transcriptions give an informal sound bite of these songs to modern audiences. Holz/Saran/Bernoulli have a structural interest in Minnesang and hope to ascertain its generative features. Their transcriptions form the basis of analytical scrutiny. Ribera uses the melodies to demonstrate his assertion of Arab-Andalusian influence, sharing with von der Hagen/Fischer an interest in the flavour of these melodies rather than their exact design. Spanning a period of eighty-seven years, these three editions of 'Loybere risen' not only present different attitudes towards philology, music editing, and the broad estimation of Minnesang, but they also propose three very different rhythmical solutions to the non-rhythmical square notation of J.[33] Ribera parses the *Stollen* and *Abgesang* into three three-bar phrases each, in a regular metre of 2/4. Bernoulli and Fischer fit regular metrical patterns onto the song's irregular textual accents. Bernoulli's understanding of the song's metre coincides with Burghart Wachinger's notion of 'emphatic accents', while Fischer follows a dactylic reading: Bernoulli's duple metre stresses '**Loy**-*be*-re **ri**-sen' and 'Sus **twing**het de **ri**phe' whereas Fischer's triple metre accents '**Loy**-be-re **ri**-sen' and 'Sus **twing**het de **riphe**'.[34] Both, however, need to make allowances to their basic systems. Fischer shifts into duple time for the second line because there seems to be no elegant way of fitting its regular alternation of stressed and unstressed syllables into a triple metre: '**von** den **boy**men **hin** tzu **tal**'. Bernoulli lengthens the penultimate syllables of the first and third lines in order to make their number of stresses/bars equal to that of the middle line. Moreover, the final line of the *Abgesang* and of the returning *Stollen* fall out of Bernoulli's regular four-bar pattern because of their additional textual accents.

Bernoulli's attempt to render 'Loybere risen' in regular four-bar phrases is reminiscent of Hugo Riemann's much criticized theory of *Vierhebigkeit*.[35] Riemann

3. (Jenaer LHS. fol. 80 b.)

Loy - be - re ri - sen Von den boy - men hin tzů tal
Blo-men sich wi - sen Daz se sint vůr - tor - ben al

Des stan blot ir e - ste. Sus twinghet de ri - phe
Sco - ne was ir gle - ste.

Ma - ni - gher han - de wŕt - zel sal. Des bin ich ghar se - re be-

trů - bet. Nů ich tzů gri - phe, Sint der win - der

ist so kal Des wird nu - we vroy-de ghe - ů - bet.

(2 Strophen)

FIG. 11.5. Riemann's transcription of 'Loybere risen'

provided a transcription of 'Loybere risen' in his multi-volume music history (Figure 11.5). It is in 4/4, although it does not include an explicit time-signature. Each verse is contained within two bars, providing a total of four beats per verse (*vier-hebig*). In order to fit the over-long lines of the *Abgesang* into two bars, Riemann slows down its third line as well as the end of the song's final line, breaking them into two half-verses of two bars each rather than deviating from the regular musical phrase-length like Bernoulli. Another characteristic feature of Riemann's transcription is the unique opening rhythm. Instead of lengthening the song's first syllable, he emphasizes the final syllable of 'Loybe**re**'. Riemann himself underlines the characteristic, systematic nature of his transcription, noting that 'transferring his reading to the other songs of the manuscript, published in a number of editions (von der Hagen, Müller, and Holz/Saran/Bernoulli), causes no difficulties'.[36] His transcription is also noteworthy for being the only one to specify b-natural explicitly in those cases in which the manuscript does not notate a flat sign. Finally, Riemann is the first to indicate within the transcription itself that 'Loybere risen' encompasses two stanzas, though he too fails to include the text-only one.

A second system of rhythmic transcription applied widely to repertoires of medieval vernacular song in the first half of the twentieth century was modal

FIG. 11.6. Gennrich's 1951 transcription of 'Loybere risen'

theory. The most fervent advocate for applying this rhythmic model to Minne-sang was Friedrich Gennrich, who claimed that his teacher Friedrich Ludwig had been the first to suggest using this model, derived from French sources of poly-phonic music, for monophonic German music.[37] In 1951, Gennrich presented an edition of 'Loybere risen' as part of his international anthology of medieval songs (Figure 11.6).[38] He had already transcribed this song as part of an article on processes of contrafacture (Figure 11.7), where he used it to demonstrate that the 'medieval rhythmic modes certainly provided no "straightjacket" for this poetry, but that musical rhythm and texts correlated with each other'.[39] In both cases, Gennrich rendered the song in a consistent compound metre of 6/4 — the 'unusual pattern of the irregular fifth mode' — because 'the alternation of two, three, four, and five syllables per bar can be accommodated without any problem in this rhythmic mode'.[40] In the earlier edition, small Greek letters above the stave indicate the music's motivic design, providing a shorthand analysis. These annotations are omitted in the anthology edition, where Gennrich instead includes the text of the second stanza. Neither of his editions, however, provides a modern translation of the text: in the article, the song is located firmly within an academic sphere — to be analyzed and dissected; in the anthology, it is showcased alongside other exhibits from the past — to be admired and performed, but not scrutinized or understood.

The anthology of German songs co-edited by Hugo Moser and Joseph Müller-Blattau conflates the divergent aims of Gennrich's two publications into a single transcription of 'Loybere risen' (Figure 11.8), leaving it curiously suspended between academic considerations and performance. Moser/Müller-Blattau eschew any extended critical introduction, placing the songs and their performance centre-stage: 'the knowledgeable user will experience that all of these songs reveal their vitality [Lebendigkeit] and Gestalt only when sung — and with all stanzas'.[41]

FIG. 11.7. Gennrich's 1948/50 transcription of 'Loybere risen'

Their volume is ordered chronologically, 'from Walther von der Vogelweide to the Lochamer Liederbuch', and may therefore have proven particularly useful in a classroom context.[42] Some of the songs come with translations, 'intended to make the edition more easily useable for the non-Germanist', and the untranslated songs such as 'Loybere risen' include a glossary for the most difficult vocabulary at the end of the transcription.[43]

In contrast to these user-friendly aids, Moser/Müller-Blattau's transcription includes a number of features which would have struck inexperienced users as odd: there is no key- or time-signature and the bar lines are merely tentative; a number of rests are inserted into the melody in brackets; and, with few exceptions, each note is given equal duration, resulting in a rather rigid, uninspired rhythm. These elements might be understood as an attempt to maintain at least a minimal degree of scholarliness. Avoiding fixed metrical systems shows an awareness of the concomitant problems of rhythmic transcription, placing Moser/Müller-Blattau beyond criticism in this respect. Similarly, their use of Ludwig Ettmüller's Low German phonetic text transcription ('Lautgestalt') of 'Loybere risen' rather than the Middle High German form found in J demonstrates their desire to base the rendition on a critically edited text.[44] This academic guise is further supported by the brief editorial comments at the end of the volume, which note the song's textual emendations.

Closely akin to Moser/Müller-Blattau's transcription is the earlier publication by Margarete Lang and Walter Salmen, which gathers together songs associated with

VII

Lö - ve - re rī - set van den bö - men
blö - men sich wī - set, dat sē sint vor -

hin tō dāl. des stāt blōt er e - ste.
dor - ven al. schō - ne was er gle - ste.

sus dwin - ghet dē rī - pe mannigher han - de wor - tel

sal. des bin ik ghar sē - re be - drō - vet.

nū ik tō grī - pe, sint dē win - der

is sō kal, des wirt nū - we vroude ghe - ō - vet.

1 Lövere rīset
 van den bömen hin tō dāl.
 des stāt blōt er este.
 blömen sich wīset,
5 dat sē sint vordorven al.
 schōne was er gleste.
 sus dwinghet dē rīpe
 mannigher hande wortel sal.
 des bin ik ghar sēre bedrövet.
10 nū ik tō grīpe,
 sint dē winder is sō kal,
 des wirt nūwe vroude gheōvet.

2 Helpet mī schallen
 hundert dūsent vrouden mēr
 wen des méijen blōte kan bringhen.
 rōsen dē vallen
5 an mīr vrouwen rōder lēr.
 dar van wil ik singhen.
 dwīngt mī dē kulde,
 aller worteln smackes gher,
 dē sint an er līve ghestrouwet.
10 worve ik er hulde,
 sōn bedrocht ik vrouden mēr.
 sus dē minncklīke mī vrouwet.

1, 1 Laub fällt. 4 f. zeigen sich verwelkt. 6 *gleste* Glanz. 7 f. so macht der Reif viele Kräuter welk.
10 *tō grīpe* anfange. 12 *gheōvet* geübt. 2, 3 *wen* als. 5 *mīr* meiner, *lēr* Wange. 7 *dwingt* quält. 8 f. Alle
Kräuter, deren Duft man wünschen kann, sind über ihren Leib gestreut. 10 *worve* erwürbe.
11 *bedrocht* bedürfte.

FIG. 11.8. Moser/Müller-Blattau's transcription of 'Loybere risen'

Lô - ve - re ri - set van den bô-men hin to dal:
blô-men sich wî - set, dat se sint vor-dor-ven al:

des stât blôt er e - ste.
scô - ne was er gle - ste.

sus dwinget de rî - pe mannicher han-de wor-tel sal:

des bin ic gar sê - re be - drô-vet.

nu ic tô grî-pe; sint de win-der is sô kal,

des wirt nû-we frou-de ge - ô-vet.

Helpet mî scallen
hundert dûsent frouden mêr
wen de mei kan bringen:
rôsen de vallen
an mîr frôwen rôder lêr,
dâr van wil ic singen.
dwingt mî de kulde,
aller wortel smackes gêr
die sint an er live gestrôwet.
worve ic er hulde,
son bedrocht ic frouden mêr:
sus de minnechlike mî frôwet.

Laub schwebet leise
von den Bäumen hin zu Tal,
leer stehn nun die Äste.
Welkenderweise
Blumen sind verdorben all,
glänzten einst aufs beste.
Nun zwingt der Reife
manches Kräutlein überall;
Sehr betrübt mich, was da dräuet.
Suchend ich streife:
da der Winter ist so kahl,
andre Freude wird erneuet.

Rühmt mir mit Schallen
hunderttausend Freuden mehr,
als der Mai kann bringen.
Rosen, die fallen
mir von Frauenwangen her,
davon will ich singen.
Zwingt mich der Froste:
was an Würzduft ich begehr,
ist auf ihr Gestalt gestreuet.
Gäb Huld mir Troste,
braucht ich andre Freud nicht mehr:
so die Minnliche mich freuet.

FIG. 11.9. Lang/Salmen's transcription of 'Loybere risen'

north-eastern regions of Germany (Figure 11.9).[45] Again, bar lines are included only tentatively, and the time-signature is questioned by its presentation in brackets. Despite the employment of stemless note-heads in order to avoid a fixed rhythm, the visual appearance of Lang/Salmen's transcription implies an equalist reading similar to that of Moser/Müller-Blattau. Lang/Salmen also use the standardized text by Ettmüller and include both stanzas of text. Although furnished with only a few critical remarks, Lang/Salmen's volume includes a very brief introduction to Wizlav von Rügen and points to some relevant secondary materials. This transcription seems to have been the first to provide a modern German translation alongside the notated melody. Salmen captures the ambivalent status of the edition succinctly in his commentary: 'the present rendition leaves sufficient space for the wide range of interpretative possibilities but at the same time tries to emphasize the characteristic traits [*Gestalten*], without enforcing a uniform system that is to apply to all melodies'.[46]

Even more space for imagination is left to the user by Ewald Jammers in his anthology of Minnesang (Figure 11.10).[47] The handwritten presentation of the notation — the text is type-set — questions the transcription's authoritative status. Jammers resists the inclusion of bar-lines or a key-signature but he does propose an F major tonality by adding flats to all but one b (arguably still inflected by the flat sign earlier in the same line). Like Lang/Salmen and Moser/Müller-Blattau,

70. WIZLÂW, Jena 80ᵇ

I Loy - be - re ri - sen
II Blo - men sich wi - sen,

Von den boy - men hin tzû tal.
Daz se sint vûr - tor - ben al.

Des stan blot ir e - ste.
Sco - ne was ir gle - ste.

III Sus twin - ghet de ri - phe

Mani - gher han - de wûr - tzel sal.

Des bin ich ghar se - re be - trû - bet

IV Nu ich tzû gri - phe

Sint der win - der ist so kal,

Des wirt nu - we vroy - de ghe - û - het

FIG. 11.10. Jammers's transcription of 'Loybere risen'

Jammers chooses an equalist mode of transcription, lengthening only very few notes and suggesting textual emphasis through arrows and a lambda above the notes. Most striking is his decision to lay out the song by poetic line, visualizing his claim that each line should be viewed as autonomous.[48] His notion of flexibility ('Spielraum') within but not beyond each line is expressed visually in the printing of the staves: these are not limited by the length of the musical notation but encompass the full width of the page, leaving ample empty space. Although Jammers states explicitly that his collection is not designed *for* performance, the detailed instructions to performers at the end of his commentary demonstrate that sounding performance should always be borne in mind when studying these melodies.[49] He stresses the impossibility of an historically accurate performance and that each transcription

80ʳ

MINNESONG XII

Loy - be - re ri - sen. von dem boy - men
men sich wi - sen. daz se sint vuor-

hin tzuo tal. des stan blot ir es - te. Blo-
tor - ben al. sco - ne wast ir gles -

te. Sus twin - ghet de ri - phe. ma - ni - gher han - de

80ᵛ

wuor - tzel sal. des bin ich ghar se - re be - truo - bet.

Nu ich tzuo - gri - phe. sint der win - der

ist so kal. des wirt nu - we vroy-de ghe - uo - bet.

Helphet mir scallen.
hundert tusent vroyden mer.
wen des meyien bluote kan bringhen.
Rosen de vallen.
an mir vrowen roter ler.
da von will ich singhen.
Tuwinct mich de kulde.
al ir wuortzel smaghes ger.
de sint an ir libe ghestrowet.
Worbe ich ir hulde.
so bedrocht ich vroyden mer.
sus de minnighliche mich vrowet.

Leaves fall in showers
down from all the trees around,
limbs are bare and slender.
Look at the flowers
lying withered on the ground
where they bloomed in splendor.
Frost thus has blighted
all the blossoms that were here,
sad am I to lose these treasures.
You are invited,
since the winter is so drear,
now to join me in other pleasures.

Join in my praises
of the charm which far outstrips
joys which May can bring.
Roses she raises
on her lovely cheeks and lips,
and of them I sing.
Though frost may shake me,
from her body comes a scent,
fragrance of blooms and summer breezes.
If she will take me,
I'll lack naught to be content,
she is everything that pleases.

FIG. 11.11. Thomas/Seagrave's transcription of 'Loybere risen'

represents an act of interpretation, but he nevertheless encourages scholars to provide editions of songs such as 'Loybere risen', for 'it is a cowardly flight if the academic leaves the interpretation of the melodies to the lay person'.[50]

Wesley Thomas and Barbara Garvey Seagrave's 1967 transcription of 'Loybere risen' stands apart from the previously discussed renditions in two crucial ways (Figure 11.11).[51] It is the only edition in an Anglophone context and the only complete music-edition of songs ascribed to Wizlav von Rügen. In a collection of Wizlav's entire output, it was necessary to emphasize the value of each individual item, and therefore the authors provide ample commentary on each song. 'Loybere risen', they suggest, 'possesses a grace and purity of style which makes it one of the most appealing of the group'.[52] Notwithstanding the analytical discussion that frames their volume, performance appears to be a central concern for Thomas/Seagrave. Notating the song in a consistent metre of 3/4 — a unique feature of their edition — the authors emphasize that this rhythm should not be understood literally but be performed freely: they hope to 'bring their songs to life in this century with the freshness and vigour which they had in their own day' and consequently include translations into English.[53]

After the three editions of the 1950s and the 1960s, 'Loybere risen' receded from scholarly view. Published almost forty years later, Mark Emanuel Amtstätter's transcription appears not to have generated any new interest in the song (Figure 11.12).[54] Amtstätter assesses the song as part of his discussion of the relationship between text and music in Minnesang. He lays out 'Loybere risen' by section, using stemless note-heads without any indication of metre. The caption 'Notenbeispiel' [music example] suggests that the transcription functions primarily to illustrate the discussion, not as a stand-alone edition of the song as an aesthetic entity.[55] Amtstätter's transcription makes as few impositions as possible, allowing the user a maximum of interpretative freedom. For Jammers, however, this lack of interference may have resembled a 'cowardly flight': Amtstätter retreats from the debates about the song's rhythm and takes up the position of a neutral observer.[56] Such a disinvested stance is unlikely to arouse a critical reaction from other scholars and might therefore be one of the reasons why Amtstätter's transcription failed to re-invigorate scholarly discourse on 'Loybere risen'.

Plural Paradigms: Performing 'Loybere risen'

Amtstätter's retreat from the debate surrounding the rhythm of Minnesang evokes the central methodological conundrum of how the transcriptions studied in this essay can be compared and assessed beyond the mere observation of diverging choices of rhythm and metre. One consideration enabled by such seemingly superficial scrutiny is the study of the paradigms which lie behind these editions. It affords the opportunity to ask with which other repertoires the editors align the songs — both in their minds and on paper — and what feature predominates their understanding of 'Loybere risen'.

Jammers and Gennrich, for example, adopt two opposing views on the generic models of Minnesang. Gennrich consistently applies modal rhythms to the extant

Notenbeispiel 2

FIG. 11.12. Amtstätter's transcription of 'Loybere risen'

melodies of German song (and those established through contrafacture). This approach rests on the belief that Minnesang is no different from its Romance models, and that monophonic songs use the same rhythmic system that had been developed for polyphonic, (para)liturgical repertoires. Jammers, in contrast, aligns Minnesang with chant. He emphasizes that the melodic lines are end-oriented and free of rigid musical metre, driven towards the cadential closure at the end of each line in a manner reminiscent of the recitation of psalms.[57] These paradigms are reflected in the editions: Gennrich subordinates the texts to the pre-existent modal patterns and shows little concern for the layout of the song on the page; Jammers presents the songs without much rhythmic differentiation, relying on the text to determine flexible emphatic rhythms, and rigidly lays out his edition by text-line.

The preference for textual and musical paradigms is also a useful way to juxtapose Bernoulli's and Riemann's transcriptions of 'Loybere risen'. While the latter adopts the musical ideal of *Vierhebigkeit*, the former seeks to achieve not only structural balance but also declamatory accuracy, consequently deviating from rigid four-bar phrasing in order to accommodate irregularities in the text's versification. Another paradigm at work in Holz/Saran/Bernoulli's project is an analytical one. 'Loybere risen' is edited to be studied as an example of the generic characteristics of Minnesang. Thomas/Seagrave, in turn, transcribe the song in their study in order to gain an understanding of Wizlav's corpus as an author; and Amtstätter's rhythmless transcription, which seeks to emphasize the structural correspondences between text and music, reveals a similar preoccupation with analysis. In contrast, Jammers and Moser/Müller-Blattau stress the importance of an experiential approach through sung performance. Moser/Müller-Blattau, moreover, situate their transcription within a diachronic framework. Like Riemann, they are guided by historical considerations whereas Fischer, Thomas/Seagrave, and Jammers show repertorial concerns for authorship and/or genre. A number of transcriptions also rely on geographical or national paradigms: Lang/Salmen, for example, envisage a characteristically north-eastern form of Minnesang; Gennrich is particularly concerned for the internationality of the vernacular song repertoire as a whole; and Ribera imagines the German song repertoire to be akin to that of Arab-Andalusian traditions.

Gottfried Emil Fischer points to a further, perhaps more fundamental paradigm that may be seen to lie at the root of all transcriptions: the placement of Minnesang along a continuum of familiarity and alterity. On the one hand, Fischer claims that 'the number of melodies which will be pleasing to today's ears and tastes — even when ornamented with a fitting accompaniment and well performed — will be small'.[58] On the other, he later concedes that 'if one has accustomed the ear to these songs by playing and listening to them frequently, then one will find quite a few beautiful elements, though achieved through other means than today'.[59] The transcriptions of 'Loybere risen' may be viewed through the lens of this paradox: they stand at a historical distance *and* establish historical continuity (Fischer, Riemann, Moser/Müller-Blattau); they are geographically distinct *and* hybrid (Lang, Gennrich, Ribera); they assert the song as generically alien *and* familiar (Thomas/Seagrave, Jammers, Gennrich); as an aesthetic entity *and* an object of analytical scrutiny (Amtstätter, Holz/Saran/Bernoulli).[60]

The present study of 'Loybere risen' in its modern transcriptions has outlined some of the plural paradigms that have informed the understanding of the song since the rediscovery of J in the eighteenth century. The song has provided a site of performance for modern users and editors in the same multifaceted way in which the fourteenth-century manuscript source itself may have afforded different kinds of performance.[61] By constructing the song's identity and affording its performance, editors themselves have performed 'Loybere risen'; at the same time, their work draws attention to the modern epistemological gap between the act of editing and sonic performance: Amtstätter, for example, seems not to consider performance a relevant concern for his rhythmless transcription; Holz/Saran/Bernoulli likewise subordinate the sound of performance to the intellectual act of analytical performance. Ribera stands at the other end of this continuum, for his edition achieves its aim of underlining Minnesang's Arab-Andalusian heritage particularly astutely in actual performance: the performed sound of Ribera's minor key transcription can evoke the intended impression of otherness even more strikingly than its visual appearance on the page. Von der Hagen and Jammers, in turn, reveal a particularly fragile position between the poles of editorial and sonic performance. The former provides readers both with sterile diplomatic transcriptions for study as well as with Fischer's modern *Kunstlied*, designed specifically for performance, while Jammers, in turn, urges editors to gear their transcriptions to the needs of performers yet refuses to admit that his own publication constitutes a performance edition.

As suggested at the outset of this essay, Minnesang scholarship has been hampered by a particularly troubled relationship with the repertoire's musicality. The prevalence of medieval sources that transmit the songs without explicit musical notation have provided, time and again, the argumentative arsenal with which to question whether these songs were ever sung or whether they were intended to be read privately, in silence.[62] The editions of 'Loybere risen' show a similarly uneasy relationship between its academic, visual representation and its performance: despite their transcriptions into modern notation, editors have been reluctant to take seriously the sound of songs such as 'Loybere risen'. Strikingly, the editorial interest

in the song waned in the 1970s — at the same time that ensembles began to engage with 'Loybere risen' in performance.[63]

Just as the present volume as a whole has sought to negotiate between different scholarly perspectives on performance, it is worthwhile attempting to reconcile the varying concepts of performance relating to Minnesang, to bring into fruitful dialogue the editorial and sonic performance of songs such as 'Loybere risen'. Doing so promises fresh insights not only into 'Loybere risen' but to the musical, performed nature of Minnesang more generally.

Notes to Chapter 11

1. Ian Bent, 'Gennrich, Friedrich', in *The New Grove Dictionary of Music and Musicians*, ed. by Stanley Sadie, 29 vols (London: Macmillan, 2001), IX, 653–55; Christoph Petzsch, 'Kontrafaktur und Melodietypus', *Die Musikforschung*, 21 (1968), 271–90 (p. 275). Hereafter, the *New Grove Dictionary* is referenced as *NGrove*; its German equivalent — *Die Musik in Geschichte und Gegenwart*, ed. by Ludwig Finscher, 2nd edn, 29 vols (Kassel: Bärenreiter, 1994–2008) — is referenced as *MGG2*.

2. Ewald Jammers, 'Die Manessische Liederhandschrift und die Musik', in *Codex Manesse: die Grosse Heidelberger Liederhandschrift: Kommentar zum Faksimile des Codex Palatinus Germanicus 848 der Universitätsbibliothek Heidelberg*, ed. by Walter Koschorreck and Wilfried Werner (Kassel: Graphische Anstalt für Kunst und Wissenschaft, 1981), pp. 169–87; Ewald Jammers, *Die sangbaren Melodien zu Dichtungen der Manessischen Liederhandschrift* (Wiesbaden: Reichert, 1979).

3. Hans Heinrich Eggebrecht, 'Jammers, Ewald (Karl Hubert Maria)', in *NGrove*, XII, 767–68.

4. Horst Brunner, 'Frauenlob', in *MGG2*, VII (Personenteil), cols 46–48; 'Minnesang', in *MGG2*, VI (Sachteil), cols 302–13; 'Sangspruchdichtung', in *MGG2*, VIII (Sachteil), cols 931–39; 'Walther von der Vogelweide', in *MGG2*, XVII (Personenteil), cols 447–50; and *Spruchsang: die Melodien der Sangspruchdichter des 12. bis 15. Jahrhunderts*, ed. by Horst Brunner and Karl-Günther Hartmann, Monumenta Monodica Medii Aevi, VI (Kassel: Bärenreiter, 2010).

5. Ulrich Müller, 'Beobachtungen zu den "Carmina Burana": 1. Eine Melodie zur Vaganten-Strophe — 2. Walthers "Palästina-Lied" in "versoffenem" Kontext: eine Parodie', *Mittellateinisches Jahrbuch*, 15 (1980), 104–11; James V. McMahon, *The Music of Early Minnesang*, Studies of German Literature, Linguistics, and Culture, ed. by James Hardin and Gunther Holst (Drawer: Camden House, 1990); Marc Lewon, 'Wie klang Minnesang? Eine Skizze zum Klangbild an den Höfen der staufischen Epoche', in *Dichtung und Musik der Stauferzeit: wissenschaftliches Symposium 12. bis 14. November 2010*, ed. by Volker Gallé (Worms: Worms Verlag, 2011), pp. 69–124.

6. A notable exception to this pattern is Lorenz Welker. See Lorenz Welker, 'Melodien und Instrumente', in *Codex Manesse: Katalog zur Ausstellung vom 12. Juni bis 2. Oktober 1988 Universitätsbibliothek Heidelberg*, ed. by Elmar Mittler and Wilfried Werner (Heidelberg: Edition Brauns, 1988), pp. 113–26. While there is ample work on Minnesang by literary scholars, many of these publications are sceptical about the repertoire's musical qualities and avoid the study of its melodies; see Günther Schweikle, *Minnesang*, Sammlung Metzler, 2nd edn (Stuttgart: Metzler, 1995), p. 218.

7. Burkhard Kippenberg, 'Minnesang', in *NGrove*, XVI, 721–30 (p. 725).

8. Brunner, 'Minnesang', col. 311. All translations in this essay are my own.

9. Johannes Rettelbach, 'Die Bauformen der Töne in der "Jenaer" und in der "Kolmarer Liederhandschrift" im Vergleich', in *Die 'Jenaer Liederhandschrift': Codex — Geschichte — Umfeld*, ed. by Jens Haustein and Franz Körndle (Berlin: de Gruyter, 2010), pp. 81–97 (p. 81).

10. Franz-Josef Holznagel, 'Typen der Verschriftlichung mittelhochdeutscher Lyrik vom 12. bis zum 14. Jahrhundert', in *Entstehung und Typen mittelalterlicher Lyrikhandschriften: Akten des Grazer Symposiums 13.–17. Oktober 1999*, ed. by Anton Schwob and András Vizkelety (Bern: Lang, 2001), pp. 107–30.

11. The only substantial study of these melodies is Erdmute Pickerodt-Uthleb, *Die Jenaer*

Liederhandschrift: metrische und musikalische Untersuchungen, Göppinger Arbeiten zur Germanistik, ed. by Ulrich Müller, Franz Hundsnurscher, and Cornelius Sommer, XCIX (Göppingen: Kümmerle, 1975).

12. Horst Brunner, 'Die Töne Bruder Wernhers: Bemerkungen zur Form und zur formgeschichtlichen Stellung', in *Liedstudien: Wolfgang Osthoff zum 60. Geburtstag*, ed. by Martin Just and Reinhard Wiesend (Tutzing: Schneider, 1989), pp. 47–60 (p. 58).

13. Recordings of the *Palästinalied* have been studied in Voigt, 'Gothic und HIP', pp. 221–34.

14. For a study of 'Der kuninc rodolp', see Henry Hope, 'Constructing Minnesang Musically' (unpublished doctoral dissertation, University of Oxford, 2013).

15. For a codicological study of J, see *Die 'Jenaer Liederhandschrift'*, ed. by Haustein and Körndle. Wizlav has been variously spelled as Wizlav and Wizlaw; the present essay adopts the former orthography (except when referencing publication titles) in order to distance itself from the assumption that the Wizlav of J is identical with Prince Wizlaw III of Rügen. See Claudia Händl, 'Wizlav (von Rügen?)', in *Literatur Lexikon: Autoren und Werke deutscher Sprache*, ed. by Walter Killy, 15 vols (Gütersloh: Bertelsmann Lexikon Verlag, 1992), XII, 383–84.

16. Friedrich Heinrich von der Hagen, *Minnesinger: Deutsche Liederdichter des zwölften, dreizehnten und vierzehnten Jahrhunderts*, 4 vols (Leipzig: Barth, 1838).

17. Taking approaches similar to those found in the present essay, Peter Jost and Honey Meconi have outlined the editorial history of Hildegard von Bingen's compositions, though their publications focus on her *oeuvre* as a whole rather than on an individual song; see Peter Jost, 'Zu den Editionen der Gesänge Hildegards von Bingen', in *Mittelalter und Mittelalterrezeption*, ed. by Herbert Schneider, Musikwissenschaftliche Publikationen, ed. by Herbert Schneider, XXIV (Hildesheim: Olms, 2005), pp. 22–53; and Honey Meconi, 'The Unknown Hildegard: Editing, Performance, and Reception (An *Ordo virtutum* in Five Acts)', in *Music in Print and Beyond: Hildegard von Bingen to The Beatles*, ed. by Craig A. Monson and Roberta Montemorra Marvin, Eastman Studies in Music, ed. by Ralph P. Locke (Rochester, NY: University of Rochester Press, 2013), pp. 258–305.

18. The phrases 'to carry into effect' and 'to act as an agent of' are two of the definitions for the term 'to perform' offered in *The Concise Oxford Dictionary of Current English*, ed. by Robert Edward Allen, 8th edn (Oxford: Clarendon Press, 1990), p. 885.

19. Basilius Christian Bernhard Wiedeburg, *Ausführliche Nachricht von einigen alten teutschen poetischen Manuscripten aus dem dreyzehenden und vierzehenden Jahrhunderte, welche in der Jenaischen akademischen Bibliothek aufbehalten werden* (Jena: Melchior, 1754).

20. As quoted in Oliver Huck, 'Die Notation der mehrfach überlieferten Melodien in der "Jenaer Liederhandschrift"', in *Die 'Jenaer Liederhandschrift'*, ed. by Haustein and Körndle, pp. 99–120 (p. 99).

21. *90 canciones de los minnesinger del códice de Jena*, ed. by Julián Tarragó Ribera, La música andaluza medieval en las canciones de trovadores, troveros y minnesinger, III (Madrid: Maestre, 1925).

22. *Die Jenaer Liederhandschrift: Faksimile-Ausgabe ihrer Melodien*, ed. by Friedrich Gennrich, Summa Musica Medii Aevi, ed. by Friedrich Gennrich, XI (Langen bei Frankfurt, 1963).

23. *Die Jenaer Liederhandschrift*, ed. by Georg Holz, Franz Saran, and Eduard Bernoulli, 2 vols (Leipzig: Hirschfeld, 1901). However, Ribera's volume arguably falls out of this category because of its lack of texts.

24. James Grier, 'Editing', in *NGrove*, VII, 885–95 (p. 892).

25. [Gottfried Emil] Fischer, 'Ueber die Musik der Minnesänger', in *Deutsche Liederdichter des zwölften, dreizehnten und vierzehnten Jahrhunderts*, ed. by Friedrich Heinrich von der Hagen, 4 vols (Leipzig: Barth, 1838), IV, 853–62. I am grateful to an anonymous reviewer for suggesting this identification.

26. Gottfried Wilhelm Fink, 'Dr. Gottfried Emil Fischer', *Allgemeine musikalische Zeitung*, 36 (1841), 721–24; Friedrich Klemm, 'Fischer, Ernst Gottfried', in *Neue deutsche Biographie*, ed. by the Historische Kommission bei der Bayerischen Akademie der Wissenschaften, 26 vols (ongoing) (Berlin: Duncker & Humblot, 1961–), V, 182–83.

27. Walter Wiora, *Das deutsche Lied: zur Geschichte und Ästhetik einer musikalischen Gattung* (Wolfenbüttel: Möseler, 1971), pp. 105–19.

28. For an explanation of these signs, see *Die Jenaer Liederhandschrift*, ed. by Holz, Saran, and Bernoulli, II, 113–21 & 127–29.

29. *Die Jenaer Liederhandschrift*, ed. by Holz, Saran, and Bernoulli, I, i. My emphasis.

30. Ibid., II, i.

31. *90 canciones de los minnesinger*, ed. by Ribera, p. 59.

32. See, for example, the tellingly-titled chapter 'Indicios de andalucismo en las formas musicales de los Minnesinger' [Andalusian Traces in the Minnesänger's Musical Forms], *90 canciones de los minnesinger*, ed. by Ribera, pp. 27–31.

33. The most comprehensive study of rhythmical solutions applied to the Minnesang repertoire is Burkhard Kippenberg, *Der Rhythmus im Minnesang: eine Kritik der literar- und musikhistorischen Forschung mit einer Übersicht über die musikalischen Quellen*, Münchener Texte und Untersuchungen zur deutschen Literatur des Mittelalters, III (Munich: Beck, 1962).

34. Burghart Wachinger, *Deutsche Lyrik des späten Mittelalters*, Bibliothek des Mittelalters, ed. by Walter Haug, XXII (Frankfurt a. M.: Deutscher Klassiker Verlag, 2006), pp. 906–07.

35. 'Vierhebigkeit', ed. by Hans Heinrich Eggebrecht, in *Riemann Musik Lexikon*, ed. Wilibald Gurlitt, Hans Heinrich Eggebrecht, and Carl Dahlhaus (Mainz: B. Schott's Söhne, 1959–75), III (Sachteil), 1032.

36. Hugo Riemann, *Handbuch der Musikgeschichte*, 2 vols (Leipzig: Breitkopf & Härtel, 1904–13), I (part 2), 268.

37. Friedrich Gennrich, 'Wer ist der Initiator der "Modaltheorie"? Suum cuique', in *Miscelánea en homenaje a Monseñor Higinio Anglés*, 2 vols (Barcelona: Consejo superior de investigaciones científicas, 1958–61), I, 315–30.

38. Friedrich Gennrich, *Troubadours, Trouvères, Minne- und Meistergesang*, Das Musikwerk, ed. by Karl Gustav Fellerer, II (Cologne: Arno, 1951), p. 62.

39. Friedrich Gennrich, 'Liedkontrafaktur in mittelhochdeutscher und althochdeutscher Zeit', *Zeitschrift für deutsches Altertum und deutsche Literatur*, 82 (1948/50), 105–41 (p. 134).

40. Gennrich, 'Liedkontrafaktur in mittelhochdeutscher und althochdeutscher Zeit', pp. 133–34.

41. Hugo Moser and Joseph Müller-Blattau, *Deutsche Lieder des Mittelalters: von Walther von der Vogelweide bis zum Lochamer Liederbuch: Texte und Melodien* (Stuttgart: Klett, 1968), p. 11. A selection from Moser/Müller-Blattau's edition was published under the same title, with the added subtitle 'Kleine Studienausgabe' [short study edition] in 1971; this version does not contain 'Loybere risen'.

42. This notion is supported by the fact that the anthology was published by the Klett Verlag, which specializes in educational literature.

43. Moser and Müller-Blattau, *Deutsche Lieder des Mittelalters*, p. 8.

44. Ludwig Ettmüller, *Des Fürsten von Rügen Wizlaw's des Vierten Sprüche und Lieder in niederdeutscher Sprache nebst einigen kleinern niederdeutschen Gedichten: Herrn Eiken von Repgowe Klage, Der Kranichs Hals, und Der Thiere Rath*, Bibliothek der gesammten deutschen National-Literatur von der ältesten bis auf die neuere Zeit, XXXIII (Quedlinburg: Basse, 1852).

45. Margarete Lang and Walter Salmen, *Ostdeutscher Minnesang*, Schriften des Kopernikuskreises, III (Lindau & Constance: Thorbecke, 1958), p. 19. Lang and Müller-Blattau had worked together on a previous edition: Margarete Lang and Joseph Müller-Blattau, *Zwischen Minnesang und Volkslied: die Lieder der Berliner Handschrift, Germ. Fol. 922*, Studien zur Volksliedforschung: Beihefte zum Jahrbuch für Volksliedforschung, ed. by John Meier, I (Berlin: de Gruyter, 1941).

46. Lang and Salmen, *Ostdeutscher Minnesang*, p. 132.

47. Ewald Jammers, *Ausgewählte Melodien des Minnesangs*, Altdeutsche Textbibliothek, ed. by Hugo Kuhn, I (Ergänzungsreihe) (Tübingen: Niemeyer, 1963), p. 211.

48. Ibid., pp. 60 & 132–34.

49. Ibid., p. 132.

50. Ibid., pp. xii & 134.

51. Wesley Thomas and Barbara Garvey Seagrave, *The Songs of the Minnesinger, Prince Wizlaw of Rügen*, University of North Carolina Studies in the Germanic Languages and Literatures, ed. by Frederic E. Coenen, LIX (Chapel Hill: University of North Carolina Press, 1967).

52. Ibid., p. 83.

53. Ibid., p. 84. The authors' previous anthology edition was also concerned with performance, including an LP with some of its songs: *The Songs of the Minnesingers*, ed. by Barbara Garvey Seagrave and Wesley Thomas (Urbana: University of Illinois Press, 1966).

54. Mark Emanuel Amtstätter, 'Ihc wil singhen in der nuwen wise eyn lit: die Sub-Strophik Wizlavs von Rügen und die Einheit von Wort und Ton im Minnesang', *Beiträge zur Geschichte der deutschen Sprache und Literatur*, 124 (2002), 466–83 (p. 476).

55. Gennrich had also labelled his initial transcription as a 'Beispiel', see Gennrich, 'Liedkontrafaktur in mittelhochdeutscher und althochdeutscher Zeit', p. 134. See Figure 11.7.

56. Jammers, *Ausgewählte Melodien des Minnesangs*, p. xii.

57. Jammers had elaborated the relationship between chant and Minnesang in Ewald Jammers, 'Minnesang und Choral', in *Festschrift Heinrich Besseler zum sechzigsten Geburtstag*, ed. by Eberhardt Klemm (Leipzig: VEB Deutscher Verlag für Musik Leipzig, 1961), pp. 137–47.

58. Fischer, 'Ueber die Musik der Minnesänger', p. 853.

59. Ibid., p. 861.

60. The concept of 'translation' provides another fruitful approach to the performativity of modern editions; see *Rethinking Medieval Translation*, ed. by Campbell and Mills.

61. For contrasting assessments of J's function, see Christoph März and Lorenz Welker, 'Überlegungen zur Funktion und zu den musikalischen Formungen der "Jenaer Liederhandschrift"', in *Sangspruchdichtung: Gattungskonstitution und Gattungsinterferenzen im europäischen Kontext*, ed. by Dorothea Klein (Tübingen: Niemeyer, 2007), pp. 129–52; Lorenz Welker, 'Die "Jenaer Liederhandschrift" im Kontext großformatiger liturgischer Bücher des 14. Jahrhunderts aus dem deutschen Sprachraum', in *Die 'Jenaer Liederhandschrift'*, ed. by Haustein and Körndle, pp. 137–47.

62. See Nicholas Mittler, *Virtualität im Minnesang um 1200: Transdisziplinäre Analysen, Kultur, Wissenschaft, Literatur: Beiträge zur Mittelalterforschung*, ed. by Thomas Bein, XXIX (Lang: Frankfurt a. M. 2017), pp. 14–20.

63. The earliest recording of 'Loybere risen' was produced by Thomas Binkley and the Studio der Frühen Musik: Studio der Frühen Musik, *Minnesang und Spruchdichtung um 1200–1320* (catalogue number SAWT 9487-A), Telefunken, 1966.

AFTERWORD

Performing Medieval Text

Ardis Butterfield

Many essays in this volume, including the introduction, have wrestled with the boundary between text and music. The notion of performance beckons alluringly as a possible mediating term, allowing us — as interpreters — to step from one to the other. To take the readiest example, the singing of a song allows us to perform both words and music simultaneously. But the very act of performance also spurs us to meditate on the familiar yet utterly strange physical process of producing a sound that is composed of two different types of sound at once.

In this brief afterword I want to comment on the way marks on a page translate into sound, and how we understand them to do so in the distinct yet closely contiguous worlds of text and melody on a medieval manuscript page. The pages on which I wish to focus are from the *Roman de Fauvel* (c. 1316–18), a satiric narrative that was remodelled in one large and imposing manuscript to include a further 3000 lines of narrative, copious, vivid line drawings, and an astonishing 169 musical items (Paris, BnF, MS fr.146).[1] Much studied by modern scholars, this copy of *Fauvel* dazzles and perplexes by the intricate care that appears to have been lavished on its visual design. Partly as a result of the sheer number of inserted musical pieces, and partly through the extravagant exuberance of its satiric strategy, many of its pages defy performance. Pieces are often not directly cued into the narrative, meaning that decisions about how to perform them are turned onto the reader of the book. For instance, some pieces directly interrupt a speech, such as the two ballades 'Douce dame debonaire' (fol. 16vb), 'Ay amours tant me dure' (fols 16vb–17ra), and the lai 'Talant que j'ai d'obeïr' (fols 17ra–18vb); others, especially in the first book, are juxtaposed on the page without any clear indication of precisely where they might be supposed to enter the narrative frame (see the sequence of four Latin items on fols 4v–5r). With the latter, the compiler, Chaillou de Pesstain, creates what I have called 'a third dimension to the work: the visual layout takes over from a linear, aural representation of the work to the extent that this linearity breaks down'.[2]

So much is well established about this musically distended *roman*: what I want to emphasize here is how promiscuously the graphic signs on the pages function to represent sound. *Fauvel*'s satiric strategies are so thoroughgoing that they extend even to the nature of the signs used to indicate text and music. In some of its most famous page openings, such as the one where Fauvel (a vice-ridden horse) prepares

for his wedding night (fol. 34ʳ), the book shows sound being recorded in multiply virtuosic ways through narrative, music, and image. We are told in octosyllabic rhyming couplets how the wedding night of the depraved horse and his new bride Vaine Gloire was disrupted by a violently noisy charivari in the streets; we are given an item of notated song performed by the rioters; and we are shown a three-layered image of Fauvel approaching his wedding bed that is positioned over two vertically aligned images of singers and musicians in animal masks banging drums and playing fiddles. Sound comes at us through our imaginative recreation of the narrative scene, through the notated refrain snippet which we can hear either in our inner ear or sung aloud, and through the visual details of the fiddles, tambours, and hand bells being played by the dancing revellers. If we were watching a performance of this page, it would come together as the sound of someone narrating and someone (perhaps the same person or else a separate singer) singing a very short song. The image could also be realised in the shape of a group of dancers, but ironically the sonic noisiness of the silent page in its combination of three media is much louder than a strict performance of the marks registering text and melody. This is partly because the details in the narrative supplement rather than precisely overlap with the image. In the image, the dancers are far less unruly than in the narrative: although we *see* only fiddles, tambours, and bells, we are *told* of a big frying pan, a kitchen hook, grill pan and pestle, a brass pot, cow bells, 'big, filthy and dirty instruments', of high cries and high notes, and a cart-like contraption with wheels that, as they turned, struck nailed iron bars with a huge, hideous sound louder than thunder. There were farts, breaking windows, damage to doors and a shelter, and a giant (Hellequin) on a horse who processed by with his shouting and raging followers.[3]

I dwell on this because — at the risk, perhaps, of stating the obvious — 'text' on this page functions sonically in two quite distinct ways. It creates a vivid street scene through a narrative voice, and it provides the words of a brief snippet of song. How do we assess these as modes of performance? In the former, the sound of the narrator's voice is supplemented by our imagination working with memory to hear silently the sounds of which he tells; in the latter we hear aloud a few words combined with music. 'Music', similarly, is heard both within our imaginative construction of the charivari through the words of the narrator, and as a sonic component of the short song. In both cases, there is a difference between sounding out the marks on the page, and allowing those marks to stimulate our imaginative recreation of quite different sounds.

As Hope and Souleau remark in their introduction to this volume, it is often assumed that 'text' and 'performance' are opposing terms. *Fauvel* is a good example of a medieval work that asks us to clarify the notion of performance by its subtle evocation of the multiple ways in which performance can be construed from writing. It is not just that we *can* perform *Fauvel* in a range of realizations, but that we must. Its formal disposition on the pages of MS fr. 146 requires a process of active judgement about its performability over and above the usual parameters of making sense of a work's cues for performance. *Fauvel* gives either contradictory cues, as in the example I have just discussed, or no cues, juxtaposing its several components

of music, narrative, and image in ways that leave performance an open question, and perhaps even inhibit it. Turning the work into an event requires conflicting and many-headed decisions: at times to render the narrative sequentially with cued musical interludes, at others perhaps to perform narrative and music simultaneously, or else to create one's own sequences of narrative and music items, or then again to create performances based on the images. The presence of so many genres of music in *Fauvel* also complicates the choices facing performers: skilled polyphony requires a different commitment from the banging of a drum.

Fauvel may be an unusually complex case, but it shows a truth about many medieval works: that the journey from written mark to performance is far more than a matter of sounding out those marks. But how far are we to see music and words as having distinct paths in this larger trajectory? Many of the essays in this volume have done valuable and provocative work to disrupt common dichotomies in debates on performance, such as sound and silence, hearing and sight, book and voice, song and book. Some of this work has drawn on the notorious debate between Jacques Derrida and J. L. Austin, taken up with a vengeance by Austin's student John Searle.[4] Here, post-hoc, it may be worth pressing a little harder on the implications of this debate for medieval works in performance.

One of the sticking points concerns the notion of context. For Austin, a performative utterance is linked to a specific moment in time, and a shaping desire or intention to bet, challenge, launch a boat, or even occasionally marry (as Derrida wryly puts it in his paraphrase of Austin). He is trying to avoid the idea that a performative utterance could fail or be fake.[5] In developing this case, Austin invokes the idea of intention as part of a sense of 'appropriate context' in which a performative utterance can be defined as such, as opposed to being 'in a peculiar way hollow or void if said by an actor on the stage, or if introduced in a poem, or spoken in soliloquy'.[6] For Derrida, Austin's anxiety makes no sense. One of his objections is to the idea that one needs to consider 'the whole context of utterance'. There is no way of determining context: speech can function without context. Taking this further, Derrida claims that speech operates under the same conditions as writing. His paradoxical assertion that speech is a form of writing points to its shared property with writing, in that both speech and writing contain the absence of intention or of a determining context as part of their condition of existing. Any instance of speech then, and not just of writing, is a rupture with context. In Derrida's celebrated example, a written signature by definition marks the absence of the signatory. Except that it also, constantly, marks the signatory's one-time presence, and it is from this property that it derives its force and function in common use, such as in bank cheques. Strictly, a signature, like any other form of writing, is detached from the consciousness of the signatory.

I rehearse this argument to draw attention to its potential to illuminate the relation between writing and performance raised by *Fauvel*. Medieval grammarians had much to say about written signs: 'Litterae autem sunt indices rerum, signa verborum, quibus tanta vis est, ut nobis dicta absentium sine voce loquantur' [Letters are the indices of things, the signs of words, in which there is such great force that

they speak to us without spoken sound [*sine voce*] things said by those absent].[7] Derrida's notion of *différance* is constructed on a phenomenological understanding of language that does not see letters 'as indices of things' but (to compress crudely once more) as indices of other letters. Yet when Priscian says that 'a letter is a mark (*nota*) of an element and a certain image, as it were, of articulate spoken utterance' then he reminds us that for medieval thinkers too, written signs reckon with absent speakers and absent signatories.[8]

These truisms of the medieval classroom — easily overlooked as such — point us to the radical pun of *nota*: sign, mark, letter, musical note. A *nota* can be simultaneously a specific human-produced sound and a silent scripture; a letter and a melodic pitch. As *Fauvel* shows us, a *nota* plays with absence and presence at the same time. A *nota*, in performance, needs no context, nor does it refer to a previous singular context. It is made afresh each time it is performed. It is not so much a performative utterance as 'a mark which remains, which is not exhausted in the present of its inscription, and which can give rise to an iteration'.[9] We should not be surprised, then, if a manuscript page projects an utterance that both performs and resists performance. In their singularity, the handwritten signs stand in for a human performer: they indicate a performer's presence while insisting on the performer's absence. All signature, medieval writing countersigns its absent performance. What makes *Fauvel* distinctive is that its handwritten pyrotechnics of layout complicate even this already complex (although utterly commonplace) relationship between writing and sound. I suggest that in the interstices between *nota* and *nota*, between the sound of words and the sound of melody, the poet-compiler-composer shows us the blurry limits of the unperformable. Somewhere between Austin's context and Derrida's rupture there is a further unplayable sound.

Notes to the Afterword

1. Gervais du Bus and Chaillou de Pesstain, *Le Roman de Fauvel*, ed. by A. Långfors, Société des anciens textes français (Paris: Firmin Didot, 1914–19); *L'Hérésie de Fauvel*, ed. by Emilie Dahnk (Leipzig: Romanisches Seminar, 1935); *Polyphonic Music of the Fourteenth Century*, ed. by Leo Schrade, 1 (Monaco: l'Oiseau-Lyre, 1956); *The Monophonic Songs in the Roman de Fauvel*, ed. by Samuel N. Rosenberg and Hans Tischler (Lincoln & London: University of Nebraska Press, 1991); *Le Roman de Fauvel in the Edition of Messire Chaillou de Pesstain: A Reproduction in Facsimile of the Complete Manuscript, Paris, Bibliothèque Nationale, Fonds Français 146*, ed. by Edward H. Roesner, François Avril, and Nancy Freeman Regalado (New York: Broude, 1990). MS fr. 146 is available online at <http://gallica.bnf.fr/ark:/12148/btv1b8454675g> [accessed 8 August 2017].

2. Ardis Butterfield, 'The Refrain and the Transformation of Genre in *Le Roman de Fauvel*' and 'Appendix: Catalogue of Refrains in *Le Roman de Fauvel*, BN fr.146', in *Fauvel Studies: Allegory, Chronicle, Music and Image in Paris, Bibliothèque Nationale MS français 146*, ed. by Margaret Bent and Andrew Wathey (Oxford: Clarendon Press, 1998), pp. 105–59 (p. 106).

3. *Le Roman de Fauvel*, ed. and trans. by Armand Strubel (Paris: Le livre de poche, 2012), ll. 4845–4935. Further images illustrating this section of the narrative occur on fols 34v–36v but the same questions about performance apply.

4. Jacques Derrida, 'Signature, événement, contexte', in *Marges de la philosophie* (Paris: Les Éditions de Minuit, 1972), pp. 367–93; translated in *Glyph*, 1 (1977), 172–97; John R. Searle, 'Reiterating the Differences: A Reply to Derrida', *Glyph*, 1 (1977), 198–208; Jacques Derrida, 'Ltd Inc', supplement to *Glyph*, 2 (1977); translated in *Glyph*, 2 (1977), 162–254.

5. This summary necessarily, for reasons of space, compresses Austin's argument to an unfortunate extent. He distinguishes 'performatives' from 'constatives', that is statements in the form of sentences which can be verified as either true or false. 'Performatives' are not subject to the true/false dichotomy because to utter a performative is to perform an action, which can be done 'happily' or 'unhappily' but is not either 'true' or 'false'. See also the contributions to the present volume by Ferreira (Chapter 4) and Cheung Salisbury (Chapter 5).
6. J. L. Austin, *How to Do Things with Words* (1975), p. 22.
7. Isidore of Seville, *Etymologiae*, Book 1, Chapter 3 (1–2); cited in Martin Irvine, 'Medieval Grammatical Theory and the *House of Fame*', *Speculum*, 60 (1985), 850–76 (p. 870).
8. Priscian, *Institutiones grammaticae*, ed. by Martin Hertz, Grammatici latini, ed. by Heinrich Keil, II (Leipzig: Teubner, 1855), p. 6.
9. Jacques Derrida, *Margins of Philosophy*, trans. by Alan Bass (Chicago: Chicago University Press, 1972), pp. 307–30.

BIBLIOGRAPHY

Manuscripts

Aix-en-Provence, Bibliothèque municipale
 MS 166
Amiens, Bibliothèques d'Amiens-Métropole
 MS 486 F
Augsburg, Universitätsbibliothek
 MS 1.3.8° 1
Bamberg, Staatsbibliothek
 MS Lit. 115
Belgrade, Biblioteka Srpske patrijarsije
 MS 219
Belgrade, Muzej Srpske Pravoslavne Crkve
 Collection of Radoslav Grujic, MS 219
Besançon, Bibliothèque municipale
 MSS 864–65
Boston, Public Library
 MS 101
Brussels, Bibliothèque Royale
 MS 9393
 MS 9508
 MS 10309
 MS 10366
 MS 10476
 MS 10982
 MS 10983
 MS 10987
 MS 11034
Chantilly, Musée Condé
 MSS 492–93
 MS 494
 MS 564
Cologne, Universität, Papyrussammlung
 MS Papyrus Köln 3221
Copenhagen, Kongelige Bibliotek
 MS 3449 8° VI, <www.cantusdatabase.org>
 MS GKS 79 2°, <http://www.kb.dk/permalink/2006/manus/218/>
 MS GKS 80 2°, <http://www.kb.dk/permalink/2006/manus/219/>
Darmstadt, Universitäts- und Landesbibliothek
 MS 2505, <http://tudigit.ulb.tu-darmstadt.de/show/Hs-2505>
Den Haag, Koninklijke Bibliotheek
 MS 78 D42, <http://manuscripts.kb.nl/search/manuscript/extended/page/1/shelfmark/
 78+D+42>

Den Haag, Museum Meermanno-Westreenianum
 MS 10 B34, <http://manuscripts.kb.nl/search/manuscript/extended/page/1/shelfmark/
 10+B+34>
 MS 10 C23, <http://manuscripts.kb.nl/search/manuscript/extended/page/1/shelfmark/
 10+C+23>
Einsiedeln, Stiftsbibliothek
 MS 33
 MS 121 (1151), <http://www.e-codices.unifr.ch/de/list/one/sbe/0121>
Jena, Thüringer Universitäts- und Landesbibliothek
 MS El. f. 101, <http://archive.thulb.uni-jena.de/hisbest/receive/HisBest_cbu_00008190>
Karlsruhe, Badische Landesbibliothek
 MS 3378, <http://digital.blb-karlsruhe.de/urn:nbn:de:bsz:31–1732>
 MS St Georgen 38
Kassel, Universitätsbibliothek
 MS 4° Ms. Theol. 15, <http://orka.bibliothek.uni-kassel.de/viewer/image/1318578645716/
 1/>
Laon, Bibliothèque municipale
 MS 243q, <http://www.purl.org/yoolib/bmlaon/7>
London, BL
 Harley MS 273, <http://www.bl.uk/manuscripts/FullDisplay.aspx?ref=Harley_MS_273>
 Harley MS 978, <http://www.bl.uk/manuscripts/FullDisplay.aspx?ref=Harley_MS_978>
 Harley MS 4431, <http://www.bl.uk/manuscripts/Viewer.aspx?ref=harley_ms_4431_f001r>
 Sloane MS 346, <http://www.bl.uk/catalogues/illuminatedmanuscripts/record.asp?
 MSID=6511>
London, Lambeth Palace Library
 MS 456
Los Angeles, University of California Music Library
 MS 744
Madrid, Biblioteca Nacional d'España
 MS B. 19 (Vit 25–27)
Messina, San Salvatore
 MS 29
Montpellier, Faculté de Médicine
 MS H. 196, <http://manuscrits.biu-montpellier.fr/vignettem.php?GENRE%5B%5D=M
 P&ETG=OR&ETT=OR&ETM=OR&BASE=manuf>
Moscow, Rossiyskaya Gosudarstvennaya biblioteka
 Collection of P. I. Sevastjanov, MS 43
Munich, Bayerische Staatsbibliothek
 MS Cod. gall. 11, <http://daten.digitale-sammlungen.de/~db/0008/bsb00086503/
 images/index.html?seite=00001&l=de>
 MS Cgm 4370, <http://daten.digitale-sammlungen.de/~db/0005/bsb00050902/images/>
 MS Clm 14610
Oxford, Bodleian Library
 Douce MS f. 4, <http://bodley30.bodley.ox.ac.uk:8180/luna/servlet/view/search?
 q=Shelfmark=%22MS.%20Douce%20f.%204%22&sort=Shelfmark,Folio_
 Page,Roll_#,Frame_#>
Palermo, Biblioteca Nazionale
 MS I.B.16
Paris, BnF
 MS fr. 146, <http://gallica.bnf.fr/ark:/12148/btv1b8454675g>
 MS fr. 188

MS fr. 412, <http://gallica.bnf.fr/ark:/12148/btv1b9006878w>
MS fr. 580, <http://gallica.bnf.fr/ark:/12148/btv1b8448967x>
MS fr. 603
MS fr. 606, <http://gallica.bnf.fr/ark:/12148/btv1b52000943c>
MS fr. 607, <http://gallica.bnf.fr/ark:/12148/btv1b6000102v>
MS fr. 835, <http://gallica.bnf.fr/ark:/12148/btv1b8449047c>
MS fr. 836, <http://gallica.bnf.fr/ark:/12148/btv1b8449048s>
MS fr. 844, <http://gallica.bnf.fr/ark:/12148/btv1b8419244o>
MS fr. 848, <http://gallica.bnf.fr/ark:/12148/btv1b105092969>
MS fr. 1176, <http://gallica.bnf.fr/ark:/12148/btv1b8448970d>
MS fr. 1178, <http://gallica.bnf.fr/ark:/12148/btv1b8448971t>
MS fr. 1179, <http://gallica.bnf.fr/ark:/12148/btv1b8448974z>
MS fr. 1188, <http://gallica.bnf.fr/ark:/12148/btv1b8448976w>
MS fr. 1569, <http://gallica.bnf.fr/ark:/12148/btv1b6000327c>
MS fr. 1740, <http://gallica.bnf.fr/ark:/12148/btv1b8448968b>
MS fr. 12148, <http://gallica.bnf.fr/ark:/12148/btv1b6000351l>
MS fr. 12615, <http://gallica.bnf.fr/ark:/12148/btv1b60007945>
MS fr. 12779, <http://gallica.bnf.fr/ark:/12148/btv1b60001038>
MS fr. 12786, <http://gallica.bnf.fr/ark:/12148/btv1b6000351l>
MS fr. 15213, <http://gallica.bnf.fr/ark:/12148/btv1b8452195w>
MS fr. 24786, <http://gallica.bnf.fr/ark:/12148/btv1b8451464z>
MS fr. 25566, <http://gallica.bnf.fr/ark:/12148/btv1b54002413d>
MS fr. 25636, <http://gallica.bnf.fr/ark:/12148/btv1b8448974z>
MS gr. 134
MS gr. 938
MS gr. 2658
MS lat. 511
MS lat. 1112, <http://gallica.bnf.fr/ark:/12148/btv1b6000450z>
MS lat. 1171
MS n.a.f. 1731
MS n.a.f. 4792, <http://gallica.bnf.fr/ark:/12148/btv1b8449713o>
MS n.a.f. 13521, <http://gallica.bnf.fr/ark:/12148/btv1b530121530>
Paris, Bibliothèque de l'Arsenal
 MS 2681, <http://gallica.bnf.fr/ark:/12148/btv1b8451475v>
Patmos, Monastery of St John the Theologian
 MS 171
Prague, Knihovna Národní Muzeum
 MS IX H 21
Private Collection
 MS Ex-Ashburnham-Barrois 203
 MS Ex-Phillipps 128
 MS Ex-Phillipps 207
Saint Petersburg, Rossíiskaya akadémiya naúk
 Collection of Sirku, MS 13.4.10
Sofia, Archiv na Bŭlgarska akademia na naukite
 MS 86
Stuttgart, Württembergische Landesbibliothek
 MS HB I.95, <http://digital.wlb-stuttgart.de/purl/bsz339701315>
 MS Theol. et phil. 2° 122, <http://digital.wlb-stuttgart.de/purl/bsz330594400>
Toulouse, Bibliothèque municipale
 MS 2885, <http://numerique.bibliotheque.toulouse.fr/ark:/74899/B315556101_MS2885>

Trent, Museo Provinciale d'Arte
 MS 1375 (olim Tr88)
Turin, Biblioteca Reale
 MS Vari 42
Vatican, Biblioteca Apostolica Vaticana
 MS Reg. lat. 1490
 MS Vat. gr. 749, <http://digi.vatlib.it/view/MSS_Vat.gr.749.pt.2>
 MS Vat. gr. 1238
Vienna, Österreichische Nationalbibliothek
 MS s. n. 2612
 MS s. n. 12883

Primary Texts

ADAM DE LA HALLE, *Le Jeu de Robin et de Marion*, ed. by Jean Dufournet (Paris: Flammarion, 1989)

Agenda seu liber obsequiorum, iuxta ritum, et consuetudinem dioecesis August. (Ingolstadt: Alexander Weissenhorn, 1547), VD16 A 661, vdm 1127, <http://daten.digitale-sammlungen.de/~db/0002/bsb00022172/images/index.html> and <vdm.sbg.ac.at>

AQUINAS, THOMAS, *Summa Theologiae*, ed. by the Fathers of the English Dominican Province, <http://www.newadvent.org/summa/>

ARISTOTLE, *Categories and De interpretatione*, ed. and trans. by J. L. Ackrill (Oxford: Clarendon Press, 1963)

AUGUSTINE, SAINT, *Sancti Aurelii Augustini, Hipponensis Episcopi, Opera omnia*, ed. by Jacques-Paul Migne, Patrologia Latina, cursus completus, XXXVI (Paris: Petit-Montrouge, 1865)

——*Expositions on the Book of Psalms, by St Augustine, Bishop of Hippo* (Oxford: Parker, 1849)

——*The City of God against the Pagans: III (Books VIII–XI)*, trans. by David S. Wiesen, The Loeb Classical Library, CDXIII (London: Heinemann; Cambridge, MA: Harvard University Press, 1968)

Biblia sacra iuxta vulgatam versionem, ed. by Robert Weber and Bonifatius Fischer, 3rd edn (Stuttgart: Deutsche Bibelgesellschaft, 1983)

Biblia sacra iuxta vulgatam versionem, ed. by Robert Weber and others, 4th edn (Stuttgart: Deutsche Bibelgesellschaft, 1994)

The Holy Bible Translated from the Latin Vulgate, Douay Rheims version, rev. by Richard Challoner (Rockford, IL: TAN, 1989)

The Bible. Authorized King James Version, ed. by Robert Carroll and Stephen Prickett (Oxford: Oxford University Press, 2008)

Biographies des troubadours: textes provençaux des XIIIᵉ et XIVᵉ siècles, ed. by Boutière, Jean, and Alexander H. Schutz (Paris: Nizet, 1964)

CHRISTINE DE PIZAN, *Epistre Othea*, ed. by Gabriella Parussa (Geneva: Droz, 1999)

——*Le Chemin de longue étude*, ed. by Andrea Tarnowski (Paris: Librairie Générale Française, 2002)

——*Le Livre de la cité des dames (La Città delle dame)*, ed. by Patrizia Caraffi and Earl Jeffrey Richards (Milan: Luni, 1997)

——*The Love Debate Poems of Christine de Pizan*, ed. by Barbara Altmann (Gainesville: University of Florida Press, 1998)

——*The Treasure of the City of Ladies, or, The Book of Three Virtues*, ed. and trans. by Sarah Lawson (London: Penguin, 2003)

Die Chroniken der schwäbischen Städte — Augsburg: Vierter Band, ed. by the Historische Kommission bei der königlichen Akademie der Wissenschaften, Die Chroniken deutscher Städte, XXIII (Leipzig: Hirzel, 1894)

DANTE ALIGHIERI, *La Commedia secondo l'antica vulgata*, ed. by Giorgio Petrocchi, 4 vols (Florence: Società dantesca italiana, 1966–68)

—— *The Divine Comedy*, trans. by Allen Mandelbaum (London: Everyman's Library, 1995)

—— *Convivio*, ed. by Franca Brambilla Ageno, 2 vols (Florence: Le Lettere, 1995)

—— *Il Convivio (The Banquet)*, trans. by Richard H. Lansing (New York & London: Garland, 1990)

DUMAS, ALEXANDRE, *Le Bâtard de Mauléon* (Paris: AlterEdit, 2008)

—— *Monseigneur Gaston Phœbus* (La Tour d'Aigues: L'Aube, 2008)

Egils saga Skallagrímssonar, ed. by Sigurður Nordal, Íslenzk fornrit, II (Reykjavik: Hið Íslenzka fornritafélag, 1933)

EINARR SKÁLAGLAMM, 'Vellekla', ed. by Edith Marold, in *Poetry from the Kings' Sagas 1: From Mythical Times to c. 1035*, ed. by Diana Whaley, 2 vols (Turnhout: Brepols, 2012), I, 280–329

FREUD, SIGMUND, *The Standard Edition to the Complete Psychological Works of Sigmund Freud*, ed. and trans. by James Strachey, 24 vols (London: Hogarth Press and the Institute of Psycho-Analysis, 1953–74; repr. London: Vintage, 2001)

FROISSART, JEAN, *Chroniques. Livre III: Du voyage en Béarn à la campagne de Gascogne et Livre IV: années 1389–1400*, ed. by Peter F. Ainsworth and Alberto Varvaro (Paris: Le Livre de poche, 2004)

—— *Chronicles*, trans. by Keira Borrill, in *The Online Froissart* (Sheffield: HRIOnline, 2013), ed. by Peter Ainsworth and Godfried Croenen, version 1.5, <http://www.hrionline.ac.uk/onlinefroissart>

Jean Froissart: An Anthology of Narrative & Lyric Poetry, ed. by Kristen M. Figg and R. Barton Palmer (New York & London: Routledge, 2001)

—— *Meliador*, ed. by Auguste Longnon (Paris: Firmin Didot, 1895)

GAFFURIO, FRANCHINO, *The Theory of Music*, ed. by Claude V. Palisca, trans. by Walter Kurt Kreysz (New Haven, CT: Yale University Press, 1993)

GERVAIS DE BUS and CHAILLOU DE PESTAIN, *Le Roman de Fauvel*, ed. by Arthur Långfors, Société des anciens textes français (Paris: Firmin Didot, 1914–19)

—— *Le Roman de Fauvel in the Edition of Messire Chaillou de Pesstain: A Reproduction in Facsimile of the Complete Manuscript, Paris, Bibliothèque Nationale, Fonds Français 146*, ed. by Edward H. Roesner, François Avril, and Nancy Freeman Regalado (New York: Broude, 1990)

—— *Le Roman de Fauvel*, ed. and trans. by Armand Strubel, Le Livre du poche: Lettres gothiques (Paris: Librairie Général Française, 2012)

GIDE, ANDRÉ, *Journal 1889–1939* (Paris: Gallimard, 1948)

GIELÉE, JACQUEMART, *Renart le nouvel*, ed. by Henri Roussel, Publications de la Société des anciens textes français (Paris: A. & J. Picard, 1961)

GREGORY I, POPE, *Sancti Gregorii Papae I Cognomento Magni, Opera omnia*, ed. by Jacques-Paul Migne, Patrologia Latina, cursus completus, LXXVI (Paris: Migne, 1857)

—— *Morals on the Book of Job by St. Gregory the Great* (Oxford: Parker, 1845)

Grettis saga Ásmundarsonar; Bandamanna saga; Odds þáttr Ófeigssonar, ed. by Guðni Jónsson, Íslenzk fornrit, VII (Reykjavík: Hið Íslenzka fornritafélag, 1936)

L'Hérésie de Fauvel, ed. by Emilie Dahnk (Leipzig: Romanisches Seminar, 1935)

ISIDORE OF SEVILLE, *Isidori Hispalensis episcopi Etymologiarum sive originum libri XX*, ed. by W. M. Lindsay (Oxford: Oxford University Press, 1911; repr. 1966)

JEAN ROBERTET, *Œuvres*, ed. by Margaret Zsuppán (Geneva: Droz, 1970)

KONRAD VON HELMSDORF, *Der Spiegel des menschlichen Heils. Aus der St. Gallener Handschrift*, ed. by Axel Lindqvist, Deutsche Texte des Mittelalters, XXXI (Berlin: Weidmann, 1924)

MACHAUT, GUILLAUME DE, *La Louange des dames*, ed. by Nigel Wilkins (Edinburgh: Scottish Academic Press, 1972)

MAHIEU LE POIRIER, *Le Court d'amours de Mahieu le Poirier et la suite anonyme de la 'Court d'amours'*, ed. by Terence Scully (Waterloo, ON: Wilfrid Laurier University Press, 1976)

Obsequiale augustense (Augsburg: Erhard Ratdolt, 1487), vdm 1071–1073, <http://daten. digitale-sammlungen.de/~db/0004/bsb00043904/images/>

La Pacience de Job (Lyon: François Didier, 1600), <http://gallica.bnf.fr//ark:/12148/ bpt6k79022w>

La Pacience de Job: mystère anonyme du XV^e siécle, ed. by Albert Meiller, Bibliothèque française et romane, Série B: XI (Paris: Klincksieck, 1971)

PETRUS COMESTOR, *Historica scholastica*, ed. by Jacques-Paul Migne, Patrologia Latina, CXCVIII (Paris: Gernier Frères, 1855)

Pontificale romanum (Rome: Stephan Planck, 1485), <http://diglib.hab.de/inkunabeln/408-theol-2f/start.htm>

PRISCIAN, *Institutiones grammaticae*, ed. by Martin Hertz, Grammatici latini, ed. by Heinrich Keil, II (Leipzig: Teubner, 1855)

RICHARD DE FOURNIVAL, *Li 'Bestiaires d'amours' di maistre Richart de Fournival e li response du bestiaire*, ed. by Cesare Segre, Documenti di filologia, II (Milan & Naples: Riccardo Ricciardi, 1957)

Secundus tomvs novi operis mvsici, sex quinqve et qvatvor vocvm, nvnc recens in lvcem editvs (Nuremberg: Hans Ott, 1538), VD16 O 1501

SIGVATR ÞÓRÐARSON, 'Bersǫglisvísur', ed. by Kari Ellen Gade, in *Poetry from the Kings' Sagas 2: From c. 1035 to c. 1300*, ed. by Kari Ellen Gade, 2 vols (Turnhout: Brepols, 2009), II, 11–30

SNORRI STURLUSON, *Snorri Sturluson Edda: Prologue and Gylfaginning*, ed. by Anthony Faulkes (London: Viking Society for Northern Research, University of London, 2011)

—— *Snorri Sturluson Edda: Skáldskaparmál*, ed. by Anthony Faulkes (London: Viking Society for Northern Research, University of London, 2007)

—— *Snorri Sturluson Heimskringla*, ed. by Bjarni Aðalbjarnarson, 3 vols, Íslenzk fornrit, XXVI–XXVIII (Reykjavík: Hið Íslenzka fornritafélag, 1941)

Speculum humanae salvationis, ed. by Jules Lutz and Paul Perdrizet, 2 vols (Leipzig: Hiersemann, 1907)

STURM, CASPAR, *Ain Kurtze anzaygung und beschreybung Römischer Kayserlichen Maiestat eintreyten* (Augsburg: Phillip Ulhart the Elder, 1530), VD16 ZV 26691 and VD16 S 10013

Testamentum Jobi, ed. by Sebastian P. Brock, Pseudepigrapha veteris testamenti Graece, II (Leiden: Brill, 1967)

Testament of Job the Blameless, the Sacrifice, the Conqueror in Many Contests, the Sainted: Book of Job Called Jobab, and his Life and Transcripts of his Testament, ed. by Angelo Mai, Scriptorum Veterum Nova Collectio, VII (Rome: Typis Vaticanis, 1833)

Testament of Job the Blameless, the Sacrifice, the Conqueror in Many Contests. Book of Job, Called Jobab, His Life and the Transcript of his Testament, trans. by M. R. James, Apocrypha anecdota: Texts and Studies, II, 5/1 (Cambridge: Cambridge University Press, 1897)

The Testament of Job, According to the SV Text. Greek Text and English Translation, ed. by Robert A. Kraft (Missoula, MT: Scholars Press, 1974)

Das Testament Hiobs, ed. by Bernd Schaller, Jüdische Schriften aus hellenistisch-römischer Zeit, III, 3 (Gütersloh: Mohn, 1979)

ÞORBJǪRN HORNKLOFI, 'Glymdrápa', ed. by Edith Marold, in *Poetry from the Kings' Sagas 1, From Mythical Times to c. 1035*, ed. by Diana Whaley, 2 vols (Turnhout: Brepols, 2012), I, 73–90

Vestfirðinga sǫgur: Gísla saga Súrssonar. Fóstbrœðra saga. Þáttr Þormóðar. Hávarðar saga Ísfirðings. Auðunar Þáttr vestfirzka. Þorvarðar Þáttr Krákunefs, ed. by Björn K. Þórólfsson and Guðni Jónsson, Íslenzk fornrit, VI (Reykjavik: Hið Íslenzka fornritafélag, 1943)

WIZLAV VON RÜGEN, *Des Fürsten von Rügen Wizlaw's des Vierten Sprüche und Lieder in niederdeutscher Sprache nebst einigen kleinern niederdeutschen Gedichten: Herrn Eiken von Repgowe Klage, Der Kranichs Hals, und Der Thiere Rath*, ed. by Ludwig Ettmüller, Bibliothek der gesammten deutschen National-Literatur von der ältesten bis auf die neuere Zeit, XXXIII (Quedlinburg: Basse, 1852)
—— *The Songs of the Minnesinger, Prince Wizlaw of Rügen*, ed. by Wesley Thomas and Barbara Garvey Seagrave, University of North Carolina Studies in the Germanic Languages and Literatures, ed. by Frederic E. Coenen, LIX (Chapel Hill: University of North Carolina Press, 1967)

Secondary Texts

ABBATE, CAROLYN, *Unsung Voices: Opera and Musical Narrative in the Nineteenth Century* (Princeton, NJ: Princeton University Press, 1991)
AHERN, JOHN, 'Singing the Book: Orality in the Reception of Dante's *Comedy*', in *Dante: Contemporary Perspectives*, ed. by Amilcare A. Iannucci (Toronto: University of Toronto Press, 1997), pp. 214–39
ALLEN, ROBERT EDWARD (ed.), *The Concise Oxford Dictionary of Current English*, 8th edn (Oxford: Clarendon Press, 1990)
AMODIO, MARK, *Writing the Oral Tradition: Oral Poetics and Literate Culture in Medieval England* (Notre Dame, IN: University of Notre Dame Press, 2004)
AMTSTÄTTER, MARK EMANUEL, 'Ihc wil singhen in der nuwen wise eyn lit: die Sub-Strophik Wizlavs von Rügen und die Einheit von Wort und Ton im Minnesang', *Beiträge zur Geschichte der deutschen Sprache und Literatur*, 124 (2002), 466–83
ARDISSINO, ERMINIA, 'I canti liturgici nel *Purgatorio* dantesco', *Dante Studies*, 108 (1990), 39–65
—— *Tempo liturgico e tempo storico nella 'Commedia' di Dante* (Città del Vaticano: Libreria Editrice Vaticana, 2009)
ARMOUR, PETER, *The Door of Purgatory: A Study of Multiple Symbolism in Dante's 'Purgatorio'* (Oxford: Clarendon Press, 1983)
ARNOLD, JONATHAN, 'Introduction', *Dante Sermon Series*, Worcester College Chapel, <http://www.worcesterchapel.co.uk/2011/dante-sermon-series-introduction-the-chaplain/>
AUBREY, ELIZABETH, *The Music of the Troubadours* (Bloomington: Indiana University Press, 1996)
—— 'Reconsidering "High Style" and "Low Style" in Medieval Song', *Journal of Music Theory*, 52 (2008), 75–122
AUERBACH, ERICH, 'Dante's Addresses to the Reader', *Romance Philology*, 7 (1953/54), 268–79
AUSTIN, J. L., 'Performative Utterances', in *Philosophical Papers*, ed. by J. O. Urmson and G. J. Warnock (Oxford: Clarendon Press, 1961), pp. 220–39
—— *How to Do Things with Words* (Oxford: Oxford University Press, 1962)
—— *How to Do Things with Words*, ed. by J. O. Urmson and Marina Sbisà, 2nd edn (Oxford: Clarendon Press, 1975)
—— 'Ἀγαθόν and Εὐδαιμονία in the Ethics of Aristotle', in *Philosophical Papers*, ed. by J. O. Urmson and G. J. Warnock, 3rd edn (Oxford: Clarendon Press, 1979), pp. 1–31
BAKHTIN, M. M., *The Dialogic Imagination: Four Essays*, ed. by Michael Holquist, trans. by Caryl Emerson and Michael Holquist, University of Texas Press Slavic Series, 1 (Austin: University of Texas Press, 1981)
—— 'From the Prehistory of Novelistic Discourse', in *The Dialogic Imagination*, ed. by Holquist, pp. 41–83
—— 'Forms of Time and the Chronotope in the Novel — Notes towards a Historical Poetics', in *The Dialogic Imagination*, ed. by Holquist, pp. 84–258

—— 'Discourse in the Novel', in *The Dialogic Imagination*, ed. by Holquist, pp. 259–422

BALENTINE, SAMUEL E., 'Job and the Priests: "He Leads Priests Away Stripped" (Job 12:19)', in *Reading Job Intertextually*, ed. by Katharine Dell and Will Kynes (New York, and others: Bloomsbury, 2013), pp. 42–53

—— *Have You Considered My Servant Job? Understanding the Biblical Archetype of Patience* (Columbia: University of South Carolina Press, 2015)

BARAŃSKI, ZYGMUNT G., 'Inferno I', in *Lectura Dantis Bononiensis*, ed. by Emilio Pasquini and Carlo Galli, 5 vols (Bologna: Bononia University Press, 2011–), I, 11–40

BARNES, JOHN C., 'Vestiges of the Liturgy in Dante's Verse', in *Dante and the Middle Ages: Literary and Historical Essays*, ed. by John C. Barnes and Cormac ó Cuilleanáin (Dublin: Irish Academic Press, 1995), pp. 231–69

BAROLINI, TEODOLINDA, *Dante's Poets: Textuality and Truth in the 'Comedy'* (Princeton, NJ: Princeton University Press, 1984)

BARTHES, ROLAND, 'The Death of the Author', in *Image — Music — Text*, trans. by Stephen Heath (London: Fontana, 1977), pp. 142–48

BATEMAN, CHIMÈNE, 'Irrepressible Malebouche: Voice, Citation and Polyphony in the *Roman de la Rose*', *Cahiers de recherches médiévales et humanistes*, 22 (2011), 9–23

BAUMAN, RICHARD, 'Verbal Art as Performance', *American Anthropologist*, 77 (1975), 290–311

BENT, IAN, 'Gennrich, Friedrich', in *The New Grove Dictionary of Music and Musicians*, ed. by Stanley Sadie, 29 vols (London: Macmillan, 2001), IX, 653–55

BESSERMAN, LAWRENCE L., *The Legend of Job* (Cambridge, MA, & London: Harvard University Press, 1979)

BIEHL, LUDWIG, *Das liturgische Gebet für Kaiser und Reich: ein Beitrag zur Geschichte des Verhältnisses von Kirche und Staat* (Paderborn: Schöningh, 1937)

BIRGISSON, BERGSVEINN, 'Inn I Skaldens Sinn — Kognitive, Estetiske Og Historiske Skatter I Den Norrøne Skaldediktingen' (unpublished doctoral dissertation, University of Bergen, 2007)

—— 'The Old Norse Kenning as a Mnemonic Figure', in *The Making of Memory in the Middle Ages*, ed. by Lucie Doležalová, Later Medieval Europe, IV (Leiden: Brill, 2010), pp. 199–214

BLOOM, BENJAMIN S. and OTHERS (eds), *Taxonomy of Educational Objectives, Handbook I: The Cognitive Domain* (New York: Longman, 1956)

BLOOM, HAROLD, *The Western Canon: The Books and Schools of the Ages* (New York: Harcourt Brace, 1994)

BOITANI, PIERO, 'The Poetry and Poetics of the Creation', in *Dante's 'Commedia': Theology as Poetry*, ed. by Vittorio Montemaggi and Matthew Treherne (Notre Dame, IN: University of Notre Dame Press, 2010), pp. 95–130

BOOGAARD, NICO VAN DEN, *Rondeaux et refrains du XIIe siècle au début du XIVe*, Bibliothèque française et romane, D: III (Paris: Klincksieck, 1969)

BOSSY, M.-A., 'Donnant, donnant: les échanges entre Froissart et ses interlocuteurs à la cour de Gaston Fébus', in *Courtly Literature and Clerical Culture*, ed. by Christoph Huber, Henrike Lähnemann, and Sandra Linden (Tübingen: Attempto, 2002), pp. 29–38

BOURGAIN, PASCALE, 'La Honte du héros', in *Nova de veteribus: mittel- und neulateinische Studien für Paul Gerhard Schmidt*, ed. by Andreas Bihrer and Elisabeth Stein (Munich: Saur, 2004), pp. 385–400

BOYM, SVETLANA, *The Future of Nostalgia* (New York: Basic Books, 2001)

BOYNTON, SUSAN, 'Troubadour Song as Performance: A Context for Guiraut Riquier's "Pus sabers no'm val ni sens"', *Current Musicology*, 94 (2012), 7–36

BRAIDA, ANTONELLA, and LUISA CALÈ (eds), *Dante on View: The Reception of Dante in the Visual and Performing Arts* (Aldershot: Ashgate, 2007)

BRENNECKE, WILFRIED, 'Hiob als Musikheiliger', *Musik und Kirche*, 24 (1954), 257–61

BROWNLEE, KEVIN, 'Why the Angels Speak Italian: Dante as Vernacular Poet in *Paradiso* XXV', *Poetics Today*, 5 (1984), 597–610

BRUGGISSER-LANKER, THERESE, 'König David und die Macht der Musik: Gedanken zur musikalischen Semantik zwischen Tod, Trauer und Trost', in *König David — biblische Schlüsselfigur und europäische Leitgestalt*, ed. by Walter Dietrich and Hubert Herkommer (Freiburg (CH) & Stuttgart: Kohlhammer, 2003), pp. 589–629

BRUNNER, HORST, 'Die Töne Bruder Wernhers: Bemerkungen zur Form und zur formgeschichtlichen Stellung', in *Liedstudien: Wolfgang Osthoff zum 60. Geburtstag*, ed. by Martin Just and Reinhard Wiesend (Tutzing: Schneider, 1989), pp. 47–60

—— 'Minnesang', in *Die Musik in Geschichte und Gegenwart*, ed. by Ludwig Finscher, 2nd edn, 19 vols (Kassel: Bärenreiter, 1997), VI (Sachteil), cols 302–13

—— 'Sangspruchdichtung', in *Die Musik in Geschichte und Gegenwart*, ed. by Ludwig Finscher, 2nd edn, 19 vols (Kassel: Bärenreiter, 1998), VIII (Sachteil), cols 931–39

—— 'Frauenlob', in *Die Musik in Geschichte und Gegenwart*, ed. by Ludwig Finscher, 2nd edn, 19 vols (Kassel: Bärenreiter, 2002), VII (Personenteil), cols 46–48

—— 'Walther von der Vogelweide', in *Die Musik in Geschichte und Gegenwart*, ed. by Ludwig Finscher, 2nd edn, 19 vols (Kassel: Bärenreiter, 2007), XVII (Personenteil), cols 447–50

——, and KARL-GÜNTHER HARTMANN (eds), *Spruchsang: die Melodien der Sangspruchdichter des 12. bis 15. Jahrhunderts*, Monumenta Monodica Medii Aevi, VI (Kassel: Bärenreiter, 2010)

BUTLER, JUDITH, *Gender Trouble: Feminism and the Subversion of Identity* (London: Routledge, 1990)

BUTTERFIELD, ARDIS, 'The Language of Medieval Music: Two Thirteenth-Century Motets', *Plainsong and Medieval Music*, 2 (1993), 1–16

—— 'The Refrain and the Transformation of Genre in *Le Roman de Fauvel*' and 'Appendix: Catalogue of Refrains in *Le Roman de Fauvel*, BN fr.146', in *Fauvel Studies: Allegory, Chronicle, Music and Image in Paris, Bibliothèque Nationale MS français 146*, ed. by Margaret Bent and Andrew Wathey (Oxford: Clarendon Press, 1998), pp. 105–59

—— *Poetry and Music in Medieval France: From Jean Renart to Guillaume de Machaut*, Cambridge Studies in Medieval Literature, XLIX (Cambridge: Cambridge University Press, 2002)

—— 'Articulating the Author: Gower and the French Vernacular Codex', *The Yearbook of English Studies*, 33 (2003), 80–96

—— 'Music, Memory, and Authenticity', in *Representing History, 900–1300: Art, Music, History*, ed. by Robert A. Maxwell (Philadelphia: Pennsylvania State University Press, 2010), pp. 19–30

—— 'Fuzziness and Perceptions of Language in the Middle Ages: Part 1: Explosive Fuzziness: the Duel', *Common Knowledge*, 18 (2012), 255–66

—— 'Fuzziness and Perceptions of Language in the Middle Ages: Part 2: Collective Fuzziness: Three Treaties and a Funeral', *Common Knowledge*, 19 (2013), 51–64

—— 'Fuzziness and Perceptions of Language in the Middle Ages: Part 3: Translating Fuzziness: Countertexts', *Common Knowledge*, 19 (2013), 446–73

—— 'Introduction', in *Citation, Intertextuality and Memory in the Middle Ages and the Renaissance*, ed. by Yolanda Plumley and Giuliano Di Bacco (Liverpool: Liverpool University Press, 2013), pp. 1–5

CALLAHAN, CHRISTOPHER, 'Hybrid Discourse and Performance in the Old French Pastourelle', *French Forum*, 27 (2002), 1–22

CAMPBELL, EMMA, and ROBERT MILLS, 'Introduction: Rethinking Medieval Translation', in *Rethinking Medieval Translation: Ethics, Politics, Theory*, ed. by Emma Campbell and Robert Mills (Cambridge: Brewer, 2012), pp. 1–20

CARLSON, MARVIN, *Performance: A Critical Introduction*, 2nd edn (New York: Routledge, 2004)

CARRUTHERS, MARY J., *The Book of Memory: A Study of Memory in Medieval Culture*, Cambridge Studies in Medieval Literature, ed. by Alastair Minnis (Cambridge: Cambridge University Press, 1990)

CASAJUS, DOMINIQUE, *L'Aède et le troubadour: essai sur la tradition orale* (Paris: CNRS Éditions, 2012)

CECCHETTO, CÉLINE, 'Médiévalismes d'une sémiose: le Moyen Âge en chanson', *Itinéraires*, 8.3 (2010), 177–88

CHEUNG SALISBURY, MATTHEW, *Hear My Voice, O God: Functional Dimensions of Christian Worship* (Collegeville, MN: Liturgical Press, 2014)

—— 'Rethinking the Uses of Sarum and York: A Historiographical Essay', in *Understanding Medieval Liturgy: Essays in Interpretation*, ed. by Sarah Hamilton and Helen Gittos (Farnham: Ashgate, 2015), pp. 103–22

—— *The Secular Liturgical Office in Late Medieval England* (Turnhout: Brepols, 2015)

—— 'Establishing a Liturgical "Text": Text for Performance, Performance as Text', in *Late Medieval Liturgies Enacted: The Experience of Worship in Cathedral and Parish Church*, ed. by Paul Barnwell, Sally Harper, and Magnus Williamson (Farnham: Ashgate, 2016), pp. 93–106

CIABATTONI, FRANCESCO, *Dante's Journey to Polyphony* (Toronto: University of Toronto Press, 2010)

CLARK, SUZANNAH, ' "S'en dirai chançonete": Hearing Text and Music in a Medieval Motet', *Plainsong and Medieval Music*, 16 (2007), 31–59

CLEASBY, RICHARD, and GUÐBRANDUR VIGFÚSSON (eds), *An Icelandic-English Dictionary: Based on the Ms. Collections of the Late Richard Cleasby* (Oxford: Clarendon Press, 1874)

CLUNIES ROSS, MARGARET, *A History of Old Norse Poetry and Poetics* (Cambridge: Brewer, 2005)

CLUNIES ROSS, MARGARET, and OTHERS, 'General Introduction', in *Poetry from the Kings' Sagas 1, From Mythical Times to c. 1035*, ed. by Diana Whaley, 2 vols (Turnhout: Brepols, 2012), I, xiii–xciii

COATES, ALAN, *English Medieval Books: The Reading Abbey Collections from Foundation to Dispersal* (Oxford: Clarendon Press, 1999)

COLEMAN, JOYCE, *Public Reading and the Reading Public in Late Medieval England and France*, Cambridge Studies in Medieval Literature, XXVI (Cambridge: Cambridge University Press, 1996; repr. 2005)

COLTON, LISA, 'Reconstructing Cluniac Music', *Early Music*, 34 (2006), 675–77

CONNOLLY, THOMAS, *Mourning into Joy: Music, Raphael, and Saint Cecilia* (New Haven, CT, & London: Yale University Press, 1994)

COOPER, CHARLOTTE E., 'What is Medieval Paratext?', *Marginalia*, 19 (November 2015), 37–50, <http://merg.soc.srcf.net/journal/19conference/19conference_article4.pdf>

COSTLEY, CLARE L., 'David, Bathsheba, and the Penitential Psalms', *Renaissance Quarterly*, 57 (2004), 1235–77

CRAMER, THOMAS, *Waz hilfet âne sinne kunst?: Lyrik im 13. Jahrhundert: Studien zu ihrer Ästhetik* (Berlin: Schmidt, 1998)

CRISTALDI, SERGIO, 'Dante e i Salmi', in *La Bibbia di Dante: esperienza mistica, profezia e teologia biblica in Dante: atti del convegno internazionale di studi, Ravenna, 7 novembre 2009*, ed. by Giuseppe Ledda (Ravenna: Centro Dantesco dei Frati Minori Conventuali, 2011), pp. 77–120

CROENEN, GODFRIED, 'Pierre de Liffol and the Manuscripts of Froissart's Chronicles', in *The Online Froissart*, ed. by Peter Ainsworth and Godfried Croenen, version 1.5 (Sheffield: HRIOnline, 2013), <http://www.hrionline.ac.uk/onlinefroissart/apparatus.jsp?type=intros&intro=f.intros.GC-Pierre>

CULLER, JONATHAN D., 'Philosophy and Literature: The Fortunes of the Performative', *Poetics Today*, 21 (2000), 503–19

CULLIN, OLIVIER, and CHRISTELLE CHAILLOU, 'La Mémoire et la musique au Moyen Âge', *Cahiers de Civilisation Médiévale*, 49 (2006), 143–62

CUMMINGS, ANTHONY M., *The Politicized Muse: Music for Medici Festivals, 1512–1537* (Princeton: Princeton University Press, 1992)

D'ALFONSO, ROSSELLA, *Il Dialogo con Dio nella 'Divina Commedia'* (Bologna: CLUEB, 1988)

DÄLLENBACH, LUCIEN, *Le Récit spéculaire: essai sur la mise en abyme* (Paris: Seuil, 1977)

—— *The Mirror in the Text*, trans. by Jeremy Whiteley and Emma Hughes (Chicago: University of Chicago Press, 1989)

DAY, JULIETTE, *Reading the Liturgy: An Exploration of Texts in Christian Worship* (London: Bloomsbury, 2014)

DAY, THOMAS, *Why Catholics Can't Sing*, rev. edn (New York: Crossroads, 2013)

DEEMING, HELEN, *Songs in British Sources, c. 1150–1300*, Musica Britannica, XCV (London: Stainer and Bell, 2013), with the companion online resource, *Sources of British Song, 1150–1300*, <http://www.diamm.ac.uk/resources/sbs/>

—— 'An English Monastic Miscellany: The Reading Manuscript of *Sumer is icumen in*', in *Manuscripts and Medieval Song: Inscription, Performance, Context*, ed. by Helen Deeming and Elizabeth Eva Leach (Cambridge: Cambridge University Press, 2015), pp. 116–40

—— 'Music and the Book: The Textualisation of Music and the Musicalisation of Text', in *The Edinburgh Companion to Literature and Music*, ed. by Delia da Sousa (Edinburgh: Edinburgh University Press, forthcoming)

DELOGU, DAISY, 'Armes, amours, écriture: figure de l'écrivain dans le *Méliador* de Jean Froissart', *Médiévales*, 41 (2001), 133–48

DENIS, VALENTIN, 'Saint Job, patron des musiciens', *Revue belge d'archéologie et d'histoire de l'art*, 21 (1952), 252–98

DERRIDA, JACQUES, *Margins of Philosophy*, trans. by Alan Bass (Chicago: Chicago University Press, 1972)

—— 'Signature, événement, contexte', in *Marges de la philosophie* (Paris: Les Éditions de Minuit, 1972), pp. 367–93

—— 'Signature Event Context', *Glyph*, 1 (1977), 172–97

—— 'Signature Event Context', in *Limited Inc.*, ed. by Gerald Graff (Chicago: Northwestern University Press, 1988), pp. 1–23

—— 'Limited Inc a b c...', *Glyph*, 2 (1977), 162–254

DESMOND, MARILYNN, 'Christine de Pizan: Gender, Authorship and Life-Writing', in *The Cambridge Companion to Medieval French Literature*, ed. by Simon Gaunt and Sarah Kay (Cambridge: Cambridge University Press, 2008), pp. 123–36

DESMOND, MARILYNN, and PAMELA SHEINGORN, *Myth, Montage and Visuality in Late Medieval Manuscript Culture: Christine de Pizan's 'Epistre Othea'* (Ann Arbor: University of Michigan Press, 2003)

DE VENTURA, PAOLO, *Dramma e dialogo nella 'Commedia' di Dante: Il linguaggio della mimesi per un resoconto dall'aldilà* (Naples: Liguori, 2007)

DILLER, GEORGE T., 'Froissart's 1389 Travel to Béarn: A *Voyage* Narration to the Center of the *Chroniques*', in *Froissart across the Genres*, ed. by Donald Maddox and Sara Sturm-Maddox (Gainesville: University Press of Florida, 1998), pp. 50–60

—— 'Alexandre Dumas, lecteur de Jean Froissart', in *Froissart dans sa forge: actes du colloque réuni à Paris, du 4 au 6 novembre 2004*, ed. by Michel Zink and Odile Bombarde (Paris: AIBL, 2006), pp. 199–211

DILLON, EMMA, *Medieval Music-Making and the 'Roman de Fauvel'* (Cambridge: Cambridge University Press, 2002)

—— *The Sense of Sound: Musical Meaning in France, 1260–1330* (New York: Oxford University Press, 2012)

DINKOVA-BRUUN, GRETI, 'Biblical Thematics: The Story of Samson in Medieval Literary Discourse', in *The Oxford Handbook of Medieval Latin Literature*, ed. by Ralph J. Hexter and David Townsend (New York & Oxford: Oxford University Press, 2012), pp. 356–75

DITOMMASO, LORENZO, 'Pseudepigrapha Notes IV: 5. The *Testament of Job*. 6. The *Testament of Solomon*', *Journal for the Study of the Pseudepigrapha*, 21 (2012), 313–20

DOSS-QUINBY, EGLAL, 'Chix refrains fu bien respondus: Les Refrains dans la "*Suite anonyme de la Court d'amours*" de Mahieu le Poirier', *Romance Notes*, 28 (1987/88), 125–35

D'OVIDIO, FRANCESCO, *Nuovi studii danteschi: il 'Purgatorio' e il suo preludio* (Milan: Hoepli, 1906)

DRABEK, ANNA M., *Reisen und Reisezeremoniell der römisch-deutschen Herrscher im Spätmittelalter* (Vienna: Verlag des Wissenschaftlichen Antiquariats H. Geyer, 1964)

DRAGONETTI, ROGER, *Le Mirage des sources: l'art du faux dans le roman médiéval* (Paris: Seuil, 1987)

DRONKE, PETER, *Poetic Individuality in the Middle Ages: New Departures in Poetry* (Oxford: Clarendon Press, 1970)

DUCROT, OSWALD, and DANIÈLE BOURCIER, *Les Mots du discours* (Paris: Éditions de Minuit, 1980)

DUFRESNE, LAURA RINALDI, 'A Woman of Excellent Character: A Case Study of Dress, Reputation and the Changing Costume of Christine de Pizan in the Fifteenth Century', *Dress*, 17 (1990), 105–17

DUTTLINGER, CAROLIN and LUCIA RUPRECHT, 'Introduction', in *Performance and Performativity in German Cultural Studies*, ed. by Carolin Duttlinger, Lucia Ruprecht, and Andrew Webber (Oxford: Lang, 2003), pp. 9–19

DUYS, KATHRYN A., ELIZABETH EMERY, and LAURIE POSTLEWATE, 'Introduction', in *Telling the Story in the Middle Ages: Essays in Honor of Evelyn Birge Vitz*, ed. by Kathryn A. Duys, Elizabeth Emery, and Laurie Postlewate (Cambridge: Brewer, 2015), pp. 1–10

EAREY, MARK, *Worship that Cares: An Introduction to Pastoral Liturgy* (London: SCM, 2012)

EDWARDS, A. S. G., 'Bodleian Library MS Arch. Selden B.24: A "Transitional" Codex', in *The Whole Book: Cultural Perspectives on the Medieval Miscellany*, ed. by Stephen G. Nichols and Siegfried Wenzel, Recentiores: Later Latin Texts and Contexts (Ann Arbor: University of Michigan Press, 1996), pp. 53–67

EGGEBRECHT, HANS HEINRICH, 'Jammers, Ewald (Karl Hubert Maria)', in *The New Grove Dictionary of Music and Musicians*, ed. by Stanley Sadie, 29 vols (London: Macmillan, 2001), XII, 767–68

EVANS, BEVERLY J., 'The Unity of Text and Music in the Late Thirteenth-Century French Motet: A Study of Selected Works from the Montpellier Manuscript, Fascicle 7' (unpublished doctoral dissertation, University of Pennsylvania, 1983)

EVERIST, MARK, *French Motets in the Thirteenth Century: Music, Poetry, and Genre* (Cambridge: Cambridge University Press, 1994)

EXUM, J. CHERYL, 'The Theological Dimension of the Samson Saga,' *Vetus Testamentum*, 33 (1983), 30–45

FAULKES, ANTHONY, *What Was Viking Poetry for? Inaugural Lecture Delivered on 27th April 1993 in the University of Birmingham* (Birmingham: University of Birmingham, School of English, 1993)

FAVREAU, ROBERT, 'Le Thème iconographique du lion dans les inscriptions médiévales', *Comptes-rendus des séances de l'Académie des inscriptions et des belles-lettres*, 3 (1991), 613–36

FEDERICI, THERESA, 'Dante's Davidic Journey: From Sinner to God's Scribe', in *Dante's 'Commedia': Theology as Poetry*, ed. by Vittorio Montemaggi and Matthew Treherne (Notre Dame, IN: University of Notre Dame Press, 2010), pp. 180–209

FINBURGH, CLARE, 'Facets of Artifice: Rhythms in the Theater of Jean Genet, and the

Painting, Drawing, and Sculpture of Alberto Giacometti', *French Forum*, 27.3 (2002), 73–98

FINK, GOTTFRIED WILHELM, 'Dr. Gottfried Emil Fischer', *Allgemeine musikalische Zeitung*, 36 (1841), 721–24

FINNEGAN, RUTH, 'The How of Literature', *Oral Tradition*, 20 (2005), 164–87

FISCHER, [GOTTFRIED EMIL], 'Ueber die Musik der Minnesänger', in *Deutsche Liederdichter des zwölften, dreizehnten und vierzehnten Jahrhunderts*, ed. by Friedrich Heinrich von der Hagen, 4 vols (Leipzig: Barth, 1838), IV, 853–62

FISCHER, NORBERT, *Augustinus: Spuren und Spiegelungen seines Denkens*, 2 vols (Hamburg: Meiner, 2009)

FLÖGEL, KARL FRIEDRICH, *Geschichte der Hofnarren* (Liegnitz: Siegert, 1789)

FOUCAULT, MICHEL, *L'Archéologie du savoir*, Bibliothèque des Sciences humaines (Paris: Gallimard, 1969)

——*Archaeology of Knowledge*, trans. by A. M. Sheridan Smith, Routledge Classics (London & New York: Routledge, 1989)

——'Of Other Spaces: Utopias and Heterotopias', *Diacritics*, 16.1 (1986), 22–27

FRANK, ROBERTA, *Old Norse Court Poetry: The Dróttkvaett Stanza*, Islandica, XLII (Ithaca, NY: Cornell University Press, 1978)

FREISE, DOROTHEA, *Geistliche Spiele in der Stadt des ausgehenden Mittelalters: Frankfurt, Friedberg, Alsfeld* (Göttingen: Vandenhoeck & Ruprecht, 2002)

GADE, KARI ELLEN, *The Structure of Old Norse Dróttkvætt Poetry*, Islandica, XLIX (Ithaca, NY: Cornell University Press, 1995)

GAGE, JOHN, *Colour and Culture: Practice and Meaning from Antiquity to Abstraction* (London: Thames and Hudson, 2009)

GALVEZ, MARISA, *Songbook: How Lyrics Became Poetry in Medieval Europe* (Chicago: University of Chicago Press, 2012)

GATHERCOLE, PATRICIA M., *The Depiction of Women in Medieval French Manuscript Illumination* (Lewiston & Lampeter: Mellen, 2000)

GENETTE, GÉRARD, *Figures III* (Paris: Seuil, 1972)

GENNRICH, FRIEDRICH, 'Liedkontrafaktur in mittelhochdeutscher und althochdeutscher Zeit', *Zeitschrift für deutsches Altertum und deutsche Literatur*, 82 (1948/50), 105–41

——'Wer ist der Initiator der "Modaltheorie"? Suum cuique', in *Miscelánea en homenaje a Monseñor Higinio Anglés*, 2 vols (Barcelona: Consejo superior de investigaciones científicas, 1958–61), I, 315–30

——(ed.), *Troubadours, Trouvères, Minne- und Meistergesang*, Das Musikwerk, ed. by Karl Gustav Fellerer, II (Cologne: Arno, 1951)

——(ed.), *Die Jenaer Liederhandschrift: Faksimile-Ausgabe ihrer Melodien*, Summa Musica Medii Aevi, XI (Langen bei Frankfurt, 1963)

GERBER, REBECCA L., *Sacred Music from the Cathedral at Trent: Trent, Museo Provinciale d'Arte, Codex 1375 (Olim 88)* (Chicago: University of Chicago Press, 2007)

GIBBS, MARION B., and SIDNEY M. JOHNSON (eds), *Medieval German Literature: A Companion* (New York & London: Routledge, 2000)

GIER, HELMUT, 'Das Oster- und Passionsspiel in Augsburg', in *Das Passionsspiel — Einst und Heute*, ed. by Wilhelm Liebhart (Augsburg: Katholische Akademie, 1988), pp. 50–65

GILLINGHAM, BRYAN, *Music in the Cluniac Ecclesia: A Pilot Project* (Ottawa: Institute of Medieval Music, 2006)

GLASSER, JONATHAN, *Genealogies of Al-Andalus: Music and Patrimony in the Modern Maghreb* (doctoral dissertation, University of Michigan, 2008), published online by ProQuest and UMI Dissertation Publications, 2009, <http://search.proquest.com/docview/304571085>

GLAUSER, JÜRG, 'The Speaking Bodies of Saga Texts', trans. by Kate Heslop, in *Learning and Understanding in the Old Norse World: Essays in Honour of Margaret Clunies Ross*, ed. by Judy Quinn, Kate Heslop, and Tarrin Wills (Turnhout: Brepols, 2007), pp. 13–26

GOERES, ERIN MICHELLE, 'The King is Dead, Long Live the King: Commemoration in Skaldic Verse of the Viking Age' (unpublished doctoral dissertation, University of Oxford, 2010)

GRAGNOLATI, MANUELE, 'Gluttony and the Anthropology of Pain in Dante's *Inferno* and *Purgatorio*', in *History in the Comic Mode: Medieval Communities and the Matter of Person*, ed. by Rachel Fulton and Bruce W. Holsinger (New York: Columbia University Press, 2007), pp. 238–50

——'Authorship and Performance in Dante's *Vita Nuova*', in *Aspects of the Performative in Medieval Culture*, ed. by Manuele Gragnolati and Almut Suerbaum (Berlin & New York: de Gruyter, 2010), pp. 123–40

GRANT, STUART, 'Some Suggestions for a Phenomenology of Rhythm', in *Philosophical and Cultural Theories of Music*, ed. by Eduardo de la Fuente and Peter Murphy, Social and Critical Theory, VIII (Leiden: Brill, 2010), pp. 151–73

GRIER, JAMES, 'Editing', in *The New Grove Dictionary of Music and Musicians*, ed. by Stanley Sadie, 29 vols (London: Macmillan, 2001), VII, 885–95

GRISWARD, JOEL H., 'Froissart et la nuit du loup-garou, la fantaisie de Pierre de Béarn: modèle folklorique ou modèle mythique?', in *Le Modèle à la Renaissance*, ed. by Jean Lafond, Pierre Laurens, and Claudie Balavoine (Paris: Vrin, 1986), pp. 21–34

GUENÉE, BERNARD, 'Ego, je: l'affirmation de soi par les historiens français (XIVe–XVe s.)', *Comptes-rendus des séances de l'Académie des Inscriptions et Belles-Lettres*, 149.2 (2005), 597–611

GURLITT, WILIBALD, HANS HEINRICH EGGEBRECHT, and CARL DAHLHAUS (eds), *Riemann Musik Lexikon*, 6 vols (Mainz: B. Schott's Söhne, 1959–75)

GUSTAVSON, ROYSTON R., 'Hans Ott, Hieronymus Formschneider, and the Novum et insigne opus musicum (Nuremberg, 1537–1538)', 2 vols (unpublished doctoral dissertation, University of Melbourne, 1998)

HAAS, MAX, *Musikalisches Denken im Mittelalter* (Frankfurt a. M.: Lang, 2005)

HAGGH-HUGLO, BARBARA, 'Easter Polyphony in the St Emmeram and Trent Codices', *Musiktheorie*, 27.2 (2012), 112–32

HAINES, JOHN, 'The Arabic Style of Performing Medieval Music', *Early Music*, 21 (2001), 369–78

——*Satire in the Songs of Renart le Nouvel* (Geneva: Droz, 2010)

HÄNDL, CLAUDIA, 'Wizlav (von Rügen?)', in *Literatur Lexikon: Autoren und Werke deutscher Sprache*, ed. by Walter Killy, 15 vols (Gütersloh: Bertelsmann Lexikon Verlag, 1992), XII, 383–84

HANDSCHIN, JACQUES, 'The Summer Canon and its Background, I', *Musica Disciplina*, 3.2 (1949), 55–59

HARF-LANCNER, LAURENCE, 'Chronique et roman: les contes fantastiques de Froissart', in *Autour du roman*, ed. by Nicole Cazauran (Paris: Presses de l'École Normale Supérieure, 1990), pp. 49–65

HARPER, JOHN, *The Forms and Orders of Western Liturgy from the Tenth to the Eighteenth Century: A Historical Introduction and Guide for Students and Musicians* (Oxford: Clarendon Press, 1991)

HARPER, JOHN (leader), *The Experience of Worship in Late Medieval Cathedral and Parish Church: Making, Doing, and Responding to Medieval Liturgy*, <http://www.experienceofworship.org.uk/>

HAUSTEIN, JENS, and FRANZ KÖRNDLE (eds), *Die 'Jenaer Liederhandschrift': Codex — Geschichte — Umfeld* (Berlin: de Gruyter, 2010)

HAWKINS, PETER S., *Dante's Testaments: Essays in Scriptural Imagination* (Stanford, CA: Stanford University Press, 1999)

HEINZER, FELIX, '*Samson dux fortissimus* — Löwenbändiger und Weiberknecht vom Dienst? Funktionen und Wandlungen eines literarischen Motivs im Mittelalter', *Mittellateinisches Jahrbuch*, 48 (2008), 25–46

HENTSCHEL, FRANK, *Sinnlichkeit und Vernunft in der mittelalterlichen Musiktheorie*, Beihefte zum Archiv für Musikwissenschaft, XLVII (Stuttgart: Steiner, 2000)

HERBERICHS, CORNELIA, and CHRISTIAN KIENING, 'Einleitung', in *Literarische Performativität: Lektüren vormoderner Texte*, ed. by Cornelia Herberichs and Christian Kiening (Zurich: Chronos, 2008), pp. 1–13

HEYMEL, MICHAEL, 'Hiob und die Musik: zur Bedeutung der Hiobgestalt für eine musikalische Seelsorge', in *Das Alte Testament und die Kunst*, ed. by John Barton, J. Cheryl Exum, and Manfred Oeming (Münster: LIT, 2005), pp. 129–64

HINDMAN, SANDRA, *Christine de Pizan's 'Epitre Othea': Painting and Politics at the Court of Charles VI* (Wetteren: Pontifical Institute of Mediaeval Studies, 1986)

HOLLANDER, ROBERT, 'Dante's Use of the Fiftieth Psalm', *Dante Studies*, 91 (1973), 145–50

——*Dante's Epistle to Cangrande* (Ann Arbor: University of Michigan Press, 1993)

HOLSINGER, BRUCE W., *Music, Body, and Desire in Medieval Culture: Hildegard of Bingen to Chaucer* (Stanford, CA: Stanford University Press, 2001)

——'Medieval Literature and Cultures of Performance', *New Medieval Literatures*, 6 (2003), 271–312

HOLUB, ROBERT C., *Reception Theory*, The New Accent Series, ed. by Terence Hawkes, (London: Routledge, 2003)

HOLZ, GEORG, FRANZ SARAN, and EDUARD BERNOULLI (eds), *Die Jenaer Liederhandschrift*, 2 vols (Leipzig: Hirschfeld, 1901)

HOLZNAGEL, FRANZ-JOSEF, 'Typen der Verschriftlichung mittelhochdeutscher Lyrik vom 12. bis zum 14. Jahrhundert', in *Entstehung und Typen mittelalterlicher Lyrikhandschriften: Akten des Grazer Symposiums 13.–17. Oktober 1999*, ed. by Anton Schwob and András Vizkelety (Bern: Lang, 2001), pp. 107–30

HONESS, CLAIRE, 'Communication and Participation in Dante's *Commedia*', in *In Amicizia: Essays in Honour of Giulio Lepschy*, ed. by Zygmunt G. Barański and Lino Pertile (Reading: University of Reading, 1997), special supplement of *The Italianist*, 17 (1997), 127–45

HONKO, LAURI, 'Introduction: Epics along the Silk Roads — Mental Texts, Performance, and Written Codification', *Oral Tradition*, 11 (1996), 1–17

HOPE, HENRY, 'Constructing Minnesang Musically' (unpublished doctoral dissertation, University of Oxford, 2013)

——'Miniatures, Minnesänger, Music: The Codex Manesse', in *Manuscripts and Medieval Song: Inscription, Performance, Context*, ed. by Helen Deeming and Elizabeth Eva Leach (Cambridge: Cambridge University Press, 2015), pp. 163–92

HOWELL, STANDLEY, 'Paulus Paulirinus of Prague on Musical Instruments', *Journal of the American Musical Instrument Society*, 5/6 (1979/80), 9–36

HUCK, OLIVER, 'Die Notation der mehrfach überlieferten Melodien in der "Jenaer Liederhandschrift"', in *Die 'Jenaer Liederhandschrift': Codex — Geschichte — Umfeld*, ed. by Jens Haustein and Franz Körndle (Berlin: de Gruyter, 2010), pp. 99–120

HUCKE, HELMUT, 'Über Herkunft und Abgrenzung des Begriffs "Kirchenmusik"', in *Renaissance-Studien: Helmuth Osthoff zum 80. Geburtstag*, ed. by Ludwig Finscher (Tutzing: Schneider, 1979), pp. 103–25

HUNT, RICHARD WILLIAM, review of *The Oxford Book of Medieval Latin Verse*, ed. by F. J. E. Raby (Oxford: Clarendon Press, 1959), *Medium Aevum*, 28 (1959), 189–94

HUOT, SYLVIA, *From Song to Book: The Poetics of Writing in Old French Lyric and Lyrical Narrative Poetry* (Ithaca, NY: Cornell University Press, 1987)

——*Allegorical Play in the Old French Motet: The Sacred and the Profane in Thirteenth-Century Polyphony* (Stanford, CA: Stanford University Press, 1997)

IRVINE, MARTIN, 'Medieval Grammatical Theory and the *House of Fame*', *Speculum*, 60 (1985), 850–76

JAMES, M. R., *A Descriptive Catalogue of the Manuscripts in the Library of Lambeth Palace* (Cambridge: Cambridge University Press, 1895; digital repr. 2011)

JAMMERS, EWALD, 'Minnesang und Choral', in *Festschrift Heinrich Besseler zum sechzigsten Geburtstag*, ed. by Eberhardt Klemm (Leipzig: VEB Deutscher Verlag für Musik Leipzig, 1961), pp. 137–47

——*Ausgewählte Melodien des Minnesangs*, Altdeutsche Textbibliothek, ed. by Hugo Kuhn, 1 (Ergänzungsreihe) (Tübingen: Niemeyer, 1963)

——*Die sangbaren Melodien zu Dichtungen der Manessischen Liederhandschrift* (Wiesbaden: Reichert, 1979)

——'Die Manessische Liederhandschrift und die Musik', in *Codex Manesse: die Grosse Heidelberger Liederhandschrift: Kommentar zum Faksimile des Codex Palatinus Germanicus 848 der Universitätsbibliothek Heidelberg*, ed. by Walter Koschorreck and Wilfried Werner (Kassel: Graphische Anstalt für Kunst und Wissenschaft, 1981), pp. 169–87

JEFFREY, DAVID LYLE (ed.), *A Dictionary of Biblical Tradition in English Literature* (Grand Rapids, MI: Eerdmans, 1992)

JOHANEK, PETER, and ANGELIKA LAMPEN (eds), *Adventus: Studien zum herrscherlichen Einzug in die Stadt* (Cologne: Böhlau, 2009)

JOST, PETER, 'Zu den Editionen der Gesänge Hildegards von Bingen', in *Mittelalter und Mittelalterrezeption*, ed. by Herbert Schneider, Musikwissenschaftliche Publikationen, ed. by Herbert Schneider, XXIV (Hildesheim: Olms, 2005), pp. 22–53

JUNOD, KAREN, and DIDIER MAILLAT, *Performing the Self: Constructing Premodern and Modern Identities* (Tübingen: Narr, 2010)

KANTOR, J. R., 'Memory: A Triphase Objective Action', *The Journal of Philosophy*, 19 (1922), 624–39

KANTOROWICZ, ERNST, 'The "King's Advent" and the Enigmatic Panels in the Doors of Santa Sabina', *The Art Bulletin*, 26.4 (1944), 207–31

——*Laudes Regiae: A Study in Liturgical Acclamations and Mediaeval Ruler Worship with a Study of the Music of the Laudes and Musical Transcriptions* (Berkeley: University of California Press, 1946)

KAY, SARAH, 'Knowledge and Truth in Quotations from the Troubadours: Matfre Ermengaud, Compagnon, Lyotard, Lacan', *Australian Journal of French Studies*, 46 (2009), 178–90

——'La Seconde Main et les secondes langues dans la France médiévale', in *Translations médiévales: cinq siècles de traductions en français au Moyen Âge (XIe–XVe siècles): Étude et Répertoire*, ed. by Claudio Galderisi and Vladimir Agrigoroaei (Turnhout: Brepols, 2011), pp. 461–85

——*Parrots and Nightingales: Troubadour Quotations and the Development of European Poetry* (Philadelphia: University of Pennsylvania Press, 2013)

KEENE, DEREK, 'Text, Visualization and Politics: London, 1150–1250', *Transactions of the Royal Historical Society*, 18, 6th series (2008), 69–99

KIPPENBERG, BURKHARD, *Der Rhythmus im Minnesang: eine Kritik der literar- und musikhistorischen Forschung mit einer Übersicht über die musikalischen Quellen*, Münchener Texte und Untersuchungen zur deutschen Literatur des Mittelalters, III (Munich: Beck, 1962)

——'Minnesang', in *The New Grove Dictionary of Music and Musicians*, ed. by Stanley Sadie, 29 vols (London: Macmillan, 2001), XVI, 721–30

KIRKPATRICK, ROBIN, 'Polemics of Praise: Theology as Text, Narrative, and Rhetoric in Dante's *Commedia*', in *Dante's 'Commedia': Theology as Poetry*, ed. by Vittorio Montemaggi and Matthew Treherne (Notre Dame, IN: University of Notre Dame Press, 2010), pp. 14–35

KIRSCH, WINFRIED, *Die Quellen der mehrstimmigen Magnificat- und Te Deum-Vertonungen bis zur Mitte des 16. Jahrhunderts* (Tutzing: Schneider, 1966)

KLEMM, FRIEDRICH, 'Fischer, Ernst Gottfried', in *Neue deutsche Biographie*, ed. by the Historische Kommission bei der Bayerischen Akademie der Wissenschaften, 26 vols (ongoing) (Berlin: Duncker & Humboldt, 1961–), v, 182–83

KÖRNDLE, FRANZ, 'So loblich, costlich und herlich, das darvon nit ist ze schriben: Der Auftritt der Kantorei Maximilians I. bei den Exequien für Philipp den Schönen auf dem Reichstag zu Konstanz', in *Tod in Musik und Kultur*, ed. by Stefan Gasch and Birgit Lodes (Tutzing: Schneider, 2007), pp. 87–109

——'Die Musikpflege bei den Kölner Bruderschaften im Vergleich zu anderen Städten', in *Das Erzbistum Köln in der Musikgeschichte des 15. und 16. Jahrhunderts: Kongressbericht Köln 2005*, ed. by Klaus Pietschmann, Beiträge zur Rheinischen Musikgeschichte, CLXXII (Berlin & Kassel: Merseburger, 2008), pp. 157–69

——'Musikanschauung im Mittelalter', in *Geschichte der Kirchenmusik*, ed. by Wolfgang Hochstein and Christoph Krummacher, 4 vols (Laaber: Laaber, 2011), I, 92–96

——'Vocabularien im Musikunterricht um 1500', in *Lehren und Lernen im Zeitalter der Reformation: Methoden und Funktionen*, ed. by Gerlinde Huber-Rebenich (Tübingen: Mohr Siebeck, 2012), pp. 203–12

——'Hiob, König David, Hl. Gregor, Hl. Cäcilia: Die Autorisierung der Kirchenmusik im Bild', in *Die Kirchenmusik in Kunst und Architektur*, ed. by Ulrich Fürst and Andrea Gottdang, Enzyklopädie der Kirchenmusik, V/1, (Laaber: Laaber, 2015), pp. 69–90

KOHLER, ALFRED, 'Wohnen und Essen auf den Reichstagen des 16. Jahrhunderts', in *Alltag im 16. Jahrhundert: Studien zu Lebensformen in mitteleuropäischen Städten*, ed. by Alfred Kohler and Heinrich Lutz (Vienna: Verlag für Geschichte und Politik, 1987), pp. 222–57

KOROM, FRANK J., 'The Anthropology of Performance: An Introduction', in *The Anthropology of Performance: A Reader*, ed. by Frank J. Korom (Hoboken, NJ: John Wiley & Sons, 2013), pp. 1–7

KRETZENBACHER, LEOPOLD, *Hiobs-Erinnerungen zwischen Donau und Adria*, Bayerische Akademie der Wissenschaften, Phil.-Hist. Klasse (Munich: Beck, 1987), pp. 141–56

KUBICKI, JUDITH, 'Using J. L. Austin's Performative Language Theory to Interpret Ritual Music-Making', *Worship*, 73 (1999), 310–31

KUCZYNSKI, MICHAEL P., 'The Psalms and Social Action in Late Medieval Prayer', in *The Place of the Psalms in the Intellectual Culture of the Middle Ages*, ed. by Nancy Van Deusen (Albany: State University of New York Press, 1999), pp. 191–214

KUNSTEIN, ELISABETH, 'Die Höllenfahrtszene im geistlichen Spiel des deutschen Mittelalters: ein Beitrag zur mittelalterlichen und frühneuzeitlichen Frömmigkeitsgeschichte' (unpublished doctoral dissertation, University of Cologne, 1972)

LADRIÈRE, JEAN, 'The Performativity of Liturgical Language', trans. by John Griffiths, *Concilium*, 9.2 (1973), 50–62

LAEMMER, HUGO, *Monumenta vaticana: historiam ecclesiasticam saeculi XVI illustrantia* (Freiburg im Breisgau: Herdersche Verlagshandlung, 1861)

LA FAVIA, LOUIS M., ' "...Chè quivi per canti..." (*Purg.*, xii, 113): Dante's Programmatic Use of Psalms and Hymns in the *Purgatorio*', *Studies in Iconography*, 9 (1984–86), 53–65

LAIDLAW, JAMES, 'Christine de Pizan — A Publisher's Progress', *Modern Language Review*, 82 (1987), 35–75

LAIDLAW, JAMES (director), *The Making of the Queen's Manuscript Project*, <http://www.pizan.lib.ed.ac.uk>

Lambeth Palace Library Database of Manuscripts and Archives, <http://archives.lambethpalacelibrary.org.uk/CalmView/Default.aspx>

LANG, MARGARETE, and JOSEPH MÜLLER-BLATTAU, *Zwischen Minnesang und Volkslied: die Lieder der Berliner Handschrift, Germ. Fol. 922*, Studien zur Volksliedforschung. Beihefte zum Jahrbuch für Volksliedforschung, ed. by John Meier, 1 (Berlin: de Gruyter, 1941)

LANG, MARGARETE, and WALTER SALMEN, *Ostdeutscher Minnesang*, Schriften des Koper-nikuskreises, III (Lindau & Constance: Thorbecke, 1958)

LANGER, SUSANNE K., *Feeling and Form: A Theory of Art Developed from Philosophy in a New Key* (London: Routledge & Kegan Paul, 1953)

LEACH, ELIZABETH EVA, *Sung Birds: Music, Nature, and Poetry in the Later Middle Ages* (Ithaca, NY: Cornell University Press, 2007)

——'Nature's Forge and Mechanical Production: Writing, Reading and Performing Song', in *Rhetoric Beyond Words: Delight and Persuasion in the Arts of the Middle Ages*, ed. by Mary Carruthers (Cambridge: Cambridge University Press, 2010), pp. 72–95

——*Guillaume de Machaut: Secretary, Poet, Musician* (Ithaca, NY: Cornell University Press, 2011)

LEACH, ELIZABETH EVA, and JONATHAN MORTON, 'Resonances in Richard de Fournival's *Bestiaire d'amour*: Sonic, Intertextual, Intersonic', unpublished

LECHAT, DIDIER, 'Christine et ses doubles dans le texte et les enluminures du *Livre du duc des vrais amants* (BnF fr. 836 et BL Harley 4431)', in *Sens, rhétorique et musique, études réunies en hommage à Jacqueline Cerquiglini-Toulet*, ed. by Sophie Albert, Mireille Demaules, Estelle Doudet, and others, 2 vols (Paris: Champion, 2015), II, 693–706

LEDDA, GIUSEPPE, 'La danza e il canto dell' "umile salmista": David nella *Commedia* di Dante', in *Les Figures de David à la Renaissance*, ed. by Élise Boillet, Sonia Cavicchioli, and Paul-Alexis Mellet (Geneva: Droz, 2015), pp. 225–46

LEDDA, GIUSEPPE (ed.), *Preghiera e liturgia nella 'Commedia': atti del convegno internazionale di studi, Ravenna, 12 novembre 2011* (Ravenna: Centro Dantesco dei Frati Minori Conventuali, 2013)

LÉGLU, CATHERINE, 'Did Women Perform Satirical Poetry? *Trobairitz* and *Soldaderas* in Medieval Occitan Poetry', *Forum for Modern Language Studies*, 37 (2001), 15–25

——'L'Amant tenu par la bride: itinéraires d'un motif dans la poésie du troubadour Gaucelm Faidit et un coffret en émail "œuvre de Limoges" du douzième siècle finissant', in *Gaucelm Faidit: amours, voyages et débats*, Trobada *tenue à Uzerche les 25 et 26 juin 2010, Cahiers de Carrefour Ventadour* (Moutiers-Ventadour: Carrefour Ventadour, 2011), pp. 149–66

——'Vernacular Poetry and the Spiritual Franciscans of the Languedoc: the Poems of Raimon de Cornet', in *Heresy and the Making of European Culture: Medieval and Modern Perspectives*, ed. by Andrew Roach and James R. Simpson (Farnham & Burlington, VT: Ashgate, 2013), pp. 165–84

——*Samson and Delilah in Medieval Insular French: Translation and Adaptation* (London: Palgrave Macmillan, forthcoming)

LE GOFF, JACQUES, *La Naissance du purgatoire* (Paris: Gallimard, 1981)

LEMAIRE, RIA, 'Femmes, jongleurs et troubadours: la mise-en-forme du discours médiéviste', <http://www.crimic.paris-sorbonne.fr/IMG/pdf/lemaire.pdf>

LESLIE, HELEN F., 'The Prose Contexts of Eddic Poetry — Primarily in the "Fornaldarsǫgur"' (unpublished doctoral dissertation, University of Bergen, 2012)

LEWON, MARC, 'Wie klang Minnesang? Eine Skizze zum Klangbild an den Höfen der staufischen Epoche', in *Dichtung und Musik der Stauferzeit: wissenschaftliches Symposium 12. bis 14. November 2010*, ed. by Volker Gallé (Worms: Worms Verlag, 2011), pp. 69–124

LIPPHARDT, WALTHER, *Lateinische Osterfeiern und Osterspiele: Teil III* (Berlin & New York: de Gruyter, 1976)

LOMBARDI, ELENA, *The Wings of the Doves: Love and Desire in Dante and Medieval Culture* (Montreal & Kingston: McGill-Queen's University Press, 2012)

LÖNNROTH, LARS, 'Old Norse Text as Performance', in *Scripta Islandica: Isländska sällskapets årsbok 60/2009*, ed. by Daniel Sävborg ([Uppsala: Institutionen för nordiska språk], 2010), pp. 49–60

LOXLEY, JAMES, *Performativity*, The New Critical Idiom, ed. by John Drakakis (London: Routledge, 2007)

LUDWIG, FRIEDRICH, *Repertorium organorum recentioris et motetorum vetustissimi stili*, ed. by Luther A. Dittmer, 2 vols (Brooklyn, NY: Institute of Medieval Music; Hildesheim: Olms, 1964–78)

MAHRT, WILLIAM PETER, 'Dante's Musical Progress through the *Commedia*', in *The Echo of Music: Essays in Honor of Marie Louise Göllner*, ed. by Blair Sullivan (Warren, MI: Harmonie Park Press, 2004), pp. 63–73

MALINOWSKI, BRONISLAW, 'The Problem of Meaning in Primitive Languages', in *The Meaning of Meaning: A Study of the Influence of Languages upon Thought and of the Science of Symbolism*, ed. by C. K. Ogden and I. A. Richards (London: Kegan Paul, Trench, Trubner & Co., 1923), pp. 451–510

MANČAL, JOSEF, 'Rotes Tor', *Augsburger Stadtlexikon Online*, ed. by Günther Grünsteudel, Günter Hägele, and Rudolf Frankenberger (Augsburg: Wissner, 2013), <http://www.stadtlexikon-augsburg.de/>

MANITIUS, MAX, *Geschichte der lateinischen Literatur des Mittelalters*, 4th edn, 3 vols (Munich: Beck, repr. 2005)

MANN, VIVIAN B., 'Mythological Subjects on Northern French Tablemen', *Gesta* 20.1 (1981), 161–71

—— 'Samson vs. Hercules: A Carved Cycle of the 12th Century', *Acta*, 7 (1983), 1–38

—— *Art and Ceremony in Jewish Life: Essays on the History of Jewish Art* (London: Pindar, 2005)

MANNAERTS, PETER, 'Die Bruderschaften und Zünfte und die kirchenmusikalische Praxis in den Niederlanden (14.–16. Jahrhundert)', in *Der Kirchenmusiker. Berufe — Institutionen — Wirkungsfelder*, ed. by Franz Körndle and Joachim Kremer, Enzyklopädie der Kirchenmusik, III (Laaber: Laaber, 2014), pp. 101–19

MARCHELLO-NIZIA, CHRISTIANE, 'L'Historien et son prologue: formes littéraires et stratégies discursives', in *La Chronique et l'histoire au Moyen Âge. Colloque des 24 et 25 mai 1982*, ed. by Daniel Poirion (Paris: Presses de l'Université de Paris-Sorbonne, 1986), pp. 13–25

MARCHESI, SIMONE, *Dante and Augustine: Linguistics, Poetics, Hermeneutics* (Toronto: University of Toronto Press, 2011)

MARNETTE, SOPHIE, 'Experiencing Self and Narrating Self in Medieval French Chronicles', in *The Medieval Author in Medieval French Literature*, ed. by Virginie Elisabeth Greene (New York: Palgrave Macmillan, 2006), pp. 115–34

MAROLD, EDITH, 'Introduction to "Glymdrápa"', trans. by John Foulks, in *Poetry from the Kings' Sagas 1, From Mythical Times to c. 1035*, ed. by Diana Whaley, 2 vols (Turnhout: Brepols, 2012), I, 73–74

MARTIMORT, AIMÉ-GEORGES, *The Church at Prayer: Introduction to the Liturgy*, ed. by Austin Flannery OP and Vincent Ryan OSB, trans. by Robert Fisher and others (Shannon: Irish University Press, 1968)

MARTINEZ, RONALD L., 'Dante and the Poem of the Liturgy', in *Reviewing Dante's Theology*, ed. by Claire E. Honess and Matthew Treherne, 2 vols (Bern: Lang, 2013), II, 89–155

MÄRZ, CHRISTOPH, and LORENZ WELKER, 'Überlegungen zur Funktion und zu den musikalischen Formungen der "Jenaer Liederhandschrift"', in *Sangspruchdichtung: Gattungskonstitution und Gattungsinterferenzen im europäischen Kontext*, ed. by Dorothea Klein (Tübingen: Niemeyer, 2007), pp. 129–52

MATTHEWS, DAVID, *Medievalism: a Critical History*, Medievalism, ed. by Karl Fugelso and Chris Jones, VI (Cambridge: Brewer, 2015)

MAXWELL, KATE, JAMES R. SIMPSON, and PETER V. DAVIES, 'Performance and the Page', in *Performance and the Page*, ed. by Kate Maxwell, James R. Simpson, and Peter V. Davies, Pecia: Le livre et l'écrit, ed. by Jean-Luc Deuffic, XVI (Turnhout: Brepols, 2013), pp. 7–15

MCCRACKEN, ANDREW, '*In Omnibus Viis Tuis*: Compline in the Valley of the Rulers (*Purg.* VII–VIII)', *Dante Studies*, 3 (1993), 119–29

McGrady, Deborah, 'What is a Patron? Benefactors and Authorship in MS Harley 4431, Christine de Pizan's Collected Works', in *Christine de Pizan and the Categories of Difference*, ed. by Marilynn Desmond (Minnesota: Minnesota University Press, 1998), pp. 195–214

McGuire, Brian Patrick, 'Purgatory, the Communion of Saints, and Medieval Change', *Viator*, 20 (1989), 61–84

McKay, Cory, 'Authentic Performance of Troubadour Melodies', <http://www.music.mcgill.ca/~cmckay/papers/musicology/TroubadourMelodies.pdf>

McLuhan, Marshall, *Understanding Media: The Extensions of Man* (London: Sphere Books, 1967)

McMahon, James V., *The Music of Early Minnesang*, Studies of German Literature, Linguistics, and Culture, ed. by James Hardin and Gunther Holst (Drawer: Camden House, 1990)

Meconi, Honey, 'The Unknown Hildegard: Editing, Performance, and Reception (An *Ordo virtutum* in Five Acts)', in *Music in Print and Beyond: Hildegard von Bingen to The Beatles*, ed. by Craig A. Monson and Roberta Montemorra Marvin, Eastman Studies in Music, ed. by Ralph P. Locke (Rochester, NY: University of Rochester Press, 2013), pp. 258–305

Meder, Stephan, *Rechtsgeschichte*, 3rd edn (Cologne: Böhlau, 2008)

Meulengracht Sørensen, Preben, 'The Prosimetrum Form 1: Verses as the Voice of the Past', in *Skaldsagas: Text, Vocation, and Desire in the Icelandic Sagas of Poets*, ed. by Russell Gilbert Poole, Ergänzungsbände zum Reallexikon der Germanischen Altertumskunde (Berlin: de Gruyter, 2001), pp. 172–90

Meyer, Kathi, 'St. Job as a Patron of Music', *The Art Bulletin*, 36 (1954), 21–31

Meyer, Rudolf Adelbert, 'Die in unseren Motetten enthaltenen Refrains', in *Die altfranzösischen Motette der Bamberger Handschrift nebst einem Anhang, enthaltend altfranzösische Motette aus anderen deutschen Handschriften mit Anmerkungen und Glossar*, Gesellschaft für romanische Literatur, ed. by Albert Stimming, XIII (Dresden: Gesellschaft für romanische Literatur, 1906), pp. 141–84

Milbank, Alison, 'Dante and the Lure of Beauty', *Dante Sermon Series*, Worcester College Chapel, <http://www.worcesterchapel.co.uk/2013/dante-and-the-lure-of-beauty-sermon-by-rev-dr-alison-milbank-february-24th-2013/>

Montemaggi, Vittorio, 'In Unknowability as Love: The Theology of Dante's *Commedia*', in *Dante's 'Commedia': Theology as Poetry*, ed. by Vittorio Montemaggi and Matthew Treherne (Notre Dame, IN: University of Notre Dame Press, 2010), pp. 60–94

Montemaggi, Vittorio, and Matthew Treherne (eds), *Dante's 'Commedia': Theology as Poetry* (Notre Dame, IN: University of Notre Dame Press, 2010)

Moser, Hugo, and Joseph Müller-Blattau, *Deutsche Lieder des Mittelalters: von Walther von der Vogelweide bis zum Lochamer Liederbuch: Texte und Melodien* (Stuttgart: Klett, 1968)

Müller, Ulrich, 'Beobachtungen zu den "Carmina Burana": 1. Eine Melodie zur Vaganten-Strophe — 2. Walthers "Palästina-Lied" in "versoffenem" Kontext: eine Parodie', *Mittellateinisches Jahrbuch*, 15 (1980), 104–11

Musa, Mark, *Advent at the Gates: Dante's 'Comedy'* (Bloomington & London: Indiana University Press, 1974)

Muschg, Walter, *Die Mystik in der Schweiz 1200–1500* (Frauenfeld & Leipzig: Huber, 1935)

Navàs, Marina, 'La figura literària del clergue en la poesia de Ramon de Cornet', *Mot so razo*, 9 (2010), 75–93

——'Le Registre Cornet: structure, strates et première diffusion', *Revue des langues romanes*, 117 (2013), 161–91

Newman, Barbara, *Medieval Crossover: Reading the Secular against the Sacred*, Conway Lectures in Medieval Studies (Notre Dame, IN: University of Notre Dame Press, 2013)

NICHOLS, BRIDGET, *Liturgical Hermeneutics: Interpreting Liturgical Rites in Performance* (Frankfurt a. M.: Lang, 1996)

NOULET, JEAN-BAPTISTE, and CAMILLE CHABANEAU, *Deux manuscrits provençaux du XIVe siècle contenant des pièces de Raimon de Cornet, de Peire de Ladils et d'autres poètes de l'école toulousaine* (Montpellier & Paris: Société pour l'étude des langues romanes, 1888)

O'DONOGHUE, HEATHER, *Old Norse-Icelandic Literature: A Short Introduction*, Blackwell Introductions to Literature (Oxford: Blackwell, 2004)

——*Skaldic Verse and the Poetics of Saga Narrative* (Oxford: Oxford University Press, 2005)

OED Online, 'Perform, v.', <http://www.oed.com>

——'Performative, Adj. and N.', <http://www.oed.com>

O'NEILL, MARY, *Courtly Love Songs of Medieval France: Transmission and Style in the Trouvère Repertoire* (Oxford: Oxford University Press, 2006)

ONG, WALTER J., *Orality and Literacy: The Technologizing of the Word* (London: Methuen, 1982)

ORCHARD, ANDY (ed.), *Cassell Dictionary of Norse Myth and Legend* (London: Cassell, 1997)

OTTER, MONIKA, *Inventiones: Fiction and Referentiality in Twelfth-Century English Historical Writing* (Chapel Hill & London: University of North Carolina Press, 1996)

OTTOSEN, KNUT, *The Responsories and Versicles of the Latin Office of the Dead* (Norderstedt: Books on Demand, 2007)

OUY, GILBERT, CHRISTINE RENO, and INÈS VILLELA-PETIT, *Album Christine de Pizan* (Turnhout: Brepols, 2012)

OZIMIC, DOLORES, *Der pseudoaugustinische Sermo CLX Hieronymus als sein vermutlicher Verfasser, seine dogmengeschichtliche Einordnung und seine Bedeutung für das österliche Canticum triumphale 'Cum rex gloriae'* (Graz: Dbv Verlag für die Technische Universität Graz, 1979)

OZTÜRKMEN, ARZU, and EVELYN BIRGE VITZ (eds), *Medieval and Early Modern Performance in the Eastern Mediterranean* (Turnhout: Brepols, 2014)

PAGE, CHRISTOPHER, 'German Musicians and their Instruments: A 14th-Century Account by Konrad of Megenberg', *Early Music*, 10 (1982), 192–200

——'Polyphony before 1400', in *Performance Practice: Music before 1600*, ed. by Howard Mayer Brown and Stanley Sadie (London: Macmillan, 1989), pp. 79–104

——*Discarding Images: Reflections on Music and Culture in Medieval France* (Oxford: Clarendon Press, 1993)

——*The Christian West and its Singers: The First Thousand Years* (New Haven, CT, & London: Yale University Press, 2010)

PARKER, ANDREW, and EVE KOSOFSKY SEDGWICK, 'Introduction: Performativity and Performance', in *Performativity and Performance*, ed. by Andrew Parker and Eve Kosofsky Sedgwick (New York: Routledge, 1995), pp. 1–18

PASTOUREAU, MICHEL, *Bleu: Histoire d'une couleur* (Paris: Seuil, 2006)

——*Blue: The History of a Color* (Princeton, NJ, & Oxford: Princeton University Press, 2001)

PÉPIN, GUILHEM, 'Quand le Béarn se disait gascon', *La Lettre de l'Institut béarnais et gascon*, 16 (2008), 6–8

PERAINO, JUDITH A., *Giving Voice to Love: Song and Self-Expression from the Troubadours to Guillaume de Machaut* (New York & Oxford: Oxford University Press, 2011)

PESCE, DOLORES, 'Beyond Glossing: The Old Made New in *Mout me fu grief/Robin m'aime/Portare*', in *Hearing the Motet: Essays on the Motet of the Middle Ages and Renaissance*, ed. by Dolores Pesce (New York & Oxford: Oxford University Press, 1997), pp. 28–51

PETZSCH, CHRISTOPH, 'Kontrafaktur und Melodietypus', *Die Musikforschung*, 21 (1968), 271–90

PHILLIPS-ROBINS, HELENA, ' "Cantavan tutti insieme ad una voce": Singing and Community in the *Commedia*', *Italian Studies*, 71 (2016), 4–20

PICKERODT-UTHLEB, ERDMUTE, *Die Jenaer Liederhandschrift: metrische und musikalische Untersuchungen*, Göppinger Arbeiten zur Germanistik, ed. by Ulrich Müller, Franz Hundsnurscher, and Cornelius Sommer, XCIX (Göppingen: Kümmerle, 1975)

PIPONNIER, FRANÇOISE, and PERRINE MANE, *Se Vêtir au Moyen Âge* (Quetigny: Société Nouvelle Adam Biro, 1995)

PIPPENGER, MARSHA MONROE, *Dinner in the City*, <http://pippengerart.com/?p=14>

PLUMLEY, YOLANDA, and ANNE STONE, 'Cordier's Picture Songs and the Relationship between the Song Repertoires of the Chantilly Codex and Oxford 213', in *A Late Medieval Songbook and its Context: New Perspectives on the Chantilly Codex (Bibliothèque du Château de Chantilly, Ms. 564)*, ed. by Yolanda Plumley and Anne Stone (Turnhout: Brepols, 2009), pp. 302–28

POIRIER, RICHARD, *The Performing Self: Compositions and Decompositions in the Languages of Contemporary Life* (London: Chatto & Windus, 1971)

POTTER, LOIS, 'Introduction', in *Playing Robin Hood: The Legend as Performance in Five Centuries*, ed. by Lois Potter (Newark: University of Delaware Press, 2003), pp. 13–19

QUEIROZ, JOÃO, and FLOYD MERRELL, 'Semiosis and Pragmatism: Toward a Dynamic Concept of Meaning', *Sign Systems Studies*, 34 (2006), 37–65

QUINN, JUDY, 'From Orality to Literacy in Medieval Iceland', in *Old Icelandic Literature and Society*, ed. by Margaret Clunies Ross (Cambridge: Cambridge University Press, 2000), pp. 30–60

RABATEL, ALAIN, *Homo narrans: pour une analyse énonciative et interactionnelle du récit* (Limoges: Lambert-Lucas, 2008)

RABY, FREDERIC JAMES EDWARD (ed.), *The Oxford Book of Medieval Latin Verse* (Oxford: Clarendon Press, 1959)

REISS, JOSEF, 'Pauli Paulirini de Praga Tractatus de musica (etwa 1460)', *Zeitschrift für Musikwissenschaft*, 7 (1924/25), 261–64

RETTELBACH, JOHANNES, 'Die Bauformen der Töne in der "Jenaer" und in der "Kolmarer Liederhandschrift" im Vergleich', in *Die 'Jenaer Liederhandschrift': Codex — Geschichte — Umfeld*, ed. by Jens Haustein and Franz Körndle (Berlin: de Gruyter, 2010), pp. 81–97

RIBERA, JULIÁN TARRAGÓ (ed.), *90 canciones de los minnesinger del códice de Jena*, La música andaluza medieval en las canciones de trovadores, troveros y minnesinger, III (Madrid: Maestre, 1925)

RIEMANN, HUGO, *Handbuch der Musikgeschichte*, 2 vols (Leipzig: Breitkopf & Härtel, 1904–13)

ROKSETH, YVONNE (ed.), *Polyphonies du XIIIe siècle: le Manuscrit H 196 de la Faculté de médecine de Montpellier*, 4 vols (Paris: Éditions de l'Oiseau Lyre, 1935)

ROSENBERG, SAMUEL N., and HANS TISCHLER (eds), *The Monophonic Songs in the Roman de Fauvel* (Lincoln & London: University of Nebraska Press, 1991)

ROSENBERG, SAMUEL N., MARGARET SWITTEN, and GÉRARD LE VOT (eds), *Songs of the Troubadours and Trouvères: An Anthology of Poems and Melodies* (New York & London: Garland, 1998)

ROTHENBERG, DAVID J., *The Flower of Paradise: Marian Devotion and Secular Song in Medieval and Renaissance Music* (New York: Oxford University Press, 2011)

—— 'The Most Prudent Virgin and the Wise King: Isaac's Virgo prudentissima: Compositions in the Imperial Ideology of Maximilian I', *The Journal of Musicology*, 28 (2011), 34–80

RUDOLPH, HARRIET, *Das Reich als Ereignis: Formen und Funktionen der Herrschaftsinszenierung bei Kaisereinzügen (1558–1618)* (Cologne: Böhlau, 2011)

RUSHING, JAMES A., 'Iwein as Slave of Woman: The "Maltererteppich" in Freiburg', *Zeitschrift für Kunstgeschichte*, 55 (1992), 124–35

RUSHWORTH, JENNIFER, *Discourses of Mourning in Dante, Petrarch, and Proust* (Oxford: Oxford University Press, 2013)

RZEPKA, VINCENT, *Sangspruch als Cultural Performance: zur kulturellen Performativität der Sangspruchdichtung an Beispielen Walthers von der Vogelweide* (Berlin: Logos, 2011)

SALMEN, WALTER, *König David — eine Symbolfigur in der Musik* (Freiburg (CH): Universitätsverlag, 1995)

SALTZSTEIN, JENNIFER, 'Relocating the Thirteenth-Century Refrain: Intertextuality, Authority and Origins', *Journal of the Royal Musical Association,* 135 (2010), 245–79

SCHAIK, MARTIN VAN, *The Harp in the Middle Ages: The Symbolism of a Musical Instrument* (Amsterdam & New York: Rodopi, 2005)

SCHENK, GERRIT J., *Zeremoniell und Politik: Herrschereinzüge im spätmittelalterlichen Reich* (Cologne: Böhlau, 2003)

SCHENKE, GESA (ed.), *Der Koptische Kölner Papyruskodex 3221, Teil I: Das Testament des Iob,* Papyrologica Coloniensia, XXXIII (Paderborn, and others: Schöningh, 2009)

SCHILTZ, KATELIJNE, and BONNIE J. BLACKBURN (eds), *Canons and Canonic Techniques, 14ᵗʰ–16ᵗʰ Centuries: Theory, Practice, and Reception History,* Leuven Studies in Musicology: Analysis in Context, 1 (Leuven: Peeters, 2007)

SCHMID, BERNHOLD, 'Das Alle dei filius aus dem Mensuralcodex St. Emmeram der Bayerischen Staatsbibliothek München (Clm 14274) und sein Umfeld', *Musik in Bayern,* 42 (1991), 17–50

SCHRADE, LEO (ed.), *Polyphonic Music of the Fourteenth Century,* I (Monaco: l'Oiseau-Lyre, 1956)

SCHUBIGER, ANSELM, *Die Sängerschule St. Gallens vom achten bis zwölften Jahrhundert: ein Beitrag zur Gesangsgeschichte des Mittelalters* (Einsiedeln & New York: Benziger, 1858)

SCHULZE, URSULA, *Geistliche Spiele im Mittelalter und in der Frühen Neuzeit: von der liturgischen Feier zum Schauspiel* (Berlin: Schmidt, 2012)

SCHUMACHER, ECKHARD, 'Performativität und Performance', in *Performanz: zwischen Sprachphilosophie und Kulturwissenschaften,* ed. by Uwe Wirth (Frankfurt a. M.: Suhrkamp, 2002), pp. 383–402

SCHÜRER, EMIL, *The History of the Jewish People in the Age of Jesus Christ,* rev. and ed. by Geza Vermes, Fergus Millar, and Martin Goodman, 3 vols (London, and others: Bloomsbury, 2014)

SCHWEERS, REGINE, 'Die Bedeutung des Raumes für das Scheitern oder Gelingen des Adventus', in *Adventus: Studien zum herrscherlichen Einzug in die Stadt,* ed. by Peter Johanek and Angelika Lampen (Cologne: Böhlau, 2009), pp. 37–55

SCHWEIKLE, GÜNTHER, *Minnesang,* Sammlung Metzler, 2nd edn (Stuttgart: Metzler, 1995)

SEAGRAVE, BARBARA GARVEY, and WESLEY THOMAS, *The Songs of the Minnesingers* (Urbana: University of Illinois Press, 1966)

SEARLE, JOHN R., 'Reiterating the Differences: A Reply to Derrida', *Glyph,* 1 (1977), 198–208
—— 'How Performatives Work', *Linguistics and Philosophy,* 12 (1989), 535–58

SEIDEL, HANS, 'Hiob, der Patron der Musiker', in *Alttestamentlicher Glaube und Biblische Theologie,* ed. by Jutta Hausmann and Hans-Jügen Zobel (Stuttgart, Berlin, & Cologne: Kohlhammer, 1992), pp. 225–32

SEYBOLD, KLAUS, 'David als Psalmsänger in der Bibel: Entstehung einer Symbolfigur', in *König David — biblische Schlüsselfigur und europäische Leitgestalt,* ed. by Walter Dietrich and Hubert Herkommer (Freiburg (CH) & Stuttgart: Kohlhammer, 2003), pp. 145–64

SHULL, JONATHAN, 'Locating the Past in the Present: Living Traditions and the Performance of Early Music', *Ethnomusicology Forum,* 15 (2006), 87–111

SINGLETON, CHARLES, ' "In exitu Israel de Aegypto" ', in *Dante: A Collection of Critical Essays,* ed. by John Freccero (Englewood Cliffs, NJ: Prentice-Hall, 1965), pp. 102–21

SMALL, CHRISTOPHER, *Musicking: The Meanings of Performing and Listening* (Hanover, NH: Wesleyan University Press, 1998)

SMITH, SUSAN L., *The Power of Women: A Topos in Medieval Art and Literature* (Philadelphia: University of Pennsylvania Press, 1995)

SOLTERER, HELEN, 'Letter Writing and Picture Reading: Medieval Textuality and the *Bestiaire d'amour*', *Word and Image*, 5 (1989), 131–47

SPEARING, A. C., *Medieval Autographies: The 'I' of the Text* (Notre Dame, IN: University of Notre Dame Press, 2012)

SPITZER, LEO, 'The Addresses to the Reader in the *Commedia*', *Italica* 32.3 (1955), 143–65

STEIN, FRITZ, *Zur Geschichte der Musik in Heidelberg* (Heidelberg: Universitätsdruckerei J. Hörning, 1912)

STEVENS, JOHN, '"Samson, dux fortissime": An International Latin Song', *Plainsong and Medieval Music*, 1 (1992), 1–40

STEVENS, MARTIN, 'The Performing Self in Twelfth-Century Culture', *Viator*, 9 (1978), 193–212

STOLLBERG-RILINGER, BARBARA, *Des Kaisers alte Kleider: Verfassungsgeschichte und Symbolsprache des alten Reiches* (Munich: Beck, 2008)

STONE, ANNE, 'Music Writing and Poetic Voice in Machaut: Some Remarks on B12 and B14', in *Machaut's Music: New Interpretations*, ed. by Elizabeth Eva Leach (Woodbridge: Boydell and Brewer, 2003), pp. 125–38

STRAUMANN, BARBARA, '"There Are Many that I Can Be": The Poetics of Self-Performance in Isak Dinesen's "The Dreamers"', in *Performing the Self: Constructing Premodern and Modern Identities*, ed. by Karen Junod and Didier Maillat (Tübingen: Narr, 2010), pp. 153–63

STROHM, REINHARD, 'European Politics and the Distribution of Music in the Early Fifteenth Century', *Early Music History*, 1 (1981), 305–23

——'"La harpe de melodie" oder Das Kunstwerk als Akt der Zueignung', in *Das musikalische Kunstwerk: Festschrift Carl Dahlhaus zum 60. Geburtstag*, ed. by Hermann Danuser and others (Laaber: Laaber, 1988), pp. 305–16

SUERBAUM, ALMUT, and MANUELE GRAGNOLATI, 'Medieval Culture "Betwixt and Between": an Introduction', in *Aspects of the Performative in Medieval Culture*, ed. by Manuele Gragnolati and Almut Suerbaum (Berlin & New York: de Gruyter, 2010), pp. 1–12

SULLIVAN, BLAIR, 'The Unwriteable Sound of Music: The Origins and Implications of Isidore's Memorial Metaphor', *Viator*, 30 (1999), 1–13

SUTHERLAND, ANNIE, 'Performing the Penitential Psalms in the Middle Ages: Maidstone and Bampton', in *Aspects of the Performative in Medieval Culture*, ed. by Manuele Gragnolati and Almut Suerbaum (Berlin & New York: de Gruyter, 2010), pp. 15–38

SWIFT, HELEN, *Gender, Writing, and Performance: Men Defending Women in Late Medieval France (1440–1538)*, Oxford Modern Languages and Literature Monographs (Oxford: Oxford University Press, 2008)

TABURET-DELAHAYE, ÉLISABETH (ed.), *Paris 1400: les arts sous Charles VI* (Paris: Fayard, Réunion des musées nationaux, 2004)

TAYLOR, JANE H. M., *The Making of Poetry: Late-medieval French Poetic Anthologies*, Texts and Transitions: Studies in the History of Manuscripts and Printed Books, 1 (Turnhout: Brepols, 2007)

TAYLOR, JANE H. M., and LESLEY SMITH (eds), *Women and the Book: Assessing the Visual Evidence* (London & Toronto: British Library and University of Toronto Press, 1997)

TERRIEN, SAMUEL, *The Iconography of Job through the Centuries: Artists as Biblical Interpreters* (Pennsylvania: Penn State University Press, 1996)

THIONG'O, NGŨGĨ WA, *Penpoints, Gunpoints, and Dreams: Towards a Critical Theory of the Arts and the State in Africa* (Oxford: Oxford University Press, 1998)

THOMAS, GEORG M., 'Der Einzug Kaisers Karl V. in München am 10. Juni 1530: zwei Briefe eines Venezianers als Augenzeugen', in *Sitzungsberichte der Bayerischen Akademie der Wissenschaften, Philosophisch-Philologische und Historische Klasse 1882*, ed. by the Bayerische Akademie der Wissenschaften/Philosophisch-Philologische Klasse (Munich: Verlag

der Bayerischen Akademie der Wissenschaften in Commission bei G. Franz, 1882), pp. 363–72

THOMSON, MATTHEW P., 'Interaction between Polyphonic Motets and Monophonic Songs in the Thirteenth Century' (unpublished doctoral dissertation, University of Oxford, 2016)

TISCHLER, HANS, 'The Performance of Medieval Songs', *Revue belge de Musicologie / Belgisch Tijdschrift voor Muziekwetenschap*, 43 (1989), 225–42

TISCHLER, HANS, SUSAN STAKEL, and JOEL C. RELIHAN, *The Montpellier Codex*, 4 vols, Recent Researches in the Music of the Middle Ages and Early Renaissance, II–VIII (Madison, WI: A-R Editions, 1978)

TREHERNE, MATTHEW, 'Liturgical Personhood: Creation, Penitence, and Praise in the *Commedia*', in *Dante's 'Commedia': Theology as Poetry*, ed. by Vittorio Montemaggi and Matthew Treherne (Notre Dame, IN: University of Notre Dame Press, 2010), pp. 131–60

TUCKER, DUNSTAN J., OSB., ' "In exitu Israel de Aegypto": The *Divine Comedy* in the Light of the Easter Liturgy', *The American Benedictine Review*, 11 (1960), 43–61

TURNER, DENYS, 'How to Do Things with Words: Poetry as Sacrament in Dante's *Commedia*', in *Dante's 'Commedia': Theology as Poetry*, ed. by Vittorio Montemaggi and Matthew Treherne (Notre Dame, IN: University of Notre Dame Press, 2010), pp. 286–305

TURNER, VICTOR, *From Ritual to Theatre: The Human Seriousness of Play* (New York: Performing Arts Journal Publications, 1982)

VAN HEMELRYCK, TANIA, and CHRISTINE RENO, 'Dans l'atelier de Christine de Pizan: le manuscrit Harley 4431', in *Du Scriptorium à l'atelier: copistes et enlumineurs dans la conception du livre manuscrit au Moyen Âge*, Pecia: Le livre et l'écrit, ed. by Jean-Luc Deuffic, XIII (Turnhout: Brepols, 2011), pp. 267–86

VILLELA-PETIT, INÈS, 'Les *Chroniques* de Froissart', *Art de l'enluminure*, 31 (2010), 24–45

VITZ, EVELYN BIRGE, 'The Liturgy and Vernacular Literature', in *The Liturgy of the Medieval Church*, ed. by Thomas J. Heffernan and E. Ann Matter, 2nd edn (Kalamazoo, MI: Medieval Institute Publications, 2005), pp. 503–63

VOIGT, KONSTANTIN, 'Gothic und HIP — Sinn und Präsenz in populären und in historisch informierten Realisierungen des Palästinaliedes', *Basler Jahrbuch für historische Musikpraxis*, 32 (2008), 221–34

VON DER HAGEN, FRIEDRICH HEINRICH, *Minnesinger: Deutsche Liederdichter des zwölften, dreizehnten und vierzehnten Jahrhunderts*, 4 vols (Leipzig: Barth, 1838)

VÖTTERLE, KARL, 'Hiob: Schutzpatron der Musiker', *Musik und Kirche*, 23 (1953), 225–32

WACHINGER, BURGHART, *Deutsche Lyrik des späten Mittelalters*, Bibliothek des Mittelalters, ed. by Walter Haug, XXII (Frankfurt a. M.: Deutscher Klassiker Verlag, 2006)

WALTERS, LORI J., 'Depictions of Books and Parchment Sheets in the Queen's MS (London, British Library, Harley MS 4431)', <www.pizan.lib.ed.ac.uk/waltersbooksandletters.rtf>

WARE, J. H., *Not with Words of Wisdom: Performative Language and Liturgy* (Washington, DC: University Press of America, 1981)

WARNOCK, G., 'Saturday Mornings', in *Essays on J. L. Austin*, ed. by Isaiah Berlin and others (Oxford: Clarendon Press, 1973), pp. 31–45

WASSELYNCK, RENÉ, 'Les Moralia in Job dans les ouvrages de morale du haut moyen âge latin', *Recherches de Théologie ancienne et médiévale*, 31 (1964), 6–11

—— 'L'Influence de l'exégèse de S. Grégoire le Grand sur les commentaires bibliques médiévaux (VIIe–XIIe s.)', *Recherches de Théologie ancienne et médiévale*, 32 (1965), 157–204

WATANABE-O'KELLY, HELEN, 'Entries, Fireworks and Religious Festivals in the Empire', in *Spectaculum Europaeum: Theatre and Spectacle in Europe 1580–1750*, ed. by Pierre Béhar and Helen Watanabe-O'Kelly (Wiesbaden: Harrassowitz, 1999), pp. 721–42

WELKER, LORENZ, 'Melodien und Instrumente', in *Codex Manesse: Katalog zur Ausstellung vom 12. Juni bis 2. Oktober 1988 Universitätsbibliothek Heidelberg*, ed. by Elmar Mittler and Wilfried Werner (Heidelberg: Edition Brauns, 1988), pp. 113–26

—— 'Die "Jenaer Liederhandschrift" im Kontext großformatiger liturgischer Bücher des 14. Jahrhunderts aus dem deutschen Sprachraum', in *Die 'Jenaer Liederhandschrift': Codex — Geschichte — Umfeld*, ed. by Jens Haustein and Franz Körndle (Berlin: de Gruyter, 2010), pp. 137–47

WERF, HENDRIK VAN DER, *The Chansons of the Troubadours and Trouvères: A Study of the Melodies and their Relation to the Poems* (Utrecht: Oosthoek, 1972)

WETZEL GIBBONS, MARY, 'Christine's Mirror: Self in Word and Image', in *Contexts and Continuities (Proceedings of the IVth International Colloquium on Christine de Pizan (Glasgow 21–27 July 2000))*, ed. by Angus Kennedy and others, 3 vols (Glasgow: University of Glasgow Press, 2002), II, 367–96

WHATLING, STUART, 'Narrative Art in Northern Europe, c. 1140–1300: A Narratological Re-Appraisal' (unpublished doctoral dissertation, University of London, 2010)

WIEDEBURG, BASILIUS CHRISTIAN BERNHARD, *Ausführliche Nachricht von einigen alten teutschen poetischen Manuscripten aus dem dreyzehenden und vierzehenden Jahrhundert, welche in der Jenaischen akademischen Bibliothek aufbehalten werden* (Jena: Melchior, 1754)

WINEMILLER, JOHN T., 'Lasso, Albrecht V, and the Figure of Job', *Journal of Musicological Research*, 12 (1993), 273–302

WIORA, WALTER, *Das deutsche Lied: zur Geschichte und Ästhetik einer musikalischen Gattung* (Wolfenbüttel: Möseler, 1971)

WIRTH, UWE, 'Der Performanzbegriff im Spannungsfeld von Illokution, Iterabilität und Indexikalität', in *Performanz: zwischen Sprachphilosophie und Kulturwissenschaften*, ed. by Uwe Wirth (Frankfurt a. M.: Suhrkamp, 2002), pp. 9–60

WISSE, MAARTEN, *Scripture between Identity and Creativity: A Hermeneutical Theory Building upon Four Interpretations of Job*, Ars Disputandi, Supplement Series, 1 (Utrecht: Igitur, 2003)

WOLF, KLAUS, 'Theater im mittelalterlichen Augsburg: ein Beitrag zur schwäbischen Literaturgeschichtsschreibung', *Zeitschrift des historischen Vereins für Schwaben*, 101 (2008), 35–45

WRIGHT, CRAIG, *The Maze and the Warrior: Symbols in Architecture, Theology, and Music* (Cambridge, MA, & London: Harvard University Press, 2001)

WÜRTH, STEFANIE, 'Skaldic Poetry and Performance', in *Learning and Understanding in the Old Norse World: Essays in Honour of Margaret Clunies Ross*, ed. by Judy Quinn, Kate Heslop, and Tarrin Wills (Turnhout: Brepols, 2007), pp. 263–81

YRI, KIRSTEN, 'Thomas Binkley and the Studio der Frühen Musik: Challenging "the Myth of Westernness"', *Early Music*, 38 (2010), 273–80

YUDKIN, JEREMY, *Music in Medieval Europe* (Englewood Cliffs, NJ: Prentice Hall, 1989)

ŽAK, SABINE, *Musik als 'Ehr und Zier' im mittelalterlichen Reich: Studien zur Musik im höfischen Leben, Recht und Zeremoniell* (Neuss: Dr. Päffgen, 1979)

ZANINI, FILIPPO, 'Liturgia ed espiazione nel *Purgatorio*: sulle preghiere degli avari e dei golosi', *L'Alighieri*, 34 (2009), 47–63

ZINK, MICHEL, 'Froissart et la nuit du chasseur', *Poétique*, 41 (1980), 60–76

ZOTZ, THOMAS, 'Präsenz und Repräsentation: Beobachtungen zur königlichen Herrschaftspraxis im hohen und späten Mittelalter', in *Herrschaft als soziale Praxis: Historische und sozial-anthropologische Studien*, ed. by Alf Lüdtke (Göttingen: Vandenhoeck & Ruprecht, 1991), pp. 168–94

ZUMTHOR, PAUL, *La Lettre et la voix: de la 'littérature' médiévale* (Paris: Seuil, 1987)

Audio-Visual Resources

ENSEMBLE LABYRINTHUS, 'Carmina Anglica', 2012, <https://www.youtube.com/watch?v=ujRpJ4rW2AI>

SEQUENTIA, *Visions from the Book* (catalogue number 05472773472), BMG Classics, 1996

VITZ, EVELYN BIRGE, 'Performing Medieval Narrative Today: A Video Showcase', filmed in 2007 and put online in 2012, <http://mednar.org/2012/06/13/samson-and-delilah/>

Miscellaneous

<http://takebackhalloween.org/christine-de-pizan/>

<https://www.rubylane.com/item/61838-506533x20nx2fa1937/Christine-De-Pisan-Earrings-Sapphire-Quartz?search=1>

INDEX OF FIRST LINES

❖

SUBJECT INDEX

9 781781 883785